PICTURING CASABLANCA

PICTURING

CASABLANCA

*Portraits of Power
in a Modern City*

SUSAN OSSMAN

UNIVERSITY OF CALIFORNIA PRESS
BERKELEY LOS ANGELES LONDON

This book is a print-on-demand volume. It is manufactured
using toner in place of ink. Type and images may be less
sharp than the same material seen in traditionally printed
University of California Press editions.

University of California Press
Berkeley and Los Angeles, California

University of California Press, Ltd.
London, England

© 1994 by
The Regents of the University of California

Library of Congress Cataloging-in-Publication Data
Ossman, Susan.
 Picturing Casablanca: portraits of power in a modern city /
Susan Ossman.
 p. cm.
 Includes bibliographical references and index.
 ISBN 0-520-08402-0 (alk. paper). — ISBN 0-520-08403-9
(pbk. : alk. paper)
 1. Casablanca (Morocco)—Civilization. I. Title.
DT329.C3O87 1994
964'.3—dc20 93-36561
 CIP

Printed in the United States of America

CONTENTS

ACKNOWLEDGMENTS

It is difficult to know where and when a project like this one begins and ends. Its themes were sparked by ads in the Paris metro, by random thoughts as I worked for a San Francisco newspaper, by notions that struck me when I adopted the apparently more serious posture of the student, huddled over her desk. Regardless of this dubious genesis, I can clearly identify those who have helped me through the long process of research and writing. Ann Henstrand, Mary Sims, Benjamin and Michael Lapp, and Professors Peter Brown and Martin Jay had particular influence on my early thoughts about images and culture. Later, as the study that would become this book took form, I was fortunate to be able to discuss the project with Professors Ira Lapidus, Todd Gitlin, and Aihwa Ong in Berkeley and Rémy Leveau in Paris. Paul Rabinow's direction and comments have been crucial from the start; without his confidence and encouragement this project would certainly not have been possible.

Lawrence Michalak, Abdellah Hammoudi, Hassan Elboudrari, Pierre Bourdieu, Jean-François Clement, and Dale Eickelman all offered incisive remarks on the project that would become this book. Miriam Lowe, Yves Gonzalez-Quijano, Jim Fabion, Abderrahman Lakhssasi, and Mustapha Kamal read different chapters or versions of the dissertation on which this book is based. Hannah Davis attentively read the entire manuscript. Catherine Rouslin and Antonella Casellato generously sent me documents and materials difficult to obtain in Morocco. Naomi Schneider's patience throughout the editing process has been decisive. I thank all of these people and my parents, Edward

and Camille Ossman, as well as my sisters, Linda, Mary, Laura, Kathleen, and Julie, for their support.

Morocco has been an ideal, if complex, place to do research. I especially thank those who first welcomed me here: Saïd, Haja Touria, Fatima, Nejiba, Nadia, Amina, and the rest of their family. During my stay in Casablanca, André Taïeb, Viviane Simon, Edward Thomas, Adrienne Alvord, and Fatima Badri each helped me in his or her own way. Mati's stories of Casablanca life, visible or concealed, played a special role in my understanding of the city. I am grateful too to the Institute of Journalism in Rabat, the British Film Institute, the AFEMAM (Association Française pour l'Étude du Monde Arabe et Musulman), Antoine Sfeir and *Les Cahiers de l'Orient*, the CERI, the University of Provence, La Maison de l'Orient in Lyon, and the IREMAM in Aix-en-Provence, all of which have provided forums to discuss some of the ideas developed in the course of this study. Many people who appear in the book will not find their names here. Pseudonyms replace the names of informants unless they have publicly signed the articles or speeches I cite.

Various stages of research for this study were made possible by grants. A Humanities Research Grant and a Lowie Grant from the Anthropology Department from the University of California at Berkeley provided funding for preliminary fieldwork. A Foreign Language Area Study scholarship enabled me to improve my Arabic. Research in France was made possible by a Bourse Chateaubriand, while fieldwork in Morocco was sponsored by the Institute of International Education and the Department of Education Grants for Doctoral Research.

The end of this project demands apologies to my son Nathanaël, who often complained about my intense preoccupation with my "computer," but who is satisfied with my work now that it has been transformed into the palpable form of a book.

TRANSLITERATION AND TRANSLATION

The conversations, articles, and television programs referred to in this work were originally heard or read in French, the Moroccan dialect of Arabic, or the Modern Arabic employed in the press. Unless otherwise noted, all translations are my own; the notes also cite published English translations.

In Morocco, many Arabic words have standard transliterations in the Latin alphabet; I have employed these when possible. Otherwise, I have relied on *A Dictionary of Moroccan Arabic*, edited by Richard S. Harrell and Harvey Sobelman. However, I have indicated only those emphatic letters included in the Arabic alphabet and have simplified the vowels in ways that will, I hope, facilitate pronunciation for English-speaking readers. Long vowels are indicated by macrons.

The following list gives approximate pronunciations for phonemes unfamiliar to most English-speaking readers:

ʔ	A glottal stop, similar to the sound *eh*
ḍ	Emphatic *d*
g̲	Similar to the French *r* (*r grasseyé*)
h	Similar to the English *h* in "home"
H	Similar to the English *h* but emphatic
q	Similar to the English *q* pronounced deep in the throat
q̣	Like the English *g* in "good"

r Like the Spanish rolled *r*

š Similar to the English *sh* in "shoe"

ṣ Emphatic *s* (like English "sod")

x Like the German *ch* in "Bach"

ᶜ A sound made at the back of the throat, unlike any sound in English

INTRODUCTION

♦♦♦ When French military officers first projected films at the palace
of the sultan of Morocco in 1913, they hoped to excite a "salutary
terror" in their subjects. Coming from the Europe of the *belle
epoch*, with its fascination for spirits, fortune-tellers, and esoteric
parlor games, General Gallieni and Colonel Marchand lauded the
pacifying powers of the cinema, saying that it "immediately gives its
possessors the reputation of sorcerers."[1] They captivated their audi-
ence by magically possessing and projecting ghostly images. What real
powers and possessions might be gained through such optical illu-
sions? This book ventures to answer this question from the perspective
of Casablanca, a city whose development parallels that of the mass
image.

The technology of the cinema was based on the repetitive, me-
chanical technology of the machine gun, yet from the beginning its
military implications were shrouded in debates about its status as a
seventh art, a scientific tool, and a commercial venture.[2] Film frames
pass through the camera and projector just as individual bullets pass
through machine guns, with assembly-line regularity, yet the separate
frames are visible only to those who actually handle the film stock itself.
A film's projected images cast a spell of forgetfulness over the makers
themselves, who lose sight of the designs of their own productions as
the steady stream of light pours out pictures and sounds. While the
movie screen reflects this steady current of pictures, moonlike, tele-
visions mimic the sun, emitting their own rays into well-lit homes.

Movies and television are part of a modern visual universe that
includes other mechanically reproduced images, among them pho-

tographs and posters. With the development of easily reproducible images, sights were rearranged and new objects brought into the range of vision. Everywhere, a new diffusion of images and discourses altered ways of knowing. Ideas about who or what should be seen were modified. Who shuffles pictures around once they are drawn? Who frames pictures? Who appears in them? Why are some kept hidden while others hang in conspicuous places?

These questions and many more troubled European modern artists and publics alike, and thus these new ways of producing images were often labeled as scandalous or revolutionary.[3] Yet, viewed from other continents, where the movie camera, the printing press, and photographs were often introduced all at once, these "revolutionary" forms appeared simply to carry on already existing European artistic traditions. In Europe, films, photographs, and magazines divided space and time into gridlike sections in accordance with Cartesian rationality. They altered ways of seeing but still took into account notions of square frames and perspective, which were a part of everyday European existence.[4] For all their modernity, the ways in which new image technologies were developed demonstrated certain deeply ingrained norms of sight.

Many avenues of expression were available to those who discovered and developed new image-making machines during the late nineteenth and early twentieth centuries. To the dismay of some artists, though, the cinema mainly adapted already widespread theatrical forms. Some European intellectuals saw movies as degenerate theater; only a few sought to develop films that were not merely stories joined to images.[5] But the direction pursued by most filmmakers is not surprising, given that the illustration of stories is central to European sensibility: think of the cartoonlike progression of the Stations of the Cross. If the camera's eye promised a "vision of Cyclopes, not of man," this new, inhuman gaze developed both humanist memories and scientific and military design.[6] And while modern artists proposed new avenues for aesthetic exploration, the development of easily reproducible images gave the impression that ordinary people now had access to a pictorial universe formerly reserved for the wealthy. In Europe, for example, painted portraits had been a mainstay of elite and ecclesiastic art for centuries. But with the advent of photography everyone could suddenly examine and display his or her own image or collect those of loved ones.[7] Snapshots could be framed or pocketed.

Intellectual and artistic traditions are rarely limited to a single "culture," if by this term we mean a shared practical and symbolic world. This is especially the case in societies where writing or other techniques for the preservation of knowledge emerge. In such instances a specialized body of knowledge can affect a variety of social settings in various ways, but with the potential of imbuing each setting with shared styles of expression or social organization. If the filmlike progressions of illustrated stories demonstrate the relationship between words and pictures in the European tradition, then what configuration of sight and sound was disturbed when pictures of people began to dance over the walls of the sultan of Morocco's palace?

The sultan possessed portraits of his ancestors, and European arts such as easel painting were known, if not practiced, in Morocco. Yet people outside the palace knew important persons by their names or legends, not their faces.[8] Unlike Europeans, Moroccans did not carve busts of their saints and heroes in stone, nor did they paint images of objects on canvas. This pictorial reticence is not simply the proof of the Muslim imperative of iconoclasm. Rather, it expresses an aesthetic and ethical understanding of the relationship between divine creation on the one hand and humanity and its innovations on the other. This understanding was certainly linked to interpretations of the law, yet this same law was conceived differently in, for example, Persia and India; indeed, in earlier eras people were standard subjects of secular art in the Middle East.[9]

In pre-Protectorate and much current Moroccan design, beauty and meaning are said to spring not from practices of disinterested contemplation but from the object's relationship to space, from the harmonious play of light and shadow. Austere exteriors of buildings often hide opulent interiors, much as the flowing robes of urban women once masked elaborate undergarments and their savant use of jewelry, which they displayed indoors.

Contrasts between black, white, and color inform the aesthetic arrangements of light and shadow, silence and sound—in short, presence and absence. And, while presence is inhabited by color, pattern, and words, people cast their shadows on emptiness.

In the Moroccan context, art is not distinguished from design or architecture. Ibn Khaldun, for example, distinguishes between two main categories of human activity, ᶜ*ulūm* and *ṣinā* ᶜ *a* ᶜ *ulūm*, or "sciences," deal with the abstract intellectual disciplines of philoso-

phy, mathematics, science, and religious sciences. Ṣinā ʿ a, or "crafts"
(from the root *s-n-'*, "to make"), include architecture, agriculture,
music, medicine, and all other manner of activities. *Finn*, or "art,"
simply means the method of perfecting a craft. Artistic practices are
learned mimetically, through imitating and then assisting a master.[10]
Any activity can be accomplished artfully. Today *finn* has also come
to mean "art" in the European sense.

Aesthetic forms in Morocco have always changed over time in
response both to changing local tastes and to influences from far-off
places.[11] Persian or Portuguese motifs appear in Moroccan embroi-
dery.[12] In Fes fashions for clothing, slippers (*blāgi*), and jewelry
formerly followed a two-year cycle based on the liturgical calendar.
Fasi ladies from well-to-do families used this calendar to decide when
to send their silver jewelry to be melted and recast in the latest styles.[13]
Innovation (*bid ʿ a*) was controlled but not arrested by religious in-
terpretations of holy law and social regulations effected by a guild
system in the cities. Patterns of power always manifest themselves in
aesthetic forms, but this relation is perhaps clearest in monarchical
systems. In Morocco each new dynasty reworked existing aesthetic
forms in unique ways; indeed, artistic periods are dated according to
dynasties. Powerful rulers sought to awe their followers, their rivals,
and posterity by building magnificent mosques, palaces, and schools
(*medāris*). These forms both symbolized might and structured social
life.

French rule and movie houses alone did not transform Morocco's
fashion and art, but these influences brought new ways of inducing and
comprehending change that came to alter the relationship between
different types of activities. People's faces and memories, their neigh-
borhoods and notions of public life, were slowly yet powerfully re-
framed with reference to changing constellations of aesthetics, ethics,
and science. When the limits of the visible push beyond habitual
frames, individuals' senses of their bodies, their identities, and their
place in the universe are transformed. Mass images have been crucial
to modern change. To take part in the world of modern sight, one needs
only to see; yet to master the production of images requires familiarity
with the rationality that sets up frames of sight. In Morocco, European
conventions of representation could not be disconnected from other
aspects of Protectorate power and new modes of economic and social

organization that accompanied it. New ways of seeing elicited novel relationships of figure and ground, the individual and the universe.

Some Arabic-speaking regions had become acquainted with modern European images and ways of knowing before the twentieth century. Indeed, leaders like Mohammed Ali in Egypt adopted and adapted some European practices in the hope of countering European power.[14] Art forms of European origin, such as the theater and the novel, played a role in the *nahḍa*, the Middle Eastern "Renaissance."[15] Although Moroccan sultans and traders took an interest in these developments, locally they had little impact. The nineteenth century was a period of internal unrest in Morocco. Moroccan leaders were preoccupied with Europe's expanding power—especially after 1830, when the French took over Algeria—but, disregarding some movements for *tanzimat*-style reform under the leadership of the Sultan Moulay Hassan, the Moroccan *Maxen* (government) adopted a generally isolationist stance.[16]

Despite official reticence with respect to Europe, during the nineteenth century Moroccans became accustomed to drinking tea from teapots forged in Manchester. Tea drinking spread from urban, trading milieus to become an integral part of hospitality throughout North Africa. And in 1894, while urban Moroccans were adding fresh mint leaves to their Asian tea in English pots, the death of the Sultan Moulay Hassan brought the fourteen-year-old Moulay Abdelaziz to the throne.

Although the sobriety of Morocco's whitewashed, unadorned walls impressed visiting Europeans, the new sultan was criticized for his interest in the new and exotic. His palace was full of phonographs, cameras, caged animals, and fireworks; indeed, some observers speculated that his advisers encouraged his taste for new gadgets to divert his attention from state affairs. Be that as it may, Abdelaziz's problems were more historically rooted and more complex than such criticisms suggest: Morocco was poorly positioned to ward off colonialist ambitions, and fighting between elite factions within the kingdom reflected varied alliances with European powers. When the Protectorate was declared in 1912, a new order was proclaimed that promised to shelve both internal divisions and the fancies of decadent rulers.[17]

Louis Hubert Gonsalve Lyautey, the first resident general of Morocco, was instrumental in establishing this new order. Displeased

with the petit bourgeois spirit that characterized Algeria's coloniza-
tion, Lyautey aimed to preserve what he saw as typically Moroccan
principles of social hierarchy and to harmonize these principles with
modern knowledge. From the start of the Protectorate, cities, edu-
cation, law, and government were all conceived according to a two-
tiered model. New French cities were built alongside existing cities
(*mūdūn*), and traditional education and the Arabic "free schools" of
the independence movement developed alongside French institutions
of learning. Most important, pre-Protectorate legal systems—as well
as the government, the *Maxen*, and the ruling Alawite dynasty—were
left intact, although their decisions were always subject to the control
of the colonial administration.

The social and spatial divisions drawn by administrators were not
always well integrated with the practices of "unruly" Moroccans and
the poor Europeans who migrated to Morocco from around the Med-
iterranean. Especially in the burgeoning city of Casablanca, people and
things came together in unpredictable ways. Streets filled with mo-
torcars, and workers moved from the fields into new factories. Ca-
sablanca grew with noisy spontaneity, a witty rebuttal to Lyautey's plan
for a harmonious separation of social groups.[18] Clocks, factories, mov-
ies, and European ladies in scant summer dresses became common
sights in Casablancan streets. New ways of arranging the visible became
part of daily life at the same time that styles of talking about pictures
and social life began to echo discourses then current in Europe.

In pre-Protectorate Morocco no public buildings were traditionally
set up for performance arts. Stories were told at home, among friends,
or in public plazas. There were scholars, but no theater critics to claim
legitimate knowledge in analyzing the dramatic arts.[19] When forms
like the theater and the cinema arrived in Morocco, intellectual and
aesthetic debates followed in their wake. Easel painting, sculpture,
artistic debates, articles about movie stars in popular magazines—all
arrived in Casablanca at once. Many ideas about the strategies of the
European cultural industries prove of little help in understanding new
uses of images in Morocco. In Europe critics often used the early
cinema as evidence to "demonstrate" the demise of bourgeois culture
and the propagation of mass culture; in Morocco there was no anal-
ogous class and cultural configuration. Yet intellectual discourses were
often adopted in their "imported" forms, and these forms influenced
how people conceived of their own practices. At the same time, issues

of colonialism came to preoccupy intellectuals both in the colonies and in France itself.

As people in Morocco became involved in increasingly global discourses of art and politics, new demands for painting, cinema, and literature adapted to "Moroccan imaginations" began to emerge.[20] Local claims for self-representation included European models of knowledge and protest imported by the elite, who also referred to the Arab East, the Mashrek, where the problems posed by these new types of knowledge had already been addressed.[21] In the 1930s young militants in favor of independence adopted Western-style theater as one means of expressing their views.[22] New social categories, like those of the artist, the novelist, and even the schoolteacher, came into existence. At the same time, orientalist conventions were given new forms with the dissemination of movies, magazines, and books from Europe. Stereotyped pictures of Arabs were now observed by the people they were supposed to represent as well as by *colons* whose position made them into bodily representatives of the European.[23] Criticisms of orientalism are common in recent scholarship, yet the problem of establishing "real" pictures of Arab cultures remains. Indeed, more attention needs to be given to demands for images deemed authentic. Documentary films, news photographs, and texts encouraging progress all participated in a discourse of social reform that transformed ways of discussing pictures throughout the world.

Louis Lumière's crew shot the first film footage of Morocco in 1895. The resulting film, *Le chevrier marocain*, was to be part of a series of films made to familiarize French audiences with distant places. Confident that he could broaden the outlook of the average Frenchman, Lumière framed his efforts with pronouncements about science and realism.[24] Education would be made pleasurable and exciting thanks to the nearly immediate contact with distant places and peoples. "The cinema takes us to Japan, to Canada, to Chile, to the North Pole, to the Cape of Good Hope; . . . it offers images *only eight hours old*."[25] While metropolitan audiences were the first to view these distant places, those in the colonies soon took their place before the silver screen. This journalistic concern with documentary and speedy viewing brought European audiences into seemingly direct contact with parts of the world that many of their leaders hoped to dominate. A taxonomy of geographic and physical characteristics resulted from these efforts, which—like academic and particularly ethnographic

studies of the period—bear witness to a certain naïveté in their confident realism. Then as now, progressive publications peddled the notion that a "realistic" presentation of social problems would somehow cure these ills and inevitably enlighten people. Those who protested the overt deprecation of the colonized often looked to science, education, and realism as means of escaping the prejudice of fantasy. The fanciful stories and commercial aims of Egyptian films and American melodramas were, and continue to be, berated by those who consider science, progress, and reform as inextricably joined.

It is significant that both progressive critics and the French government saw the development of the Egyptian cinema and its popularity in Morocco as a major source of grief, although for different reasons. After World War II the French authorities realized that the only films in Arabic reaching Moroccan audiences were coming from Egypt. The Centre Cinématographique Marocain (CCM) was created in 1947 to encourage the development of a Moroccan national cinema that could be controlled by the Protectorate. This policy echoed those developed by Lyautey decades earlier to encourage a local press to offset the influence of newspapers published in the Spanish-controlled north.[26] At the beginning of the century French journalists were quickly deported if their messages did not conform to the official outlook. Similarly, those who sought to use film to criticize the exploitation of women or workers could hardly hope to relay any nationalist slogans through a Protectorate institution. Still, the realists hoped at least to avoid the sentimentality of popular Egyptian films.

The most important issue for those in power was the creation not of art but of audiences. Some popular forms of entertainment, like the music hall and popular theater, could include local or idiosyncratic themes, but the cinema relied on large audiences and repeatable experiences. In Morocco audiences of all origins could be exposed to the same images and stereotypes current in Europe.[27] National news items and drama alike could be uniformly diffused in this way. Commercial success depended on attracting crowds and developing themes with wide appeal. Audiences and publicity agencies came into being all at once, giving birth simultaneously to stars whose personae were projected on screens, newspapers, and city walls. Stars' and politicians' images sprang out of movies and into daily life to incite new social practices, altering clothing styles, slang, and ideas about relations between men and women. Practices previously associated with

bohemian outsiders and manners invented by idiosyncratic stars could be quickly adopted by eager movie fans. New combinations of commerce and sentimentality became possible as people of diverse backgrounds and mother tongues were immersed in a suddenly similar world of visual and literary references.

These changes affected all aspects of life in Morocco during the Protectorate, and since independence the debate about national art, cinema, and television has remained lively. Would new forms of power be expressed "realistically," following the contours of modern truth, or would the mass media perpetrate new kinds of delightful fantasy, mimicking the Egyptian movies that, according to most progressive intellectuals, perverted the masses? Two general styles of perceiving and acting out relationships among drama, images, and ideas of society are suggested if we think of this contrast in terms of the two modes of Muslim piety in Morocco: Salafite reformism and Sufi brotherhoods.

Salafite Islam animated many of those in the Moroccan movement for national independence. Different currents of reformist ideas were associated with the Wahhabites of eighteenth-century Arabia and writers like Egypt's Mohammed Abduh. In Morocco, as in neighboring Algeria, nationalists reacted against both the colonial power and popular religious practices in the hope of encouraging a more sober, text-oriented style of religious expression. Those influenced by Salafite ideas used "the emphasis on divine unity . . . as the basis of a bitter critique of Sufi beliefs and practices. The reformers denounced the veneration of saints and beliefs in miracles and attempted to use rational arguments to demystify rural Sufism."[28]

Sufism was particularly strong in Morocco, where it provided mystical alternatives to the orthodoxy of the ᶜ*ulamā* (religious scholars, notables) and laid the basis for a complex system of tribal alliances that was the main mode of political organization before the accession of the Alawite dynasty in the sixteenth century. Indeed, the present king himself is a *šrīf*. His family, like other saintly families, is esteemed for its links with dead holy men and ultimately with Mohammed; many people look to saints and their descendants (*šurfā*) for spiritual and practical guidance. Today Sufi brotherhoods (*zawāyya*) remain models for group association even though their explicit power has waned. They provide networks of solidarity and continue to shape religious feeling through often spectacular rituals.

The distinction between those who venerate saints and the Salafites is not absolute in daily practice. For this reason one might see the contest between Maraboutism (saint worship) and reformist currents of Islam as a metaphor, but not a taxonomical guide, for understanding the complex intertwining of thought and aesthetic expression in contemporary Morocco. While the Salafites point toward austere rationalism and iconoclasm, saints serve as intermediaries between the self and God. While the words of the Koran and the Sunna are the main signposts for reformers, music, dance, and ecstatic states mark the rituals of brotherhoods like the Aissawa, the Tijanniya, and the Hamadsha.[29] Magic, like mysticism, is opposed by reformers.[30] How could they sanction using Koranic verses as mere talismans for such purposes as harming a neighbor, winning back a husband's affection, or driving off the *žnūn* (genies)?

As mentioned above, General Joseph Gallieni hoped that the magical aspect of motion pictures would serve his designs, but magical images are powerfully ambiguous.[31] And while we might designate sorcerers as beyond the pale of usual human concerns, their power in Moroccan society cannot be ignored. In contrast, the Salafite viewpoint and secular intellectualism, both inherently rational, eschew ambiguity in favor of verbal debate and legal consensus. Words might be veiled, but ideally they have single meanings. Dichotomies between reason and fancy, austerity and baroque display, seemed at first to be problems that could be eliminated by the spread of literacy and related notions of piety. We must keep in mind that discourses of education, progress, and power available in Morocco also depended for their diffusion on the increasingly refined magic of internationally or nationally produced mass images. Similarly, scholars have suggested that those who fought for national independence—from Abdelkrim, who led the early resistance to the Spanish in the north, to the bourgeois leaders of the *Istiqlal* (independence movement) and the socialist leader Ben Barka—had to adopt the relational styles of the *zawiyya* to be credible to their followers.[32]

The Protectorate had laid the groundwork for new, "rational" arrangements of the visible. Yet these new visions were often understood in terms of social relations that were not in perfect synchrony with the plans of administrators or the modern boulevards of Casablanca. The future seemed to belong to leaders who could portray their modern schemes in charismatic or magical forms, combining existing local

motifs with international ones. After independence in 1956, power was no longer made palpable in the French symbol, Marianne;[33] nevertheless, the ways of representing power introduced by French administrators and movie magazines would live on.

With the return of King Mohammed V and the monarchy's resumption of effective power in 1956, new traditions developed for representing the relationship between royal persons, now photographically embalmed, and the people. The king's image was given a new role as the entire fabric of vision became ever more enmeshed in the routinized creation of charisma. The quality of *baraka* (grace) had always been attributed to saints, wise men, and sultans. Like the qualities of *ʔdāb*, correct and graceful comportment, *baraka* is perceived immediately. One can neither claim it nor sense how one recognizes it; it simply is. With the advent of the camera, *baraka* was represented with increasing frequency through photographs and film.

Today photographs of the king are mandatory in public places. In homes, too, people often display pictures of authority figures: the king, fathers, sons. Youths often sleep in bedrooms filled with the dreamlike images of Bob Marley or Aouwaïta, the Moroccan track star. In stores one finds pinups, travel posters, and advertisements for Egyptian films, all ranged alongside photographs of the king. Koranic verses are taped over old advertisements for car oil, and soccer heroes take their place next to Bruce Lee or Sylvester Stallone. This seamless wallpaper of posters, postcards, and photographs fails to divide experience in terms of Lyautey's division of Moroccan and European. Television brings the public world into the heart of the home in the form of a moving, framed picture.

Studying how these images participate in creating contemporary Casablanca may be likened to deconstructing the movies as an experience, a form of knowledge, and a technique. As we watch a film, a shadowy linking of persons and objects builds up narratives that we can understand, at least if we are familiar with the character types and the script's formulas. As audiences we want to know how stories end; as citizens or subjects we wonder about how these stories influence us to accept opinions or purchase products. We think less often about what technical rationale underlies the smooth projection of a film, or how images give rhythm to our lives, or how they help to arrange space and create group sentiment. To study mass images is to consider each

of these matters by pondering the meaning of places these pictures cannot or should not go. There are no photographs in mosques, nor are there movie screens in offices, yet mass-produced images clog our streets, pervade our conversations, and clothe our bodies. The ingenuity of these pictures is at once diffuse and directed, centered in specific strategies of power, and constantly being recomposed through extensive though minuscule changes in the everyday disciplines of self and society.

The outline of the present project was first traced in Paris in 1983 when I began a historical study of Moroccan cinema and television. In 1987 and 1988 I traveled regularly between Paris and Morocco to conduct in-depth interviews with those who create and select images for television, movies, and the press. At the same time I began to examine how people of diverse backgrounds watch, talk about, and make images. Originally I planned to concentrate on those groups who depend most on mass images and information for gaining knowledge: that is, not the elite, who can acquire firsthand information about national or local issues, but rather those "middling" people whose cultural and economic capital allows them the broadest possible access to mass imagery but who are less likely to have personal connections to powerful figures. This approach had the advantage of avoiding preconceived notions of social, family, or group status. However, the actual research proved more complex than I had envisioned. By the time I settled in Casablanca in the fall of 1988, it was clear that my research would be about the limits of images in Casablanca and the limits of my own images of society drawn from American and European scholarship. How could I distinguish between "European" and "Moroccan" discourses about sight and society in a place where such talk has developed in a context of constant interrelation?

Paradoxically, the modern situation—with its proliferating media, international trade, mobile populations, and regional and global conflicts—intensifies exchanges between countries and regions while defining the nation-state as the legitimate seat of power and the primary source of identity. Some anthropologists have examined the effects of the world economy on local life and beliefs, often presenting a scenario in which worldviews confront each other, with the weaker party being transformed by the stronger. Often symbolic worlds and whispered stories are seen as potential sources of resistance to external powers. Here I suggest that, although powerful differences in worldviews must be considered, we can understand our modern antinomies only if we

remember that they are shared, even though such sharing may engender or deepen inequities. This consideration suggests that we must reexamine both the role of the state and holistic notions of culture. Indeed, we must reconsider how state or regional formations promote specific ideas of culture and how academic approaches to the study of society incorporate—or fail to incorporate—the conceptions of the people themselves.

Communications specialists generally adopt European and American research methods to conduct studies throughout the world. In such studies the notion of social class, for instance, is often seen as given. The nuclear family grouped around the television is proposed as the norm, and the head of the household, usually the father, offers his profession as a sign of his family's sociological status. But how do we determine who in a social group, and especially in a family, should be considered the source of economic and cultural capital? The nuclear family is becoming increasingly prevalent in Morocco, yet the extended family remains important. Still, compared to families in American and European societies studied by media analysts, in Morocco even nuclear families are often quite large. In nearly all of the settings I have come to know in Morocco, people of varied backgrounds gather to discuss images on television and in magazines. In a region with very high unemployment, non-work-related identities are often more important than those related to professional activities. Maids and other servants are common in households that are far from well-off by American and European standards, and these servants are intimately involved in the lives of family members. Widely diverse economic and cultural backgrounds can exist within a single family: it is not uncommon for a university professor or the president of a large company to have an illiterate mother. Linguistic competencies also vary within groups or even in a single individual in different situations. My research did not refute assumptions that social class affects how people view and relate to images, but my findings did inflect those assumptions by considering the variety of social situations in which images participate in daily life and the perpetual reinvention of society.[34]

The people I write about give much importance to determining social status, but their ways of according status differ. Identification with neighborhoods is often used to indicate social position. I met with people in the "popular" (working-class) quarters of Aïn Chok and Derb Kebir, in the elite areas of Anfa and Polo, and in the changing neighborhood of the Maarif. Many of my most intriguing observations

were made in public areas like the Arab League Park and the wide boulevards of the city. I spoke with people of all ages, individually, with groups of friends, or at home with their families. When I generalize about "Casablancans" or "youths" or groups, I draw on countless encounters with people in Casablanca and throughout Morocco. These generalizations are based on the frequency with which I heard or observed certain discourses or practices. I do not pretend that they are representative in a statistical sense, for my purpose is not to reveal an average or to discover a single system of "Moroccan" representation. The limits of the possible, the lineaments of the seen, the contours of meaning—these are not the same for all Casablancans, let alone all Moroccans. However, in my search for the frameworks of social distinction, I was perhaps most astonished at how often people from different areas of the city, and even different nations, brought up similar issues. Their positions with respect to the matters in question differed widely, but the patterns and themes they evoked were strikingly consistent. The rhythms of modern technique certainly had something to do with these regularities.

In this study I have tried to follow the constructivist path evoked by Roland Barthes in his study of photography. This study, he remarks, has

> nothing to do with a corpus, just some bodies. In this debate, after all quite conventional between subjectivity and science, I came upon this bizarre idea: why wouldn't there be, in a way, a new science through the object? A "mathesis singularis" (and no longer universalis)? I accepted therefore to take on as mediator all of Photography: I would try to formulate, starting from some personal movements, the fundamental trait, the universal without which there would be no Photography.[35]

In Casablanca I could perceive no single fundamental trait, but certain motifs appeared regularly in images, in texts, on streets, and in people's words. Once I identified these motifs, I pursued each through questioning and observation. I adopted what I call a "strong placement" of myself in an effort to follow these pictures rather than others. By this I mean that I deliberately focused on specific images that, without providing a key to the entire society, appeared to offer ways of comprehending apparently inexplicable practices. By saying that my position as a researcher was "strong," I likewise seek to underline the fact that the images that I saw and the discourses that I hear were often

previously known to myself and the people I met in Casablanca. This meant that my own position required taking stands and expressing preferences concerning these shared references. From the beginning I found the process of debating, disagreeing, and learning new approaches to already known problems were central to my research: I was not merely soaking up local culture. Throughout this project I constantly restated and reworked my chosen subjects in interactions with others. The object of the study, my own image, and the tone of my relationships with many people were touched by this initial framing of purpose. Amid the movement of Casablancan life, I used these chosen images to focus my gaze and to determine the significance of what I might witness. The different frames given to specific images often coincided with limits of daily discourse or practice.

As you read, you will certainly notice that I dwell most on unusual or problematic practices or events. Because meaning and action are founded in difference and choice, the range of possible practices and imaginations is often best exemplified by the peculiar, the dangerous, the new and strange.[36] For native Casablancans and foreigners alike, the familiar and the strange continually blend, entwine, diverge, and metamorphose. Instead of showing itself all at once, strangeness gradually entered this study as I tried to understand what remained hidden behind all of the ostentation of modern Casablanca. Part of the unseen was unseeable, like the logic behind the regular flow of people in the street. Other obscure objects appeared unthreatening at first but inspired fear or uncertainty on closer examination. The strangest stories I heard had little to do with ideas of the supernatural or the alien. The dangerous zones were not those places haunted by genies (*žnūn*), who—like all sensible beings—flock to water. Instead, people complained of being seized as they entered the stairwells of modern office buildings, of being taken forcibly to police stations, of being accosted as they walked to school. That which is not visible usually cannot be directly named. Outcasts or children may speak of unseeable objects or persons, but mature and right-thinking members of societies tend to recognize only the legitimate invisibles, whether genies or quarks. Only in exceptional situations do the norms of visibility become a matter of intense debate.[37] That which is hidden is not simply what is strange to outsiders. The unseeable is often strangeness itself, and it can embody the inadmissible or unexplained in oneself or in relationships, including those between nations or social groups.

Visions appear in nightmares or crystallize in delightful fantasies. Seeing is not always believing, but by arranging what is visible, people attempt to convince others that some visions are true, others mere chimeras. Even "natural" practices—gestures of friendship or respect, manners of walking, judgments on neighbors' new clothes—can suggest how groups are formed, see themselves, and wish to be seen. Why cling to certain objects as significant cultural traits while throwing others on the scrap heap? This question is posed daily for Casablancans and anthropologists alike.

What I have called a "strong placement" of the researcher assumes that anthropology is a reflexive activity, but one that cannot today be presumed to be based on an "ethnographic" experience of utter difference (in which the researcher yet seeks some universal human community). Neither the process of research nor the object of study can be represented as a separate theater with its own cultural script. Complicities and conflicts between ethnographers and those whose lives and societies they try to describe take place on stages that are partially shared. The fact that an ethnographer or an informant may be viewed as a representative of one or another group is important, but we cannot accept such simple equations as the basis of ethnographic study itself. In this book I seek to explore ways of taking into account variable identities and their relationships to knowledge. Only by distinguishing these variations and their relative significance can we begin to discover which "concrete universals" bear the most weight. Only once we determine these universals can we begin to comprehend the subtle strategies of modern powers.

Part of what determines one's role in international exchange is the language one uses. Casablancans generally speak Moroccan Arabic, and Arabic is the main language taught in public schools. Knowledge of French and other European languages has become more widespread since the end of the Protectorate and the expansion of public education. Berbers are increasingly bilingual but continue to speak their own languages: Rifian in the north; Tamazight in the Middle Atlas, Central High Atlas, and Sahara; and Tashelhit in the High and Ante-Atlas.[38] Television and movies have familiarized many people with other dialects of Arabic.

The existence of a single creed has had important effects on how images operate in Morocco. Islam's central text, the Koran, does not offer easy or unique solutions, as indicated by the many contrasting

interpretations of the religion.[39] But it does assemble these diverse voices in a common claim to truth.[40] The main points of contention among the various interpretations are now translated in differing positions regarding what should be seen and what concealed. Debates about good and evil, orthodoxy and heresy, often focus on problems of what should be seen or hidden and when. Because positions in the religious realm imply points of view concerning authority and power, religion and politics often share a common symbolic space.

In writing about images in Casablanca, I quote both Casablancans and scholars. The text offers a collage of discourses calculated to raise questions that do not always receive definitive answers. In the first part of the study I enter the city of Casablanca and sketch an initial impression; I then return to places and situations that display some of the regularities that organize sight or make it a subject of conflict. In the second part I explore how images are created and changed in political dramas. How does mass-produced imagery affect national borders? Is it productive or destructive of the nation? How have modern ways of diffusing ideas altered the relationship between various nations and their leaders? The third part of the book investigates how images pattern everyday life and influence values. The role of portraits is especially important, for despite appearances, mass imagery cannot easily represent practical power as legitimate authority. How can any single figure extricate itself from the contemporary profusion of images to gain singular influence?

After the sultan Mohammed V was exiled by the French for his nationalist stance, people said that they saw his image reflected on the moon.[41] Hence, the moon served as the first screen for projections of the national image. Now the tides of life daily immerse people in imagery, strewing the sea wrack of photographs and posters and magazines across living rooms already inundated by the watery blue light of television. People live their lives in the company of pictured persons they will never meet, but the details of whose lives they feel they know. To express alternatives to these images, or to use them for one's own designs, requires an understanding of the logic that animates them. Perhaps the switch from the moon to electronic screens can be best understood from the perspective of the uncultured port city of Casablanca. There the moon is often hidden by thick fog, or by the throbbing of neon signs.

Chapter One

URBANITY AS A WAY TO MOVE

*There is only image in movement, and in
no case can we define art by the form that
it uses as a support.*

Pierre Francastel,
L'image, la vision et l'imagination

♦
♦♦ Images freeze movement, demonstrating choice. Once sights
♦ are set in pictures, fleeting experience is stilled. Movement is not
banished; rather, it appears residual, a memory of the process
of fashioning the image, a reference to potentially disturbing spaces
beyond the edges of pictures. The image becomes an object or an icon.
Nasser's face becomes an effigy: does it express Arab nationalism, or
does it help constitute that complex concept?

If photographs demonstrate choices and form ideas, it is no wonder
that many people in Casablanca flee photographers in the street. What
kind of knowledge might one procure by fixing their figures? What
words might describe these transitory impressions?

Photography and film have long been used to survey, examine, and
create identities. Susan Sontag notes that "starting with their use by
Paris police in the murderous roundup of communards in Paris in June
1871, photographs became a useful tool of modern states in the
surveillance and control of their increasingly mobile populations."[1]
Photographs and films, like maps, systematically create identities and
highlight traits, whether of people or cities. In Morocco, where much
of the population lived a seminomadic existence before their "paci-
fication" by the Protectorate, the ways in which moving or still pictures
can be used to observe, classify, or create cannot be considered as
simply a means of creating stillness out of sudden population move-
ment. Indeed, if there are only images in movement, the momentary

identity recorded on celluloid must be put into a broader narrative before it can assure knowledge and control. Stillness makes us feel the existence of things or persons, yet it is their trajectory through space and time that makes them objects of knowledge. Movement, whether that of histories or of stories, makes pictures make sense.

To know Casablanca, the observer must note the patterns of its abrupt contrasts between frenzied motion and collected composure, then listen to the stories people tell to explain these shifts. The cadence of these tales is already set for the visitor according to how he or she arrives in the city.

The high-speed train from Rabat to Casablanca is comfortable, and its passengers are calm. People are on their way to work or to see friends. Some chat politely; others look out the window at patches of countryside interspersed with factories and low-income housing. From the train, the shantytowns we pass coming in from the north appear not quite real. They glide past swiftly, reminding me of photos of poor children in ads for charities in magazines. A young mother beside me is reading *Snow White* to her daughter. A man across the aisle studies an engineering manual while a woman knits a sweater.

The train skates smoothly over the rails, but arrival makes everyone jump up and prepare to move in new ways. At the Casa-Port station, the door slides open to let all of the noise and dust of the metropolis dispel the smooth and orderly version of the city that the train has lulled us into accepting as real.

Driving from the station toward home, Amina and I begin to move and converse to the syncopated rhythm of frenetic traffic, weaving between trucks and motorbikes down long, broad boulevards. The city's four- and five-story apartments, all nearly identical, all pale-complexioned, appear solid and stable next to the haphazard world of the street. As we make our way homeward, horse-drawn carts provoke traffic jams and set irate motorists on edge. Horns mix with pedestrians' shouting. Taxi drivers pilot their vehicles amid motorbikes as though we were all in an enormous video game.

From the car we see the city close-up. But unless we take a cab with a talkative driver, our thoughts about what we see remain tied to languages and perspectives that we ourselves have brought to Casablanca. On the bus, by contrast, we get a chance to tune into the distinct accents of this fast-paced, multilingual town. When I take bus number four to visit my friend Halima, I whisk past signs in Arabic and French and hear women inside the bus, on their way to visit relatives, conversing in Berber dialects. Everyone rushes, and even words

seem in a hurry to get somewhere. Like riders hopping off buses or speeding to the train station, conversations in Casablanca reduce the scattering words to the shortest, most essential forms. This is true not only of the Moroccan dialect of Arabic, which tends to eliminate or shorten standard Arabic vowels, but also of the local treatment of foreign words, which are rapidly incorporated and shortened in daily discourse: the street itself is referred to as the *šanṭe*, gleaned from the French word *chantier*, "construction site."

Indeed, Casablanca itself is a perpetual *šanṭe* in both senses of the word. Because of its apparently chaotic movement, Casablanca is often said to be a city without memory. Its population seems more intent on tearing down and building anew than in preserving vestiges of the past. Most of Casablanca's people are recent or second-generation migrants from elsewhere in Morocco. Peasants move to the city fleeing poor harvests or drought; Fasi businessmen from old urban families seek new business opportunities there; youths hope to acquire technical training in the city's trade or business schools. No one quite knows how many people live in Casablanca, but official estimates of three and a half million appear to be low. The birthrate is high throughout Morocco, but higher yet in Casablanca. The average person is under twenty-five years old. In recent decades the rural exodus has certainly exceeded by far the latest census figures.[2]

In the street, communication seems fierce, swift, effortless. Talk is rampant, greetings effusive. In fact, though, establishing continued links with other people can be quite difficult. Casablanca is enormous and growing daily. Bridging distances requires money, time, or both. Telephones remain luxuries because of a paucity of lines. People stand in long queues at the post offices to make phone calls, send telegrams, or mail packages or letters. Many people cannot write, and those who can often explain that they are too busy to write letters to friends. Bus lines crisscross the city, yet riding buses demands patience, especially at rush hour, when the buses are packed. Not surprisingly, even poor Casablancans will make enormous sacrifices to purchase cars or motorbikes. Once "motorized," one is free to move from place to place, in search of a friend, a newspaper, or an ocean breeze on a humid August evening.

What image might make sense of all of Casablanca's exuberance? Photographs and films proffer light's reflections as evidence of being, proof of the real. Like rays emanating from distant stars, the reflected

light embalmed in photographic images is always proof of something that *has been*. While maps of Casablanca create an illusion of order, rushing residents are caught in a heady struggle to produce a present that can be formed into an image only at some later time.

Images from the past take on meaning as people weave stories around them. This process is clear when people talk about significant pictures:

> We watch a film in which Mohammed V appears with his daughter, who wears only a scarf covering her hair. Khadija explains to me for the fifth or sixth time that this means that her father has allowed her to appear in public. (We have seen this image together several times on television and in the newspaper.)

The film reveals a face and a scarf to show how the monarch condoned new norms of appearance for women following Morocco's independence.[3] The film clip remains a subject of discussion, a springboard for stories about the moment when the monarch unveiled his daughter and, consequently, other women of her generation. The image from the past generates contemporary discussions about Moroccan history and women's place in society. Khadija learned to repeat the story of the scarf from her mother, who was a young woman at the time. As Khadija recounts the tale, her mother nods, sometimes interjecting her own comments about the independence movement.

If images were self-evident, mothers would not need to explain pictures to their children. When people in Casablanca insist that their city has no past, they mean that pictures of the past fail to link their own experiences to meaningful stories about the city as today. Casablanca is the largest city in Morocco, but much of what goes on there can appear meaningless if placed within historical frameworks of urban life in Morocco.

All around the Mediterranean the division between urban and rural remains the most pertinent separation of space and society.[4] Ibn Khaldun uses this contrast to analyze the rise and fall of North African dynasties, equating the Bedouin lifestyle with the group ᶜṣbiyyah (social group feeling) that animates conquering peoples. The progressive adoption of urban ways leads to the gradual fragmentation and decadence of each successive conqueror.[5] Once a dynasty has become "urbanized," its power will inevitably wane; other groups, armed with ᶜṣbiyyah, will take control, and the cycle begins again.

In pre-Protectorate Morocco, residence within a city did not automatically confer urban identity, which depended instead on profession or descent from a saint. Kenneth Brown notes the perception of this stratification in the words of the scholar ad-Doukkali, who wrote in 1895 that "the rural way of life (*al-badiya*) differs from the urban way of life (*al-Hāḍara*). The former is practiced by peasants and the needy of the city; the latter includes the learned, gentlemen farmers, craftsmen and merchants, builders, officials and those with lineages."[6] Urbanity did not include the lower orders of society, even if these people actually resided within city walls. A map alone could not explain the city. Social and cultural considerations necessarily inflected the meaning of city limits.

Today social categories related to this older urbanity remain perceptible in the ways in which people categorize one another. People from the historic cities of Fez, Meknes, Rabat, Marrakesh, and Sale continue to claim special knowledge of urban lifestyles. Fasis (people originally from Fez) are often seen as particularly representative of the kind of exclusive lifestyle developed in Moroccan cities in the past. Protectorate policies saw to it that prominent families from Fez and other urban centers were favored for educational and business advancement. Despite this favored status, such families played a leading role in the movement for independence and have consolidated their power since that time. However, the symbolic import of the urbanity associated with the old imperial cities goes beyond relationships of power. The contrast of Fasi ways to peasant (ᶜ*rubi*) manners is a constant theme in Casablancan conversations.

Casablancans preserve links to their extended families who live elsewhere. For some, relations with the countryside remain important because they glean revenue and products from rural property. For others, especially those of the traditional urban trading class or the rising Soussi merchant families from the south, family and regional connections prove more essential than actual products. These personal relations, like the relations between the various regional groups, are being transformed in and by the new urban universe. Practices and identities continue to refer to the past, but they are juxtaposed to other ways of life, whether reinterpreted traditions or new inventions. For example, one Casablancan woman told me, "Fasis aren't really Moroccans. They speak French, eat like foreigners, and act like them." Fasis and others from old cities respond to such remarks by claiming a superior *art de vivre*. This superiority apparently justifies their

continuing claim to cultural and economic dominance. The Fasi cuisine or accent is contrasted to ᶜ*rubi* manners. Indeed, one uses these "types" to talk about people who are "like" Fasis, which might imply that they are too dainty, too squeamish, too sophisticated. Originally the term ᶜ*rubi* referred to people from a region just east and south of Casablanca, but it has come to include unworldly or uncultured behavior or persons in general.

Despite an influx of migrants from older urban centers, Casablanca's urban lifestyle differs from those of the historic Moroccan or Muslim cities. While people from the traditional imperial cities (Fez, Marrakesh, Sale, Rabat, and Meknes) cling to older ideas of the urban, massive migration from the countryside has brought rural practices to Casablanca in a cross-fertilization of varied traditions that has changed the meaning of the urban in Morocco. Such processes of change are also apparent in the countryside. Today most nomads have been made sedentary, and modern agribusiness, first developed during the Protectorate, exists alongside the small plots of family farmers (*fellāHīn*). Thus, industrial modes of production, consumption, and time management are not unique to the city. This interpenetration of urban and rural manifests itself in striking images: some Casablancans keep chickens and goats on their roofs; and in the High Atlas, I once watched in awe as a peasant woman, resplendent in white, spike-heeled shoes and a tight miniskirt, painfully made her way up a muddy red trail in a thunderstorm.

In the mountains or at the beach, tourists lounge around elaborately decorated hotels, cocktails in hand. Tourism not only brings in foreigners but increasingly puts rural people into contact with Moroccans from the city. People from the countryside also travel to Casablanca and other cities, in both Morocco and even Europe, to work or visit friends and relatives. Even the most isolated villagers have radios, and many display photographs or decorated plates purchased in distant cities or local markets. For some migrants to Casablanca, the immensity of the city and the long hours in the streets prove unbearable, and they return to their homes with a new outlook on life. One man I met, who had returned to his mountain village after working briefly in Casablanca, commented:

> I just didn't like it there very well. It was so humid and polluted. I had to live in miserable conditions, and work wasn't always easy to get. I like it up here in the mountains where things are calm. I just

couldn't get used to the city life. Too many people! My brother's
down in Rabat; I visit him sometimes, but I don't want to live there.

While some people leave Casa to return home, others go abroad to
work or study. As we shall see, dreams of "elsewhere" are extremely
important in how Casablancans talk about their own actions and ideas.
Often such "elsewheres" are important because the places shown on
posters or television are associated with the styles and ways of knowing
so essential to social mobility in Morocco itself. If Casablanca illus-
trates the necessity of new movements, it is not surprising that people
often express impatience with the limits they find as they try to make
a life there. The "other" places to which one might travel in one's
peregrinations may come to include romantic versions of the coun-
tryside, or even one's family's village.

One hotel I visited illustrated graphically the transformation of the
countryside into a romantic getaway. As I was passing through a village
in a desolate valley in southern Morocco, I found a pleasant-looking,
smallish hotel. As my friends and I crossed the threshold, we were
greeted by a mixture of African music and French and English con-
versation. A short black man in a cutoff T-shirt and white turban,
unlike any I'd seen before, welcomed us."Hey man, bonjour, I'm
Speak," he said.

"Yeah, that's Speak," chimed in a skinny Frenchwoman carrying a
baby.

The hotel did not have electricity, they told us, but candles were
provided. Water could be had only from an outside well, which, we
discovered, bore the inscription "Françoise and Hamid 1985." Soon
other guests arrived in an assortment of colored vans—Swiss, they
said. The big boss, apparently the Hamid of wishing-well fame, led
them to a back room. Later the new guests played at drawing water
from the well. As they lugged the water into their room to wash, we
noticed that each room already had running, if cold, water.

During the evening they all brought out guitars and began singing
folk songs in English. An evening breeze brought the odor of their
smoke—and the loud, off-key sounds it engendered—into our room.
What did any of this have to do with our tour of Morocco? It seemed
like a sentimental mixture of Jack Kerouac and Paul Bowles, not a way
to come to know the Moroccan countryside.

In the nearby mountains, whole villages lacked fresh water and
electricity. Here, by contrast, the hotel owners and guests played

with deprivation, as if they wanted to banish what was happening in the mountains, or to parody it. All distinctions of nation and race, city and countryside, seemed to vanish into thin air. This evening spent listening to weak voices cough up songs from the 1960s made it, for me, the quintessence of tourism, for tourism is defined not so much by material comfort or relaxation as by the creation of this indistinct, never-never land of nonspace. Here the tourist space was defined not by any locality but by an opposition to other tourist spaces.[7]

Large hotels in Casablanca form a part of this tourist world as much as they do a part of the city itself. The Hyatt hotel in the center of town stands out like a black beauty mark against the white walls of the rest of the city, its decor a tracery of red.[8] A page in my field notes contrasts its air-conditioned predictability with the August city streets:

> When the summer air is hot and gray with pollution, we can be as cool and as collected as any film star by going to the Hyatt. After all, here we can go to a bar called "Rick's Place," where the world of daily cares fades as quickly as the heat of the city. People are cool, and most appear well-off. Unidentifiable songs play as we order Heinekens.
>
> "Casablanca? Why it's everywhere here; just look at Bogie laughing at us up there!" proclaims an Austrian tourist, pointing at one of the posters from the film *Casablanca*. We all laugh at his comment, for we know that we are conversing in a world that has little to do with the heat of the Casablanca summer.
>
> But perhaps we laugh too quickly. People from all over the city and the world come to Rick's Place to savor this Casablanca, with its air-conditioning and cocktails. And although the experience is relatively affordable for foreigners with European salaries, the success of this dream of the city is clearest when we see local people here. They are paying a high price for Rick's version of the place where they live. Maybe it acts as an antidote to other versions of Casablanca.

The city that is a place where people sleep, eat, and talk hides behind the elusive exoticism promised by the stills from the movie. In the hotel, people's differences are subsumed under simple headings of nationality and profession. Perhaps the controlled atmosphere of the Hyatt comforts those people who desire to flee complexity and confusion, to escape momentarily the sheer, unexpected variety of daily life.

People's stories rarely begin in Casablanca: it is an end or waypoint of narrative, not its origin. When questioned, those who are "just Casablancans" usually relate stories of how their families came to the city from elsewhere. If we think of the experience of Casablanca according to older divisions of urban and rural, we will see it as a nonplace, a passageway. But this city is more than a transitional space between urban and the rural, the local and the foreign. Indeed, its emerging brand of urbanity might point to new combinations of identity and society. Casablanca might then be seen as a vision of what Morocco might become, even though the contours of this possibility remain inchoate.[9]

Residents often seem to excuse the city's problems as a necessary evil, part of the cost of work or investment opportunities or cosmopolitanism. These matters are in turn related to the city's openness to international currents and its ready access to the port, airport, and road system. People who do want to emphasize their Casablancan identity often do so defensively, insisting that their families have lived in the area for many generations, if not centuries; yet they speak as though their claim to identification with the space of the city is in vain. Just as the film *Casablanca*, shot in California, offers an illusion of Casablanca, so too does the city itself seem to be made of dreams and prefabricated houses; it is impossible to link it to a time before movies, imported from elsewhere.

Indeed, the city's name conjures up a romantic movie set in the minds of most Americans and Europeans. The film *Casablanca* is about getting to the promised land, flying off to America or joining the Resistance. It tells of unhappy love and sacrifice. Its characters seem destined to meet once only in this way station called Casablanca. We do not glimpse the city itself; only its name shapes this interlude that determines each character's destiny. Casablanca exists only as a place to leave.

> "Can I tell you a story?" Ilse asks. Then she adds: "I don't know the finish yet."
> Rick says: "Well, go on, tell it. Maybe one will come to you as you go along."

The film is epitomized by this invitation to unfold an uncertain script.[10]

Casablancans might be expected to dislike foreigners' incessant references to the filmic Casablanca as an imaginary substitute for the actual place. In fact, few people seem opposed to such a blending of cinema and real life. Most Casablancans have come to the city from elsewhere, and many dream of leaving again some day. The fervent desire to find love and a promised land that animates the film's protagonists is not foreign to those who come to Casablanca in search of work, a visa, or a more exciting life. Casablanca is a crossroads. In an uncanny way, the celluloid Casablanca is emblematic of the complex social relationships that actually take form in the real city. For those who live there, it often seems that Casablanca has taken Rick's advice and let its story come to itself as it goes along.

If pictures need memory's stories to give them meaning, then the assorted rhythms, styles, and languages that have created Casablanca have yet to be linked by coherent relationships with the past. The radically different Casablancas we experience if we enter the city by train, by car, or by bus might provide a clue to the etiology of the city's collective amnesia. People must keep moving toward the climax of their stories in the city; only later can they sit down to tell and retell tales of how they got to where they are now.

Perhaps these stories will begin with the antique city of Anfa, which stood on Casablanca's present site. They will surely mention that as early as the eighteenth century Casablanca was an important center of trade. By the nineteenth it was attracting people from throughout Morocco and from abroad to try their fortunes in this new "boom-town." As Paul Rabinow writes:

> Casablanca's dynamic commercial activity, its ethnic mix, its wide disparities of wealth and power, and its particular energy and order were evident from the early years of the century. Casa's population had risen from 700 in 1836 to roughly 20,000 (including some 5,000 Jews) by 1907, including a floating population of 6,000 Moroccans fleeing rural drought and drawn by the city's commercial activity. . . . During the period of insecurity and invasion from 1907 to 1912 the European population of Casa exploded: from 1,000 in 1907 to 5,000 in 1909 to 20,000 in 1912 (12,000 of them French). . . . By the beginning of 1914, Casablanca housed some 31,000 Europeans (15,000 French, 6,000 Spanish, 7,000 Italians, etc.). Two-thirds of the Europeans living in Morocco lived in Casa. The Jewish population expanded rapidly, reaching 9,000 by 1912, as did the Muslim (30,000 by 1912). On the

eve of the Protectorate, "la bourgade miserable" (the miserable market town) was thriving.[11]

Although Casablanca was never reputed for its cultural or intellectual contributions, it was known for its commerce, for its role as a catalyst for popular revolt, and for the nouveau riche display of its successful businesspeople and administrators. It is no surprise that the "Marechal" Lyautey actively disliked this port town, where the marks of money and power were clearly visible from the first. The brute force of wealth, and the potential for disorder among the emerging working-class or lumpen proletariat populations, too clearly revealed the duplicitous nature of the Protectorate's harmonies.[12]

Presently at least 50 percent of Moroccans live in cities, most of them in a single coastal strip running from Kenitra in the north to El Jadida in the south. By the end of the century this urban sprawl will include at least 60 percent of the population. Even the old parts of historic cities like Rabat and Sale account for small parts of the total urban area. The kind of road-oriented, makeshift environment common in Casablanca is becoming more prevalent in all other urban zones of Morocco as well. Many of the intermediate-sized one-company towns of the center, for example, resemble working-class Casablanca neighborhoods.[13]

Interestingly enough, Lyautey's complaints about Casablanca live on in the worries of the authorities who try to organize the city and in the words of many people who live elsewhere in Morocco. Rabatis, for example, often complain about Casa's noise and disorder or the near absence of green spaces. Rabat, chosen as the country's capital by Lyautey, is only forty-five minutes away from Casa by train, and the cities are linked by the only freeway in the country. Another major industrial city, Mohammedia, lies between these two; thus, the urban area between Casa and Rabat appears increasingly uniform. Yet Casablancans often view Rabat as orderly, policed, and set in its administrative ways, whereas Rabatis frequently complain that Casablancans care only for money and power and intimate that Rabat has somehow preserved ancestral values. But many people from rural Morocco see Rabat and Casablanca as a single urban agglomeration, indistinguishable parts of the same anonymous, dog-eat-dog world.

Casablanca's relation to the past points the direction for the rest of the country. Its most "traditional" quarter is a reproduction of Fez,

imagined by French architects and built to standards of modern hygiene.[14] This neighborhood seems a fitting monument to the manner in which Casablanca continues to reinterpret what it sees as its heritage. The recent wave of postmodernist architecture again brings up the controversial use of the past in current visual forms. Roman columns mix with green-tiled roofs and mock-traditional arcades on the façades of new buildings; a violet Chinese pagoda perches on a large romanesque villa; corrugated-iron mosques spring up in shanty-towns that squat beside huge homes on the outskirts of the town. Casablanca spreads out as though it were trying to incorporate the entire world. To make sense of these collages of meaning, collages that seem to annul the very notion of significance, one must keep in mind that it is impossible to purchase maps showing the current city limits.

In 1980 a new planning commission was created in Casablanca to try to remedy some of the problems posed by the city's uncontrolled growth. Casablanca had already been the object of two major plans, directed by the French architects Henri Prost and Michel Ecochard,[15] yet they were unable to stem the disorderly urban growth. While they provided a sturdy skeleton for the city—those streets that are so essential to the Casablancan experience—the flesh that clothes this skeleton, the blood that circulates through the city, has remained subject to the whims of the population or of speculators. The new planning commission hopes to curb the habits of these unruly inhabitants. Significantly, the planners wish to employ the city's own motorized energies to trace or hinder channels of communication. The only freeway in the country splits the city in two, forming a barrier between the city center and the predominantly poor suburbs. The large boulevards of the city, the new freeway to Rabat, and the Mohammed V International Airport make for easy crowd control compared to the tiny alleys of the old *medīna*.

Roads orient people's paths and divide and categorize neighborhoods. The road system alone distinguishes Casablanca from pre-Protectorate cities, in which residence was not immediately associated with social class. Formerly, neighborhoods were built around kin groups or religious divisions, as in the Jewish quarters known as the *MellāH*. Some professions tended to group together, and "rural" people were not integrated into the idea of the urban; nevertheless, the social divisions were not the same as those assumed by the designers of cities like Casablanca or the *villes nouvelles*, built outside

of traditional cities (*mūdūn*). For French urban planners, the major
social differences were race and class.[16]

In post-Protectorate Morocco, the *villes nouvelles* of the departed
Europeans have been inhabited and extended to include people of all
backgrounds, or at least this is how it appears on maps. *Bidonvilles* and
other "savage," unregulated settlements fill open spaces around the
city. The freeway again serves as a reminder of social differences,
distinguishing apparently "legitimate" urban dwellers in cars from the
"illegitimate" pedestrians, who treat this new *šanṭe* as a substitute for
parks, plazas, or commons. Driving on the freeway is perilous because
pedestrians cross it as they might any other thoroughfare, often without
checking traffic carefully. Children and grandmothers alike ignore the
bridges that have been erected for foot traffic, favoring more direct
routes across this annoying obstacle. People cut through or destroy
fences or other barriers. Small, slow motorbikes accompany the nu-
merous Mercedes and BMWs that speed down this major thorough-
fare. Even the vehicles that are legally entitled to travel down the
freeway often do so as though their drivers were instead leading donkey
carts to market, while others consider the open space an invitation to
engage in a major international racing competition.

Many changes are planned for Casablanca, including a metro,
extended freeways toward Tangier and Fez, and the destruction of
parts of the old *medīna* to make way for a new boulevard from the
center of town to the Hassan II mosque on the coast.[17] In spite of these
changes, few believe that Casablanca will escape the kind of criticism
leveled against it in the past, for this image of frenetic movement does
not reflect simply the disorder or blatant commercialism of the city
itself. Rather, Casablanca's portrait is an emblem for what Morocco
is, and even more, for what it will become. It stands for both the
horrors and the potentials associated with vast social change. Con-
sequently, it evokes both desire and disdain.

Maps and photographs betray the designs of those who create them.
Because these aims rarely coincide with our own motivations, they
bear little resemblance to the personal maps we draw with our feet
as we go about our daily occupations. These maps intersect with the
places captured on postcards or designated on maps, but our personal
footpaths give these scenes different meanings. When Mohammed
Boughali asked illiterate people in Marrakesh to draw diagrams of
their city and the world, many of them sketched the city as a network

of lines between the places that they visited regularly; other places were represented as small and insignificant, if they were identified at all.[18] This is perhaps a reliable description of everyone's experience of the places they live in or visit. Even those whose activities and sentiments draw them beyond the city limits, and who have knowledge of the kind associated with photographs and maps, continue to perceive the city as the center of the world.

In drawing their first "world" maps, many illiterate people represent Morocco as a very large, central circle, with outlying areas labeled, in tiny letters, "France" or "the Sudan."[19] Such maps accurately depict the city dweller's experience of the urban world. The city is the center of the world not because we know it from afar, as on a map, but because we are immersed in it as a set of concrete spatial and social relationships. Casablanca is crisscrossed by footpaths worn by incessant movement. It is the second largest port in Africa and is the most important place for land transit of people and things in Morocco. From inside this central hub of activity, it is difficult to keep any single version of the city in focus. The order imagined by those who draft the city's maps come to regulate our personal trajectories. Mastering our own movements requires knowing the objectives that organize space, time, and talk.

Learning how to traverse Casablanca means establishing social links. These include family members, coworkers, and neighbors. Political contacts can be important in extending individual power or influence. Yet membership in a political party, connections with officials, or a mere demonstration of allegiance to the king does not mean that one necessarily acquires or even demands a say in state affairs. Nor does political activity always indicate that one holds strong opinions about political issues or party platforms. Generally, political beliefs are more a matter of allegiance to a set of people than to a set of ideas.[20]

Politics permeates daily life in ways that party platforms or public debates cannot thoroughly explain. The politically prominent are generally expected to extend their influence and wealth in all areas. While many people complain about corruption, nearly everyone occasionally benefits from their informal family or business ties to obtain a permit or enroll a child in school. It is very difficult to extract oneself from such ongoing networks of favors and obligations to demand reform, although reformist discourse is pervasive. International discourses of liberalism, socialism, and the like are discussed in newspapers or on

television as well as in the street. Universal concepts tend to be appropriated to local uses, but not without some radical changes and questions about their meanings.

Education and Employment

People give meanings to words in ways that are related to their ability to set them down on paper or register them on records, cassettes, or film. Many of the passionately debated issues in the following pages bear witness to conflicts associated with different relationships to knowledge and its recording. Educational backgrounds and the cultural aptitudes that go along with them are important factors of social distinction in contemporary Morocco. Until independence in 1956 few Moroccans had European-style educations. Nourreddine Sraïeb writes that "in Morocco in 1956 the European population's children all attended school. The Jewish Moroccan population was at 80% while Muslims at only 13%. . . . In 1955, Morocco counted only 19 Muslim doctors and 117 Jewish doctors, 6 Muslim and 11 Jewish pharmacists, about fifteen engineers for each of these denominations and 165 high ranking executives in the government."[21] Following independence the government established new schools for teachers and made efforts to extend public education. However, the educational system emphasized educating professionals and high-ranking executives who could develop the infrastructure necessary to the political regime; general education was neglected. Today most children in urban areas are able to acquire some schooling, but those in the countryside are often bereft of qualified teachers. In the city different educational trajectories are instrumental in marking out social differences and in permitting access to different types of knowledge.

Many children continue to receive their first lessons in Koranic schools, where they memorize verses from the Koran and learn to write Arabic. Attendance at a Koranic preschool is a prerequisite for enrolling in a public elementary school. Most Koranic schools now include activities characteristic of the French *maternelles*, preschools that have become another standard institution.[22] Preschools are available to many people, but those run by the French government are generally attended by children from privileged backgrounds. Having completed preschool, children from the French schools usually continue to follow the French curriculum; however, the children of the

very wealthy often attend the American school in Casablanca. The vast majority of students attend either Moroccan public schools or locally owned private schools. Public schools are overcrowded, and many of the private ones are clearly more interested in making a profit than in educating their students. For the limited number of students who make it through these schools and pass the baccalaureate examination, there are public universities and private colleges in Morocco, but those who have the means usually go abroad for their university studies.

Styles of authority and relationships to the community are formed in these diverse educational settings.[23] Different relationships between teachers and students and attitudes toward the community spring from what and how children learn. As one university student remarked:

> The systems aren't just different systems. Each has its own way of thinking and working. Even the different courses in a bilingual school are altered by the language used. For example, in my school Arabic teachers were very stern. They reminded me of the old *fuqahā?*, or Koranic school teachers. I went to a public school but I never really learned written Arabic until later.

Until the 1970s those who received degrees from *lycées* and universities in Morocco or abroad generally had little difficulty finding work. However, as more young people attend school, the number of graduates has exceeded the number of jobs for which they qualify. The job market is likely to worsen as more young people enter it each year. The scarcity of employment affects people in very different ways according to their social status. The very wealthy might be educated in the world's most prestigious institutions, but their social situation does not depend primarily on employment related to academic knowledge. However, schooling is an important means of involving the children of the newly rich in older networks of elite society. Education is perhaps necessary to the maintenance of elite status, but it is not sufficient to its attainment.[24]

By contrast, education and employment based on "school" knowledge are often crucially important for the growing group of Moroccans who form the middle layer (*musṭwa*) of society. The expansion of mass education following independence and the need to substitute Moroccan for European clerical workers, engineers, and managers since that time have been important in this layer's creation. Shopowners,

small businesspeople, and those in the liberal or intellectual professions are also a part of this important and diverse group. Many people achieve or preserve their middle-class status by performing some specific skill or possessing technical knowledge.

Few counseling services are available to students who hope to select a career or enter a trade school. Some private schools offer good advanced instruction, but entrepreneurs—many of them unscrupulous—have entered the field of education. Many families and youths cannot evaluate teachers' or schools' credentials, and some find themselves disappointed by the paucity of work available after investing money and time in programs of study. Yet as one teacher explained: "Families continue to have faith in education as a means of social promotion, even if many of the students do end up taking a long time to get work. Those who are educated nearly always do find something, even if it takes time and even if it's not what they really want to do. Those who drop out of school might never find a job at all."

The diversity of educational strategies is further underscored by the difference between men's and women's positions. For girls, the possibility of going to school or traveling abroad is generally determined by their father's feelings concerning women. Wealthy conservatives might prefer to keep their daughters near home, far from the influence of "licentious" European ways. By contrast, poor or middling families might save to send a particularly bright daughter to the university, hoping that she will be able to achieve a position that marriage might not offer her. Many young men, while not necessarily thinking that their wives should work, prefer to marry educated women. People from widely varying backgrounds often say that educated girls are more serious, and their broader experience is considered beneficial in raising children. Some young, college-educated men I spoke to about this issue also said that they would have nothing to talk about with a woman who had not gone to school. In the eyes of many people, changing expectations for the marriage relationship, as well as traditional attitudes of respect for knowledge, make education a laudable pursuit for a woman whether or not she intends to seek work outside the home.[25]

The relationship to knowledge among the middle layers of society is what most sharply distinguishes them from the upper strata. For the middle classes, knowledge is not strictly a matter of schooling; rather, it also involves the kind of information needed to participate more fully in the political and economic realms. While members of the elite

can obtain face-to-face information concerning political or economic events, those of the middle classes must rely on newspapers, television, or rumor for their news. Their knowledge permits them to follow events with great precision, yet they have neither power nor extensive, direct experience with the powerful. Nor do they share the common experiences of elite culture, which go far beyond the lecture hall. Extensive experience in foreign places is often a part of this elite culture.

In Morocco, whether one is a doctor, a beautician, or a businessperson, the dominant discourses and practices of one's profession are mainly developed outside the country. If we were to chart the different fields of activity in Morocco, as Pierre Bourdieu has done for France, we would find that few distinct areas of activity can be located only within Morocco.[26] To make sense of people's practices and the ways in which they are legitimated, we must extend our gaze far beyond the country's borders. This does not mean that we can locate the "center" of each field, since specific sites need not be associated with fields of knowledge or practice. Theories that offer simple graphs of center and periphery to explain all manner of disequilibriums from the economic to the cultural cannot capture the subtlety of concrete situations.[27] The key to these relationships can be found in the interplay of the hierarchy of fields, a hierarchy that emerges only in practice. We can note, however, the variable intensity of exchange and change within given fields in certain places, whether geographical or social. We must also recognize how political boundaries and decisions influence the relationships among various fields. Despite the importance of nationalist discourse and the overdetermining of all fields of activity by the political, everyday life continually refers to places beyond the nation.

Generations of the Moroccan elite were formed by their common experiences of France. There many participated in the activities of the Union Nationale des Etudiants Marocains (UNEM) or belonged to other associations or political parties. Those with diplomas from American schools also have an association. Many of these students form lifelong bonds with others who studied there; such a group can become a sort of second family, with those of each generation tending to have extensive knowledge of others who studied in France at about the same time. I myself studied in Paris, and after I arrived in Morocco, talk about student life in France became a standard part of my conver-

sations with others who shared similar experiences. Just as Moroccan schools inculcate local practices and values in their students, so too do the foreign colleges and universities shape the attitudes of students who spend years living abroad; indeed, such a foreign sojourn can have even greater effects. In the past foreign-educated Moroccans were able to lead a comfortable lifestyle once they returned home. Today, though, even those lucky enough to receive foreign diplomas often have difficulty finding work on returning to Morocco.

The problems raised for the elite by increasing numbers of educated youths were already apparent in the 1960s. In 1965 King Hassan II stated, "There is no danger for the state as grave as that of the so-called intellectual. It would be better if you were all illiterate."[28] In the 1980s and 1990s the political implications of a large educated but unemployed population have become manifest. Many of these youths, disappointed and angry, have organized associations of unemployed college graduates and staged sit-ins and hunger strikes to publicize their plight. But while many of those who protested actively have now been given jobs, their younger brothers and sisters will soon complete their studies and join the ranks of the unemployed.[29]

Profound economic differences are immediately visible throughout Morocco. The minimum monthly wage is about 1,000 dirhams (about $130); however, large numbers of workers are not paid even this meager sum. Employers prefer not to declare workers to avoid taxation, and maids and other servants are given meals or other compensation rather than money. Small children work as maids, baby-sitters, or textile workers, farmed out by their parents when they themselves cannot feed the family.[30] Some youths seek odd jobs or turn to prostitution. In the old *medīna* several families huddle in single rooms, sometimes sleeping in shifts.[31] Compared to these urban nomads, those who can simply order their lives around regular rhythms of work and sleep are fortunate.

Getting Around

Besides family origin, one's place of residence or employment is the most obvious marker of identity. Just being in a specific office building, house, or shop is an identifying sign. To cross a threshold is to screen oneself from the view of those who remain outside, and the limits of inside and outside are often drawn explicitly with streets or walls. Types

of social interactions at any given place also form barriers. Consider how the homes of the very wealthy are guarded. First, large villas are built alongside one another in expensive residential neighborhoods with names like "Anfa" or "California." The vast majority of these houses are protected from the outside gaze by cement or brick walls. As the visitor approaches the door or gate, it is not uncommon to be questioned by the family's guard or a maid whose role is to survey the movements of people in the street and to determine whether any of the activities there might endanger or bother residents. This inter-mediary also inspects those who arrive at the door, scrutinizing their clothing, vehicle, language, or other external signs. Once the person at the door is judged worthy of entry, the guardian may send a message to those inside through an intercom; alternatively, the visitor may be led to the entrance of the house or—if the visitor is delivering food or performing domestic tasks—the kitchen door. Within the house the distinction between protected and open spaces continues, with some places reserved for private uses and others open to guests.

Only rich people can afford to have extensive private areas and a closely surveyed space in which to live; however, the criteria for identification used by their guardians resemble those employed by less well-to-do people throughout the city. The broadest traits are imme-diately associated with one's appropriate social standing, much as an identity card succinctly notes height, weight, or eye color as though these adequately described a person. For guards or neighbors, one of the most significant signs of identity is the way in which a visitor arrives at the door or in the neighborhood. Did she come by foot, in a cab, or in a fine car driven by a chauffeur?

In the anonymous world of the *šanṭe*, the way in which one moves about determines one's experience of the city and one's identity. Casablancans often express social differences according to where people "go." One "goes" either to the old Oliveri ice-cream parlor, to the newer, more expensive Fiori café, or to an ice-cream stand on a corner. A young girl either "goes" out or stays within the traditionally feminine world of the home. During the summer teenagers with a few extra dirhams "go" to one of the popular swimming pools—the Miami Plage (Miami Beach) or the Tahiti Plage. Those with fewer dirhams take the bus to the free but very crowded public beaches.

Having a car is in itself a sign of relative financial well-being. Vehicles and gasoline are expensive, and everyone is aware of the

prices of various makes and styles. While the Renault 4L or old Fiats are common among workers and employees, businessmen boast of their large Mercedeses. Many of these are painted in garish shades of yellow or even pink to hide the fact that they were stolen in Milan or Bruges and hastily imported to Morocco through specialized channels. Whatever its origin, a Mercedes is an object of distinction. A taxi driver in his mid-twenties explained to me that a Mercedes we saw was made up like a girl getting married, painted and glistening with shiny chrome.

Those who take international, not local, frameworks of distinction and taste into consideration might drive not a Mercedes but a BMW or a rare and costly sports car. The majority of those who purchase expensive cars, however, select large, conspicuous models of whatever brand they fancy. These automobiles boast of their owners' status much as do the enormous villas of those who have "made it."

Middle-class and wealthy Casablancans nearly always have a car, considering it a necessity in Casablanca's Los Angeles–like expanse. I do not own a car, and many friends have tried to convince me that walking around the city by myself can be not only inconvenient but even dangerous. It seems odd to them that a middle-class foreigner might actually prefer to walk, take the bus, or hop a cab rather than invest in a car and costly insurance. My own concern about the increasing number of vehicles and the pollution they cause is an even greater mystery. "You're stuck in your Western frameworks," one well-off friend said. "Here we can't afford to think about pollution." (This man drives an Audi.)

Even poorly paid secretaries save for years to be able to move freely about at any time of the day or night. Fatima, a secretary, invited me to take a ride in her new, used Renault 5:

> I've been saving for this for years. Imagine: now I won't get all muddy on the way to work like I used to when I rode my minibike. I was always afraid too that I'd have an accident. [In Morocco most of those who ride minibikes or motorcycles don't wear helmets.] And especially, I can go out on my own now at night to visit friends or go out. Having a car will save me so much time and it's real freedom. Turn on the tape, will you? Who would you like to listen to: Oum Khalthoum, Bob Marley, Edith Piaf?

While we rushed along to the rhythm of rock, we passed poor families riding three to a motorbike. Indeed, peasants still bring goods to

market in horse-drawn carts, and rush-hour crowds push and shove to find places in overcrowded buses.

The breadth of the space one can reserve for oneself and one's family demonstrates one's importance. Owning a luxury automobile follows the same logic as building an enormous villa or covering vast expanses of land with office buildings. This logic is confirmed by the way in which many intellectuals or the very wealthy disdain the "vulgarity" of the simple association of money and taste. One intellectual I know underscores his own refusal of the equation of money and ostentation by calling Mercedes drivers *Hmir*, or donkeys, that most customary—and most often insulted—means of transportation in Morocco.

With all of its noise and pollution, the street pulls Casablancans together. It is the only truly communal space in which people of all conditions meet; consequently, it is one of the places in which it is important not simply to *be* something but to demonstrate that identity through one's appearance. Cars, clothes, and companions add to one's physical "look." (This sense of the English word "look" corresponds to French usage of the same word.) "Le look," essential in determining social standing, demonstrates one's inherited or chosen cultural models. The color and texture of hair, the shade of skin and eyes, the elegance of mannerisms, the style and price of clothing and jewelry, the brand of cigarette—all of these details indicate origin, social class, and even level of education. The speed and accuracy with which people can judge one another concerning family origin, educational background, and current wealth is remarkable.

Power and Possession

Acquiring expensive objects indicates rising status and authority. According to André Adam, the conspicuous display of wealth in the city resulted from competition with Europeans under the Protectorate: although the French may have monopolized the political and educational realms, wealthy Moroccans could equal and even surpass most Europeans in the economic realm by flaunting their new acquisitions. Adam notes that previously unadorned façades of houses (and of selves?) came to be elaborately decorated. But the forms chosen to express wealth and economic success may be related to a more pervasive influence than competition for distinction:[32] the shift

also represents changes in notions of aesthetics and visibility themselves. The transformation of the relationship between authority, power, and sight was linked to emerging forms of knowledge as much as to momentary battles for prominence.

Today the necessity of displaying one's wealth or power persists. Indeed, the influence of European and American styles has intensified since independence. Other influences, especially from the Mashrek (Middle East), are also perceptible in clothing, architecture, and music. Conspicuous consumption has perhaps been caused less by direct competition with Europeans and their image than by an increasing involvement in international values of consumption and an appropriation of these values in the local context.

In the Moroccan context—as in many other contexts—to exercise authority one must possess certain objects. Not only should a boss earn more money than his subordinates, but he must also demonstrate his wealth through certain types of consumption and gift giving. The authoritative man or woman must manifest his or her own position not just for individual satisfaction but also for that of subordinates. In a sense, by parading one's claim to power or authority, one validates the fact that one holds a powerful role and controls others. It is easier to be submissive to someone who demonstrates his (or, more rarely, her) legitimacy to everyone through immediately perceptible means. If hierarchical differences must be demonstrated, then equals must also adhere to common norms of conduct and appearance. Peers encourage one another to respect certain signs of prestige. To be "one of us" is to accept certain signs of belonging. Karim insists that his friend Toufik, who has been promoted to the status of "cadre" or executive, buy a new car and go out to the "right" places. Toufik is reserved and doesn't want to "show off" (*bga ybān*), but little by little he begins to buy more expensive clothes and, finally, a new car. Friendly horizontal pressure is important in helping people form models of behavior that depend on slight differences within a vast and changing cultural repertory. The interplay of differences weaves the fabric of urban life, giving people a sense of self within emerging groups.

Commercial activity has always played an important part in urban life in Morocco and, indeed, throughout the Muslim world. The prophet Mohammed's first wife was a wealthy widow, skilled in commerce. The *tāžer* (merchant) is a central character in Moroccan history and many stories. The infamous Joha, a favorite figure in Moroccan

tales, has many encounters that include buying and selling. Today the
kinds of economic success have changed, yet the patron-client relations
described in historical and ethnographic accounts remain typical of
commercial interactions in Casablanca. However, new emphasis has
been placed on horizontal games of distinction.[33] We see such alter-
ations in the recent willingness of Fasi families to marry their daughters
to successful Soussi merchants, although these two groups have widely
different traditions and even different mother tongues.

The new influence of the Soussis is expressed aesthetically as well
as economically. This aesthetic influence is perhaps clearest in the
latest fashions for weddings. City people in Morocco have usually
adopted the Fasi rituals for their weddings, but recently a Berber
outfit has been included among the several dresses worn by middle-
or upper-class Moroccan brides during their wedding parties.[34] When
Zohra speaks dreamily about her still hypothetical wedding, she re-
marks that certain "traditions" will be introduced while others will be
ignored:

> I would like to have one of those Berber dresses. They're very pretty
> and everyone is wearing them these days, even the Fasis. Anyway, ev-
> eryone tries to imitate the Fasi ceremonies as it is. My mom's from
> Fez, but we prefer simple parties. I don't want to be carted around.
> You know, it was an old custom that they've revived: they put the
> bride on a sort of carriage to be carried. I wouldn't want that. I don't
> want them to sing the song about the bride either. It's an old song,
> but it makes it sound like they're selling her to the groom and his
> family. Most modern [ᶜ*ṣriyya*] girls don't let the relatives sing that
> nowadays. It's not right to talk about women like that. They say that
> Berber husbands are strict. But I think that maybe I'd like a Soussi
> husband. They say that they don't drink or spend a lot of money.

Metaphors for Moroccan society have often been found in the
process of exchange exemplified in the market, or *suq* (plural *swāq*).
If we enter the world of buying and selling, of haggling and penny-
pinching characteristic of commercial life everywhere, the continuing
validity of this metaphor is clear.[35] *Swāq* remain lively meeting and
trading points throughout Morocco, including Casablanca, but new
forms of relations between vendors and customers, objects, and pur-
chasers coexist with the *swāq*. Each setting requires a good eye for
quality and a clear sense about prices, but shopping in a supermarket

or department store necessitates a different approach to these variables. Lawrence Rosen sees bargaining as extending even to ontological matters, but not everyone can persuade others of the truth of one or another "reality." Some people insist that "money has no odor"; yet when it comes to spending it, there are definite lines that people do not cross. Certain types of people buy certain objects or frequent particular kinds of stores. As in other aspects of life, objects purchased abroad or imported play a special role in the bargaining process. Shopping malls in Casablanca include deluxe boutiques featuring imported French fashion and bargain basements crammed with false crystal and colored glass. The city is noted throughout the country for its commerce, and it offers an impressive number of places to find all that money can buy. As the commercial center of the kingdom, it offers the widest choices at the best prices in all manner of goods.

One of the first places I ever visited in Casablanca was the local department store, Alpha 55. Zohra, the teenage girl who accompanied me there, said that she was tired of visitors seeing only what she calls the "backward" parts of her country. She compared Alpha 55 to stores she had visited in Paris. While Parisian stores set standards of excellence for many Moroccans, my host considered the local version of the department store a sign of modernity. Her opinion seemed to be borne out during the December 1988 Francophone and African States Summit meetings in Casablanca. During this international meeting, heads of state from sub-Saharan Africa could be seen popping in and out of Alpha 55, while their limousines waited for them in the street below. Perhaps like Moroccans visiting from countryside, these officials perceived Casablanca as a step up (on the way to Europe?) in the purchasing hierarchy.

From the street Alpha 55 resembles any Woolworth's or Prix Unique, but this impression fades once one enters the building. The signs pointing the way to different articles are written in Arabic and French and embellished with photographs clipped from magazines. The signs are both eye-catching and functional since they help illiterate or semiliterate customers find their way. The makeup poster boasts bright red lips, eyes taken from a cheap perfume advertisement, and various cutouts of beauty products—but these are, in fact, brands that aren't sold at Alpha 55. Posters indicate where to go for toys, women's and men's clothing, and household goods. They also feature photos of food, for the top floor of the store is given over to

a cafeteria. At the same time that this visual stimulus urges the customers toward a specific goal, rock music blasts out from all sides. Most of it is American, and all of it is loud and distinctly unlike the comforting pap of Muzak. The shop girls seem not to mind its driving beat. In fact, they appear generally oblivious to their environment, including the customers who bop along in time with Michael Jackson. A salesgirl mouths the injunction "Do it, do it baby" as I approach her to ask how to find a particular brand of wineglasses. "Over there," she says, gesturing vaguely. "Somewhere."

The mass of objects in all of the departments is astounding: stacks and stacks of glasses, belts, dresses, socks, toothbrushes. What can't be found here? Provincial families, having heard the store's ads on the radio, are struck dumb by this mass of stuff. Yet despite the volume of merchandise, Alpha 55 rarely offers absolute customer satisfaction. The problem is uncovering the object one actually needs. Brands come and go with alterations in available stock. Sizes are often merely approximate. Indeed, it is not choice so much as sheer wealth of numbers that attracts customers. This is certainly true in most shopping areas throughout the world, but it is played out a bit differently in each. For example, at Alpha 55 customers try to haggle over prices or purchase one saucer from a twelve-piece table setting.

Employees wear uniform blue blouses reminiscent of the white or pink robes donned by Moroccan high school girls. In spite of this superficial resemblance, many locals consider the shop girls potential or actual prostitutes and identify their low salaries as the root of the evil. But this reputation must also stem from the fact that vendors are generally men. Do clients extend the commercial criteria of these endless tables of products to the young women who find their places among them?

Everyone seems to come to buy things at Alpha 55 at one time or another. Women, men, teenagers, grandfathers, diplomats—they fill the store, especially during Ramadan, when the store is open until 2:00 A.M. so people can conduct business after breaking their fast at sunset. It is a practical spot since one can buy nearly everything at one time—food, clothing, pots, pans, toys. In fact, this is not really so different from what one finds in the many conglomerations of shops throughout the city. The goods at Alpha 55 are not cheaper than those sold elsewhere, and they are rarely presented as valuable or displayed in "real-life" settings as they are in European and Amer-

ican stores. What is original is the *claim* to be a modern department store. In the world of shopping, Alpha 55 is certainly not an elite production, but it isn't a popular art form either. Unlike either rural markets or luxury boutiques, it is an utterly impure mix of people, cultural forms, and objects. When we go there we become like Alice in Wonderland, faced with innumerable shelves of immeasurable glitter; and like Alice, in the midst of this splendor each object loses its appeal as we draw close to it.

Objects are deemed interesting or trivial depending on the uses we will put them to. Some ways of using things are learned from our parents, following apparently unquestionable practices that, if we name them at all, are often labeled as "tradition." But other things we choose to purchase reflect our preoccupations with how we, as individuals, will appear in the mirror of others. Does the false diversity of products help to quell doubts we have about our own uniqueness? For most Casablancans, the most immediate judgment is offered by the collective gaze of their peers. The judgment of these closest "others" is phrased in the language of fashion, whether "modern" or "traditional."

Places to See and Be Seen

The Arab League Park, in the center of the city, offers cool, tree-lined avenues where students pace back and forth, notebooks in hand, learning their lessons by heart. Teenagers meet there and promenade along the boulevard, hoping to attract potential dates or just participate in a feeling of collective animation. Young people show off the latest fashions, and a certain anonymity allows for open flirting and invitations to ice-cream parlors or cafés.[36] In this kind of open, public space, one feels far from the eyes of the neighborhood *berqaqa* (busybodies) like the grocery store clerk, the parking attendant, or neighbors and family.[37] This and similar areas—swimming pools, cultural centers, cafés, ice-cream parlors and fast-food joints—provoke discussion and worry among Casablancans of all walks of life, including those young people whom one can meet regularly in such places. For they offer lively demonstrations of changing divisions of public and private, feminine and masculine spaces.

As people mill about parks, pools, or beaches, they look and know that they are being seen themselves. Is this merely a sort of market

of "looks," or is it a sign of a more fundamental search for transcendence of the daily grind?[38] As I sit at a café in the park with a group of friends, I watch a young man looking. He sits at the center of a colorful, fast-moving world, making no attempt to speak with anyone, his gaze focusing on flashy outfits and cars. Meanwhile, other men in cars pass along the avenues trying to pick up young women. (According to some of the men, many girls get in, no questions asked. An encounter in a car is seen as safer since people you know won't see you—as they would in the street!) A group of high school girls tease a too-insistent flirter. My friend Bouchra, seated beside me, confides, "I always try to look nice. What if a nice guy sees me out with my friends? You never know when he might come along." Bouchra expects that once this suitor's gaze has been captivated by her beauty and good taste in clothes, he will hope to marry her. What looks good might be a *zellāba* in the latest style, clothes brought back from Paris by a sister who's a student there, or home-sewn outfits based on models found in fashion magazines. The park is not the place for the very wealthy of Casablanca to meet. Nevertheless, in exclusive clubs or at weddings, the same importance of caring for one's image by managing one's appearance is manifest.

Many people can be seen with friends in the park, but the most conspicuous in this public *vitrine* are groups of flirting boys, prostitutes, and other girls of presumably questionable morals. These "types of people" have become objects of debate between all kinds of people in Casablanca. Some Casablancans describe them as merely a nuisance, but many others express a more profound disdain. For these Casablancans, the street people represent what is "wrong" with their society.[39] The lines between these most conspicuous public features and the "fun" activities of their own children or siblings is too ambiguous not to be threatening. For girls, this threat is particularly clear.

All of these random glances and appeals to sexuality seem at first sight to argue that people in Casablanca have little to do with the usual images of the Mediterranean world as one of separate sexes and strictly controlled expressions of sexuality. But if one stays long enough in the park or other public places, it appears that the worrying voices of elders and moralists echo problems experienced by youths. Many young people testify to the difficulty of finding legitimate ways to express new relationships between men and women, the seen and the unseen. Why are young couples so often in the street instead of

at home? Why do groups of women in their mid-twenties giggle so nervously when one of them is approached by a man, when it seems that they promenade in public precisely to make the acquaintance of members of the opposite sex? Perhaps the sometimes brusque or even violent expressions of some young people, or the terrible shyness of others, stem from the lack of a socially validated script or scripts for acting out relationships between men and women in situations outside of marriage and the family. The park frames a public space that is newly incorporated into ideas of public practice. The intensity of vision and judgment there is both playful and menacing.

The link between the visible and the invisible, the real and imaginary, is a point less of play than of anxiety for many people. Adults are expected to bear themselves with gravity and dignity. Play is associated with those who are not yet adults—or those who have the good luck to find themselves among children. Many young people I met expressed a fear of not corresponding visually to some set idea of the self. Although many forms of socializing from Europe have been incorporated into certain Moroccan milieus, costume parties have not. Indeed, situations in which people adopt other roles—or playfully, if momentarily, invest themselves with an alternative identity—are rarely part of the repertoire of diversions. Rituals associated with masks and masquerade have fallen into disrepute.[40] They are associated with the countryside and the past, and their imaginative forms rarely surface in city amusements. Theater and television offer actors in all manner of roles, but this arena appears to be strictly restricted to professionals.[41] Why, when people rely on intense dramatization in everyday life, is it so dangerous to play it out in other spheres? People rarely play the fool at parties or act silly, although they tease one another mercilessly. What if one really turned out to be silly or the terrible witch one plays at a party?

Perhaps when people are unclear about the security of their social or economic positions, the importance of visibly demonstrating who they are makes playfulness appear dangerous. Life paths cannot easily correspond to what one knows about how one's parents or grandparents lived. For example, previous generations of men and women took it for granted that they would marry and have children, but young people now find it increasingly difficult to adhere to this model of adult life. Adulthood is sealed by marriage, but fewer people can afford to marry. In addition, young people are changing their expectations of

the institution of marriage. New personal dilemmas arise because of changing frameworks of gender and knowledge. What if a young woman is better paid or better educated than her prospective husband? Some men insist that they prefer a wife who stays in the house, a traditional woman. Others say that they like women whose worldly experience and education is equal to theirs. Some educated women I spoke with prefer not to marry at all, for they relate the institution with the restrictions suffered by their mothers and grandmothers.

Like Bouchra and her friends, many young women I spoke with reject the "traditional" role of the homebound woman, yet they hope to marry and have children. Some are teachers, others secretaries; many are unemployed. They hope to marry men able to support them. Yet many of their male counterparts who could do so are married to professional women or to women from wealthy families.

If today's young women meet boys in the street, they remain much like women of former generations, who used to be hidden from the view of male guests but were allowed to peek out at them through peepholes. The men that most of them want to meet ignore them, while those who notice them might not actually approach, worried that they don't possess the attributes necessary to "get" one of these girls. Some boys even complain that some girls are too aggressive. "They scare me!" Khalid says. "What do they want when they look at me like that?" The seductive poses of some young women often elicit anxiety among young men. For them, the new arrangements of sight are no easier to understand than they are for girls.

The park offers a splendid vision of youth, color, and amusement. Even the large patios around its omnipresent cafés turn the inside out, offering the world of private meetings to the public gaze. For many of the women one meets on these café terraces, their history is the history of absence. "Back then, when my mother was small," they say, "or in other regions, like the south, women didn't or don't do things like we do." The "modern" girls and boys never cease to describe their differences with the past or other regions of the country. They tend to see homebound women today as a vestige of that past, as invisible beings. Yet when I watched an American television series about a high school date, the eighteen-year-old boy sitting next to me was astounded. In fact, Driss admitted, he did like to go out, to meet girls and "all of that," but he was still amazed: "But their parents!" he exclaimed. "Parents welcome the kids' dates? They meet their girlfriends? My parents would never go for that. I could never talk about

my girlfriends with them. They would be outraged." Manners of being and doing are not always easily related to ways of talking about action. Whether or not all parents would in fact be outraged is an open question, but the world of the open street and that of the home and the family remain radically separate. Once the sun sets, people return to their neighborhoods and their homes. And if one day Zohra or Driss finally "is seen by" or "sees" the man or woman of their dreams, they will seek their family's approval of their singular "date." It is in the context of families and neighborhoods that the childishness of "dates" is left behind for the serious business of marrying and having children.

Neighborhoods

Considering the population of Casablanca, its center appears small and, in the evening, empty. New quarters push the limits of the city farther into the countryside each day, and many neighborhoods now offer most of the services of the center. Superficially these areas appear very similar—row after row of three- and four-story apartment buildings—but each small center has its particularities. Assumptions about acquaintances met in the park or at work may well have to be revised if one were to follow such people home. More than once friends visiting from Europe or America have exclaimed at seeing a fashionably dressed, high-heeled young woman walking off into what looked like a muddy, empty field. Where might she be going? "Home, of course," I would answer. "She lives in the bidonville hidden by that wall over there." Many people in Casablanca do live in shantytowns, concealed behind white walls. However, the majority is perhaps best represented by a neighborhood like Aïn Chok (Black Source). Across the freeway from the center, Aïn Chok is home to many low-level white-collar workers, teachers, secretaries, and tradespeople. Part of the area is pleasantly designed in a neotraditional style, but most people live in small apartment buildings. The typical home includes a kitchen, a living room, and one or two bedrooms. Bathroom facilities are often rudimentary, hot water a luxury. However, numerous public steam baths are accessible. Other public buildings include mosques, a post office, a police station, and administrative offices.

One can easily satisfy all of one's daily needs without leaving Aïn Chok. Or, more precisely, one can find the things associated with the lifestyle of a *populaire* (working-class) quarter of town. Shops are dark, and bakeries sell only ordinary, round white bread (whole-wheat

bread, formerly made at home, is now considered a luxury). Bananas and other expensive fruits and vegetables can be difficult to find. While many of the residents superficially follow the same fashions as those in upper-class areas, often copying Parisian or Egyptian styles, a closer look reveals that many of the men wear second-rate clothing. Most women wear homemade dresses or suits made of cheaper fabrics than women in wealthier neighborhoods. And although younger girls wear the same styles as those in high-status quarters, most of the mature women wear *zellāleb*. Newspapers, especially foreign ones, are less readily available than in more central quarters. Buses operate during the daytime hours, but from about five until eight people must often wait for long periods just to board a bus. In the evening most of the bus lines stop at nine, and those that continue are reputedly filled with "drunks." The cultural activities of the center seem far away, except for those lucky enough to own cars. In the evening most people stay home, surrounded by their families and watching television. While neighbors and shopkeepers scrutinize people who venture outside their homes, the television presents stories, news, and images of other worlds, often closer to the dreams of the central boulevards than to the dusty atmosphere of neighborhoods like Aïn Chok.

Each neighborhood gives a particular color to the people who live in it. For example, Leila, a teenage girl from a higher-status residential area, often uses the insult "He acts like he's from Aïn Chok." (She also refers to shantytown dwellers as "Apaches.") While she herself is unemployed, she lives in a "good" quarter, the Oasis. More than any detail of her personal background or identity, she puts this item forward as a claim to belonging to good society. Her words demonstrate the success of the idea of class-based neighborhoods introduced during the Protectorate.

Among the numerous neighborhood centers, some have evolved into new centers of leisure. Gentrification has even begun in the former European working-class area known as the Maarif, where the Ben Omar Center and the Gallerie Ben Omar—a pair of shiny shopping malls—offer a wide selection of consumer products for eager executives and professionals. A pizza parlor in the Ben Omar Center offers lunch to a mainly female clientele, while beauty salons abound in the area. Neighborhood businesses include a specialty coffee shop, cafés, a health food shop, a pet store, and a French *charcuterie* (delicatessen). Stores display local and imported clothing, and arti-

sans' shops are juxtaposed with new, expensive apartment buildings. The market is one of the most expensive in the city, but it boasts good vegetables, fresh fish, shellfish, and imported cheeses.

In many ways the Maarif resembles any middle-class European neighborhood, yet most of the current residents of the quarter are Moroccans. The former poor European population, of Italian, Spanish, or Portuguese background, has mostly emigrated. Adam suggests that the urban model for Casablanca was that of French townspeople, and, indeed, a petit bourgeois atmosphere pervades this quarter.[42] Most of the Europeans now living in the Maarif work for banks, consulates, high schools, or large companies. The pizza parlors and the new cultural center in the area, run by the local Union Socialist des Forces Populaires (USFP; the socialist party), offer leisure activities not only to those who live in the neighborhood but also to people from throughout the city who increasingly come to the Maarif to entertain themselves.

The ambiance of this central quarter is lively and cheerful. Its inhabitants might be middle and upper-middle cadres, professionals, or professors. Nonetheless, it is quite different from the "residential" quarters, where the wealthy build large homes surrounded by gardens, or the middle-class housing tracts on the cities outskirts, which offer downscale versions of the elite's abodes. Older apartments are identical with those in less elegant parts of town. New apartments tend to be spacious and equipped with the most up-to-date bathrooms and kitchen facilities, yet some people have criticized the poor quality of their construction. Perhaps quality is associated not with durability but with a contemporary veneer. The well-displayed, high-quality objects in shop windows and the efforts made to beautify the central plaza of the cultural center break the monotony of the seemingly endless, uniform blocks of apartments that characterize other parts of the city. The urban flavor of the area also distinguishes it from the wealthy quasi-suburban residential neighborhoods like Anfa or California, where individual homes line almost deserted streets.

Homes

The home represents the most basic social unit, whether the house is located in a wealthy residential section of town or amid the poorest dwellings of the *medīna*. Architecturally, a home associates a housing

unit with a family. In the past Moroccan families were generally large, multigenerational, and patrilocal. Such families were less common in Casablanca, however; from the beginning of the Protectorate, working-class and European housing in Casablanca was designed according to European norms for nuclear families, except in the old *medīna*.[43] Today the extended household is becoming increasingly rare throughout Morocco, and housing shortages in cities make it difficult for people to establish even small families. Big old houses are often divided to accommodate several households. Even those who are fortunate enough to have a large villa often house nonrelated servants alongside family members.

The family's identity is given form in the living quarters themselves, and it is no surprise that one of the first acquisitions made by those doing well financially is a piece of land on which to build a villa; barring that, they will try to save for a down payment on a condominium. But in whatever quarter a house might be situated, there are some standard ideas about what a home should be. While the details of home organization can be used to distinguish the family or the individual, what strikes the outsider first are the ways in which certain ideals of the home appear to be shared across social classes and regions. While this ideal is not always followed by architects or many Moroccans, it remains a sort of blueprint for imaginations about how a home, regardless of its neighborhood, ought to look and function.[44]

The Moroccan home turns its gaze inward on itself. One moves through this ideal home in a circular way. Its rooms, and consequently people's movements, spread out around a central patio. Rooms around the courtyard are long, rectangular. In the patio itself old homes often had wells, with kitchen facilities either in this central area or in a separate area outside the main living quarters. Windows, and all activities, face the patio, spinning around the center. Windows on the street, if they exist, are tiny. The only openings are toward the patio, or on the roof, where the women do laundry and socialize. In most new homes and apartments this arrangement of the home remains only implicitly. In European-style apartments people may use the entryway, originally designed only as a passage to other rooms, as a central space to congregate, eat, or entertain guests. The central room (called the *salon* or the *bit ed ḍiāf*) serves at once as a dining room, a study for children, and a place to sleep. Its dimensions are generally rectangular, and it is lined with couches and pillows. This arrangement

makes it possible for several groups of people to converse at separate ends of the room or to engage in different activities. In well-to-do and middling urban settings rugs line the tile floors, which are generally cleaned daily. Rooms are decorated by the ever-present *vitrine* (a glass case, from the French word for a shop window) for precious objects. Photos of the family, illuminated Korans, or statuettes fill the shelves of these treasure chests. Often a photo of the father, grandfather, or eldest son is placed prominently in the room—usually high up, while most of the room is low to the ground.

This living room, whether inscribed in the architect's plans or defined by the occupants, is the central node of the house and of family communications.[45] In contemporary urban homes the kitchen is usually dominated by the women of the family, but the salon is generally open to both sexes at all times. Men and women are not confined to specific spaces, but in certain contexts age or gender will determine who will feel comfortable in the presence of one or another person. Thus, when Mohammed and his friends from work gather for lunch in the salon, his sister Samira demurely serves them their meal without exchanging more than a polite greeting. When one of them teases her in a friendly way, she smiles broadly, indicating that she enjoys his company, but then leaves to watch television in another room. Similarly, when Mohammed returns home to a room full of Samira's friends, he usually retreats to his own bedroom. While men and women have different roles to play in entertaining guests (Mohammed never serves Samira's friends, although he might serve his own), very few of the families I have known in Casablanca confine men or women to specific spaces. Both share the house and the central room. The salon is usually the most carefully decorated part of the house and the source of noise. With or without an actual hearth, the warmth of the room is manifest. It seems that the central patio or salon offers a model of the haven of the family—of the group solidarity of the household members and their connections to welcomed guests.

Central to any salon is its function as a place to eat. At mealtimes family members and guests gather around low, usually round tables to eat from collective dishes. In some families women and men continue to eat separately; however, this is not the general practice for daily meals in most Casablancan households. In well-off households many families have begun to have two different salons with distinctive dining arrangements, Moroccan and European. In the European salon

a higher table, with chairs and individual place settings, dominates the room. As one man who had two dining areas explained to me:

> I like to have a choice of how I am going to sit. For example, when I eat a *tajine* [stew], I like to be relaxed, eat with my fingers, sit closer to the floor. On the other hand, I can't imagine eating smoked salmon this way. It just feels right to sit higher, and to delicately cut the slices of salmon with a knife and fork.

Specific foods and ways of eating and even languages are commonly associated with different occasions or types of social interaction. For example, in European-style restaurants many Moroccans speak French with waiters. This isn't the case in fast-food joints or in most homes. In homes various eating practices are mixed; for example, some people set individual places on their low, round tables. Whatever type of table or service is provided, the important thing is to offer varied and plentiful food to guests. However simple one's daily fare, hospitality requires that one offer the most sumptuous meal possible to guests. Only the most formal occasions call for a strict cuisine or protocol; however, a host or hostess is expected to evaluate the kinds of people who will be present at any meal and harmonize the kinds of food and ways of serving it according to tastes and social positions. Visiting *nāṣarā* (Christians, foreigners) are often given cutlery and plates even in families where such utensils are rarely used. I remember one occasion when an entire family began using their forks and knives to dig into a communal dish until I set aside my own fork to eat with my hands. I sensed a half-audible sigh of relief among the family as they followed the lead of their guest. By contrast, my own five-year-old son objected when I used cutlery at home. "But Mama," he protested, "you're Moroccan now: you have to eat with your hands!"

Visiting

One day I walked up to Mrs. Bennis's modest villa. She greeted me at the door and led me to her salon, where some of her daughters were sitting together while a servant sped in and out of the room preparing afternoon tea. One adolescent girl studied physics while another read a women's magazine, *Intimités*. I noticed, through the open door of a bedroom, a disorderly pile of newspapers. But the salon was spotless and, unlike my own living room, uncluttered by random magazines,

books, or papers. The entire impression of the scene was one of calm and order. Yet there was something jarring about this welcome, coming not from any of my hosts but rather from a constant noise—the television set in the center of the family room. Cheerful, insistent voices urged us to buy Tide detergent and Yop yogurt drinks; young women announced the day's programs; images of mosques and the sound of children singing jingles for chewing gum followed us throughout our afternoon conversation. Maria, one of the daughters, served us sweet mint tea as we ate cookies and talked about our families. Aunt Aicha was ill. How was Hamid doing in school? Was Touria still studying in Paris? When would she visit? Miriam hoped that she would bring her back some Hermes perfume and maybe a dress. Tina Turner caught our attention: was she selling soft drinks or a way of dancing?

Throughout our conversation I noticed that the salon, the center of the house, was not such a private place as one might expect. While it was architecturally protected from the street, with no windows and a single large door, the television brought distinctly public messages into the home. We drank tea, speaking the Moroccan *dāriža* (dialectal Arabic), while Egyptian soap operas, French documentaries, and advertisements of many origins flashed before us. Some, like Tina's dancing, caught our attention and evoked comments; others simply served as background noise.

In older homes of wealthy residents of cities like Fes or Marrakesh, the inner patio was a place of comfort and relaxation. Blue- or green-tiled fountains were often a part of the architecture, designed to encourage conversation or restfulness. The sounds of water, trickling down to brightly colored pools of *zellīž* (mosaics), seem now to have been replaced by the television's ever-present drone. Yet, while the fountain evokes coolness without ever directly calling attention to itself, the television cries out, actively trying to grasp the attention of the listeners. Using sounds as human as any of those in the room, it beckons the family to its side, inciting them to take up new topics of conversation or introduce new objects into our lives. The cool sound of water falling in on itself might be echoed in Andalusian melodies, the spray-cast rainbows captured in poetic verse—but the television rarely inspires such abstract sentiment. Its rhythms and themes express themselves directly, proclaiming the existence of other musics, other voices.

Today nearly all Moroccan homes in urban areas (and many in the countryside) have television sets. A good number of middle- and upper-class people also have videocassette recorders. Any strictly income-related account of television or radio or video ownership is misleading. Like the notion of the inner courtyard—the central patio serving as a society-wide manner of arranging space, the television has become a central aspect of Moroccan architecture, home decoration, and family life except among the very poorest people. Those who cannot purchase their own sets can go to cafés to watch television or visit neighbors or relatives, whose salons become centers of sociability. One man told me that he always associates his first encounters with television in the 1960s with his first experiences with girls. His family bought a television set before the others in his town in southern Morocco, and soon his living room became an important gathering place for neighborhood people. At that time only a few hours of programs were scheduled each day, and Fou'ad's home went dark during those hours, like a miniature cinema. And as in a theater, the dark provided privacy for those who flocked to see the moving images. Consequently, young people of both sexes were brought together in a public secret. While his mother was engrossed in the stories on the screen, Fou'ad could kiss his neighbor.

Today people watch television in a more informal way. Habiba, a new mother and wife of a tailor, makes no secret of her great interest in television, proudly explaining to me that she has already had three televisions during her two years of marriage. Now she has purchased a video recorder. Her television cupboard is not simply a table on which to place the television; instead, it is a showcase. For Habiba the television cupboard serves simultaneously as her vitrine. The only high-standing piece of furniture in her home is a storage space for knowledge and dreams. Her television is covered with lace doilies, flanked by fashion reviews, trade manuals, and a Koran. While caring for her baby son, Habiba leafs through magazines, which she reads with difficulty. She is often too absorbed in her work to watch television, but she listens to it to keep up on her favorite soap operas or hear the news. She wants to know what I think of various programs.

At a home in a bidonville I drank tea with people originally from the countryside near Marrakesh. Like other people in more prosperous neighborhoods, they too had constructed a sort of television cupboard in their makeshift salon. Theirs is an old, white kitchen

cabinet, placed upright but upside down to provide a perfect lodging for their large black-and-white television. As we watched an Egyptian soap opera one afternoon, their eight-year-old son did his homework; an aunt lit a gas burner on the floor in an adjacent "room" and began to cook dinner, and we could hear people passing along the muddy path that served as a street in the shantytown. Yet the thin, corrugated-iron walls seemed to afford some sense of privacy. The television, unlike water or the collective sanitary facilities of the neighborhood, belonged to this family as much as did the photographs of their children hung on their walls. Yes, they said, many neighbors without televisions did come to watch theirs. In an article concerning the ways in which the *bidonvilles* are included in the urban universe, three Moroccan architects commented that

> at the level of mentalities, the impact of modern media is particularly strong, since it appears that the access to radio is generalized and access to television is as well (between 40 and 80 percent of the households in bidonvilles have a television). The television is preferred to a refrigerator or a stove. Social integration and attachment to modernity in these quarters are therefore undeniable.[46]

The living room is a place where family intimacy greets outsiders. The vitrine offers private treasures to the view of all. The television reflects images the other way around, bringing the world inside—and the guests it introduces are not all welcome. The images on the television compete with other images in the living room, most often those of the head of the family or, in some cases, the king. Only in those homes most touched by foreign living and education does the television appear less central than other objects; in such homes our gaze rests instead on a stereo, artwork, or musical instruments. While homes of this type are unusual, their placement and use of television is especially instructive for its difference. While intellectuals or professionals whose homes fit this description are sometimes seen as "too foreign" or "modern" by other groups, may we not say that this way of relegating the television to a subaltern position in the household maintains the kind of intimacy of the pretelevision salon?

The less central role of the television as a decorative element does not necessarily indicate less eagerness to watch it; however, it might imply a different relationship to the images it projects, perhaps the result of a different relationship to these apparently distant people or

places. Much like the port or the airport, television links each living room to places beyond the neighborhood, Casablanca, or Morocco. "Other" places—Paris, Rome, Tokyo—can apparently be known through television. The ways in which these other places are represented become themes for family discussion on all manner of subjects. Tahar expresses a critical perspective of the media when he says that "American serials don't reflect American life. They only want to show us rich Americans, like on *Dallas*." He asks me to talk about the "real" America, calling up examples taken from the television itself to phrase questions about racism, homelessness, crime. He then goes on to compare the American situation to what he knows about France, a place that figures more often on television and in the French newspapers or magazines that are regularly available in Casablanca and other Moroccan cities.

A sense of ambivalence about the different "other" places is apparent in his shy questions and reasoning. Tahar feels that he somehow knows them, not only from the television but from reading and studying at the university. Nonetheless, he suspects the validity of this knowledge, for he knows that television images are so easily manipulated and distorted. They can be seen but not touched. One can listen but not establish a dialogue with them. Their authenticity is always questionable. Are producers, states, or commercial enterprises responsible for them?

Many people express their ideas about the "elsewheres" on television by referring to specific narratives or behaviors that for them have absolutely no grounding in experience. For example, an episode of the series *Santa Barbara* shows an adolescent confiding to her friend that she is still a virgin. The character is ashamed and feels that she is a social outcast. Most Moroccans simply cannot imagine such a situation. Shame (*Hšuma*) is an important emotion in Morocco, but the notion that it could be shameful to be a virgin seems preposterous, even scandalous. On various occasions young people mentioned this episode to me as they tried to come to terms with the idea of a society so different from theirs. "How could women be ashamed of their virginity?" Najat wanted to know. She explained that she had thought that Americans were less concerned about "just sleeping around" than the French. This television episode had unsettled her assumptions.

Television can express the very questions people ask themselves, and in a very dramatic way. These diverse approaches to such fun-

damental issues as sexuality and family relationships are confusing, encouraging, or maddening depending on one's own views and social status. The problem that Tahar brought up of the lack of fit between media and real social practices only adds to the confusion. Between stories and life there is often an unbridgeable abyss. One American resident of Morocco explained to me what she liked in Morocco: "The food is good. People are so sensual when they walk, and the way they take each others' hands and kiss to greet one another is so different than the stiffness I feel in the States." This woman perceives Moroccans as somehow more directly sensual or honest than Americans. Likewise, a group of young Moroccan men repeated virtually the same words to me concerning American frankness (they did not, however, praise American food). All of them seemed to be searching for what they felt was lacking in their own experience, and they thought they were finding it in "other cultures." As we shall see, people turn to the idea of "other cultures" for political alternatives as well as personal ones.

The mass media, penetrating into the very center of the home, profoundly influence not only the ways in which people locate themselves in urban life but also the kinds of messages that can be diffused by those in power. As Rémy Leveau has noted, the ways in which Casablanca and the other coastal towns relate to government control distinguishes them from other regions:

> These cities are . . . more infiltrated by the influence of radio and television, diffusing the discourses of the king and minister as well as an indirect propaganda in favor of the governmental party. . . . By contrast, the administration has fewer means of influencing people than in the countryside, and these elements are more difficult to handle. The distribution of subsistence food through Muslim aid societies, permits for professions like taxi drivers, are not negligible, but they don't touch the entire population to the same degree. The anonymity of large towns, economic independence, contacts with diverse milieus, permit the diffusion of ideas and doctrines that escape those in power.[47]

In the moving, often confusing universe of Casablanca, people are cast into a dizzying plethora of seemingly ungrounded objects and attempt to bring them together in meaningful ways. The constant movement in the city, the maelstrom of social changes, the farrago of images from afar—all challenge the very relationship of truth to

goodness, self to stranger. But to what extent do such images, in the heart of the home, realize some political mythology, and what do they have to do with collective discourses? Mass images structure social transformation by instituting new possibilities for both social discipline and discipline of self.

While schools, industrial production, or even neighborhood plans in Casablanca invariably face problems in reaching the majority of the population, the media offer apparently ideal means for involving people in an everyday experience of power as their images enter homes through television, radio, newspapers, and magazines. The kind of global identification and mimesis credited to these images seems a simple and ominous tool for those who seek to exercise influence. From the start television was considered too potent a force to be left to anyone but the central authorities.[48] While newspapers were left to political parties, television, like radio, was immediately assimilated to government directives and used as a potent means of internal control—as dissuasive and persuasive in its way as a stockpile of missiles.

The very organization of television programs—not only in Morocco but throughout the world—revolves about the time slots of the news programs, which are, from the perspective of technocrats and governments, a highly controllable medium of information. However, media products are perhaps not best categorized in terms of their national origin. Does the news consist simply of bits of information cut and pasted together differently in each region of the world?[49]

Part of the political import of news is the way in which it situates national versus international reporting. Much of the task of those in power, or those who hope to gain power, is to develop visual representations of the nation. In Morocco most television images are produced in France, the Middle East, and America. But these cultural spaces are in themselves highly diverse and mobile, and they take form as distinct national entities in images in the same way Morocco does, in opposition to other images labeled according to national origin. Yet J. R. Ewing spoke French in Morocco, and some favorite Moroccan singers, like Samira Ben Saïd, sing in Egyptian Arabic. Viewers cannot always discern the national identity of the stars whose images glimmer on their screens. Across the world, images are increasingly similar, but they enter into the visual orders of different places in subtly different ways. In Casablanca unique sets of individual and collective choices

and obligations frame internationally available images in ways that are decidedly different from those of Cairo, Taiwan, or Melbourne.

On visiting Fez after a long absence, Jacques Berque noted the

> abundance of postcards and of photos in shop fronts. Here we were far from the apparent interdiction of the image and the portrait. Today this society likes to contemplate itself in its own mirror or in the mirror of the other. It makes itself seen to others, trying to recognize itself in that which the other sees of it. Thus, it might find markers in its dizzying transformation.[50]

Which signposts might mark off the self or designate the other? Mirrors and photographs are not the same. A photograph fixes what the camera's lens sees, while one can slip out of the frame of a mirror. If I can see someone in a mirror, he or she might also catch a glimpse of me. A photograph is closed and offers no exit, only a one-way view. It cannot establish reciprocity between the viewer and the viewed. One might juxtapose different photographic images or put them into motion in a film to give the chemically produced image a feeling of time and direction. However, even cinema or television cannot quite match the fluidity of the mirror.

Once the order of photographic, reproducible reality is generalized, and world atlases become common possessions to stack alongside Korans or Bibles in personal home showcases like the Casablancans' *vitrines*, how do these frames shift? Who determines the objects to be collected or dissected by the eyes of both cameras and our minds? The new world of the mass image—or of the colonizing domination of the image, the model, or the plan—touches all aspects of experience. It cannot be conveniently roped off like a costly painting in a museum. Yet such images of community, creativity, or legitimacy often take on the role of the art object in the hands of those who seek to institute social order. Perhaps we could talk of a "disinterested" contemplation of power. Politics, economics, or nationality could thus be set aside, at a distance from those whose images represent these now objectlike realities.

One way to consider the kinds of choices available in Morocco is to focus on the national image as it appears on national and international television and in photographs or mirrors in homes. In delimiting the boundaries of the object of study, we cannot simply decide, however, to fix our gaze on photographs; mirrors must also be

turned to the interplay of moving imagery, words, and melodies that define the national image. To do so in the context of Casablanca I will concentrate on two events. The first, an image technically outside of Morocco, concerns a French election; the second, an international conference, suggests how the national image is created through a rearrangement of Casablanca. The events themselves thus act as time frames for my study, although some explanation of them requires looking backward or forward around the edges of their officially stated beginnings and endings.

Chapter Two

TELEVISIONS AS BORDERS

◆◆◆ Each day in Casablanca I stop at the newsstand to buy *Le Monde*.
During Ramadan 1988 the headlines in the paper drew my
attention to the French presidential elections, an event that
attracted others' attention toward me. During Ramadan people fast
from sunrise to sunset, and offices shorten their hours; thus, they have
time to pass thinking about what is in the papers or on television. I
myself often walk about the center of town with a newspaper or a
magazine in hand. During this period the recognizable layout of *Le
Monde* apparently indicated to passersby that I was enmeshed in the
political world of voting. In the street or in the park, I spent many
hours each day responding to questions from strangers about the
elections.

One day I was besieged by a short, rotund, middle-aged man. Well
dressed and friendly, he had all of the qualities of the "benevolent
patriarch" that he attributed to his favorite candidate, Raymond
Barre.[1] After greeting me, he asked for whom I intended to vote. When
I responded that I wouldn't vote, the entire edifice of the friendly
patriarch dissolved in a wavelike motion of incomprehension. "But
mademoiselle!" he exclaimed. "You have the right to vote! It is your
duty as a citizen!" How could I relinquish such an occasion to express
my choice?

Only after taking a moment to calm down, following his outburst
in favor of the republic and *bon sens*, did he permit me to explain that
I could not vote. He took a moment to position me in light of this new
fact and asked, "So, what are they trying to do, these French?" Once
he had placed us both beyond civic responsibility, this political theater
became suddenly distant. Having escaped the role of public relations

officer for the actors, I was now offered the dispassionate voice of the
observer. But were we not in the process of deceiving ourselves by
limiting our participation in this event to the simple act of voting?

In Morocco, as in France, each afternoon during this period the
streets, living rooms, and parks echoed to the names of Mitterand,
Chirac, and Le Pen. The dramas of the elections were projected onto
Moroccan television screens on the state-run Moroccan channel, RTM
(Radio Télévision Marocaine). Extensive news and both rounds of the
elections and the Chirac-Mitterand debate were televised by the RTM
and closely followed in the Arabic- and French-language presses; in
Rabat coverage was also available on francophone TV 5. These images
appeared in counterpoint to the special Ramadan programming. Tele-
vised discussions between *fuqahā?* (specialists in Islamic jurispru-
dence) were followed by commentaries from the activist Dany Cohn-
Bendit, tirades from famous French soccer players fed up with politics,
or shots of the champagne-soaked crowds who thronged the Place de
la Bastille following Mitterand's victory. It was then that we remarked
the only intrusion of the censor: the television went black just as a joyous
but naked socialist appeared before our eyes.

Discussions concerning the elections were sometimes intense and
unexpected, sometimes staid and disciplined. But in all types of
encounters one of the most surprising aspects of this period was the
enthusiasm that people showed in expressing their views concerning
France and, on occasion, Morocco. Words and debates burst from all
directions, erupting around this political event and its issues.

Politics links power to speech. Since Aristotle it has often been
conceived as a debate between citizens. To the extent that politics
remains attached to citizenship, this debate is centered on certain
sites, to bounded territories in the modern world. What, then, are we
to think of these debates and discussions among noncitizens who speak
in varied tongues? Benedict Anderson writes that the most striking
fact about the nation is that "it is imagined because the members of
even the smallest nation will never know most of their fellow mem-
bers, meet them, or even hear of them, yet in the minds of each lives
the image of the nation."[2] The image of the citizen is mirrored by that
of the noncitizen, the outsider, the outcast. Yet the national commu-
nity is not alone in associating people who will never know each other
and who yet share common identities, whether of belief, language, or
professional competencies. National sentiment need not be synony-

mous with any state organization or the individual's rights, duties, or possibilities for action in the political arena. National feeling can overflow borders or concern only part of a state's constituents, as national movements from Bosnia to Quebec never cease to remind us. Kurds or Basques live divided by political maps; debates and wars arise because of desires for new state boundaries.

Ghassan Salamé notes that after World War II the territorial status quo largely benefited the United States and the Soviet Union:

> Gradually, when it came to the Third World, the two superpowers (and their social scientists) have generally shifted the discussion from the state as such to the kind of political regime (strong or weak, capitalist or socialist, authoritarian or democratic) prevalent in these countries. World War II seemed to have abruptly closed a lively discussion in Europe on what states to give birth to, what territories to allocate to them, and what populations to involve in this process.[3]

Today European unification and the end of the post–World War II order reflect growing attention to the historical nature of the nation-state as well as to the varying influences of the idea of the state on the social sciences. Anthony Giddens remarks:

> If it is supposed that the most important influences upon social change derive from factors inside "societies," and if it is held in addition that these factors are primarily economic, then is it hardly surprising that sociologists are content to hive off the study of the political relations between states to a separate field of investigation. Although there must be divisions of labor and specialism within the social sciences, there can be no justification for the theoretical aberrations which this particular disciplinary partitioning tends to perpetuate.[4]

Marc Abélès affirms that one of the main problems in constructing a political anthropology of industrial and postindustrial societies is to determine "how to think of the political in our societies without falling victim to the fascination of the institutional state model and the language of which it is a vehicle."[5]

Studying power without remembering the state would require a radically new approach to modern culture and society. Most analyses that attempt to avoid referring to the state in the contemporary context concentrate on either local groups or broad economic forces that engulf states in a worldwide system of exchange and domination. Anthropologists have often shown how local cultures may resist the

onslaught of state policies or of global economic or cultural domination.[6] But even a study that tries to "forget" the state must inevitably show how national sentiment and the international "system" are interrelated. A simple contrast of local to global cultures or ideas cannot account for the political and cultural formations that we observe in contemporary societies. Part of the effort to disengage social theory from presumptions about the state must involve the study of the varieties of state formation and the perpetual creation of cultural referents and social orders based on state institutions.

If we take a critical view of the nation-state, images and identities cannot be presented as simply reflecting that presumed totality. Neither can images be quickly assimilated to products that are locally produced or imported. Strong states might influence others, but they do not do so simply by exporting "cultural products." More important is the increasing universality of manners of organizing knowledge, manners that include the camera's regular gaze and the map's standardization of space. Processes of globalization produce novel differences and often strengthen notions of national belonging and the primacy of national identity. Omnipresent photographs of national leaders can provoke feelings of importance, and news bulletins speak of international affairs as state-related matters, daily underscoring the state's claim to control. Yet both local powers and individuals rely on networks of thought, practice, and power that inevitably extend beyond national borders.

Nation-states cannot imprison fields of practice and knowledge, for their own claim to legitimacy rests in part on fields of knowledge and practice beyond their grasp. But national discourses can gather strands of far-flung references and knot them together around the image of the state itself. Similarly, such discourses can claim the persons who practice in these fields, much as political maps distribute territory: thus, medical knowledge cannot be appropriated by any nation-state, yet a doctor can be presented as an "American" or a "Moroccan" specialist. Personal national identity appears to overshadow the impersonal claims of modern science. Praise for having such knowledge accrues to the nation-state, and individual accomplishments represent collective glory. Differences between "strong" and "weak" nations might be measured in terms of the material, intellectual, and symbolic resources necessary to legitimize this ongoing process. Current sit-

uations and the imaginations of history meet to define here and there, inside and outside.

In Morocco the contrast between the inside (*daxel*) and the outside (*xāriẓ*) is used in different ways according to the subject of discussion or circumstances. Inside is home when outside is the street. The inside is Morocco while the rest of the world is turned outside. People from northern Morocco, from Tetouan or Tangier, often refer to those of other regions as those of the interior, *dāxliyya*.[7] This term is pejorative, emphasizing the "interior's" lack of contact with regions beyond the Mediterranean. Inside and outside take on either negative or positive attributes according to a given situation. Muslim to Christian, Moroccan to Middle Eastern, first world to third: binary terms place borders according to the threats or promises perceived in a given situation. The *xāriẓ* can be menacing in its strangeness or attractive in its promise of loosening the grip of some interior social situation. The process of exerting influence or control includes simplifying the play of inside and outside. One way to fix identities is to view them in terms of ideas of place that are maplike and motionless.

Whatever their family origin or social position, Casablancans are joined to other Moroccans not simply through common habits or languages but also through the shared framework of law and power exercised by the state. Blood, not place of birth, confers Moroccan citizenship; being physically "outside" the country does not alter one's status. The right to participate in politics is bestowed through the father's lineage.[8] Women can and do participate in politics, but even a woman elected to the legislature must have her husband's permission to obtain a passport or take her children out of the country on vacation.[9] Territorial and patrilineal references pervade Moroccan political life in an uneasy relationship.[10] Elections are held in Morocco, although at irregular intervals,[11] and the national assembly, which does meet regularly, includes members of the opposition; yet Morocco remains a monarchy. However, the king himself stays aloof during elections.

In describing Moroccan political culture, John Waterbury remarks the political consequences of Moroccan unwillingness to take sides in arguments. Moroccans prefer not to have to choose, he says; rather, they try to maintain an equilibrium between groups. When a choice must be made, people often imitate others: "One might make a political

choice simply because a father or brother did so first. A choice of this kind is seldom taken with regard to a program or ideology, but rather because X says it's a good thing."[12] Yet elections are staged crises that force people to take sides or suggest solutions. The 1988 elections, which took place "elsewhere," seemed an occasion to express ideas or ideals outside of the immediacy of daily exchanges. Both the elite and "ordinary" people posed straightforward questions and gave definite answers. Had the society changed since Waterbury's work in the 1960s, or had tongues been loosened because the issues did not directly involve Morocco?

Daily economic and cultural exchanges, as well as the historical connection with France, act to make French politics of practical interest to many Moroccans. When most Moroccans refer to *nsāra* (Christians), they implicitly refer to the French, and Moroccans compare their country to France much more often than to other countries. During American or Brazilian elections, for example, many people have a hard time remembering the names of the candidates, let alone their political affiliations. Discursive habits associated with French democratic procedures and political divisions are traced with respect to French convention and often through the French language, which has broadened its influence in Morocco since independence in 1956. Administrative practices also bear the mark of the Protectorate. Neither the Moroccan state, nor family groups, nor economic enterprises ignore France and other foreign countries in their strategies. Nonetheless, in conversations, even those conducted in French, people bring up the fact that Morocco and France are and must be separate, and the act of voting clearly designates the legitimate participants in the election process.

Many people with whom I spoke about Moroccan politics during this period hesitated to express their opinions, fearing social or political retribution for expressing beliefs deemed undesirable by one or another power holder (including those whose power comes from the state but also other authorities like bosses, families, or spouses). But discussion about another place, especially a place that many people know something about, offers an ideal way of sidestepping these fears. Talk of the election offered an occasion to clarify one's ideas and offer them for discussion. Thus, even if one could not vote, one could prefer a candidate or a platform. Expressing an opinion put men and women in the starting position for political participation.

One was ready to be asked to choose, but by whom? Ahmed, a young businessman, explained that "these elections act as a lesson in democracy for Moroccans. The authorities promote this interest as a way of preparing the conditions for democratic debate." His friends, who were sitting beside us in a café after sunset, took him to task for this opinion. According to Ahmed's perspective, Abderrahim pointed out, Moroccans need only follow the French lead to attain a democratic system of government. "We should have our own road to democracy!" he exclaimed.

In another discussion on the other side of town, Hassan, a former political prisoner but now a government worker, told two friends about his feelings concerning the elections. Speaking in French, he insisted that his political ideas were based on a universalist position, without regard to the specifics of French politics. He vividly described how Mitterand's first victory in 1981 brought a festive climate to the section of the prison he then shared with other political prisoners: "We were so excited, it was a big party. We've been a little disappointed with Mitterand since then, but I'm for Mitterand because I think that he will be best for France. I think that he is more interested in human rights than Chirac." This reference to the past brought me to describe my own recollections of 1981; I had distributed tracts for the Partie Socialiste in suburban Paris, but I learned of Mitterand's victory by telephone at my parents' home in California. Thus, Hassan and I had something in common beyond a notion of universal human nature or a particular culture: our participation in a universally publicized event provided a point of departure to discuss all manner of ideas and memories.

Ideas about politics drifted easily back and forth across the Mediterranean during the election, yet in Morocco these words and images lacked a place to settle, a privileged moment to take form as intentions for action. The Moroccans could and did speak of political matters, but they were perplexed by the impossibility of giving weight to their words through voting or through local political involvement. The discourses themselves were abstractions, tainted by their lack of practical implications. Knowledge of this abstract quality gave an unreal cast to some discussions, as people tried almost desperately to meld their debates to their lived experience. While discussion about the election flourished, the severing of debate from practical consequences finally showed the French political stage to be a chimera, or

at least some entity distinct from a lived reality in which talk might be linked to power.[13] When images of the election were projected on Moroccan television, people learned about France, but they also learned to notice the distance between France and Morocco. A popular joke concerned an immigrant who visits his family in Morocco and boasts to them of the wonderful lifestyle he has in France: "We really have freedom of speech. We can say whatever we please," he says. "We can even criticize Mitterand." Unimpressed, his brother replies, "But we have freedom of speech too! We too can criticize Mitterand!"

Political practices in Morocco might seem far removed from those of France. Yet if Moroccans of all walks of life seized on any opportunity to discuss the French elections, perhaps there was more to their interest than can be explained by the eventual consequences of the elections for Morocco itself. Having listened to Casablancan and Parisian conversations during spring 1988, I concluded that French voters and Moroccan subjects shared at least some of this experience. Images and discursive practices were not the simple result of a sudden invasion by the "media"; rather, they derived from the partially shared world and regional history that has helped to shape both modern Morocco and contemporary France. Various versions of each nation were put forth in images and conversations, conversations that were especially explicit concerning Jean-Marie Le Pen's National Front.

In both Paris and Casablanca, Le Pen provoked discussions about democracy, and his image became a symbol of injustices suffered by Maghrebians in France.[14] Disillusionment, often expressed as fear, was mixed with a sentiment of injury by many people I spoke with in Casablanca. In the eyes of many Moroccans, "the French" were permitting their political leaders to use the North African presence in France as a token of debate, and this development was endangering the very edifice of the French republic. People in Casablanca had varied notions of *democracy*, but the term was never open enough to include the platform of Jean Marie Le Pen. Yet, I asked several people, if "democracy" could not include him, could the polis be expected to banish him?

A student approached me in the park to ask timidly: "But madame, will Le Pen win? Why does he hate Arabs?" He said that he had difficulty understanding the accounts of the elections in the French newspapers. He reached into his pocket and brought forth a photo of

his brother and his nephew who live in the Barbes neighborhood of Paris, as do many immigrants. He pointed at the photo and asked, "How can it be that they've become of such importance for the French? What have they done to become the center of all of these discussions?" He again expressed his confusion and disillusionment at the idea that many French people, with choices that seemed to him so vast, would actually choose a candidate like Le Pen. He said that Le Pen's relative popularity showed that "the French hate Arabs." (He never mentioned the problem of "Moroccans" in France. Instead, his sentiments and perspective made him use the term *Arab* to inquire about my views.)[15] He perceived the simple presence of Le Pen in the campaign as a threat to democracy, and Le Pen's candidacy brought him to doubt in one breath both democracy and "the French people." Knowing next to nothing about French politics, he was quite convinced that Le Pen might easily become president. With a sigh he wondered aloud, "Fascists are imposed; how could they be elected?" Although I tried to explain that Le Pen would not be elected, he still seemed uncomprehending.

In Morocco one often gets a sense from declarations in the press or on television that the formal apparatus of the constitution, the stylized display of the election process, and the impressive use of words like *democracy* or *liberalism* or *equality* can magically alter power relations. The notion that intense conflict might form the background for democratic exchange did not fit with at least this man's understanding. In Casablanca the consensus of the community remains so tightly wound up with notions of the polity that it can effectively alter what an election or form of government might mean.

While many Casablancans passionately followed the elections, most people in France itself ignored the interest of their trans-Mediterranean neighbors, focusing only on foreigners within the borders of their territory. What links might these people have with the places they had come from? Yet the issue of North African migration to France was hotly debated among the presidential candidates and formed a major topic of conversation in both Paris and Casablanca throughout the election period.

A butcher in suburban Paris explained to me that he would vote for Le Pen because he was the only candidate who appeared ready to listen to his problems. As he cut me a tender slice of veal, he carried on his running conversation with the world represented in the persons

of his clients: "Le Pen is representing us. All of those others do nothing
about the foreigners. There are just too many of them. Besides, the
others never listen to ordinary people like us." When I told him that
I was not French-born, he jumped a bit, then explained, "Well, you
see, I mean all these Africans and Arabs." The issue of immigration
during this election concerned the stranger with a specific identity and
physical appearance. Taxonomies as crude as those of turn-of-the-
century film documentaries were being used to indicate the "us" and
the "them." Only this time there seemed to be no space, no sea, to
give the impression of security among one's own.

French presidential elections are held every seven years, and all
French nationals over eighteen years of age are eligible to vote. For
people who watch television at home, the distance between the elec-
tion process and the real sentiments or problems of life seems wide.
Looking from Morocco, Marseilles, or Brest, one often sees only a
vague, faraway image of the political infighting in Paris. Even those
who enthusiastically attend party meetings and rallies in support of
their candidates come to represent a crowd for the eye of the television
as much as they figure as an ear for the declarations of "their" can-
didate. Yves Pourcher, in a study of public rallies in France between
1985 and 1988 (including the presidential election), writes:

> The rally tends to adopt the style of political television programs, to
> transform itself into a stage. After Le Pen, with his hair pushed back
> in front of his public like an American T.V. evangelist, comes Chirac,
> whose first part of the campaign was marked by the television-like
> set-up of his stage as a T.V. debating room. . . . "It is in fact the rally
> of 2000, and it will send back the electoral rally of the old fashioned
> type back to the stone age. It's the Chirac show, just as all of the big
> cities in France will see it."[16]

Pourcher explains that although the crowds at rallies try to get can-
didates to engage in direct discussion, traditional speech making, and
debate, television influences the sequence of appearance of leaders
(Mitterand arrives right at eight, in time for the eight o'clock news that
most French families watch). Candidates are prepared to be seen by
cameras more than by the public. Yet television seems not to transmit
the passionate atmosphere of a rally or a debate. Candidates' sup-
porters boo television cameras or chant to get "sincere" responses
from their candidates, yet they are increasingly frustrated.

I visited a suburban Parisian town hall to observe voting on several occasions:

> At the polls, party members mill about while "ordinary" citizens quickly enter booths, make their choice, and return home. When the end of the voting period comes, groups from the local chapters of each of the parties participate in counting and recounting the votes of their town or neighborhood. Eager friends, family members, or party members encircle those who counted the ballots. People speak of many things, not simply about the elections, but one senses that they feel a personal stake in the results of the voting.

In the presidential elections most people never thought of staying around the town hall after voting; they returned home to a Sunday with the family or sports on television. Eventually the television would tell them the results of the elections, would make them feel involved in their nation's leadership. Indeed, most people had learned about the different candidates, their platforms and their personalities, through the images of the mass media. Televised images had been especially central in determining people's instant of involvement in the "polis" at the polls. Platforms and personalities of the political realm daily competed with ads and sports shows for the audience's attention.

Considering that most of those voting are spectators in this event from start to finish, one wonders whether elections are more accurately described as "political rituals" or as mere performances. On television we observe details of the candidate's face more clearly than we would at a rally or even in a face-to-face meeting. But this inspection fails to immerse us in the sense of collective feeling so characteristic of rituals. Often rituals involve an inversion of social roles, but no such inversion occurs in elections or other political events; instead, such events objectify identities around the plausible and controllable ones of daily life. The kinds of faces shown are strategically orchestrated by state or party powers in a kind of "impression management," as Erving Goffman phrases it. Although the candidate appears

> ostensibly immersed and given over to the activity he is performing, and is apparently engrossed in his actions in a spontaneous, uncalculating way, he must nonetheless be dissociated from his presentation in a way that leaves him free to cope with dramaturgical contingencies as they arise. He must offer a show of intellectual and emotional in-

volvement in the activity he is presenting, but must keep himself from actually being carried away by his own show lest this destroy his involvement in the task of putting on a successful performance.[17]

Spontaneity is not abolished, but it sneaks in like an uninvited guest.

Polls and election results do not include the manner in which spectators assemble and argue about the images thus provided. We rarely consider how such images and discourses extend beyond national borders.[18] Nevertheless, the ways in which national images reflect outward are intimately related to their means of establishing internal identities. How might the election of a national leader resemble this common dilemma of choice? Under what circumstances would citizens of one country perceive an election in another country as being of cardinal importance?

An election is often presented as an event in which a knowledgeable polis chooses its leader. This model of the election process depends on what Jürgen Habermas refers to as "undisturbed communication."[19] In this ideal situation all speakers are equal, all voices freed of rhetorical seductiveness, as individuals seek to engage in rational argument for the collective good. All participants would share both a cultural background and what Habermas calls "life chances." But does such an ideal situation ever occur on a large scale? Asymmetry between sender and receiver seems to be an inevitable part of the election process in particular and of political exchange in general. If mastery of political action includes competence in practicing "unequal" communication, then we cannot understand politics according to Habermas's ideal model. In France or Morocco, daily life rarely, if ever, resembles the ideal polis so often presented for collective deliberation. Instead of a rational exchange of equal participants, we find individual, unequal voters window-shopping among candidates who present ready-made platforms.

Yet the political scene set up by an election cannot be considered solely as a commercial exchange and explained by models of the exchange of messages. Lines drawn between senders and receivers must be given various weights, colored in terms of the histories of both, and nuanced for the innumerable particularities of the place, timing, and tenor of the exchange. Stuart Hall suggests that varying "competencies" among audiences can account for varied interactions between broadcast images and viewers.[20] However, his approach, like

other theories of communication, fails to explain how such "competencies" are acquired; rather, competencies are simply associated with class identity or linguistic communities.

Pierre Bourdieu, with his notion of *habitus*, provides a more nuanced account of the relation between experience and social position.[21] His dynamic sociology shows how relations among different "capitals" are always shifting, yet this approach remains ahistorical and fails to delimit "fields" of knowledge/practice except with reference to an already given society. In the case of the French elections, the political action labeled as "French" includes Morocco, but it does so in such a way as to fragment the "political" into variegated relations. These relations are complex and merit further study, but we can remark similarities concerning the intertwining of economic, ethical, or aesthetic discourses in both places;[22] for instance, the identification of the "outsider" played a significant but different role in each setting. In France, many people explain the rise of the National Front as a result of the bankruptcy of party politics; the "other"—foreigners in general and North Africans in particular—appears responsible for a general malaise that no one appears ready or able to cure. On the other side of the Mediterranean, some Moroccans attack this vision of North Africans by offering similar images of the French.

Generally, French men and women and Moroccans who had no developed ideas about the political positions of the candidates expressed strong feelings about their personal attributes. This type of judgment depends directly on the images disseminated by the television. Aesthetic and moral judgments were especially common among less educated women, who found Chirac "handsome" or Mitterand "uptight." When people had more sources of information, the issue of image became less important. This type of involvement in the elections falls outside the ideal notion of the polis, in which reasoned debate is central to the harmonious, collective life. Is it political involvement at all?

Hypothesizing about the reasons for the extensive coverage of the elections by the RTM, people in Casablanca came up with many explanations. One intellectual simply said that "the democratic aspirations that are frustrated in Morocco are satisfied by this voyeuristic glance at France." In Morocco the "right" of representation is continually evoked in official discourse and party communiqués. Still, while the opposition might criticize details of government policy, they

accept limiting their demands to those issues that will not fundamentally question the legitimacy of the monarchy. These limits to their questioning of the "system" spring more from strategic considerations and analyses of the political possibilities for change than from any consultation with their constituency.

In talking about the elections, no one hesitated to note how Mitterand had become a central, even kinglike figure,[23] and caricatures of the president dressed him in royal attire. Considering paired pictures of kings might make some people simply view all political systems as theaters turning around unique persons. Comparing portraits of different leaders during the election encouraged several people in Casablanca to explain to me that the chasm between the talk of politicians and concrete actions prevailed everywhere. Here there was no talk of difference, of "lessons in democracy," or of any type of discursive exchange. Politics appeared as an immobile and unpleasant fact of life that one must learn to put up with.

From the perspective of Paris, any reference to politics as linked to verbal constructions in elections seemed ironic or naïve. The lack of "real" debate concerning the problems of daily life itself became a major topic of articles and conversations during the presidential campaign. People never ceased commenting on the "death of ideology" and the replacement of issues of general concern by the candidates' carefully crafted images. Le Pen claimed to "say aloud what everyone thought quietly." But in fact many people seemed to be thinking about the *lack* of thought as it is usually expressed through words.[24]

Pictures are not simply a reflection of some other reality, some more fundamental political or social structure. Rather, their forms and diffusion shape political and social realities according to ever-changing norms of representation. Images are themselves enmeshed in ways of talking about them. What Georges Balandier has called the "remaking" of sovereigns consists of new ways of emphasizing rulers' authority and power by consistently centering our gazes on their images.[25] This refashioning draws on aesthetic conventions of the media as a perpetual reminder of peoples' relationships to their national leaders. The leader is charged with guarding the inside and negotiating with that which is outside, even if it is "inside" national borders, as in the case of immigrants in France. When people "outside" increasingly live in a common conceptual universe with those

"inside," and when the political stage seems to merge with visual conventions developed for soap operas or sporting events, a new map of politics takes form.

Viewed from Morocco, the French elections were primarily a consumer sport in the realm of cultural drama. Nonetheless, because of the continuing intensity and imbalance of relations between Morocco and France, Moroccan consumption must be conceived of as a process rather than an isolated act. The sovereignty of states is often defined by their legitimate use of violence within national boundaries; yet how can states retain this authority when information escapes the realm of the physical and geographical, when international standards· or institutions determine states' competence or policy? These are some of the important questions that are daily faced by states and experienced in peoples' lives, if not necessarily in the political arena. On one noteworthy afternoon a soccer match offered the occasion to observe the extent to which the idea of voting has permeated social practice.

A fever for athletic pursuits had been heated in Morocco recently by the successful performances of Moroccan athletes in international track and field events and by the national soccer team's remarkable performance during the 1988 World Cup. In 1988 the Africa Cup for soccer was held in Casablanca and Rabat. Throughout these televised matches, which were inundated by crowds, the streets were deserted. Those without televisions jammed cafés to catch each move of their favorite players' maneuvers. Only at halftime did people frantically rush away, by car or by foot, to get to another television set for the second half. The rhythms of entire cities were timed to the beat of the game. In homes televisions blared at full volume when the Moroccan team played, especially during the game with Algeria.

I happened to be invited to a party on the date of a game. No, the hostess said adamantly, this is not a party for watching soccer. She suggested music and conversation as appropriate activities for friends. However, many of the guests thoroughly disapproved of the hostess's view of television. After long argument a vote was taken, and the supporters of television won by a slim majority. The long room permitted those interested in the match to sit next to the television while others assumed places farther away, as if the physical distance could temper the loud voice of the sportscaster. Still, the television's noise intruded, and a loud cassette player was turned on next to the tele-

vision. Discussions, music, shouted encouragement of the players—
the audio effect was more than confusing. It was as if two parties were
amusing themselves in the same space. The conflict was tacitly re-
solved when the national team began playing exceedingly well. The
dancers, following the beat of the cassette with feet and drums,
heightened their rhythm as the game got hot. Good plays were ap-
plauded by instruments, and everyone laughed at this resolution of the
television debate. Many guests, like myself, craned their necks to
watch the television in spite of their uncomfortable positions.

At this party the television's role appeared as an addition to an
already full program. When the hostess argued for the elimination of
television, she did so in the name of an imagined conviviality. In such
contexts the television itself becomes like a movie star or sports hero.
For some it plays the villain's role, a potential often evoked in the
opposition press's columns or cartoons, which depict television as a
metonym for the absurdities or inanities of the modern or of the
current political situation. At this party we talked about how sport and
television related to social aims. Had the eruption of soccer into the
home encouraged nationalist designs, pushing more fruitful reflections
from people's heads? Did it elicit a confrontation between various
notions of sociability? In general, men watched the match while the
women danced and chatted among themselves, but this gender gap
did not indicate that women as a group feel that watching television
is inappropriate during social encounters; rather, the women seemed
merely to object to watching sports on television.

While we discussed the match and television's social role, the
Moroccan team went on to win. Our voices progressively included
more yells to encourage the team, rising in a crescendo of shrieks
and *zgārid* (ululations) when the team played exceptionally and won.
With the victory of the national team, streets that were empty while
people sat before their televisions suddenly filled with joyful noise.
People celebrated, sharing more tea and cake, or dinner, before
driving home to the beginning of another week.

In front of the television, national sentiment can override careful
argument. The state's legitimacy is derived from international con-
ventions;[26] moreover, because the methods of enforcing and repre-
senting state power are increasingly homogeneous, the ways of defining
power structures are becoming ever more similar internationally,

among both "ordinary" people and the elite.[27] Media images are not "injected" into the collective unconscious, but they are nonetheless effective.[28] This effectiveness cannot be wholly explained by the relationship between images and words; rather, we must consider the logic of images themselves and the process by which they influence identities—both personal and national—and the rhythms of power. In the next chapter I examine an explicitly transnational event, the Francophone and African States Summit held in Casablanca at the end of 1988. Here we begin to understand how international fashions affect both insiders' and outsiders' visions of the state simultaneously.

Chapter Three

CREATING SIGHTS

The City as Event

◆◆◆ The introduction of mass imagery fractured Moroccan experi-
ence. New ways of seeing and being seen emerged, and por-
traits of power and authority became ever more imbricated
with "elsewheres." But visual splendor had taken part in interna-
tional exchange long before it learned to apply makeup for televi-
sion cameras. Decorum and vivid ceremonial had always impressed
visitors to the sultan's court. Later, while the French were learning to
see Morocco as an ideal setting for cinema, some Moroccan leaders
were offering their own dramatizations of power to the eyes of their
"protectors." Gavin Maxwell describes how Tuhami El Glaoui, pasha
of Marrakesh and lord of the entire Moroccan south during the
Protectorate, welcomed guests with a banquet in his palace at Mar-
rakesh, among them Theodore Steeg, the French resident general
from 1925 to 1929. Taking leave of his guests in the evening, El Glaoui
announced: "Excellency, tomorrow you are going to see the men
and women of my country. They know little of France, but they
know that they want peace. They know too that France is powerful.
You have no need of soldiers to escort you—here peace reigns."[1] The
message that El Glaoui had sent out to the tribes of his realm ran as
follows:

> El hadj T'hami El Glaoui, Pasha of Marrakesh, requires you all, with
> your horses, your rifles and your women to line the route from Mar-
> rakesh to the pass of Tiz-n-Tishka. Every man will be armed and will
> see that his powder is dry. Every musician will come with flutes and
> tambourines. The women will wear their finest clothes; they will line
> the roadside and will sing with their finest voices as the procession of
> cars passes through their village. Every armed warrior will precede the

procession to the pass of Tiz-n-Tishka, and will be there by dawn. On
the arrival of the procession in the pass each man will fire his rifle
twenty times.[2]

As Maxwell comments, putting on such a show over so many miles of
new and poorly traced roads was tremendously difficult. Nonetheless,
El Glaoui and his guests did reach the pass, after being hailed by
villagers all along the way.

> At the pass of Tiz-n-Tishka M. Steeg was confronted by a spectacle
> impressive even to his haughty, colonialist's eyes, for no less than ten
> thousand mounted Berber warriors awaited them in the gorge, and
> each fired his rifle twenty times in salute. The noise was deafening,
> the fumes from the powder formed a huge drifting grey cloud against
> the mountain walls; and some French officials made rapid mental cal-
> culations on the expenditure involved in a salute of two thousand
> rounds. The banquet took place in a vast tent of white wool, richly
> carpeted; several thousand women danced and drummed and sang,
> while several hundred black slaves were engaged in roasting sheep in
> traditional pit ovens and carrying the food on great silver dishes. At
> the end of the banquet the ten thousand warriors formed a circle
> round the tent and saluted again the three figures of majesty, Caid
> Hammou, T'hami el Glaoui and the Resident-General.[3]

Hospitality and generosity are highly admired, and expected, in
Morocco. This tradition does not require simply that one be kind to
visitors; rather, the obligation evokes a panoply of dramatic displays
of friendship, special meals, entertainment, and conversation. The
custom holds among all kinds of people, wealthy and poor alike. Each
person will greet his or her guests according to the means available;
whatever the circumstance, people willingly make sacrifices to provide
their guests with the very best. Naturally, when a guest is considered
powerful or respectable, great efforts are made to treat him or her in
the proper manner.

The spectacle produced for the French visitors was impressive in
its proportions, but it was not a novelty: dramatizations of authority,
generosity, and force have always been integral to the Moroccan
Maxen. The life of the court is carefully arranged to give symbolic form
to relations of power within this elite. The number and composition
of this intimate circle might fluctuate, but its choreographed rituals
of power change slowly. On some occasions ceremonies include large

numbers of people. Rachida Cherifi writes of the "allegiance" cere-
mony (*bay c a*). As he leaves the palace, the king

> moves toward an escort and his ministers, his personal guard, and the
> principal dignitaries. The sovereign is the object of manifestations of
> sympathy and enthusiasm. As the king approaches on his horse, the
> representatives of each region kneel to signify the renewal of their
> allegiance. The allegiance ceremony has become increasingly solemn
> and taken international proportions. In addition to the consular per-
> sonnel certain well-known foreigners, heads of state or kings, are in-
> vited. The *Maxen* seems to want to prove to certain countries the un-
> deniable attachment of the Moroccan people to its king.[4]

Occasions like the allegiance ceremony demonstrate how "old" ways
are adapted to new techniques of mass representation. People at home
watch the ceremony on television and chat about the kind of welcome
each visitor receives. Latifa's family watches the reception inquisi-
tively: How did the king extend his hand to be kissed? Did he withdraw
it quickly, or did he allow it to be kissed on the back, or even on the
palm as well? The television exhibits the present state of personal
relations among the powerful. Foreign visitors are shown the "at-
tachment of the Moroccan people to their king" while Moroccans
themselves scrutinize the reception granted to these visitors in search
of signs of royal favor.

These dramatizations of power may indicate unchanging ritual or
reinterpreted traditions. It is clear, however, that such practices can-
not consolidate power in the same way that they did before the advent
of television, foreign reporters, and paved roads. Old forms persist, but
their performance changes because of new modes of representation.
To render them vividly in photographs or on television screens, new
scripts must be invented, new stages constructed.

Paved roads were introduced in Morocco during the first decades
of this century. These roads offered new landscapes and images for
altering transportation practices, crowds, and the spectacle of power.
El Glaoui's visitors were interested in the cost of the spectacle they
witnessed, wondering how many individuals lined the roads to the
Tiz-n-Tishka and who would pay for it all. The massing of dependent
tribespeoples around the new road seemed a quantifiable venture.
Despite the novelty, roads, public plazas, and new ways of ordering
people would soon appear to be quite ordinary things in Morocco—

and so would the accounting of people and place that seemed so important to El Glaoui's visitors.

Roads: 1988

On a Thursday afternoon in December 1988, I was waiting for a bus to visit a friend in Aïn Chok. Because of the conference of African and francophone states in Casablanca, traffic had been rerouted to ensure security for visiting heads of state and their delegations. This conference, which joined all of the French-speaking countries of Africa, Europe, and the Americas, was an important event in Morocco, for while Arabic is the official language, Morocco is now a member of the francophone group.

As I waited for my bus, I noticed that the downtown walls had been cleaned and whitewashed in preparation for the event. Streets had been cleaned in a preconference frenzy and buses rerouted. A crowd formed at the bus stop. People looked furtively up the street, and some began to ask whether the bus would indeed show up. Then a van drove up, followed shortly by another. The first driver told people to get in. I hesitated for a moment, worried by the prospect of an unknown driver, then approached the second van, where a police officer was helping people climb in. I thought that there must be an order to transport people in private vehicles since the buses had been delayed.

So, following the other passengers, I tried to take my place in the van. "No, madame!" exclaimed the police officer, who promptly hailed a cab. Judging from faces of the other passengers, I decided to comply with his instructions. So, tired and confused by all of these changes in my daily routine, I hopped into the cab, still wondering what was happening. Was the policeman afraid, as is often the case, that "madame" might not feel comfortable riding in the back of a van among poor Moroccans? This explanation seemed untenable since I was en route to a poor area of town, waiting for a bus that could hardly be deemed comfortable. It was only afterward that I fully realized why I was not a welcome passenger.

That day the city did not lack buses; indeed, it was full of them. But they were all going to the same place: Mohammed V Airport, where President François Mitterand was scheduled to arrive. All of the buses and many other vehicles had been snatching up people right and left: people on their way to work or to school, people who would miss

meetings with friends or afternoon shopping. These people would be
assembled to extend hospitality to Mitterand in the name of franco-
phone solidarity.

The road, so necessary to Casablancans' daily lives, had become a
turncoat. Rather than allowing people to pursue their individual tra-
jectories, it threw them off the street and into a space defined by a
foreign visitor. Under the severe gaze of the police—themselves under
the passionless eyes of the camera and answerable to their superiors—
these people lost all claim to individuality and independently motivated
action. They no longer belonged to groups; rather, they simply ren-
dered their bodies as specious evidence of collective enthusiasm. The
Casablancan crowd, so often feared by the authorities and on many
occasions brutally discouraged from forming, was turned inside out and
made a caricature of itself. It became a throng of individuals to be
quantified but disassociated. The masses, far from a threat, unwittingly
became a way of representing state power to the international media.
The men and women whom El Glaoui summoned moved as tribes to
impress their leader's guests. In 1988 the Casablancans assembled to
welcome Mitterand had only their individual physical appearance—
associated with their "Moroccanness"—to identify them.[5]

Naturally, I could not accompany my usual bus companions be-
cause I could not be included in the national "tableau." Indeed, each
resident of the city had played a given role in the conference. Classes,
neighborhoods, and families would be re-created for the summit. The
city became at once an audience for the conference and its major
attraction. Poorer residents, like those on my bus, served as bodies
with hands to clap. The crowd was expected to project a repeatable
vision of a united and joyous Morocco. But the entire population
watched these images of Morocco played back on television screens
and captured by photographers. El Glaoui could certainly never have
imagined that his tribesmen and women would go home following
rowdy ceremonies and relax in front of their own or relatives' pictures.
The mirroring between inside and outside, the watched and the
watcher, was carefully orchestrated. The plans that set these mirrors
in place began long before any guests arrived.

Preparations

In October 1988 I made an appointment with the manager of the local
Casablanca telephone office to ask when I might expect to receive a

phone line. "Unfortunately," he politely explained, "we can't take care of your line immediately. Wait until after the summit. All of our energies are centered on that right now. We have to install extra lines so that journalists and heads of state are provided for." This exchange gave me only a small idea of what this summit might be about. The coming event established a timetable for my long wait for a telephone. (Indeed, the phone arrived shortly after the close of the conference.)

As the summit drew closer, it gradually gained a prominent place in the press and in conversations. At first the changes wrought in the city by the event were invisible. Phone lines were installed or improved; hotel rooms were reserved; airlines booked passengers, and caterers selected their most succulent recipes. But by December these nearly invisible procedures were joined by more obvious signs of the momentous occasion. Streets suddenly swarmed with painters, gardeners, and tar pots. The old post office on the central square appeared like a splendid matron decked out in new white robes. Major approaches to the city were spruced up, and the routes to the airport received not only new makeup but new lanes and hundreds of lamps. Fresh advertisements appeared on the boulevard leading to the airport. Palm trees were clipped with amazing speed, and garbage seemed to be whisked up even before it could be left next to the curb. The quiet efforts of the phone company were thus gradually joined by more boisterous and splendidly public arrangements. But both types of preparations laid the groundwork for a readjustment of Casablanca with an eye to the world beyond. For at the conference the city would show herself and see her image reflected back to her.

The months preceding all of this activity in Casablanca had been marked by several events and themes of discussion pertinent to francophone states. The construction of the new Hassan II Mosque was underway, and there were many jokes about how the population had been "asked" to finance it. The builder of the mosque is French, but the French press also played an important role in criticizing the use of public funds for such a sumptuous construction. The francophone community in Casablanca wondered about the sudden disappearance of the magazine *Lamalif* and the continuing controversies surrounding the newer French-language magazine *Kalima*. Rumors about the planned new "private" television station—the first in Africa or the Arab world—had begun to spread. Meanwhile, TV 5 Europe (a francophone channel) would soon appear on the screens of Casablancans. The favorite radio station, Medi-1 International, already broadcast in

a mixture of French, dialectal Arabic, and Modern Standard Arabic, depending on the program and the subject. The linguistic and musical patchwork of this station would serve as a pattern for other ventures in cultural exchange.[6] The summit underscored the continuing role of French language and culture in Morocco.

If the conference took place in a climate of vague grumpiness in Morocco, the regional picture was downright uneasy. In Algeria martial law had been imposed following demonstrations and rioting, events that had received detailed attention in Morocco.[7] The conference was not explicitly concerned with these occurrences, yet it was inevitably related to it, for the role of the French language is central and problematic to Algeria and Tunisia as well as Morocco.[8] This role goes far beyond the simple use of the language: the continuing use of French helps maintain institutions introduced during the colonial period. It facilitates the continuing flow of French products and techniques to her former colonies, and it influences the evolution of Arabic. While the role of France and the French language differs from state to state, depending on their history, the continued import of French information and television, of French language and thought, was undeniable.

Algerian journalists whom I encountered in Casablanca during the conference were quick to tell me about the relative freedom of the press they enjoyed in Algiers. Their criticisms of Morocco were rather harsh, and they spoke about liberty, information, and journalism in words indistinguishable from those of their French colleagues. Still, they and many Moroccans complained that the French media had the wrong "take" on Algeria and that they were blowing the problems out of proportion. Algerians were frustrated with the policies of the Front de Libération National (FLN), and just before the summit in Casablanca huge demonstrations had taken place in major Algerian cities. The Front Islamique de Salut (FIS) was also gaining force. It was not yet clear that the Islamists would become a major force in Algerian politics, yet already policies forbidding the use of French in schools and government business were being applied. In short, the apparently "simple" issue of language is one of the most complex problems facing the entire Maghreb; here, discourses on language are central to any political or even personal stance. The promoters of *francophonie*, who sometimes see themselves as the inheritors of the *mission civilisatrice*, often describe their efforts as a battle against the linguistic dominance

of English—a conflict that remains a lively topic in France, especially in the context of an increasingly "anglicized" Europe.

Just as the preparations for the conference transformed Casablanca's material face, so too did the summit alter relations among the Casablancans themselves, stimulating effervescent conversations about their trials and triumphs. Each group was subtly or directly requested to play a role in the script of the event. For example, once the town was tidy, the event's organizers requisitioned some of the finer private homes, which were refurbished to accommodate the visiting delegations. Wealthy homeowners could grumble about the inconvenience of having to move out of their homes, or they could assuage themselves with the thought that they would consequently have new video systems and fashionably decorated salons. Prestige might be gained by housing a particularly well-known visitor. According to rumor, some homeowners requested that their houses be put on the list of those to be used for important guests. The names and number of the guests and the modifications of the houses remained lively subjects of gossip among the wealthy for weeks after the summit.

> "Did you hear about Mme. X, you know, the lawyer? She didn't get an official note asking her to lend her house in Anfa for the summit. You know what she did? She called up the authorities to *ask* why not!"
> A young professional woman responds: "So they finally did accept her offer. I wonder what they thought about her?"

With the arrival of the visitors, the wealthy areas of the city were closed to all of those who did not have official functions or permits indicating that they lived in those neighborhoods. The flow of traffic was channeled by police and soldiers, who performed the essential function of differentiating spaces and roles. Their uniforms and voices acted as fences and road signs, defining spaces and the proper occupants of those spaces. The police and the army served as mobile, easily identified walls, their movements determined by the presence or absence of foreign leaders, diplomats, and reporters. When an important person visited a site, the area around him or her was enclosed, made part of the inner space of the conference participants. Insiders to the conference remained within the official, badge-wearing world of the summit.

Prearranged social activities on the "inside" kept journalists busy, their schedules "full"—and safely confined among their international

colleagues. As one visiting journalist complained, contact with the population was not prohibited, but it was effectively reduced to a minimum by the hectic schedules and obligations of the official time-table. While the police demarcated space, these schedules ordered time to limit contact between the insiders and the more numerous outsiders: the usual inhabitants of Casablanca.

After the event I spoke to some of the journalists, many of whom had sensed that exceeding the boundaries of time and place would have been impolite and perhaps would have exposed them to danger. For people unfamiliar with the local situation, the proximity of Algeria—whose troubles had been emphasized by articles in the French press—also helped instill a sense that the "outside" was somehow either more passive or more active than it seemed to Casablancans. For example, a visiting French journalist later brandished his attachment to "dissidence" by saying that he had met a Moroccan Communist during the conference. What he failed to recognize was that, regardless of rhetoric, the Moroccan Communist party (PPS) is a part of the legal government. Might even dangers be created for those who seek them through a simple line of uniformed men?

While the insiders, arriving from other places and other time schedules, had no habits in Casablanca, the usual city dwellers did. To enforce the separations and definitions of space in the city, the police had to alter its daily rhythms. Thus disturbed and interrupted, the usual activities became increasingly subject to rhythms scored in the script of the conference. Sometimes the script called for the population to serve as a positive image; but more often it merely required that the residents alter their routines to accommodate the shifting limits of the conference's stage.

The use of the population of Casablanca was of special interest. Casablanca seen as crowd could now represent a particular pleasure to those who projected its energies out to the world. Images of orderly, clean, palm-lined streets replaced the chaotic images that had haunted Lyautey and subsequent rulers. Once set askew from the usual urban fabric of society and space, chaotic tendencies were neutralized. On television the orderly image of Morocco could be contrasted to the recent violence in Algeria. A middle-aged Frenchwoman called me and described the tropical aesthetic projected into her Parisian living room during the conference as "lovely, so clean; quite different than what I remember Algeria as being like when I visited it in the sev-

enties." The implicit comparison of these postcard images with other Arab or African countries was not fortuitous.

Of all of the images of Morocco, the most important was that of the king. The inside space was not only created for him, as it was for the other leaders, it was also created by him. His unitary image was presented to the guests, who were encouraged to see Morocco as standing among the "avant-garde of liberation and unity of Africa"—a notion apparently reified in the smiling, waving crowds and the orderly, well-tended streets. Terms such as "the people" or "authenticity," used daily in the print and broadcast media, projected a vision of a positive national entity. Yet the version of Moroccanness that emerged from discussions concerning the French elections in 1988 was mainly defensive, conceived as that which differed from the positive example of France or the negative examples of other Arab or African states. This photograph of Moroccans portrayed merely their ordered bodies. In these snapshots people smile, but their actions offer neither new ways of seeing nor argument over issues. They appear on television screens, presented as being "natural," unaffected, utterly themselves: gay, colorful, happy. Their costumes are predictable; their voices mix and swirl in songs and chants whose words are indistinguishable.

The extent to which the image can change is apparent from the many photos of the king in costume—wearing a *zellāba* with Gadhafi, a suit with Mitterand, a red fez with Tunisia's Ben Ali. But beyond all of these changes of costume stood the government's desire to present Morocco as an open, hospitable place, a world between Africa and Europe where the average vacationer can at once have the comforts of civilization and the exoticism of tribal dances or picturesque *swāq* (markets). In the interior this image of the country is joined by the omnipresent portraits of Hassan II and the still common photos of his father, Mohammed V. These harmoniously blended images seem to reflect a homogeneous society, defined by a single creed and a single manner of thinking and doing. However, one widely traveled European woman told me that the ever-present pictures of the king reminded her "of authoritarian regimes around the world. They all do that." Yet we might wonder how it is that certain images can impose themselves on the world scene, while others are a source of local unrest.

We can too readily see the image of a country's leader as synonymous with the "psychological characteristics" of its people, thus substituting a simple construct for a complex but unknown reality.

Indeed, the length of a leader's reign influences this tendency inter-
nationally, perhaps most thoroughly among those who have the least
experience with the place itself. When I called a friend in New York
from Casablanca, her secretary called for her to come quickly:
"There's a call from Sri Lanka for you," she explained. The most
typical slip of tongue is "Oh, you live in Monaco? Wasn't Grace Kelly
married to the king?" This question, quite common in the United
States, is unthinkable in Europe. The concrete influence of historical
experience and geographical proximity are not erased by the floating,
abstract quality of modern information.

As we have seen, in discussing the French elections many Casa-
blancans tried to use events in a highly visible elsewhere to make sense
of their own situations. They examined the closest of the "other" worlds
to frame their own ideas about themselves and their destiny. For the
summit, local discussions had no place in the street or in the media.
The king instead appeared in all of the varieties of Moroccanness
through his changes of dress. He became bodily the entire nation, at
once Muslim, francophone, African, and Arab. In the street people
spoke much more about the transformation of their city and habits than
about issues concerning the French language or the future of Africa.
Some people had the right passes to go to forbidden areas, like the
neighborhoods where the visitors lived or even the hotels housing
journalists. People asked, "Who did you see? How are they living?
What are they doing?" as though they were speaking of a far-off place.

The leaders of the African and francophone states appeared to
present their colloquium not as some mundane discussion but as a
meeting of the gods on Mount Olympus. Their inner circle represented
power, power that was negotiated and orchestrated within the bounds
of Morocco and beyond the interference of those outside of this elite
circle. On television each nation was represented by the figure of its
representative, whose security was assured by the host, Morocco. Just
as the population had been reduced to the status of audience, so too
had the heads of state become both observers of this audience and its
major subject of discussion and news; in this dual framing the positive,
officiating role of the Moroccan government apparatus was contin-
uously apparent. The social order in daily life was demonstrated by
those same forces that had altered the urban landscape with such
apparent ease. The role of power was doubly present in this disruption
and in the welcome extended to the visitors in the name of the nation.

The Moroccan nation was presented as competent and welcoming as we watched its guests arrive, visit famous Moroccan landmarks, or attend meetings. But if we listened to what was said at the summit as it was reported on television or radio, we heard little about any consequent debate even among the representatives allowed into the inner circle. "Francophony," the subject of the conference, is a vague concept that, while it seems a linguistic problem, touches all kinds of cultural, economic and political projects. Subjects discussed at the conference included economic aid, educational policies, and cultural exchange.

In Morocco the conference was followed by a new change in secondary school policy by which scientific subjects would again be taught in French rather than Arabic. A major street in Casablanca was renamed Avenue Houphouët-Boigny in honor of the president of the Ivory Coast. Yet concrete actions and projects were not the main point of the conference. Indeed, issues that would have brought up differences between the participants were played down in front of the press and their cameras. Speeches about the essential role of Morocco as a mediator between Africa and Europe were applauded. Morocco appeared on European and African televisions and in the press, where this conciliatory role was repeatedly put forward. Hassan II compared Morocco to a tree whose nourishing roots are plunged into African earth, but whose leaves rustle in the winds of Europe.[9] Following this summit, *Le Monde* congenially added, "Morocco confirms its entrance onto the international scene."[10]

Yet all did not go as planned. One of the main sites to which conference insiders were taken was the new mosque being built on the Casablanca coast. This mosque, which the local paper compared to the Egyptian pyramids, St. Paul's, and other buildings noted for their grandeur, was expected to welcome François Mitterand (this busy guest failed to comply).[11] Extra taxes and "voluntary" donations had been demanded of Moroccans to build the mosque. Thus, as one French journalist wrote considering the state of mind of the population with respect to this enterprise,

> it was just as well that Moroccan television couldn't show the
> president of France on the anti-earthquake foundations that plunge
> 10 meters down into the Atlantic to hold up an edifice of 150,000
> cubic meters of cement with a 172-meter minaret that will be
> equipped with a laser beam directed toward Mecca.[12]

Visits to monuments or historic sites, as much as political platforms or speeches, define the persona of a public figure. Similarly, Daniel Dayan suggests that conferences and other spectacular events offer key insights into the norms that different societies hope to project as their own. He writes:

> Grandiose television spectacles are increasingly international. They are, for any given society, an occasion of a self presentation to other societies at certain privileged moments. These moments are those when the practices of the society in question conforms to its own explicit ideals but also permits it to illustrate norms that are not simply its own but those of the international community, or more precisely, *an* international community.[13]

The francophone conference was one such event. The national image was constantly reasserted, much as it was in the Moroccan debates concerning the French election. In both events the image of the nation was projected to and constantly reinterpreted by its inhabitants. The distinction between international and local norms cannot always be expressed simply by opposing inside to outside—a point that becomes clearer if we consider what aspects of people and place are underscored by such events. What parts of the political or aesthetic picture were not introduced as elements of the national picture?

Comments concerning yet another spectacular event, the annual celebration of the king's birthday, show how many people perceive such events as having little to do with their own lives. Individuals and groups can defend themselves against being used as passive elements in national pictures. A schoolteacher explained to me how some of her colleagues sidestepped "national" obligations:

> All of the attractive young female teachers are told that for the holiday they are required to come nicely dressed in caftans [traditional festive dresses]. For the rest of us, regular clothes are considered okay. Anyway, most of the girls refuse to bring fancy clothes, at least in our school. They pretend that they don't own caftans, just modern clothes. They come to school with all of us, and sometimes the school then provides them with the necessary traditional garb. All of us are told to get into a bus, and off to the stadium or parade route we go. Sometimes, since the holiday is at the end of the year, our last pay slips are given to us on the bus. This means we must go to line the streets for the official processions to get our vacation pay. This year they didn't do that, at least; we just showed up late for the bus and

said we'd go in our own cars. But the poor young girls! They really
have a hard time of it since they cannot just be part of the crowd
but are placed in front of the others. This means that the king and
his guests will see only the most beautiful women—all expected
to be smiling, of course—to welcome them. Naturally, this is in-
tended to please and flatter them, but the reason for this practice
also lies with the television. The images of these beauties can be thus
displayed to local and foreign correspondents, thus indicating the har-
mony and joy of the Moroccan people through the faces of its young
women.

This middle-aged woman remarks cogently on the ways in which
the feminization of the crowd serves male egos. Her comments reveal
a certain relief that she, in her forties, no longer has to put up with
the particular burdens placed on younger colleagues. At the same
time, she knows the extent to which women's worth is measured by
their youth and beauty. She explicitly draws my attention to these
issues to point up the arbitrary nature of male vanity and control of
women's bodies. But perhaps her complaints about the ways in which
people's bodies are presented may be extended to include men as well
as women.

Crowds are amassed for official occasions by haphazard means, but
the process nevertheless instills a sense of the arbitrary nature of a
power. The eye of the camera dwells on certain physical character-
istics, yet there is no contest to see which young woman's beauty might
best represent the nation: young women are shown as a class, as the
personification of a certain idea of youthful feminine allure. Their
individual characteristics are of no import. The only way to oppose this
image of oneself is to refuse to be photographed. One is "late" or
"forgets" one's caftan on the given day.

This mode of quiet dissent is embedded in many social interactions
that are not directly political. As mentioned above, Casablancans often
hesitate to refuse any request made on them; they prefer to satisfy the
person at hand, only subsequently coming to terms with conflicting
promises to various individuals. As a friend said, "When I tell Halima
that I will go to visit her, I really mean it. I really want to. But then
things get into the usual routine. I don't forget exactly, but I don't go
to see her. When we meet again in the street or on the bus, we always
repeat our promise to visit each other." Similarly, disagreements are
not always settled by stating one's opinion. This practice is so wide-

spread that one man made a point of his difference to me by saying, "I am frank. I say no when I mean no—unlike other people."

Neighbors may comment on people who fail to jump in the van to meet Mitterand, and colleagues may gossip about dissident school teachers. But these social defaulters fail to form any part of the limited picture of the nation, for that image emerges specifically from such public occasions. Similarly, on these occasions the social mass is conceived of as an audience to watch the crowd's image at home. Whether as members of a crowd or as viewers seated in front of television sets, people are imagined as individuated, forming abstract social groups or classes, but not as concretely involved in forming these collective bodies. Those who never show become invisible.

The process of creating one's self-image, often through reference to images from elsewhere, depends on careful surveillance of one's own and others' appearances. One cannot absent oneself from this process without sacrificing one's existence. Those in power do not ignore this concern for control; in particular, proponents of a purely "scientific" approach to the audience argue against those who aver that the audience is best controlled by appeals to morality and the personality of leaders. In either instance, audience identity is reduced to simple categories of class, divided along the poles of traditional versus modern and urban versus rural, and ultimately named as national. The "Berber tribesmen" of the 1930s were displayed as tokens of El Glaoui's power. However, they appeared as a group, wearing their best clothes, but they were not yet labeled "traditional" or "Moroccan" by anyone other than European guests. By the 1980s this "European" or "outside" view had come to inform the practices and notions of Moroccans themselves. In both politics and daily life Moroccans are altering their perceptions of the nature of the individual and the division of social spaces, creating new dramatizations of power, hospitality, and solidarity. Raymond Jamous, in a study of the relationship of past to present in the rural Rif, notes that "the values of the past continue to be present in the contemporary social life of the Iraq'yens, even if they must manifest themselves by often devious means. In fact, everything happens as if these Rifians are trying to adapt the modern world to their traditional ideology and not the opposite."[14]

The summit is an example not so much of old values as of a will to maintain power and a certain status quo. While elements "from the past" are used in dramatizing power, it is difficult to see what coherent

"traditional ideology" Casablancans might oppose to the modern world. Indeed, their lives are part of this modern world, and here as almost everywhere, their versions of modernity include inherited practices, ideas, and beliefs. Thus, we must ask why certain older practices are disparaged while others are displayed as synonymous with the nation—or, to phrase the question another way, why certain "imported" values or practices are adopted while others are ignored.

Dramatically staged spectacles have not been the sole domain of power and authority in Morocco. Indeed, considering visually dramatic practices on certain holidays, both religious and secular, one might expect to find an aesthetic contrary to the theater of politically orchestrated events. Might the conference not be shadowed by a jesting double, as so many other serious occasions are?

The role of laughter in the serious political arena is not negligible, even if it is officially ignored. People joke about political leaders, but they do not openly question the seriousness of the king. As Hassan II himself recently stated, "There's no place in the Moroccan spirit for a *Canard Enchainé*" (a French satirical newspaper).[15] Laughter is a politically dangerous and ethically charged mode of expression. The international context encourages ever more playful styles of presentation of world leaders.[16] However, some elements of the Moroccan repertoire—particularly the use of masks and the parodic, community-wide theaters that sometimes arise—are not acceptable. This repression of the ludic could derive from the reformist sensibility so instrumental in the independence movement, but such a strict observance of the limits of the serious and the humorous must also have other roots. One area to be explored is that of identity: national identity, as reflected in the kind of ideal persona discussed by Bromberger and brought up here by examples of political spectacle; personal identity; and the ways in which the national image either corresponds or fails to correspond to desires of its members. Playfulness might imply that in the end nothing really matters, but it might suggest, as in the stories woven around Boujeloud, subtle references to roles that are only too well understood by those who take part in the drama.[17]

Clifford Geertz has drawn attention to the way in which the *nisba* adjective permits a single individual to have several "names." For example, the *nisba* allows a place-name to be made into a proper name: someone from Rabat becomes "Rabati." A name can also refer

to one's profession: for example, a tailor is called *xayāṭi*. (The *-i* ending is characteristic of the form.) Geertz sees the fluidity of naming processes as fundamental in understanding notions of group and identity in Morocco. An individual might hold one status in one context, and be named accordingly, and yet be called by another name elsewhere.[18] In similar fashion, Lawrence Rosen extends the metaphor of the *suq* or market (which Geertz employs in emphasizing the flexibility of social constraints and identities) to argue that reality itself is "bargained for" in Morocco.[19] But how are social relations bounded and individual possibilities limited? What makes some attributes more valuable than others? These and other questions are constantly discussed among people in Casablanca's streets. When roles are unclear, and when choices cannot easily be translated into reality, playing with categories of people and things becomes threatening.

New ways of knowing and legitimating one's role as an authoritative person transform the limits and qualities of social identity, resulting in what Casablancans themselves often call excessively "personalized" relations. While social roles vary according to time and place (in Morocco as elsewhere, of course), some *nisbas* are heavier, more solid, than others. The lines of tension that stimulate people to develop or emphasize certain aspects of identity are tied to structures of power that extend beyond the local setting.[20]

Walking Man

It is March, and today is the Throne Day holiday. The streets are full of all sorts of people one doesn't often see downtown. They have come to the various parties and musical performances organized to celebrate the anniversary of the king's coronation. A working-class couple passes. They look out of place here; perhaps they are visiting relatives. The woman is resplendent in a sparkling gold *żellāba* with a miniature straw hat pinned near the bottom of her long, unbound hair. Her little daughter sports a fancy dress, fancy slippers, and a hood, although it isn't cold. The father wears a cheap suit. They seem to be attired in their best clothes, but somehow they give the impression that they are displaying a collection of valuables instead of just wearing them. Looking uncomfortable and out of place in the city center, they glance furtively at the crowd. Nearby a teenager in jeans and tennis shoes, his hair gelled into spikes, listens to his yellow Walkman. Despite his appearance, he is extraordinary simply because his gaze meets no one else's. Women in the street avoid meeting the eyes of

others, but this young man does not merely avoid gazes—he seems beyond them. He walks alone with his music. Perhaps, like music, the gaze has distinct modes. The family walks in a country mode, looking around at the people, the streets and buildings. The youth's mode is that of the international top ten. With his Walkman he sets his own beat—or at least a different beat—and blocks out the official holiday music blasting from the loudspeakers. He seems happy but distant; that is no doubt his intention. Who is more involved in creating culture in this situation? How can we characterize the different rhythms to which these people walk?

Besides speaking and being heard, the creation and continuity of styles of power also requires establishing and maintaining collective rhythms and habits of sociability. The mass media, especially television, influence daily practices and initiate rather than reflect public discussion. Talk around the television screen and in the street turns around images, seeing and being seen, as people think about sexuality, fear, and humor. A creative surveillance of self and other emerges from constellations of power and image. There is an ongoing interplay between what are often seen as "external" constraints of mass media and politics and the images and practices that are most vital in daily practice.

Studying the relationship of media to practice is not simply a matter of identifying how communication is distorted between an easily designated sender and receiver; it is an issue of much broader and more intractable dimensions. We might compare those with formal political power to the wicked queen in *Snow White*. The queen must constantly ask her mirror to confirm that her power is matched by her beauty. That she is the most powerful, the mirror knows; but it likewise understands that it can occasionally speak the truth even to the queen herself, for it is the source of her knowledge. The mirror knows that the queen cannot break it; she needs it to confirm her own existence. She needs to *know* that all that is beautiful springs from her and cannot elude her gaze.

Knowledge and power go hand in hand, reinforcing each other. Yet to objectify thought, as modern empiricist science does, is itself to set one object of knowledge against another, severing the relations between them. Snow White is not a person but an image. She represents the perpetual frustration of the will to power. If she did not exist, where might power extend its gaze? What image would the queen use to perpetually restate her own vanity?

The next part of this study focuses on how daily practices both challenge the status quo and offer ever new territories for power to conquer. As Hubert L. Dreyfus and Paul Rabinow remark in their discussion of Foucault: "Discipline does not simply replace other forms of power which existed in society. Rather, it 'invests' or colonizes them, linking them together, extending their hold, honing their efficiency and above all making it possible to bring the effects of power to the most minute and distant elements."[21]

The phantom world of images appears distant from our lettered ways of analyzing cultural form and social organization. Our own professional practice depends so completely on linguistic performances that we sometimes assume that images "talk" to one another in an arcane tongue of their own. But can pictures be set aside to create a realm of pure, disinterested thought? Would such a "bracketing" free them of any ethical import? Perhaps pictures are what obstruct the clear debate between citizens that Aristotle saw as the basis of both politics and ethics.[22]

Let us turn then to rhythms, pictures, and images of people as they appear in Casablanca. In Casablanca images from "elsewhere" (France? Egypt? the United States?) dislocate experience. The relocation of experience, part of the discipline of state and society, can be seen where streets join televisions as means of organizing the day-to-day motions of the city. Do violent or spectacular approaches to public control abruptly cease as we cross the threshold of a home or the courtyard of a school?

ILLUSTRATIONS

1. *Casablanca Cityscape.* Single-family homes and gardens are uprooted in central areas of Casablanca to make way for upscale, multistoried apartment buildings. In less wealthy quarters, some families also add to their homes second or third stories to rent out, or to house family members. Notions of relationship, whether to family members, neighbors, or passersby, vary in accord with changes in arrangements of urban space.

2. *Apartment Buildings.* An old home faces destruction to allow more high-rise apartment buildings to be built. The urban landscape grows simultaneously up and out toward the city limits.

4. *Renovation Project (opposite, bottom).* The old *medīna* of Casablanca is being refurbished along this avenue joining the port to the new Hassan II Mosque. Until now, the *medīna* was of little "historical" interest, but apparently Casablancans and urban planners alike are becoming more interested in preserving remnants of their city's past. This renewed interest in and reuse of old forms is reflected in many renovation projects throughout the country.

3. *Walls in Poor Neighborhood.* Walls hide a shantytown from view along the coast.

5. *Beach*. While some people swim and sunbathe, others simply look out at the sea. The intense activity and visual stimulation of Casablanca's coast abruptly give way to the ocean's calm.

6. *Restaurant at Aïn Diab*. Images flourish in the touristy Aïn Diab area. Here, we get a view of a restaurant where one can "eat meat as our prehistoric ancestors did."

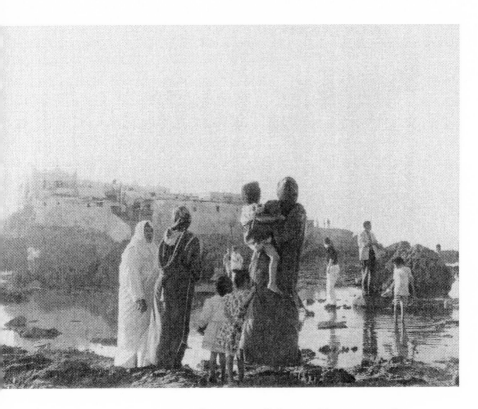

7. *Mausoleum.* Just off the Casablanca coast, the mausoleum of Sidi Aberrahman is a favorite weekend destination for Casablancans. Some come because of the saint's reputed ability to cure sterility, others to picnic or swim.

8. *Window View.* Laundry is hung out to dry, partially veiling the broad "panoramic boulevard" of Aïn Chock. While laundry is displayed, no open balconies or large windows line the streets of Casablanca. The street is the domain of public sights; television is the only intruder of interior spaces.

9. *Traffic in the Maarif.* Although the Bon Vigneron is now simply a corner grocery store like any other, the Maarif has retained the quality of a provincial southern European town. Its narrow streets are filled with shops of all kinds, as though the entire neighborhood were a shopping center. In fact, the area has become a major center of attraction for people throughout Casablanca.

10. *Election Posters*. Rectangular frames and layouts emphasize the serial nature of making choices in election posters and movie advertisements. Both allow us to draw close to scrutinize a face or read a party's platform. In France, election announcements are lined up in a similar fashion.

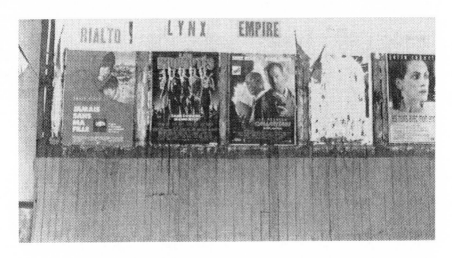

11. *Movie Posters.* Bruce Willis and Julia Roberts are among the familiar faces on this Casablancan street.

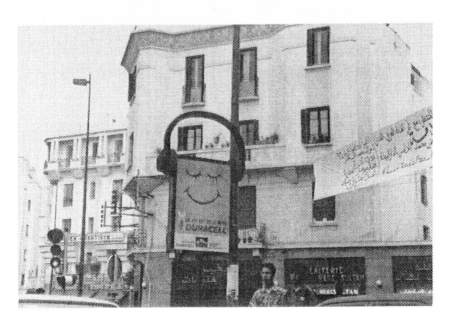

12. *Mers Sultan Street.* An advertisement for batteries wears headphones to attract attention amid banners, traffic lights, and signs in the central Mers Sultan area of Casablanca. Passersby make up part of the collage of the downtown scene.

13. *Plumbers.* Waiting is just a part of life for these plumbers, who advertise their professional identities by displaying homemade sculptures made of pipes, tubes, and sprockets. They converse, argue, or smoke together until a customer comes to haggle over a price. Once one has been chosen, he follows the customer home to repair a sink or a leaky faucet, returning afterward to his designated space in the line.

14. *King Mohammed V*. One of the earliest "pictures" of
Mohammed V for display in shops was not a picture at all
but a plaster model.

15. *Hairdresser and Model.* A young hairdresser poses with a poster displayed outside the shop where she works. Her hair, and even the earrings she wears, emulate the face we see in the picture.

16. *Venus Beauty Salon*. Posters and painted pictures outside a beauty salon attract potential clients.

17. *Coca-Cola Sign*. A large Coca-Cola sign spreads a red stain across the white walls of the city.

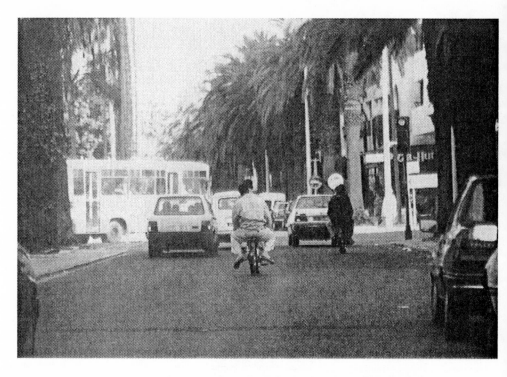

18. *Moulay Youssef Boulevard.* Moulay Youssef Boulevard is lined by palm trees and upscale office buildings and apartments. Traffic, as it is elsewhere in the city, is heavy until late into the night. Posters and signs are more discreet than in the city center.

TIME'S POWER

My city collapsed
The clock was still on the wall
Our neighborhood collapsed
The clock was still on the wall
The street collapsed
The clock was still on the wall
The square collapsed
The clock was still on the wall
The house collapsed
The clock was still on the wall
The wall collapsed
The clock
Ticked on.

Samih Al-Qasim,
"The Clock on the Wall"

◆◆◆ The most intimate and the most public affairs rely on senses of time to order the flux of life. What does it mean if clocks continue to tick when the very walls on which they are hung collapse? Ways of knowing are intrinsically ways of beating time. If the clock ceased ticking, how could we understand why our house might disappear?

In Casablanca the ability to master the ebb and flow of city life relies on diverse ways of measuring time. Knowing how to wait or when to leap into action is an integral part of city life.

Hamid is often late to class. He lives far from the university, near the industrial quarters to the north. Each morning he walks two kilometers to the bus stop, then takes three different buses to get to the university. But the morning isn't the worst of it. He can get up early, and his student schedule allows him to leave just after the morning rush hour. It is in the evening that he sometimes spends hours just getting home. The city's public transportation is overcrowded. Crowds form at

bus stops near the center of town, and people push and shove to
board the infrequent buses. Often one must wait until several buses
have passed before being able to find a place to stand.

Hamid waits at bus stops and stands in lines to use public phones
in post offices. While he waits, he watches cars and bikes pass him by.
Those who have money are able to circumvent some of the usual
waiting in administrative offices and bus stops, the forced "hanging
out" that is an activity for the poor. Yet, while some can pay others
to do their waiting at the electric company or the post office, no one
can completely master his or her own time.

> Fatima waits for her boyfriend with me in a café. She wonders aloud
> whether he is late because of negligence or simply because of the lack
> of buses. Has he had to stop to have a coffee with a friend he met
> by chance? "I just have to wait," she says, unsure what to think. She
> hasn't seen Khalid for three days, and neither of them has a phone or
> a car. They plan to meet in advance, but other obligations sometimes
> prevent them from making their rendezvous. Often Khalid doesn't
> show up, and Fatima returns to work unsure whether to be angry with
> Khalid or the bus company. Should she express frustration with the
> contradiction between lunch-hour schedules and social norms, or
> should she blame her lack of technical means to negotiate the dis-
> tances of a large city like Casablanca? I ask her whether she doesn't
> get furious sometimes. She just sighs, shrugs her shoulders, and tries
> to hide her disappointment.

The impersonal injustice of bus schedules mixes with personal fears.
Who can make another wait, for an appointment, a phone call, or the
return of a favor? Observing who waits for another, or whose con-
versation must be carefully timed to respond to the lead of the other's
words, gives clues to the nature of relationships.

Casablanca is a place for moving, perpetually demanding that its
residents rethink where they are heading and how. Nonetheless, most
people spend much of their time waiting—in lines, for work, to move
to some other place. Boredom is motion without direction. One waits
for those who have power to act—in our favor, against us, or in any
way whatsoever. Hierarchies are often played out in elaborate rituals
of waiting.

> At the governor's office in Casablanca (*wilāya*) people wait day and
> night to be received by the *wālī* (governor). Each has a problem to

resolve that might be solved by other means, but direct appeal to the highest city official can avoid bureaucratic problems that would otherwise take extra weeks or months to resolve. People also bring their personal worries or disputes into the governor's office for arbitration. But whatever their reason for coming to ask for the *wālī*'s help, few can get it without spending long periods in the waiting rooms of the *wilāya*. On entering the building, one is greeted by an official who asks for what reason one is there. Those who have come to take part in the *wālī*'s public receptions are duly directed to various sitting rooms according to the rank assigned them by the officer at the door. Wealthy and important people are directed to comfortable, spacious sitting rooms near the office where the governor receives them. Poor, less influential people line the benches in the building's hallways. But everyone must wait.

The *wālī*'s schedule is sporadic. One cannot ask for an appointment. When he is absent, people read newspapers or chat; when he suddenly arrives, a wave of expectation grips the assembled crowd. His manner of holding us all in wait makes time itself seem to issue from his person. His authority is underlined as much by his ability to make us wait as by his decisions themselves.

It is not only in the explicitly political realm that one makes others wait, or expect to be waited on. Wives wait for and on their husbands; children do the same for their mothers and older brothers.

A large family waits for the arrival of the father after work. During the afternoon the wife and her unmarried, unemployed daughter watch their favorite television programs. (They do the housework in the morning, leaving the afternoon free for soap operas and videos or visits to friends.) But once the father arrives, they abruptly spring into motion. Dinner must be prepared and the television tuned to the news, which he always watches. The voice of the newscaster seems to initiate the beginning of the evening for the entire family. After the indolent movements of gossip and soap operas, a new sense of efficiency has been introduced into the household with the father's arrival. One girl offers him a drink; another sits quietly beside him as he watches the television. She appears to be waiting for the ads to come on after the news to hear her father's news of the world, which will follow the televised version of the day's events.

In struggles to define power relations, the combatants often rank themselves by seeing who can force the other to be patient. At the same time, patience is a virtue to be cultivated: one seeks the op-

portune moment to make a suggestion to one's boss, one's father, or even one's colleague. To the extent that people's intentions are strategic, this patience and attention to timing are necessary and easy to describe. When less readily identifiable goals are at issue, it is more difficult to notice how patience and power are intertwined.[1]

The ability to control time organization is a mark of power in day-to-day affairs. But other, less immediately personal manners of using time also structure our daily rhythms. These rhythms are not imposed by signs, prohibitions, or laws but are instead embedded in the very nature of social life, thus accounting for their apparent invisibility and efficiency. Bus routes might not be numerous in the expensive Anfa neighborhood, yet its residents can be seen in restaurants or cinemas far from home on any evening. In outlying areas, by contrast, myriad early buses assure that workers arrive in the city center for work each morning, but only a few buses run in the evening. Bus schedules, national holidays, and work schedules for religious holidays all pattern people's daily rhythms.

Casablanca's involvement in worldwide ways of understanding time must be viewed alongside its sense of space. While Hamid watches cars passing him by as he waits for a bus, his waiting and their motion express social relationships: his poverty and the affluence of others. Similarly, the daily interaction of space and time in mass images demonstrates how what one lives differs from the places and time they portray. Elsewheres and other times are juxtaposed with the daily grind of waiting as examples of imagined places beyond one's firsthand experiences.

Television now plays an important role in connecting Casablanca to other places, other times. In turn, these images of elsewheres situate local and personal experience because they draw contrasts between what one lives and what one observes. The magic box fulfills an imaginative function that orders the movements of the city. By simply assuring that people will be sitting in front of their televisions at given times, it helps create a certain social predictability. It is hazardous to presume that one can easily orient public opinion through television programs, that one can inspire people to imitate certain narratives or purchase certain products; yet it is fairly reasonable to assume that people in Casablanca, like people in London or Tokyo, will settle themselves in front of their television sets each evening and for much of the weekend. In fact, they may be watching

many of the same programs, and they will certainly obtain much of their news from the large, international agencies. Their involvement with the images they see cannot be analyzed strictly in terms of categories of class or other social differences solely within national boundaries. The space-time of television involves all viewers in an international society that cannot be compared to a village.[2] Watching television, like looking at paintings, is not simply a matter of being tuned in to a singular "message." The television experience involves individuals and groups in partially shared worlds of meaning, but it also offers respite from daily life.

While watching television, one gets a sense that the world is moving quickly in many directions, or fading quietly into the all-encompassing plot of a love story or a spy film. The televised illusion of instantaneous action collides sharply with the waiting that takes up much of the day, providing a refreshing alternative to patience. The television's quick visions are always available, and all but the most needy and powerless can invoke those visions. As we have seen, even the poorest people in Casablanca prefer to buy a television before a refrigerator or a stove. Their investment is progressively offering more, as more hours of programming are available on their screens. While the RTM begins its programming at about one in the afternoon, 2M starts early, at about ten in the morning; and those who can afford satellite dishes can watch television around the clock. All of the local channels broadcast until one or two in the morning. Television and other mass media provide a break from the here and now by making other places and other times visible.

There is no "dead time" on television (newspapers, too, must fill the entire page). A constant stream of stories or news trickles onto the screen. The fast-paced rhythm offers exciting narratives that contrast with the monotony of waiting that forms much of people's daily experience. Anyone who can buy a television can command it—at least if a father or elder brother isn't around to take possession of the remote control![3]

Television as Time

We watch the Disney Channel and learn about the incredible success story of Annette Funicello. Eventually the channel—in English with French subtitles—moves to a subject of greater interest to us: Zorro comes to life in the defense of justice. As the plot thickens, he wields

his sword to save his friends from a group of no-good California gam-
blers; suddenly, with Zorro's arm raised to the heavens, the black-and-
white program cuts without warning to the image of a clear blue sky,
pierced no longer by a sword but by an austerely beautiful minaret.
The muezzin sounds the evening call to prayer as the camera descends
the height of the tower to show spring leaves in a garden, with the
same azure sky dominating the scene. The prayer ended, we leap in-
stantaneously back to the masked man's courageous gesture. The move
from the pure lines of religiosity to the curved strands of Don Diego's
mustache is too much for twenty-year-old Latifa. With a disgusted
grin she cries, *"El din w-el-dūnya!"* (Religion and the world!), then
bursts into ironic laughter. Only at the end of the program does she
go to the next room to perform her own prayer.

Latifa's sense of religious "time" depends not on the clock but on
the order of her daily life. She prays regularly, but her prayers are not
regulated by a strict time clock. The television mixes sacred and
secular rhythms. Latifa has no objection to television time in itself, but
the comic juxtaposition of the two amuses her. It is as if the television
has turned prayer into a cartoon or a soap opera.

Several employees at the RTM also brought up the problem of
reconciling the hours of prayer with those of their programs as a major
dilemma they face in their jobs.[4] While prayer hours change daily with
the Muslim religious calendar, television programs must fit into a
largely inflexible schedule. In incorporating religious images into daily
spaces and times, it is essential that the producers create not simply
"reflections" of power but daily practices that involve the habits and
symbols of power. In this day-to-day routine time is divided in specific
ways, ordering everything from the flow of traffic to the hours when
one decides to "show" oneself at the "right" place. During the meeting
between heads of francophone states, the reworking of Casablancans'
habits practically demonstrated how the city can become a stage for
the playing out of stories of power. Each day the city is ordered by
similar, if more regular, rhythms that are also linked to considerations
of power. Morocco follows the European habits of days and weeks,
with only some government offices or schools being given time off on
Friday afternoon, the Muslim day of rest. This European rhythm,
which distinguishes Morocco from some other Muslim countries,
indicates the kinds of changes wrought during the Protectorate as well

as choices made by contemporary leaders who seek to promote international exchange.

Time is invisible, and the ways in which we use objects to evidence it are complex. Television brings multiplex time senses into the home by marking both the hours of prayer, which are ordered by the rising and setting of the sun, and the regular clock time of other televised programs. It is noteworthy that Moroccan workers in Europe have demanded that employers recognize their prayer hours and set aside prayer rooms in the workplace. What relationship might the capitalist organization of production time bear to the organization of sacred times, considered a "private" affair and thus apparently equated with leisure?

In "Time, Work-Discipline, and Industrial Capitalism" E. P. Thompson describes how the development of modern capitalism in eighteenth-century England altered the society's time sense.[5] In mid-eighteenth-century England clocks were status symbols, intricate in design and often wrought in precious metal. Yet, Thompson notes, by the close of the century clocks were increasingly common. Not only did the large public clocks in town squares beat out the hours, but domestic routines were dominated by the long and short hands of time as they made their way around the face of the clock.

Unlike the "task-oriented time" of preindustrial societies, the "clock time" of industrial societies no longer centered on the rhythms of the home. The increasing importance of the clock in home life itself indicated the triumph of the capitalist workplace over the domestic universe. Piecework and the alternation between periods of intense labor and relative idleness gave way to the organization of workers' time into days, weeks, and months. The abstract time of the factory dominated even the terms of workers' protests:

> The first generation of factory workers were taught by their masters
> the importance of time; the second generation formed their short time
> committees in the ten hour movement, the third generation struck for
> overtime or time and a half. They accepted the categories of their em-
> ployers and learned to fight back with them. They had learned their
> lesson, that time is money, too well.[6]

Thompson argues that this schema is inapplicable to situations beyond Britain, yet he remarks that the "energies" of industrial societies are founded on this time sense. The incorporation of new parts

of the world into the industrial-capitalist economy has usually been analyzed as reflecting the imposition of the regimented space-time of the market on an indigenous time sense.

Pierre Bourdieu conducted research in Kabylia in 1962, at the end of the French occupation of Algeria. Bourdieu noted the contrast between the kind of time described by Thompson, what he calls "Western time," and the time sense of Kabyle peasants. The peasants' experience of time was linked to ritual, to seasonal cycles, to history as a repetition of sameness.[7] This nature-oriented, circular time differed markedly from what Bourdieu referred to as the capitalist time sense; this time, he said, depends on abstract clock time and, more important, presents the future as a broad field of possibilities. Bourdieu thus recognizes sacred or noneconomically oriented time, whereas Thompson emphasizes economic changes between modes of production. Nevertheless, Bourdieu shares Thompson's assumption that industrialization has altered the agricultural time sense of the Kabyles: the factory remains the social as well as the economic instigator of the transformation of senses of time. As in the English case, task-oriented time was introduced in Kabylia in the 1950s and 1960s because of the integration of the Kabyle men into factory life and the consequent changes in family and social rhythms. In both accounts factory schedules are the central feature by which the new time discipline of capitalism must be understood.

For Bourdieu, economic position is related to an individual's capacity to decide his or her own future;[8] those peasants interested in orchestrating their own futures inevitably had to understand the time of the factory. Theories of "development" take an evolutionary perspective on this issue, assuming that rationality, as described by Max Weber, goes hand in hand with the inevitable modernization and disenchantment of the world. Production is central to this process, even if it concerns mainly men at first, since it comes to dictate the organization of life for everyone. But how can we relate production to modern situations in which industry is a relatively minor part of the local economy? When "patrons" do not hold total control of a "rational" ideology for the economic or legal systems? When a traditional monarchical system like the Moroccan *Maxen* perpetuates itself in part through a savvy mixture of sacred time and the "rational" time of industrial production?[9]

The sacred appeal of the Moroccan order is tied to times that appear at odds with the clock. Indeed, administration attempts to stem urbanization might be viewed as efforts to tie people to rhythms and practices associated with the traditional political structure. In a study of Moroccan politics during the early 1960s, Rémy Leveau points out the continuing importance of the rural areas for the maintenance of the power of the *Maxen*.[10] Since that time urbanization has continued, and distinctions of urban to rural have themselves changed. Today schedules are imposed not only by factories but also by the new industrial organization of farming. The service sector too is important in forging new time senses: tour buses and health clubs cater to a clientele fixed to the clock. Explicit demands for the observance of sacred times are loudest today in urban areas, where new reformist Islamic groups have increased their following.[11] For those who are unemployed or who remain at home for other reasons, television is one of the conveyors of a uniform time sense.

In a 1982 study of mass media and publics, Ahmed Akhchichine and Jamal Eddine Naji examined television use in the midsize town of Kalaa es-Sghrana. People who worked regular "administrative" hours told them that they had less time to watch television because of their strict schedules. Those who did not have set work hours could watch more television. Housewives, unemployed people, and shopkeepers, for example, watched television at home or with friends in cafés; not only were they "free" to watch television, but they could structure their time according to the television schedules.[12] Television can serve as a clock to people not directly involved in the world of "rational" production, whether or not they have family members who work at nine-to-five jobs.

> Fatima is a housewife. The radio accompanies her morning cleaning and cooking, but her afternoon builds toward the evening television programs. She prepares dinner early while her children watch cartoons after school. She helps them with their homework before serving dinner; the family eats in front of the television, watching the news and discussing their own news of the day. Her husband, an office worker, gets off fairly early, but his schedule seems to have little impact on the life of the rest of the family. He and Fatima both say that the evening begins when they join the family around dinner, before the television. Yet when one asks them to discuss time as personal history, they refer

to events like weddings, the completion of studies, or family occasions like births and deaths.

The daily order of time seems not to encompass these narratives of personal history. To speak of such competing times and the role of images in giving them form, we must first distinguish some of the different aspects of time. In classifying various time senses, Krzysztof Pomian refers to four modes of organizing time: chronometry, chronography, chronology, and chronosophy.

> Chronometry represents time by the indications of calendars and measuring instruments, beginning with sun dials and clepsydras and continuing to the current generation's atomic clocks. Chronography, by means of successive notations of chronicles and by the narrative of changes that have taken place. Chronologies, on the other hand, chart time's passing through series of dates and names that demonstrate the suite of eras and their subdivisions from the point of origin until the present, the distance between the two having undergone an enormous expansion during the course of the three last centuries. Chronosophy, finally, unveils the evidence of time in bones, tortoise shells, the entrails of birds, the behavior of animals, and the movement of heavenly bodies, in documents and monuments, and, in our time, in the data furnished by nearly all of the scientific disciplines.[13]

Chronometry is close to nature. Both the call to prayer of the muezzin, grounded in the movement of the sun, and the clock time of television, determined according to Greenwich mean time, are established according to natural determinants that have become embedded in social practices. While the earth's rhythms provide the basic frames of reference for chronometries, these measures of time can nevertheless become divorced from natural processes.

Chronography, linked to human experience, is a social determinant. People's stories emerge in lists of specific events, sometimes linearly perceived. While chronometry is as cyclic as the sun's rising and setting, chronography attempts to separate human concerns from natural repetition; persons and events take precedence. Chronology links these events of human life to the measures of days, eras, or centuries measured by chronometry. Chronology measures and orders events in serial fashion.

We can adopt Pomian's "time orders" to help identify the plurality of time senses that coexist in Morocco. There chronology is based on

two main systems. The most important is that imposed by the advent of Islam. The rising and the setting of the sun divides days according to hours of prayer determined by the sun's position. Years are then arranged with respect to the *hiẓra*, beginning with the date of Mohammed's flight from Mecca to Medina. A fact of chronography—a biographical, human, occurrence—consequently establishes the chronology in this system. Muslim historians have developed this chronology to include all types of human experience, yet the exemplary experience remains that of Mohammed, linked not to the practice of historians or the creation of objects but to theology. The ritual cycle of religious observance, while circular in its observance and thus a sort of chronometry, is tied to the life of Mohammed and the history of his followers.[14] If the idea of "generation" (as a period of time) is first witnessed in Muslim writings, it does not reflect the simple concept of "age sets" such as those E. Evans-Pritchard has described for the Nuer.[15] Rather, the Muslim concern for generation (*ẓil*) is tied to a chronosophy that sees history as a record of moral decline since Mohammed and the first generation of Muslims.[16] Biography, modeled on the *Hadīt*, dominates Muslim historiography. Present actions are consciously formed by reference to narratives of past lives. For example, the *iṣnād* confirms the link between a firsthand observation of an event and later descriptions, guaranteeing the reliability of information by announcing the moral qualities of the scholars who passed it on. Patrilineal bloodlines play a similar role. Hassan II, for instance, is a *šrīf*, which means that he traces his bloodline back to Mohammed; he thereby commands significant "ethical force." Some measures of time in Morocco are connected to events other than the hegira or the factory clock. In particular, the agricultural year has its own set of celebrations, among them the festival of the Lyali; this holiday, a survival of the Roman "Ides," celebrates the beginning of the agricultural year.

By transcending the present and aiming for the future, every chronosophy aspires to apprehend the entire path of one or another trajectory of history, from beginning to end. Chronosophy seeks to see time's becoming, to grasp the totality before it is realized, to replace necessarily incomplete knowledge with transcendent meaning.[17] The "open-ended future" seen as typical of the West by Bourdieu involves this predictive perspective. This view of the future might rely on clock-time, but it could just as easily depend on another

chronometric system. In Morocco this belief in an open-ended future collides with competing time senses. The technocratic elite—whose social status depends on their symbolic commitment to Western time and its forms of knowledge—often complain that the Moroccan population misunderstands the importance of being "on time" and of using space "rationally." Social planning has become an essential element of government or business strategy, required if the country wishes to benefit from "modernization" projects administered by entities such as the World Bank or the United Nations. But what social agencies could alter the way that time is thought and experienced in order to make this new "scientific" and "rational" time practically convincing?

Factories and schools have taken part in this attempt to reorder habits of time according to the clock. Other institutions, like television and radio, also inculcate the chronometrics of the clock, yet they simultaneously fill time's "spaces" with the narrative of chronography and the order of chronologies. The repetitive, cyclical nature of mass media's products encourage people to tune in at certain hours, but the effect on the audience's time sense is unclear. Television involves people in the rhythms of the clock, offering interesting narratives that they may compare with their own lives. However, its influence in presenting the future as a "broad field of possibilities" is limited. In fact, television escapes the circular time experienced by its audience only when its narratives relate directly to themes in daily life and to possibilities for future, planned action.

Marshall McLuhan affirms that television keeps us in present time.[18] We must also remark that it works alongside other media to remind us constantly of places and histories beyond our immediate knowledge. As in the example of the French elections, if no concrete link exists between television narratives and the narratives of daily life, then the television narrative is easily compartmentalized, walled into an "other" universe, interesting to observe but overlapping only partially with "real life." The crux of the relationship between mass imagery and social meaning can be identified if we look at this point of overlap.

What makes Latifa laugh in front of her television set is neither Zorro nor the call to prayer but their juxtaposition. This incongruous attempt to meld two orders of time serves as a metaphor for all of the synthetic projects of those who recommend a simple cultural "mixing" or "bricolage" to dissipate cultural conflict. Two ways of measuring

time meet and clash. Many Moroccans feel that both types of time are essential; and, although Latifa might laugh, she, like most people, easily accommodates both rhythms in her daily life, switching smoothly between them. The differences between these times, however, are not simply dispelled by her laughter; one time does not simply swallow up the other. Rather, they coexist, if unequally, an emblem for social interactions and conflict. The two times collide, offering, even on television, a vision of contradictions that are essential to the social order as it is lived today. These contradictions might sometimes be avoided, but it is not easy to make them disappear.

Various discourses and persons rely too heavily on either "technocratic" or "religious" time for one to crush the other. While clock time apparently dominates day-to-day exchanges, at work or in front of the television, religious occasions continue to march to the contrary rhythms of the moon. Indeed, even national holidays do not necessarily fall on given dates but are declared by royal decree, often at the last minute. Royal prerogative itself relies on both sacred and clock times. Conflicts between time senses mark every area of life. During Ramadan Muslims must fast from dawn to sunset; thus, workday schedules no longer include a lunch break. People have shorter hours, but they must still work, especially if they conduct business with non-Muslim countries: this in spite of their hunger or exhaustion after days of fasting, evenings of revelry.

Clock time is abstract and uncompromising, insisting that each minute be filled with activity. Newspapers, magazines, and televisions require that all space and time slots be filled; the content is less important than the necessity of leaving no blank spaces. It is significant that many Moroccan youths speak of trying to find things to "fill" time slots between television and meals. Those who don't work or attend school regularly—and there are many—say that they go shopping or play video games to "fill" their time. Discussions about football (soccer) help pass the time in cafés where men without work spend hours talking and watching people pass. Some use bars and drugs to fill darker hours. For women, housework extends to fill the day. Other pastimes, like baking bread or knitting, provide sustenance and clothing for the family. Families or friends frequent the old *medīna* or the new shopping centers, as one student told me, "to forget themselves, and to feel like they're doing something when they buy stuff or just look." Even working people explain that they watch television to "fill"

evenings and weekends that would otherwise be empty. More and more people are dividing and filling their time.

The clock time of television is necessary to industrial production and to full participation in international exchanges. The Casablancans most involved in the ordering of time usually have positions of power, often because they can function within "rational" schedules. At present this group includes a considerable number of the city's inhabitants. While people's schedules may differ from those adopted in other countries, Casablancan schedules differ no more from those of, say, Madrid, than those of Madrid differ from Oslo's. Historically, the upper levels of urban society might have had more experience with clock time through their contact with France and international business. But today Casablancans differ little in their use of productive clock time and seasonal calendars; now they are distinguished by the kinds of activities they select to "fill" their time—or in their liberty, or lack of liberty, to make such selections.

A manager at a large corporation in Casablanca told me that his main problem was "getting the workers to follow schedules. They just laze around. They have no concept of time at all. How can one have a rational strategy in business in this situation? You really have to act differently than in Europe. You have to act severely, not like an equal. This was hard for me when I first started my job." Cases like this suggest less about the workers' understanding of clock time than about the moral force with which many "efficient" managers invest the hands of the clock. Managers can gain prestige and self-regard by making promptness and efficiency a social value that they enforce among their subordinates. The relationship between clocks as value and status became clear to me when a cadre told me that he saw little reward in working too hard or being careful about how he used his work time: "Why bother?" he commented. "I can't move up anyway. Everyone higher up is only a few years older than me, and the younger people they're hiring are very highly qualified."

When people line up for movies or rush to the bus station an hour before their bus's departure, they are not tardy. Perhaps the issue of productive time might be less a problem of "mentality" or even of culture than of motivation. Is the future one of open possibilities? If so, for whom? Although discourses promising a malleable future permeate Casablancan society, many people lack the prospects to realize such a future.

Time can be "filled" with productive labor, but it can also engender a sense of rage at not being able to fill moments meaningfully. People may see their days as hourly grids or blank spaces, but the kinds of activities permitted during these "time blocks" are circumscribed. The national television channel (RTM) fosters a chronology based on the history of national independence and the role of the reigning monarch. Chronographic portraits of kings, sports heroes, and other important persons are shown in conjunction with historic accounts of other places or fictional portrayals of believable characters. When "national" production fails to fill all of the time, stories from elsewhere are imported after being approved by the censor. Certain objects are eliminated by his hand, yet these tend to be just bits and pieces of images and stories: a kiss here, a wayward critique of a political figure there. The censor eliminates certain images or even whole programs, but his or her role is often ineffectual. Censorship generally ascribes special significance to certain images; but few censors, official or unofficial, realize the potent threat of the very logic of the image itself, as McLuhan became famous for pointing out.

Television reinforces a sense of segmented, abstract time. It also offers images of worlds where linear narratives have social meaning and are linked to instrumental rationality and action, at least for the length of a soap opera or a news story. Yet these narratives succumb to the greater imperatives of the orderly progression of images through a given cyclical schedule. Thus, television inculcates a notion of cyclical time. Any single image it offers takes on chronosophic meaning only when it is set in the context of available discourses that give it more than a fleeting weight. Specific narratives on programs may ebb and flow, but the result is a pattern of eternal recurrence.[19] Day in and day out, time is filled with images, but they do not create that orderly march toward the future implied in Bourdieu's depiction of Western time or Pomian's chronosophy. The time of Western history, with its implied future of broad possibilities determined by past occurrences, has little place on television screens. Television is one manner of controlling both the physical rhythms of the population and the kinds of stories circulated to them. However, if television is not accompanied by alternative institutional methods for linking images and stories to a vision of the future, it may propagate radically inconsistent messages.

John Waterbury remarks that Moroccan politics and social life in general can be characterized as a stalemate. People tend not to confront one another openly about differences; this unwillingness afflicts the elite in particular, since they constitute a very small group whose members know a great deal about one another. This reluctance to confront others is, Waterbury comments, "Rooted in the ambivalent attitudes one has towards enemies and allies and in the acute sense of the temporary nature of victory. Practically all social and political activity is permeated by this attitude."[20] He argues that the posture of the Moroccan regime is basically defensive, an attitude that makes it incapable of developing a future-oriented program. However, since the time of Waterbury's study the educated groups in Moroccan society have come to include people of varied social origins, members of these sectors of the elite have voiced many demands for open debate, with some effects. Between the beginning of my research in 1987 and the present, Moroccan television, press, and radio have become bolder in revealing the rifts behind the thin veil of consensus. Waterbury's conclusions may still characterize many types of social interaction, but the "stalemate" he observed may reflect his own "future-oriented" understanding of policy, a perspective that emphasizes state action for general change in a way that seems untenable anywhere today. To what extent does the open expression of opinion alter the situation? A closer look at the formation of opinions and narratives demonstrates that one may openly state *certain* differences, yet remain ambivalent about any long-term evolution.[21]

Television abounds in tension, drama, and suspense, but its narratives do not lead to any immediate project or conclusion. Like water gushing from an open tap, television streams in, always available. It proposes methods of and subjects for thought, but it cannot itself provide any answers, realize any future. It is effective in explaining to people how they should order their days and how they should think about them. It orients the frameworks of discussion and the rhythms of family life. Unlike the clock, which moves people *out* toward the factory, television brings people into their homes. Domestic routines are the first things altered by the television's presence. Yet the images projected by the television contrast markedly with the domestic universe they enter. The time and space in which they evolve differs radically from the day-to-day interactions taking place around the television set.

The cinema offers an all-embracing world of dreams that enter the everyday world, but this oneiric world remains geographically outside the quotidian realm, confined in theaters. Television, by contrast, is a fixture in most homes. Its pictures and sounds become possible subjects of critical conversation and reflection among those who happen to be within hearing of the television set. Groups of people around the television dispute the veracity of information they are receiving and reexamine their own opinions with respect to the stories and pictures they are watching. Often television programs can provide opportunities for viewers to discuss sensitive subjects by ostensibly talking about "something else" that is on television. This is one way to circumvent silences concerning oneself that are implicit in family situations or more generally.

While watching a detective movie from France, Leila remarks that the main character, a private eye, is a woman. She follows the plot, admiring the protagonist's ability to solve problems and, if necessary, risk violent confrontation. She begins to complain that in Morocco one would never see a woman detective. Can you imagine? she and her family exclaim. They discuss how women are "confined" in Morocco. "They" would never accept a woman so strong and courageous. How lucky they are in Europe to be able to do so many things!

The entire family, men and women alike, follow the film as the plot thickens, all expressing great admiration for the detective's abilities. After the film no one speaks about it again. Aicha, the eldest daughter, has a well-paid job as a trilingual executive secretary. "That's the way it is here in Morocco," she says, dismissing the film with a shrug. Despite her good job, she is not married at age thirty-three. She connects her lot with what she sees as the oppression of women by men and the system at large. The image of the French detective contrasts sharply with her own situation; however, her ultimate reaction is a shrug. On some days she has been even more resigned. "At least my brothers aren't nosy," she says, or she consoles herself with a pleasant thought: "With my own car I'm able to go where I please." Her sense of confinement appears to be heightened by her constant watching of television, reading of novels in French, English, or German, and attention to French magazines. "At least," she says, "it's not as bad in Morocco as in other Arab countries."

By distancing herself from the European and American stories, she compares her situation favorably with what she assumes would be her situation in other Muslim countries. An unmarried woman, she spends

nearly all of her evenings in front of the television, often with a copy
of a photo-roman beside her. Work and television are the poles around
which her schedule revolves, in spite of the "freedom" granted her by
her car.

While television narratives often demonstrate the distance between
lived experiences and the presumptions of European or American
shows, they can also point up surprising similarities. For example,
Moroccans often associate the behavior of characters on the American
serial *Dallas* with the habits of rich inhabitants of their own country:
the bad guy, like J. R., wins in the end. Perhaps America isn't really
so different from Morocco after all! This cross-cultural perspective
avoids the criticism of specifically Moroccan or Arab traits, com-
mented on in the discussion of the detective film. Yet in both instances
the Moroccan audience apparently sees the "good guys" as caught in
a losing battle, at least in Morocco and perhaps everywhere. Film
critics have noticed that in the few Moroccan films produced so far,
the protagonist is nearly always a loser, a loner, unable to fulfill his
dreams.[22] Apparently, Moroccan artists and residents alike accept the
failure of the "good guy" as inevitable.

As Moroccan families watch television, the members often compare
the narratives shown there with lived experience or with information
gathered from books, magazines, or conversations. Sometimes de-
bates become heated, but rarely do they continue long after the show
ends. The narratives presented on television do occasion ongoing
discussion when they directly involve moral concerns, particularly
sexuality. The social issue of redefining norms for feminine visibility
and action begets active and regular debate in Morocco; this issue also
touches directly on differing interpretations of Islam.

News, because it is about true stories, incites discussion. On the
news we see the places where things happen—Paris, Washington,
Bonn. People wait to hear the king's speeches on television to discover
what kinds of political activity are taking place in Morocco. However,
television coverage of elections, congresses, and demonstrations bears
little resemblance to the residents' actual experience of political pro-
cedure, relentlessly formal though that may be. Moroccans participate
in worldwide currents of knowledge and opinion as disseminated by
the major news agencies or by more detailed documentaries. But their
only hope for collective representation in the international media,
especially television, rests in the king and his appointed ministers: they

must look up to their political leaders, hoping that their desires will be mirrored from them to the world at large. This notion of change and action moving vertically—which reflects the continuing importance of face-to-face, patron-client relationships in Moroccan society—has its counterparts in domains as diverse as academics, fashion, and business: Moroccans present the mantle of expertise to foreign intellectuals, Parisian designers, American management consultants—not to themselves. Judgments and ideas come from "above," and most people scramble to learn what they can about these other "spheres." Television, along with other media, provides information about "experts" or "stars," treating them as exotic creatures. Its manner of presenting these people or ideas adds to the sense that they live in a universe that is different and untouchable.

The sense of exclusion from places where news is made parallels a feeling that time, too, is "elsewhere." Many people in Morocco seem to feel divorced from important historical actions. Events like the francophone meeting present pictures of power in Morocco itself, yet these still seem to take place in an alternative place and time far from the quiet precincts of daily life. Casablancans express their sense of powerlessness through complaints about the oppression of the Third World or of Morocco. Ahmed, a university student, explained to me that Salman Rushdie's *Satanic Verses* was paid for by "the Zionists as a part of their plot." In his estimation, "The CIA works with the Zionists to make people in the West hate Islam and Arabs." (Such comments are common, although various "conspirators" are targeted.) The image of the British author offered Ahmed a target for anger born of many wrongs, past and present, real and imagined. Ahmed's anger, and his directing it at someone he sees as a renegade Muslim, brings to mind Pierre Bourdieu's analysis of the situation of the lumpen proletariat in Algeria prior to independence. As Bourdieu notes, people who have some liberty to choose their own future have a different sense of "revolt" than do people who feel condemned to an eternal present of exploitation. For the latter, "Revolt is directed above all against persons or situations known to the individual, never against a system that it is the subject to systematically transform. And how could it be otherwise? That which is perceived is not discrimination, but racism; it's not exploitation, but the exploiter; it's not even the boss, but the Spanish foreman."[23] Here, power is seen as elsewhere. For others, life is elsewhere.[24]

Elsewhere is often pleasant but untouchable. One might opt for diverse elsewheres, like the youths who adopt the styles of their favorite foreign centers, bearing emblems of far other worlds in their stance, their clothing, their language. Young Casablancans often say that they must leave Morocco if they wish to participate in developing new ideas, new styles. Many people talk about Morocco as a sleepy way station; elsewhere, time moves quickly, and people do not loiter. Television bombards its viewers with images of an outside world in eternal motion, filled with places that appear much more exciting, moving, and significant than they are for those who live in them.[25] These moving universes invariably appear even larger, more fast-paced than ordinary day-to-day life in Casablanca. As one young man told me, "We just aren't like that. We can't do things like that here in Morocco like they do on television." Morocco's slow, circular time is often taken to be part of "the way things are," but it is also seen as reflecting the Moroccan "national character." Television is most destructive in making people devalue what they have, who they are. Such self-deprecation does not derive simply from the content of television programs—for example, those that present a negative view of Arabs. Such a message is implicit even in images produced in Morocco; for example, the other places become the upscale homes shown in commercials. Images and stories from outside of the viewer's own experience appear more compelling than "real life."

Some people reject mass imagery as propaganda, arguing that election coverage, for example, does as much to create false representations of life in the West as the most fantastic of melodramatic series do; often these are the same people who most adamantly reject Egyptian melodrama. While their suspicions of the media echo scholarly warnings, other people accept the fanciful images of the cinema or television as a respite from the daily grind. They usually know very well that these pictures are not directly related to their own lives or actions. A young woman born long after Marilyn Monroe's death told me, "Marilyn, ah, she's my dream. I would give anything to visit Hollywood, I dream of being like her, becoming an actress. I dream it, but I know it's not possible."

If images from other times or places cannot provide a sense of the future, they nevertheless merit attention for the dreams they create each day. Such dreams are especially important since there is little public discourse beyond the terms set by mass imagery. Images might

give birth to ideas or alternatives—but without a public forum for debate, resistance is often discreet or couched in terms of consumer choice. But, at least in Morocco, even these inchoate visions are important in understanding how interpersonal relationships are changing in Morocco. Transformation of these relationships is important in a political system that has relied heavily on personal and family ties up until today, but that sees the basis of this "personalism" undermined as more varied groups acquire economic and cultural power and know-how. What role might mass images play by introducing leaders' faces into homes or diffusing images of far-off lands?

Mass images change the ways we draw political maps. Similarly, strategies developed for the use of images and the creation of new kinds of personal links will affect the usual definitions of modern bureaucracy. In Casablanca neighborhood "watchers" like parking attendants and guards emerge to fill the gaps of anonymity. Schoolchildren teach each other the new song "Pepsi, Pepsi Cola, voyage, voyage cola" as they play patty-cake, then teach their parents all of the right words to the national anthem, also learned on television. The future is unclear, but a single word resonates among all sectors of Moroccan society when one speaks of personal, political, or economic aspirations. That word is "choice."

Chapter Five

OBJECTS AND OBJECTIONS

◆
◆◆ The heroine turns, her gaze leading us to a shot of her lover, his
◆ eyes intense, searching—for what? Touria, a Muslim "sister"
well versed in Hollywood film conventions, knows only too well.
Following the plot on TV 5, she sees that the story will now traverse a
dangerous passage and culminate in a kiss. She lowers her eyes to let
the danger pass. Once a new scene banishes the threat of the kiss
from the screen, she again lifts her eyes to enjoy the end of the melo-
drama.

When TV 5 Europe began broadcasting in Casablanca in Decem-
ber 1988, connections between pictures and morality, seeing and
believing, became the subject of myriad conversations.[1] The new
channel provoked excited discussions about the programs it offered,
including several produced in French-speaking countries—among
them France itself, whose sense of morality differs considerably from
Morocco's. What might people in Casablanca think of French shows
like *Sexy Follies*?

Potentially shocking images seemed to creep into even the most
sedate subjects. A program about books suddenly displayed a naked
woman; a documentary on AIDS produced larger-than-life plastic
penises to demonstrate the use of condoms. Images like these inev-
itably caused discussion (or embarrassed silence) among some Ca-
sablancan families. Some people, like Touria, solved the dilemma of
unwelcome images by constructing a grid for watching, thus recon-
ciling their desire to enjoy television with their personal interpretation
of Muslim norms.

TV 5 entered the lives of Casablancans who were already accus-
tomed to welcoming images from afar. From the beginning of the

twentieth century the city's streets set images of people and things in novel webs of visual meaning, spun partly from the stuff of movies, photographs, and arts. A new sense of visibility extended from the realm of the arts to include the mundane displays of everyday life, the way that people offered themselves to sight in public and in private. European women strolled down boulevards barefaced; in cafés couples sat together, indifferent to the public gaze. With Morocco's independence, Moroccan women began to alter their involvement in public space, and the transformation of their appearances and practices came to signify social change in general. During the Protectorate the French had attempted to order cities by juxtaposing the traditionally Moroccan to the modern French. Could the introduction of a foreign television station be reduced to a correspondingly simple distinction between inside and outside?

The images on TV 5 animated conversations that often contrasted inside and outside, male and female. Yet daily practices now have a different relationship to these foreign images than such practices had when Lyautey proposed to build new modern cities alongside traditional *mudūn*; at least soap operas and newscasts on television, whether TV5 or the RTM, recalled the daily lives of city dwellers. The moral problems posed by these images could not be conceived solely in terms of a single television channel or a single medium of communication.

Toufik explained to me that images have no moral effect whatsoever; this, he told me, was the only perspective a "modern" person could adopt. Yet even he admitted that he avoided watching certain programs in the company of his father: such programs might have sexually explicit images, and he feared that his father would be made uncomfortable. Images and dramatic performances are always social, and their forms inculcate norms of sight and perception. Aesthetic norms may well express a community's cohesiveness while simultaneously airing complex and controversial moral messages. While Rifala Rifa'i al Tahtawi was staying in Paris from 1826 to 1831, he wrote home to the Middle East that

> the Parisians have a place of entertainment called theater or spectacle, a place where reality lives upon the stage. In fact, its playing is education in the form of fun. For the French, the theater defines morality—one sees the good deeds praised and the bad ones ridiculed. The plays are full of what makes us laugh and much that makes us cry.[2]

Television requires a different way of experiencing pictures and stories than the theater, and the education of the French public surely has different ends than those sought by Casablancans. But what remains constant is the dramatic medium's teasing of the limits between tears and laughter, right and wrong.

While some people in Morocco complain that European images are largely immoral, some media analysts in Europe and America criticize the supposedly unsophisticated uses to which non-Europeans put the audiovisual media.[3] Each group ignores the complexity of the local situation. Touria's refusal of the kiss relies on a thorough knowledge of cinematic conventions. She sets up her own frameworks for distinguishing the merely playful from the morally perilous; when she focuses on the kiss, she objectifies it and then tears this "unseeable" act from the rest of the film. Her judgment is crystallized by an absent image. She rejects the act not because she witnesses its sensuality but because she is acutely aware of the formal progression of the film. (We know the kiss is coming, but not how it will be played: the actress might suddenly turn her back on her lover, perhaps even pinch or strike him.) The narrative context of the film, with a penultimate signal in the looks exchanged by the lovers, permits Touria to identify the threatening kiss; but how could she, or we, judge an image appearing isolated, out of context? Seated in front of the television, we forget the work of producers, technicians, and actors; the perfection of television images depends on our denying the process of creating the fiction.[4] The images of the actors Touria sees kiss each other. Is this a real embrace or a game?

Maybe Touria is saying that certain stories should remain serious; perhaps her moral disapproval mirrors criticisms of mass imagery that bemoan the way in which the mass media participate in breaking the world into pieces of measurable value. Many scholars of culture argue that the lack of hierarchy in the mass media is part of a larger process of secularization and commodification. According to Marx's notion of fetishization and corollary theories, the quantification of modern experience derives from the dominance of economic criteria under capitalism. Some writers on the media suggest that mass imagery intimates that we view ourselves and others as composed of quantifiable "looks" and attributes, offered either for sale or simply "for window shopping."[5] Touria equates the kiss with other "dangerous" objects, but the dangers she sees are not the equivalent of any other

objects. Nor can all personality traits, details of self-presentation, or claims to knowing be negotiated:[6] however mechanical the means of isolating dangers might be, the objects thus extracted from films or behavior cannot be as even and anonymous as an architect's grid or an accountant's ledger. Certain images or "territories" remain more symbolically and ethically charged than others. Besides, purchase and voyeurism are absent from Touria's designs; she refuses to window-shop.

Many of those who create or select programs for national television in Morocco argue that they must shield the audience (or themselves?) from socially unacceptable images. They seek to censor kisses that are too ardent or cut out scenes in which women too clearly demonstrate their ability to do things that men are expected to do. One veteran journalist explained to me that

> people in Morocco are not used to these things. They become angry when they see them. They need to be progressively adapted to seeing this so as not to confuse images and reality. This process of modernization is already completed in the West, but not here. So we have to control what goes on television so as not to offend people.

He said that Moroccan television would eventually progress to the state of being able to show everything—the position that images are merely shadow plays.

Roland Barthes brings up the same subject differently:

> Today pleasure arises through the image; this is the great change. This inversion brings up questions of ethics—because when it is generalized, it completely "derealizes" the human world of conflicts and desires under the cover of illustration. What characterizes the so-called advanced societies is that these societies today consume images and no longer, as before, beliefs. They are thus more liberal, less fanatical, but also more false, less authentic: this is translated into daily language through boredom, nausea, and a sense of a world without differences. By abolishing images, we preserve the immediacy of desire (desire goes unmediated).[7]

Perhaps by abolishing images that portray erotic relations, Touria is indeed protecting her own version of desire.[8] But if images are to replace beliefs, how do they mediate some desires and not others? When Touria averts her eyes from the television screen, she proclaims her knowledge rather than her innocence. She responds as an actor

in a world in which "derealized" images abound, but in which they are not always judged in identical fashion. Some other Muslim sisters explain their way of reading women's magazines:[9] "We don't read about makeup or dates or those things. We just choose articles from the table of contents that are appropriate for Muslim women, things about nature and cooking, and especially about raising children." Reading becomes emblematic of strategies of self-discipline, yet this process also reasserts the power of images and stories as modes of understanding and viewing. It is through the learned ability to recognize film or magazine conventions that dangerous objects become visible by their absence. An empty frame elicits questions about what one might have seen in it.

Many of the images that people see as dangerous concern thresholds for contact between masculine and feminine, secular and sacred. Many Casablancans—and anthropologists—remark that *any* male/female contact in Morocco can be perceived as potentially sexual.[10] But not every appearance of men and women together in pictures troubles television viewers or censors. Rather, it is the moment when the narrative promises the realization of erotic possibilities (or the image thereof) that is to be avoided. As we shall see, a similar pattern emerges when people talk about actual relations between men and women.

The identification of gender-based spheres of activity is an acute source of conflict in Casablanca. One Muslim "sister" told me that "women should be able to go out, or work if they want to. If their husband doesn't make enough money, they should also have the right to work. But if girls are modest and don't wear provocative clothing, there's no harm in them working alongside men." The limit of male and female intercourse is located by the word *provocative*. Does a woman or an image issue provocation by displaying certain objects amid a sea of visual or sexual desire? Some people define provocation as the exhibition of specific areas of the body or the performance of specific actions.[11] Others argue that attitude or intention is most important. Distancing the sexes is not as much at issue as is the regulation of the distinctions between masculinity and femininity. It is not mere accident that women's scarves or other head coverings are called *Huzūb* (protections). This type of visible protection is one way to assert both femininity and the social order.[12] While much attention is given to the distinctive attire of Touria and her Islamic sisters,

women who wear "Western" or "Moroccan" clothing, paint their nails, or curl their hair into bouffant styles are equally engaged in defining and redefining their identities as female in what were formerly masculine public places. Men also participate in this arrangement by avoiding any behavior or appearance indicating femininity—for their masculinity is also at stake in the mixing of genres so typical of the modern workplace.[13]

While Touria avoids the televised embrace, her sister-in-law revels in that same moment. Leila laughs at those who, from her perspective, "confuse mere images with reality." But she adds that she "really would like it if people became more tolerant about men and women going out together and expressing affection in public." She wishes life were a little more like films or television. Although Leila says that images are mere visions, her relationship to the fantasies they offer is ambiguous. Touria's and Leila's different ways of judging pictures carry over into their conception of their own manner of presenting themselves in public.

Leila likes to go walking in the park with me or her other friends, subtly seeking male attention as she strolls along. She explains that the Koran does not say what one must wear or see, just what one shouldn't do. She argues that "girls who want to be sisters just want to be able to get husbands. They know that men like women who believe that men are superior. Those kinds of girls want to pretend that they're better than everyone else. Some of them want to hide a shameful past under their new clothes."

Figures of women and young men take a prominent role in discussions about who should be seen, and how and where. And whatever the various opinions about self-presentation, the issue of truth is a key to understanding why visual expressions are so provocative. Leila claims that images aren't real. Another woman criticizes a friend for being too made-up, too artificial. When I introduced Erving Goffman's work to a university-level class, the students posed similar questions. How can we speak about public personas without immediately bringing up moral problems. They told me that they feel torn apart by the different social roles they are required to play, that each of their personas is a lie. Where, they wanted to know, might their *real* selves be?

Such questions are linked to the introduction of modern types of knowledge. Only in Europe, it seems, have being and thinking become

(ideally) unhinged in intellectual discourse.[14] Even there, until the sixteenth century most people believed that truth could be perceived only by persons who were "susceptible" to knowledge, usually because of their moral worth; asceticism and truth were always more or less obscurely linked.[15] However, after Descartes it was conceived as possible to be immoral, yet know the truth: the personality of the observer of an event no longer changed the quality of his or her reporting. This approach to the truth made possible the institution-alization of modern science. The times and spaces of this science have become essential to the forms and disciplines that modern society has established in Europe and, indeed, throughout the world. We hear their everyday echo in Leila's claim that images are merely pictures, detached from anything real: reality is beyond appearances. Yet Leila is not alone in seeking to judge this basic reality through the appear-ances that people offer to her gaze. When she criticizes a boy who *bga ybān* (literally "wants to appear"; that is, wants to seem more im-portant than he is), she remarks on his pretensions by indicating how his expressions and clothing fail to correspond to his *true* social position.

To make sense of the way in which people talk about images in Casablanca, we must contemplate this gulf between appearance and reality. Educated people in Casablanca refer to "science" to justify all manner of arguments. Often such calls to science and technology have nothing to do with the domains of scientific knowledge; rather, people complain that scientists and managers have still not dissolved the links between personal authority and knowledge in daily life. Practically, though, this desire for disembodied truth can never be fulfilled: nowhere has reason brought about the reign of disembodied knowl-edge, as conditions in the United States, Europe, and elsewhere demonstrate. The world is not "disenchanted," even if some people see its continuing reliance on quasi-magical means as a failure of modernization. Anonymous bureaucratic savoir-faire will not stop people from going to fortune-tellers (*šuwwāfā*) or seeking to be healed by a *fqih*. Some girls will persist in dreaming of being Marilyn Monroe; men may fear marrying she-demons or imagine that they will meet a fairy-tale queen in the park. The world of the mass image reenchants and disenchants at one and the same time.[16]

Nonetheless, many of the journalists and specialists whom I met in Morocco explain that they hope to free mass-produced images from

the grip of moral claims. Most explain that this modernizing process will put images in the role of sending out either pleasure or information, each sphere being clearly defined. New social groups strive to gain prominence by developing new practices of reporting information, surveying audiences, and advertising goods and services. Professionalism, a collective adherence to a group's norms, proposes guarantees of truth and objectivity. Expertise is no longer explained as a moral or a political issue, nor does it depend on the general moral or intellectual qualities of the person creating images or telling stories. Instead, "expertise" is grounded in a notion of truth as revealed by scientific method and rational planning.

One young Moroccan journalist, Latifa Akharbach, writes that she identifies with the kinds of goals shared by her colleagues throughout the world. Yet she recognizes that she and her fellow journalists in Morocco have a difficult task practicing journalism because of explicit political interference in the everyday world of information and media. She notes that in interviews she conducted with "leftist" journalists, they inevitably saw their work as primarily political. Censorship and the unwillingness to share information hinder the emergence of both journalism and political freedom, she argues. She concludes that the future of the profession in Morocco is linked to the development of democracy. Truth, professionalism, and political destinies appear to develop together.[17]

Professionals of all sorts, journalists included, often accept knowledge and professional practices developed in Europe and the United States uncritically, without distinguishing what is applicable to their situation; descriptions of the societies in which the knowledge is produced are treated as indisputable theorems or maxims.[18] This tendency, which is not unique to Morocco, derives from the perception, on the part of scholars and professionals in poorer or smaller nations, that they labor on the periphery of the intellectual world. But it also has to be related to the complexity of local competition, for groups who can claim that they practice internationally legitimated science (or art, for that matter) can promote their own interests by insisting on the universal validity of such knowledge. Accordingly, people I spoke with thought that the journalistic profession should be purged of incompetents and people hired only because of personal connections or their willingness to eschew professional objectivity and seek political goals through the media. Many argue for restricting the

role of "bosses"—that is, newspaper publishers, government minis-
ters who regulate television and radio, and perhaps more particularly
the party leaders who monopolize newspapers. Some even go so far
as to complain that the supreme leader, Hassan II, takes up too much
space on the front pages of newspapers and on the television screen,
a position that indicates that he remains the strategic center of all
imagery. The public should be presented with "the facts," and the
government or political parties have no business interfering in this
process. Some journalists see the media as a major independent power
in Moroccan society, transposing language used in America or Europe
to attempt to explain the local situation or, more likely, transform it.
But does the Western idea of the audience correspond to Moroccan
conditions?

In a 1982 study of the publics of Kalaa es-Sghrana, Ahmed Akh-
chichine and Jamal Eddine Naji apply "state-of-the-art" methods of
interviewing and analysis to media use in a small town. Their work,
which provides extensive information concerning the programs pre-
ferred by different social groups, analyzes the audience in terms of
language preferences and time slots. Their work represents the first
professional technocratic reaction against the "hypodermic" theory of
media in Moroccan intellectual and professional discourse, which
portrays the audience as being injected with images by those who
control the broadcast media. Akhchichine and Naji investigated what
people actually watch and listen to: news, Egyptian movies, Moroccan
soap operas. Their study occupies a space left wide open by more
intellectualist discourses, but they do not consider the broadest issues
of power and influence. They want to study the "real" conditions of
the media's influence and begin with the claim that the need for
television is "real—in spite of people's critiques."[19]

But Akhchichine and Naji do not explain or justify this "need."
While studies such as this one (and this is just one among many, if the
first on the media) seem to ask for a more objective, scientific per-
spective, they also suggest that the media must change simply to
become more attractive to a perceived audience. Emphasis on images
of powerful persons is undesirable when it is boring; boredom is
inefficient. The attention to "audience freedom" as a technical ne-
cessity has a certain critical potential, but that potential can be un-
dermined by a refusal to state bluntly its obvious political and social
implications. The ambiguity of Akhchichine and Naji's study derives

in part from censorship, but it is likewise encouraged by international trends in media analysis.

If the sources for earlier discussions about the cinema were generally to be found in French and European discourses concerning realism and progress, these new orientations in audience research methods developed first in the United States. Todd Gitlin analyzes the development of this type of research since the 1930s, when it was linked in the United States to the development of important media institutions and the incorporation of the media into a capitalist society based increasingly on consumption.[20] In this research, scholars consider consumer behavior in the choice of media programs or specific newspapers or magazines. While they have amassed statistics and details about consumer choice for the industry, they never ask the critical questions about why the market should serve as the model for the media and for people's use of the media. Specific television programs and magazines are treated as distinct objects of consumer choice. A map of society should correspond to this set of media objects: one chooses a program in line with one's "occupational category." As Gitlin remarks, scholars have amassed mountains of data in this research effort, but they have never ascended to any "conclusions," for they cannot question the basic market orientation of their own studies.

In America and, more recently, in Western Europe, such consumer-oriented studies appear convincing because they fit common assumptions about motivations for consumption. Because the research methods developed in tandem with international trends in America, they resist analysis; researchers are tied to the commercial conditions that created the object of their studies. More recently, theorists of media use, such as the British scholar David Morely, have started to pay attention to how people use media in concrete settings.[21] But these studies are generally restricted to regions where the media were introduced into a context in which the clock, the factory, and schools had long habituated the population to modes of social discipline along capitalist lines and where the metaphor of consumption can be used as a key to understanding many aspects of society.

In Morocco, by contrast, media studies have developed in a vastly different social context. Even educated, urban scholars and journalists have only recently begun to use reputedly scientific means to describe (and imagine) audiences. Generational differences are partly respon-

sible for this time lag, for some men who played an important role in
the independence movement continue to hold important positions in
the media, as in other key institutions.[22] Many people who promote
a more professional or scientific version of journalism express their
demands in contradistinction to this "old" generation. While the
elders tend to speak of the "people" or of "Moroccans," many younger
journalists prefer to speak of "the audience" and of the need to
describe this "mass."[23]

Generational differences alone do not determine social and intel-
lectual positions; personal and family situations also influence the ways
in which individual professionals perceive their work. Those who have
established their positions through personal ties usually insist that
good journalism depends on some innate intuition, or they argue that
the ultimate professional honor is to stand close to the king and
function as his spokesperson. The other group, whose claim to legit-
imacy rests more directly on education or professional experience,
challenges "personalism" in all its forms. Their interests parallel those
of the rest of the growing technocratic elite that is coming to run the
major businesses and the administration. Ironically, proponents of
"objectivity" are courted by the "personalist" elite if they achieve
remarkable success in any area.

One journalist, close to the government, explained to me that
journalists are always subject to censorship because politicians, while
aware of the necessity for freedom of speech, "forget" its importance
when there is some compelling governmental necessity. He also ex-
plained that he sees the "powers" as becoming more attuned to the
necessities of the journalist's profession.[24] Morocco claims to be
"open" to other countries and to the capitalist "system," and it actively
courts the European Economic Community and foreign investors.
The Moroccan state is bound to these powers on which it depends.
Consequently, human rights issues, including freedom of speech and
the press, must be accommodated in national political discourse,
however difficult such accommodation might be. Recent Moroccan
media production has started to follow international trends, including
more in-depth reporting of certain local issues.[25] Yet censorship con-
tinues.

Abdellah Laroui suggests that the "positivist" option has been
especially common among Moroccan intellectuals.[26] This argument
for the legitimacy of "science" is not a simple product of ideology or

the "superstructure"; rather, it demonstrates the ongoing, concrete involvement of Morocco with fields of knowledge and practice that extend beyond its borders. However, appeals to science or modernity are not explicit rejections of personal power or charisma. In Morocco the world of the professional remains relatively small; this fact alone encourages personal as well as professional contacts, which broaden the sphere of individual qualities known to one's peers or superiors. Like the small-scale groups based on family origin or neighborhood, professional associations and contacts tend to be face-to-face.[27]

In the nation-state system, modern administrative control is assumed to provide for a more "objective" society based on rationality.[28] But in Morocco administrative rationality is not simply opposed to or evolving out of a prerational, personalistic situation. At the same time that international discourses appeal to the impersonal knowledge of science, with individual choice for the consumer as the standard of success, Moroccan imaginations of social order continue to bear witness to alternative ways of establishing truth and right. Is the promise of modernity perhaps more ambiguous than much sociology and political rhetoric would lead us to presume?

A journalist told me about his difficulties with his boss. He wanted to introduce a quicker, more interesting type of news program, one that could introduce more controversial topics—and, indeed, he had already produced such programs. To demonstrate the unorthodoxy of one of his programs, he said that before it was aired it was referred "to him" (i.e., King Hassan II) for approval. The journalist saw his radicalism as defined by the controversy that his themes evoked at the highest levels: even self-proclaimed outsiders seek legitimation through the figure of the king. It is striking that some of those who speak out most loudly for the introduction of international trends are often the first to appeal to personal authority in practice.

People often refer to the status quo, yet the definition of orthodoxy shifts. As one intellectual commented, "In Morocco one never knows quite what one can or cannot say. We live in a sort of intermediary system in which one can say everything, but in certain ways. The problem is that one never quite knows what those ways are. Much depends on chance—on who reads what when." The French-language magazine *Lamalif* stopped publication after twenty years because of circumstances described to me in slightly different ways by several different sources. The magazine had published an article about

Moroccan history that described the ways in which those in power use time and waiting to demonstrate their importance. While this article seemed quite anodyne compared to many that had previously appeared in the review, it was published immediately following a trip by Hassan II to Algeria during which the foreign press had remarked on his conspicuous lateness. Rumor has it that the magazine's publisher was subsequently summoned to speak with the minister of the interior. After three days of questioning, the publisher decided to abandon the review and leave the country. What can we conclude from this scenario? Whatever the truth of rumor, what was important was the general emphasis on the suddenness of the controversy. Why should there have been problems at that moment and no other?

Some journalists and artists attempt to "raise consciousness," as they put it, through indirect reference to social or political issues. As one said, "Depending on how one writes it, an article on painting or television can be as critical in opening up people's ways of seeing as can a political article, especially since they are inured to this language. People are not stupid; they understand what is going on." "Culture" and intellectual activity form distinctive fields of activity in Morocco only insofar as they are involved in international trends.[29] Those involved in any sort of public activity can be criticized for engaging in political activity (which is presented as necessarily bad or impure).

One way of indirectly giving voice to thorny issues is by telling jokes. By law, Moroccans may not joke about their national institutions,[30] yet there is a lively exchange of jokes about those in positions of authority. People happily jest about Khatri Ould Jumani, the representative of the Sahara at the national assembly. As Olivier Vergniot notes, Jumani is not the first well-known target of numerous jokes, but he crystallizes problems of identity and politics: Jumani, a Sahraoui tribal leader, personifies many of the difficulties of reconciling current and previous modes of political organization. Popular jokes often portray Jumani and his wife as country bumpkins who haven't a clue about machinery, bureaucracy, or modern politics. For example, one story relates, "One day Jumani's car broke down. He got out and started tinkering with the motor. His wife looked out the window and asked, 'Is there something wrong with the insurance or the car registration?'"[31]

While anonymous jokes may name their objects, important figures can be criticized in a veiled fashion in signed articles in the press through the use of nicknames. One popular journalist in the daily

paper *Al Itihad Al Ichtiraki* writes of the problems faced by those who seek to provoke laughter among their readers:

> Mr. Qador said, "Boum belkefti" [a nonsense word].
> Mr. Fatneck replied, "What did you say?"
> Mr. Qador said, "I said, 'Boum belkefti.'"
> Mr. Fatneck asked, "What does it mean, 'boumbelkefti'?"
> Mr. Qador said, "It's 'boum belkefti'!"
> Mr. Fatneck said, "This is a dangerous word!"
> Mr. Qador said, "What?"
> Mr. Fatneck answered, "Every word that we don't understand is dangerous . . . dangerous, Mr. Qador."[32]

In classical texts as well as in daily conversation the figure of the leader is staid, serious, grave. One does not openly poke fun at him, draw caricatures of his earthly face, or defile his sacred person by associating it with impure words or images.[33] Mitterand made lame jokes during his campaign, and Ronald Reagan's wit (if it can be called that) made him famous. However, Moroccan leaders seem less likely to seek laughter than their American or European counterparts. The national image, as projected by its leaders, is serious, unlaughable, with its ultimate, somber personification in the king.

Yet contemporary international iconography presents world leaders in all imaginable circumstances. Their world is different from the everyday one, but perhaps for that very reason it bears witness to ordinary actions. Few situations seem too personal or informal to be the subject of official photographs and press releases. News of Charles and Diana's marital problems traverses the international press. We see Hassan II and Reagan in cowboy hats, surrounded by their blue-jeaned families.

Whereas the gravity of authority's image guards its claim to sacredness, contemporary trends in portrait photography introduce symbolic contradictions. Many of those who produce images are caught in a bind if they attempt to follow the latest fashions, for the moral import of the image is not simply a matter of taste or choice. Real sanctions face those who infringe on its seriousness. Even unauthorized images of the "people" are interdicted, as government treatment of French-language publications makes clear. (French is commonly spoken in Casablanca, and few foreign residents learn to read Arabic.) For instance, the magazine *Kalima* was censored for

publishing an extensive article on male prostitution in Marrakesh. Many youths independently mentioned this article to me, and most of them explained that the issue of prostitution was important to them.[34] One man explained that he saw daily reports about AIDS in France and poverty in America; what did it matter if a few foreigners read about Morocco's problem with sexual tourism? Perhaps the desire to project a positive national image is stronger than the desire for concrete social reform.[35]

But from what fabric are new national imaginations to be sewn? In Casablanca posters of movie stars are taped up on grocery walls beside portraits of the king. Kisses are eliminated by careful surveillance of one's own vision. Demands for morality often center around questioning of leaders' characters. New practices emerge from rereading the Koran or by identifying with Madonna or Bob Marley. Different reactions to change are part of a general effort to make sense of streets, homes, and cafés that are suddenly filled with a farrago of mutually contradictory images. The ambiguity of practices belies any easy conclusions we might reach from taking these multiple images of society for its totalized portrait. People are seeking and creating social roles and objects from the things that are at hand. Knowing and judging are central to this process, but when "every word that we don't understand is dangerous," the difficulties of approaching this process with a sense of creativity become patent.

Words and pictures can present real dangers and concrete hopes. The way in which they are shuffled about in mass images can make us forget this force or center our analyses on discrete images like kisses or graphic violence. Yet relationships between words, images, and their begetters are complicated because their very form entangles moral issues with problems of power and social order. In Arabic, *ʔdāb* means literature, but it can also signify one's struggle to unite thought and action through a reasoned refinement of oneself. *ʔDāb* is a social quality. Like the classical quality of *paideia*, it is expected to show immediately through politeness and graceful behavior.

Peter Brown describes the political importance of *paideia* in ancient Rome. Government, he says, depended on a careful honing of individuals' characteristics, for the entire political apparatus could function only if the leaders could predict the behavior of their subordinates. Brown shows the close resemblance between *ʔdāb* and *paideia*.[36] In the past the Moroccan *Maxen* could rely on specific

people and special relationships between them to carry out its policies; similarly, Muslim scholarship made the verification of the personal qualities of those who handed down knowledge an important aspect of truth. But the time is past when the models of comportment proposed by these systems can persist unchanged. While lineages of blood and learning have not disappeared, they must claim their legitimacy alongside new social relationships and new versions of individual excellence. These new excellencies concern power as well as style, authority as well as desire. The transformation of *ʔdāb* in all its modes can best be noted by studying some of the figures or words perceived as "dangerous" in Casablanca today. Are they menacing because they are unknown—like "boumbelkefti"?

In daily life as in political discourse, thorny issues are often pushed into the realm of the joke. Meanwhile, serious concerns are epitomized in the figure of the king himself, whose image is beyond laughter. Noting what this image can or cannot embrace is one way to follow the fine thread between the visible and the speakable.

Chapter Six

PORTRAITS AND POWERS

◆◆◆ In 1953 the sultan Mohammed V was deposed and exiled by the French. But during his absence his image remained. Some women say that they saw his face reflected on the moon; others saw the leader astride a white horse projected on the celestial screen. Many men kept their leader present by cherishing photos of him in their wallets; thus, his image often rubbed shoulders with another image banned by the Protectorate, that of Egypt's Nasser. During the Protectorate the monarch's claim to political and spiritual power continued to be expressed verbally through references to the historic role of the Commander of the Faithful (*Amir el mou'minin*). But with the advent of photography and cinema, Moroccans could know, for the first time, the precise personal features of their monarch. When Mohammed V returned to Morocco on 18 November 1955, an enormous crowd greeted his procession. Today film of this event is periodically rebroadcast to remind people of the role played by the Alawite monarchy in the reinstatement of Moroccan sovereignty.

Portraits of the Alawite sultans existed before the arrival of the French, but only after independence and the development of the press did people become familiar with them. The monarch's face first appeared on coins and bills at that time; plaster busts or photographs of Mohammed V and then Hassan II became mandatory in public places. Visual illustrations of power paralleled the importance of the word, written or recited, of early periods.

In ordinary conversation the king is often referred to as *sidna* (literally "our lord"), *sa majesté*, or simply *huwa*, "he," the third-person masculine singular. This latter usage makes him in a sense any man, and in another *the* man.[1] The particular and the general, the

humble and the powerful, meet in this utterance. A journalist complaining about the rising price of milk does not invoke the name of the person responsible for government policies; instead, he speaks only of an anonymous *he*. But who is this *he*?[2] Obviously, it is the king, and the journalist uses *huwa* because any critique of the royal person must be indirect.

We might see all such unattributed *huwas* as allusions to the nation's leader, but in fact Moroccans use this word to refer to any figure of authority, secular or religious, wealthy or influential. The *he* does not name; rather, it designates a reluctance to name directly. Nevertheless, one may cite "his" acts or words, even when the person himself remains anonymous. Through an abstract appellation the person remains multifarious and distant, associated with infinities.

The third-person masculine singular is used to refer to authority figures and unequal power relationships. By contrast, *she* is excluded; and, just as women cannot be included in this reference to indeterminate power, so too *he* is neither a young, unmarried man nor a non-Muslim. There are multitudes of portraits, photographs, and films of the king, but none departs from a central reference to a singular man, to the aspects of "him" that represent the density of references to *huwa*.

A clue to the historical depth of the refusal to name authority figures may be found in traditional Muslim biography and history. These texts grant the authoritative third-person singular only to selected persons, and then only in selected matters; indeed, most of the persons discussed are either rulers or the scholars who recorded their deeds. This tradition leaves little place for dialogue or self-portraits of the kind now current in historical and biographical accounts in Morocco and elsewhere. These *hes* are named, but much about their lives remains unmentionable: detailed accounts of their emotions, the women in their lives, or the opinions of their contemporaries do not figure in these biographies.[3] A man is said to have been honorable, clever, or ambitious, but one gets little sense of how he actually lived, with whom he spent his afternoons, or what motivated him to become a judge or a scribe. Contemporary photographs, portraits, and narratives, with their wealth of minute detail, differ greatly from former representational practices.[4]

Now novels dwell on psychological particulars, and we learn even the specifics of characters' family lives, psychological difficulties, and

financial hardships. Historians in Morocco dwell more on the *longue durée* of agrarian practices or structures of power than on the moral attributes of leaders.[5] However, when speaking of those in power, people refer to impersonal *he*s in much the same fashion of earlier historical and biographical genres. Does power continue to be experienced in ways that validate the abstract, patriarchal, and moral claims of narrative conventions generally deemed outdated?

In everyday life many people experience power through the actions of some male figure. They also often identify their own means of expressing power through male figures—husbands, fathers, bosses, or national political or religious figures. When *he* acts as a figure of authority or power, *he* is not simply a self, in the sense of the psychological person portrayed in novels or soap operas. When people use *he* to name power, there is no sense of a dialogue that brings "me" to address "you." Instead, they refer to impersonal qualities tied to specific social positions generally associated with law, religion, virility, and physical might.

The law demonstrates masculine power and responsibility by keeping women subordinate to men and making men accountable for their wives' and children's food and lodging. Moroccan law interprets Islamic law as permitting Muslim men to marry "women of the book" (a category that includes Christians and Jews), whereas Muslim women are prohibited from marrying non-Muslims. Women and minors are often portrayed as needing protection, which is, of course, provided by men.[6] *He*—the husband and father—ensures social order through his position as head of household and controller of women and youths. Sometimes this power can benefit the less powerful. In a recent interview the journalist Khenatha Bennouna explained how she evaded an early marriage—her family's wish—through the intervention of a famous nationalist leader.

> I passed my days ruining my eyes reading books instead of taking part in healthy feminine occupations! What a disappointment it was for them when I told them I had other projects in mind. My maternal uncle, Si Larbi Idrissi, who was a historical figure of the resistance and very influential in Fez, could not understand how I could stand up to him, he who had resisted the French army for a month in Fez in 1944, who had been tortured without any results, and who had given all of his land and all of my mother's to the army of national liberation. Using his unlimited moral authority, he did everything to get me

to change my mind and to accept the "future plans" set up by my parents. Finally they decided to ask the opinion of Sidi Allal Al Fasi, who was a spiritual adviser for our family. After having "tried me out," he told my uncle and my father, "If you have another daughter, get her married. This one here, I'm adopting. Morocco needs her."[7]

Many older women who had the opportunity to attend school attribute their good luck to their father's love or farsightedness. References to an unnamed *he* are not always linked to the details of faces in photographs or to unique individuals of the sort portrayed in soap operas. Principles of power and privilege are not abolished by rendering those who can embody them as understanding toward others. Yet representations are perhaps not simply "appearances," and changing relationships between "he" and others are significant.

The entanglement of word and image opens new vistas for the illustration of personal traits. When we see pictures of the king throughout the city, his name is echoed and reechoed through their repetition. These visual refractions appear more varied in expression than naming. Photos show the monarch conducting all of the mundane actions of life: drinking tea, purchasing bread, praying. But he also meets important heads of state, appears on royal steeds, smiles beside his newlywed daughter. *He* implies multiplicity; *he* is not pinned to a single name. Images bear witness to important events: he met Margaret Thatcher, dined with some other head of state. Like biographies, photographs themselves observe, projecting the minutest traits of face or manner. Their determinacy and regularity—the way in which they pose all their subjects in a uniform space and time—seem to diminish the mystery and awe inspired by *him*.

If *he* remains fearsome and unmentionable, it is perhaps because images are not the sole means of manifesting power. Yet images influence how we use words and structure actions. Images have implications for political strategies: in an international situation in which images play an important role, funding for armies or for economic aid is not distinct from the leader's ability to mold an appropriate persona. The image of the Moroccan monarch is required in each public building—no trivial detail.

The screen of the "cyclopes" machine presents each image as one among a sequence. Claims to truth are based on the camera's ability to take myriad pictures that appear to demonstrate power's ubiquity.

Yet, unlike the endlessly reverberating *he*, images need repeating. An endless sea of images is called on to cancel the impression of finitude implicit in any one photograph. While the photographer's aim might be controlled, nothing in the logic of any particular image gives it precedence over other pictures. The multiplication of images in the urban landscape comes to include not simply *he* but *she* and even *it* and *they*.

> When I enter a grocery store in Casablanca, I am greeted by a soccer team, Egyptian and French actresses, a snapshot of the family of the shop owner. Amid these assorted portraits it is difficult to see how anyone might come to upstage the others. In some homes walls are left barren save for the portraits of authoritative fathers or the king. But in public places we notice the figure of Hassan II placed beside photos of Sylvester Stallone or Madonna.

While the word *huwa* can encompass all that is associated with authority and right while simultaneously denoting a single individual, photographs offer the particular, a record of unique times and places tying them to sentiment and personal narratives. Through photographs or films we cherish memories of moments past; the idiosyncrasies of a face are captured, imprisoned by those who spin off their own memories or dreams around them. Pictures show and call on other pictures or stories in our minds. We remain tied to notions of time and space in a way incommensurate with the divine, infinite echo of *huwa*. The prayer can be called out in the name of a sovereign, which associates his name with Allah. But what mechanical god do photographs invoke? What personal narrative joins pictures of power to sentimental reminiscence?

Photographs, films, and other images engage people in national or international conversations. They also simply keep them at home in front of their television sets. However, once people are set in front of still or moving pictures, even when the content is apparently controlled, the effect of imagery on daily life remains unpredictable. Some journalists in Morocco explained to me that certain televised images could engender upheaval "among the uneducated" or fire fundamentalist propaganda; others welcome these images as signifying liberty. As elsewhere, people in Casablanca have different reactions to any given story or image. But does not the very form of the mass media, the way in which they place each subject under a unique

light, alter people's conceptions of their sense of place and of power? When so many images propose diverse models of behavior set in the fixed frame of the television or photograph, can *his* image remain different from the others?

The crowd of images offered on television, in magazines, at the cinema, or in the street seem to give no *logical* precedence to the staging of such moments. When we see powerful men on television or in newspaper photographs, the degree of their authority or power is visible only because of their numbers and the paucity of women and young people. We are mainly aware that they belong to a common world of media-generated pictures. They are elsewhere. How can elsewheres be brought close enough to our own experience that we may judge it? The narratives that we bring to these pictures extricate them from the routine world of photographs.

The photographic eye desacralizes authority at the same time that it gives it a more central role on the international stage. The assimilation of *his* image with those of other persons includes the photographic records of details of comportment that are not included in the image of a serious, willful, and powerful *him*. The person who emerges through pictures is distant but may seem close to us if we come to understand him through stories. One might use a picture of a father or a political leader as a reminder of authority, for example, by giving *him* a spacious wall of his own in the living room. Yet, although space can be manipulated to demonstrate the centrality of certain powerful figures, they become increasingly ordinary. The hierarchy of images becomes a matter of measuring how much time or space a particular picture or figure may command. But this is no real hierarchy of authority, just a juxtaposition of different particulars, the goal of their intermingling left unresolved.

The image of the central male is taken as paradigmatic by those who seek to establish their own claims to authority and power. Some of the "scientific" and "nationalist" discourses mentioned in previous chapters have come to serve this end. The Moroccan feminist Fatima Mernissi categorizes this type of discourse as "terrorist."

> His terrorist tactics can be expressed in two sentences: firstly, "What you are talking about is an imported idea" (referring to access to the cultural heritage); secondly, "What you're talking about is not representative" (referring to access to science). What is the meaning of

these two sentences so often thrown at any Moroccan citizen, male or female, who puts forward any idea which appears to upset the established order?

The first phrase implies that the person speaking sets himself up as the guardian and legitimate and exclusive interpreter of the cultural heritage and its content, and excludes *you* from access to this national heritage. Not only does he ban your access to it, but he accuses you of the worst crime in his book—treason to the national cause. You are an agent of foreign enemies.

The second phrase—"What you're talking about is not representative"—refers to science, but the mechanism and the implications are the same. The person speaking sets himself up as the general guardian of scientific truth, and it is in the name of scientific truth (confused by him with representativeness) that he intimates that you should hold your tongue.[8]

The perceived danger posed by those who cannot talk, because of their ignorance or apparent lack of nationalist sentiment, is heightened by changes in the educational system, changes that allow women to gain scientific knowledge by sitting next to unknown men in university classrooms. Modern knowledge is expressly apersonal and apparently asexual, and despite obstacles to employment or recognition, women are extending their public appearances. Some men react to women's increasing power in the public realm by violently lashing out at anyone or anything that might point out the fragility of men's positions and "traditional" social order. To assert himself, the "terrorist" must build a larger house, express himself more loudly, and honk the horn of his car with more conviction if he is to exert the prerogative that he feels is his. Not all men and women accept any one man's claim to associate his person with a transcendent male authority. The ambivalence toward this kind of masculine discipline is perhaps clearest among the young.

The very idea of the adolescent or teenager has appeared in Morocco just at the time when the main signs of adulthood, marriage and employment, have become more difficult to acquire. Young men especially are touched by these changes, since they are expected to acquire the capital necessary to start a household. Seen in isolation, these issues apparently concern only women and youths. But seen through the lens of the camera, or measured by standards of social visibility, these figures evoke issues that transcend their own experi-

ences. Their visibility indicates new relations of seeing, showing how notions of femininity and masculinity, of love and family, and of authority itself are reworked, if not utterly changed, by the involvement of life in the image. This rearrangement of visibility requires new individual choices and consequently a heightened sense of how appearance and self must be created. Even those who might wish to reiterate the patterns of power represented by *him* are forced to come to terms with these choices.

In forming a self-image, an individual must be able to partake in or create social relations that affirm his or her ideals and desires. Part of the challenge of creating new visibilities is to elaborate narratives that associate images of formerly "hidden" people, or aspects of people, with valued qualities. Individuals can broaden their self-images if they have access to many currents of knowledge and to various versions of correct comportment. Yet, as Aihwa Ong's study of Malaysian factory women shows, those who are offered mainly negative stories of self may find the creation of new narratives quite arduous. In recent decades Malaysia, like Morocco, has witnessed an "explosion of sexual discourses . . . produced out of conflicting modes of control exercised by dominant groups deeply ambivalent about social change in Malay society."[9]

In Morocco the modes of control cannot be understood simply by identifying dominant groups. The many available logics—the cult of the dominant male, the procedures of bureaucracy, the claims of scientific knowledge, and the silent meaning of images—may conflict with or complement one another at various moments or places. A sociological consideration of domination is necessary but not sufficient to explain the ways in which these logics intertwine. The moral heuristics that Touria uses to block a kiss from her vision demonstrates the strength of her narrative. Fatima Zohra tells me about how her mother tries to make sense of even the most incomprehensible, impersonal images:

> My mother speaks only Berber. She loves television. She hardly understands anything that's said, but she invents her own stories to go along with the pictures. Sometimes we talk about a program we've watched together. It's amazing how different her version sometimes is! What was most amazing was the way she talked about a scientific program on AIDS on TV 5. There were all kinds of little colored balls representing viruses or blood cells. Little arrows gave information about the

infection and all. My mother watched the whole thing, fascinated. What did she think about it? I don't know, but she seemed to be happy enough with her own stories to watch it.

These personal narratives are not mere products of ignorance. When I asked a large family to identify pictures of famous people in a local paper, the stories they were able to tell me about each of them varied considerably from person to person. Everyone recognized and told stories about Mohammed V and Marilyn Monroe, but only the older women recognized Nehru or had clear ideas about Nasser. One older woman used the pictures to bring up her own stories about the independence movement. Younger women were familiar with these stories, but they did not relate them to non-Moroccan leaders who had also fought for their countries' independence. The portraits proved a lesson in history for the children and in contemporary film and music for the mother. Would the lessons learned from others in the family be remembered, or is the weight of one's own involvement with images and stories heavier than any lessons from the past?

The hierarchy of images—and, likewise, the extraction of *him* from the sea of images—depends on a personal and collective narrative that leads people to interpret *his* image in a specific way. Given this dependence, we must examine the dynamics of the family to understand why some narratives develop rather than others. Although the city's workplaces, parks, and other public areas have become increasingly anonymous, people return home in the evening and watch television or relax with their families. Even young married couples who have been lucky enough to find a place to live visit family members or close friends in the evening. The family milieu continues to be basic to social identity. It is also the most intense arena of social interaction. Important decisions about whether and where one will study or whom one will marry are family matters as much as individual ones. While styles of interchange among different families vary, nearly everyone sees the links between parents and children as of the utmost importance.[10]

Yet many youths see their families as asking them to fulfill impossible roles. Some say that families give little room for individualism, not permitting the children to mix and match styles of living or dressing. It is common to hear youths explain that they would *like* to do something: go dancing in nightclubs, take a trip with their friends,

or study abroad. But they complain that their parents want them to stay home in the evening with their brothers and sisters, go on vacation with an aunt or uncle, or study in Morocco. Parents' expectations are undesirable, they say, or even unrealistic. Such complaints are common whether the parents are older or younger, wealthy or poor, well educated or ill educated.

Perhaps all young people regard their parents' pressures as obligations. Families do have (different) expectations and hopes about their children's marriages, work, residence, and habits, and most children are willing at least to try to fulfill some of those expectations. But young Casablancans find it increasingly difficult to fulfill many of these expectations, whether "fundamental" (for instance, that they marry and raise families) or "modern" (that they receive a college education and get good jobs). Even if a youth has a diploma, high unemployment makes it difficult to find work. Once one gets a job, housing is hard to find, and expensive if one does find it. Getting married is also difficult. As the period of "youth" or "adolescence" is extended, a generation gap develops. Some parents strictly refuse to admit change; others, by contrast, are open to nearly anything their children may choose to do. Still others find their children becoming vigilant about their elders' "bad habits," criticizing them for not conforming to "Islamic" precepts. Very few hard and fast rules are followed universally. In the street or in the park, young men and women walk, laugh, and drink coffee together, taking in the passing scene as they themselves become a part of it. In such places, away from families or neighbors, they can freely meet their friends.

Many youths speak about liberty as the alternative to their predicaments, yet the concept is only loosely defined. "Tradition," "family pressures," and "political repression" are all indicted for keeping people from becoming free, but the nature of freedom remains ambiguous. Many young people emphasize that while they seek to be able to choose, they do not want "total" freedom. When youths speak of individualistic acts, they talk of "letting oneself go," of being "free." The same language applies to behaviors that explicitly contradict "outdated" norms, especially those involving open relations between men and women. Many boys and girls complain about their parents' prohibitions on dating, for example, yet they also note that extreme liberty or passion may well be undesirable. Perhaps they complain about their parents' expectations to deflect some of their own worries

and fears. What might happen if one were suddenly freed from real
or imagined family constraints?

Rita told me about her friend Najat, who became involved with a
young man, married him, and divorced only a couple of months later.

> They met in a discotheque. He was handsome, young, and a good
> dancer. Najat could think only of him. He wasn't from her kind of
> family; you've seen her house, she's quite well off. Anyway, in spite of
> this she was mad about him. I think too that she just wanted to know
> how it was, you know, how it is to have physical love. She was really
> crazy, that was all she could think about. Don't you remember how
> she asked you all of those questions about it? She was overcome by
> this curiosity and passion.
>
> So they got married. The wedding was a big deal since she's the
> only daughter in the family. After the wedding she never came to see
> us anymore. She abandoned her girlfriends, like so many girls who get
> married. She only had eyes for her husband, at least for a couple of
> months. Once she saw that their physical love wasn't enough, she
> started to notice how alone she was. He had very little money. They
> had to try to live on two thousand dirhams a month in a little apart-
> ment in Aïn Chok. For a girl like her this was terrible. Once she came
> to know what he was really like, they fought all of the time. She
> wanted to return to her mother. Her mother, a widow, told her that
> she should get a divorce if she wasn't happy with her husband. Every-
> one thought they'd gone too quickly. We weren't surprised. We all
> thought that it was better to be alone than to remain married to some-
> one you couldn't get on with. So now Najat is back at home. We see
> less of each other these days, but I think she made the right decision
> to return to her mother. It was crazy to get married so quickly.

Rita would like to marry, but she is wary. She wants a prospective
husband to be reasonably well off. She also expects him to love her,
but maybe not in the way her friend conceived of love. For her the
best guarantee of a good marriage is reason ($^c aql$), not passion. A
moderate man is what she wants, she says: someone who drinks, but
not too much; someone who knows how to have a good time without
spending all of his time in nightclubs or bars; someone who will
provide for her and the family. But Rita thinks it's hard to find such
a man. How could Najat have expected her husband to provide both
passion and all of the other things necessary in a marriage?

In love as in other temptations, excess is to be avoided. Many boys
as well as girls explain that a good person is hardworking, moderate.

To "let go" is to risk losing one's reason, being exposed to some unknown force that may destroy all of the protection of one's family, wealth, and education. And if one has no such protection, letting go may mean losing the chance to improve one's lot.

As in marriage, prudence is also encouraged in work. When Jamila quit a good position as an accountant at a large company to start her own business, her colleagues were concerned, even outraged.

> You know, they really think that if someone has a taste for taking risks, they're nuts. I know that the economy is bad and all of that, but I just can't take sitting behind that desk anymore. I have to try to do something on my own. All of the other employees come and tell me how I have a good salary, a stable job, good benefits. Why shouldn't I spend my entire life at the company? Most of the others will. I just can't imagine it, and I guess that this is why everyone thinks I'm crazy. They just can't imagine being open to luck or misfortune, since they see so many people out of work. Well, I've never followed the crowd.

The fear of transgressing boundaries is thus not confined simply to relations between men and women; economic and intellectual matters of all sorts are transformed into problems of judgment that resonate in the highest emotional registers. Fear of exceeding some unwritten limit is apparent in all matters of life—love, work, informal talk, intellectual expression. Such fears are exacerbated by the precariousness of the Moroccan economy, which has dimmed many people's hopes of upward mobility. People fear that they may lose even what they have, and many avoid complete involvement in any single project, "hedging their bets" in the event that it does not work out.[11]

Nearly everyone has a story about people who could not "manage" their freedom and "let themselves go" through vice: drugs, alcohol, prostitution, or simply hanging around with the wrong crowd. Ira Lapidus comments that Muslims influenced by Sufi strains of piety associate lack of self-control with disbelief; an *outer*, apparent lack of control reveals some inner weakness—arrogance, ignorance, a disposition to evil. Harmony is the key concept, with reason situated between two extremes. One uses reason ($^c aql$) to achieve harmony between the self and the world by restricting one's drives in a disciplined life.[12] But what pattern of disciplined life can make sense to young Moroccans? Part of the challenge of daily existence is simply making an orderly and meaningful collage of the wealth of available images and stories.

Many people I spoke with in Casablanca expressed ambivalence about the patterns of life available to them. Often they present their choices as dualistic or simply illusory. Some people manage to lead lives composed of two or even three layers, deftly sealing friends, families, and lovers into separate compartments. The balancing of inner and outer, self and world, becomes a problem of arranging one's life to keep these worlds separate. But the walls between these worlds often seem fragile, ripe for collapse. How can one "keep face" across so many diverse situations?

Jamila goes to meet her boyfriend, but she tells her parents that she is seeing a girlfriend or has a lot of work to do. Mariam takes evening classes as a way to meet her friend, Ahmed. Words for one context, such as the family, cannot describe the lived reality of another. Just as an illiterate mother can be threatened when her children speak about her in French, so too might she be upset by hearing of her children's meetings and discussions with friends—or at least this is how the children feel. (In fact, many parents are perhaps not as opposed to discussion as their children think they are, but a sense of propriety keeps parents and children alike from acknowledging certain issues in front of the other. This is especially true of problems dealing with sexuality and the observance of religious precepts.)

A similar approach can provide answers for those who feel that their conflicts lie within themselves. One young hard-rock enthusiast explained to me that although she loved to dance and was familiar with all of the latest music from Europe and America, she would never do anything that would "disappoint her father." She repeated this sentence to me several times for emphasis, apparently hoping to convince me that her musical taste did not contradict her respect for her father's wishes. As her comment indicates, she saw a relationship between her favorite music and sexuality, but she seemed unsure how to talk about it. She indicated that she "knew" about sexuality and about the foreign world where the music she likes is produced. Her travel experiences and her mastery of English had, she insisted, put her in a position to know how to judge Moroccan and European ways of life. She told me that she didn't like France very well because the French, in contrast to Americans, "lack family feeling. The children seem to have no respect for their parents. I think that we Moroccans, as Muslims, have this. It is very important to keep this respect and," she repeated, "not

anger our fathers. We must keep our traditions." Many young people
in Casablanca praise those who seem able to follow modern fashion
yet not "let go." In this case it is not sexuality that is dismissed; rather,
one tries to show respect by ceasing to discuss such subjects when
parents, and especially fathers, are around.

He is not an appellation devoid of sentiment. Many people have
relationships with their fathers and other patriarchal authorities that
are similar to those that Paul Veyne describes as typical among a king's
subjects. They can either revolt or accept his rule, but they cannot
avoid referring to him as they construct their self-images.

> Suppose that he [an individual] is the "subject" of a king; in this case,
> he will not obey unconsciously, as animals seem to do: he will think
> something of his obedience and of his master, and also of himself as
> the docile or rebellious subject of his king. Therefore, an individual is
> not a beast in a flock; he is on the contrary a being who attaches a
> price to the image he has of himself. The concern with this image can
> push him to disobey, revolt, but it can also, and more often, push him
> to obey even more; from this perspective the individual is not at all
> opposed to society or the state.[13]

Self-respect tends to form a circular pattern. One obeys, trying to
respect that which one obeys in order to preserve one's own sense of
self. But what does one do if it is impossible to fulfill the father's
demands? Sometimes fathers themselves admit that they cannot guide
their children. Dale Eickelman, in his study of traditional education,
discusses an elderly scholar who sends his children to modern schools
rather than to the Muslim school in Marrakesh where he himself
studied.[14] Parents are perhaps not as out of touch with changes as
some young people's comments would lead us to believe. But they
have no easy answers to offer their children.

In Europe as in North Africa, the mass media, especially television,
have been seen as a part of a trend isolating people from one another,
and especially from the affairs of the community. Jean Baudrillard
points out the contradiction between the kind of passive identity
encouraged by television and the still normative European emphasis
on action, sacrifice, and efficiency. He argues that the system today
does not rely on repression or oppression; instead, its strategy is to get
the "liberated subject" to produce words. These words spew out

from all sides, but they are sterile because they have been emptied
of meaning. Baudrillard writes that

> [in] a system whose argument is between oppression and repression,
> strategic resistance is the liberating demand of the subject. But this
> reflects the anterior phase of the system, and even if we continue to
> confront it, it is no longer the strategic field; the argument of the sys-
> tem today is to maximize speech [*parole*] and the production of mean-
> ing. Thus, strategic resistance is to be found in a refusal of speech—or
> of a hyperconformist simulation of the system's mechanisms them-
> selves, which is another form of refusal and rejection.[15]

Have words ever been as filled with meaning as Baudrillard implies,
or is the reference to a concrete but fading possibility of using words
to liberate ourselves a last breath of romantic nostalgia? What if
people seek and create meaning as they are caught between appar-
ently warring systems of knowing? Following the density of images
through Casablanca, one understands the intuitive brilliance of Bau-
drillard's emphasis on the sheer weight, the exponential production,
of words and images. Can we simply cut off this Casablancan expe-
rience from that of Europe and speak of a system of meaning as though
it is the equivalent of geographical or cultural frontiers? Some images
are meaningful and related to the very construction of subjects and
objects, whereas others bear little significance. We need not express
relations as a simple oscillation between repression and liberation to
recognize this fact.

For many people I spoke with in Casablanca, images from afar help
support them in their quests to control themselves—indeed, to be-
come themselves. Pictures are not received as a simple flood; ordering
them and arranging them is a necessary step in understanding the
world. Nor are images seen as empty or meaningless. Many people say
that while words may cease to have some meanings, especially in
political rhetoric, they retain important relations with the things they
are supposed to represent. The concern is not that words are weight-
less but that their meaning is unclear. With respect to criticism of
authority, fear keeps people from expressing many of their ideas and
feelings. This fact alone shows that words remain important and
potentially dangerous. (Remember the example of how even nonsense
words can be a threat!)

Narratives that explain pictures take form under the weight of
prohibitions and ideals. Just as political and moral talk focuses on

those figures who are not *him*, so too does talk in homes make use of images on television to avoid directing gazes too intently on family members themselves. A boy tells me (in French—to achieve distance) that while he loves his girlfriend, *words* of love seem to burn his lips. The contrast between consuming and productive selves seems not to engender the guilt and contradiction that Baudrillard sees as pandemic in other contexts. Perhaps such problems do not exist here because the political question has been "solved" by the strategic location of people in front of televisions. Or perhaps the general lack of interest in political activity reflects not the social decay of "privatism" but the actual weakness of effective political opposition.

"Dangerous" images tend to be discussed more in moral than in political terms. As Touria has shown us, morality can be fetishized into discrete acts or objects, with danger represented as proximity with these objects. Yet in day-to-day life many Casablancans enthusiastically watch kisses on television, read magazines with pictures of movie stars in tight outfits, and buy clothes advertised in women's fashion magazines. Touria might find purity in avoiding these "dangerous" objects, but her sister-in-law seeks to incorporate the desirable aspects of these dangers into her daily life. Because she is modern (^c*sriyya*; the term also means "contemporary"), she says, she hopes not to avoid but to imitate the kinds of actions Touria finds so immoral. Of course, she says, "I cannot go beyond certain limits. I know for example that in Europe a girl can live with her boyfriend without getting married; here I can't sleep with a man before marriage. But does that mean that I shouldn't meet men or dress up? How else will I meet a husband I'd like? Anyway, my parents know that I can take care of myself, that I wouldn't do anything rash. They trust me." Leila's mother agrees with her. She hopes that her daughters will enjoy their youth, and she reminisces with visible pleasure about her own good luck as a young woman, when she married her kind and open-minded husband. He was, she says, so wonderful that "he took me to the cinema nearly every weekend!" Today she sees her daughters go to the movies with their friends, and since they are not married she tries to pay attention to their comings and goings. She says nothing when they come home late, but she explains to me that "in Morocco one has to be aware of what people say."

Jean Noël Ferrié and Saadia Radi consider the ways in which, despite the apparently strict rules for women in Muslim societies, there

is still room for individual decision. In particular, they look at the practice of *fātiHa* marriage among immigrants in Marseille to note how men and women can "live together" without loss of "face." They discuss a woman who, nearing thirty-five, seeks to marry and have a child quickly; she thus convinces her boyfriend to marry her in a *fātiHa* wedding. This ceremony was formerly recognized in Morocco, but it no longer has as any legal status there or in France; nevertheless, its religious connotations satisfy the young woman's family back home, since they are ignorant about French law concerning weddings. After a week of "marriage," though, the young woman discovers that her boyfriend is in fact already married under French law, and she asks him to leave. She is already pregnant, but her weeklong "marriage" ensures that her family will accept her baby as legitimate. By French law she is an unwed mother, but for her family she has saved face through an ephemeral and outdated marriage ritual. The authors conclude:

> In Muslim society private life generally takes place beneath the gaze of the other . . . or in the fear of this gaze. This attitude persists among immigrants (in France) as much because the Muslim commu-nity is recomposed as because immigrants continue to be set into the family network and relations network of the society from which they come. . . . Underneath the cover of the respect of norms of conduct, individuals can live their lives (more or less tranquilly). . . . The wrap-ping doesn't necessarily indicate the content: where one believes one is dealing with strict rules and stringent practices, perhaps it is help-ful for our understanding of others to look for behaviors based on propriety.[16]

People offer public faces behind which they can live what they sometimes call "their own lives," but in the public arena even the nature of the rules is constantly being challenged. Public debates are important not only for determining individual liberty but also for altering the gazes of others. Images and appearances are used to state things about oneself, true or false, temporary or long-lasting. They also display one's ideas about society in general and one's perception of one's own identity. Models of thought, action, and dignified behavior can spring from many sources, and the dynamic between ideal and real is enmeshed in ongoing social discussions about how and when people should look at one another. The social mask alters its expressions, and

the collective gaze sheds light on diverse aspects of personal experience according to time and place.

Social action does not simply pit constraint against freedom; rather, particular interpretations of "norms" in given settings interact with actions of individuals who can alter—sometimes dramatically— the ways in which rules are enacted. Change makes the simple handing down of bodily techniques and polite actions from parents to children insufficient to educate young people in appropriate behavior. This insufficiency is perhaps clearest in the case of families newly arrived from the countryside, whose children often present a savvy urban appearance quite different from that of their parents. But given the progress of relentless cycles of fashion in appearance, music, literature, and religious practice, even parents or elder siblings born and bred in cities seem out of date and out of touch with changing modes. The very idea of youth is often defined as a willingness to keep up with trends. If young people see their parents and older siblings as too old-fashioned, they will turn to images of women and young men offered by films, magazines, and television for models (although not absolute ones) of desirable or reprehensible comportment.

Models appear in images or stories, but it is unclear how one is to appropriate them for one's own use. A slender fashion model is chosen because she shows the lines of a dress without distracting the observer's attention with her own bulges or curves. Models of appearance or comportment may be adopted at the moment when the client actually buys the modeled dress and, glancing in the mirror, sees the fabric newly shaped around her own hips. The dress may fit, or she may feel it needs alterations to suit her figure. She may reject the dress, not because it is uncomely in itself but because she feels that it doesn't suit her. Sometimes she may notice that a dress that appeared quite plain on the skinny model assumes a softer, more appealing line when pressed against her fuller figure, or that its color brings out her own. The model may not be an ideal but a standard against which one can evaluate possible appearances.

New models are appearing, some representing the return to tradition exemplified by Touria, others representing the "modern style" of which Leila is an exemplar. Everyday discourse separates the two women, noting that Touria wears the *Hizāb*, a scarf that assigns her an Islamist identity. Yet both Leila and Touria are twenty-five, and

both are faced with the problem of how to appear in public settings. Both young women may ultimately lead fairly similar lives as mothers and wives, since neither of them has a profession. Nonetheless, their expectations even in the private world will be colored by their choice of different public images.

> Leila is pretty, and today she wears a hot-pink skirt and blouse and a black blazer to match her pumps and purse. Her pink lipstick is, as she says, "Not too strong: it's not becoming on young women." She smiles and sometimes giggles when men look at her or talk to her in the street. Her hair is shoulder length, and she likes to wear a black headband to reveal her small gold earrings glittering as she passes. We once went to the American consulate together, where a Marine on guard flirted with her, teasing her to get her address. She didn't give it to him, but she boasted to her family about his compliments when she returned home. One of her sisters exclaimed, half-laughing and half-serious, "Maybe he'll marry you! Why didn't you give him your address?" I asked whether Leila would be willing to go out with a non-Muslim. "Well, he might convert once he knew me. My family would accept that, but anyway, it's not serious!" Leila is, in fact, a serious girl, not given to loud speech or ostentatious display. While she is spirited and enjoys a good joke, she gives the impression of the respectable, "classically" attired French bourgeois style she admires. Like a French dame, she is careful not to draw too much attention to herself.[17]

Touria, by contrast, prefers to avoid all contact with men outside of the family. She wears stockings to cover her ankles, and she wears makeup only at home, for her husband. When she goes out, she dons a *zellāba* and covers her hair with a scarf; she looks at the sidewalk, not at people. Shy and reserved, she nevertheless has an active social life. She meets often with girlfriends who share her religious convictions. They sing, speak about all manner of subjects, and watch television. Although Touria disagrees with her family and her in-laws about religious matters, they respect her and turn to her husband for details about the Koran. As one aunt stated, "We all care about Islam, but I like to wear shorts in the summer since I don't believe that Islam is against it." Debate is often lively in their large and friendly household. Although Leila and her family are educated and can speak French, Touria and most of her friends are from less "bourgeois" backgrounds.

The links among appearance, belief, and action are not as straight-forward as the word *model* might lead us to think. By looking at how different models are appropriated or discussed, it is easier to under-stand why new dispositions of visibility raise moral problems for most people. People's choices about which aspects of available models they will incorporate in their own images tell us much about their social position, actual or desired.[18] The rules of Muslim behavior are di-versely interpreted by people of different regions and different social status; even within groups individual interpretations may vary. Once one understands local norms (and some norms are far from hazy), one can use them as a mask, transforming them into codes that may govern social behavior but do not organize one's own moral outlook.

How, amid this sea of images, do some images emerge as models for behavior and organizers of discourse? Answering this question is essential for understanding strategies of power and for devising one's own tactics to gain social recognition. To investigate this issue, I will turn to some of the models cited by Moroccans as guides to dress, behavior, and general lifestyle. I have specifically chosen models that cannot be incorporated into the authority of *huwa*: these "unserious" images are at once the most common in discourses and the most problematic.

Madonna

One of the most forceful influences at the end of the 1980s has been the figure of the American singer Madonna. Her name conjures up images of the Virgin Mother in Christian countries, but in Morocco her slightly sacrilegious persona is lost on most of her followers. When she sings "like a virgin, touched for the very first time," few Moroccans understand the words, nor do they seem to mind that it's only *like* a virgin. Madonna often appears in black underwear, reminiscent of pornographic photographs. On television or in videos most of her allusions appear to be sexual, and she often sings of the relationship between sex and money, as in "Material Girl." She refutes the qual-ities of womanly excellence as most of my interlocutors in Casablanca have explained them to me.

The dominant discourse in Morocco defines the ideal woman as reserved, demure—certainly not as brazen, openly erotic, or willing to sell herself for material goods. *Hšuma* (shame, reserve, reverence)

is a desirable trait in both women and men. Although *Hšuma* has been seen as the trait of the powerless, it suggests a sense of propriety: being sensitive to different social contexts, knowing one's particular place in each, and being able gracefully to judge the ways in which each circumstance indicates different frameworks of polite behavior. In short, *Hšuma* is not a set of rules but a willingness to subordinate oneself to a stereotyped ritual of social interaction. By contrast with this image of the woman, it is quite difficult to imagine Madonna deferring to anyone. Her figure represents egoism, or at least narcissism. She is the epitome of self-referentiality; her own body becomes an instrument in the fulfillment of her egocentrism.

Hšuma implies respectful, considerate, other-directed behavior. What this behavior *consists* of can change, but when one cries "*Hšuma!*" at someone, it usually means that that person has gone beyond the limits of propriety, forgetting others in their awkward or passionate quest to fulfill personal desires. For example, a mother scolds her child who has stolen cookies from a friend's cupboard by saying, "*Hšuma!*" When people see couples embracing too ardently in public, they cry, "*Hšuma!*" The term itself can be used differently in different situations, but it is always directed at behavior that forgets other people. Images of Madonna show her bent only on this type of individual satisfaction.

One might imagine that Madonna's brash, plastic figure would be little esteemed in Casablanca, where many of her admirers hold that women are weaker than men and that they should be interested primarily in the home or in feminine occupations like education. Yet those most captured by her image are neither educated women, who might select her as a symbol of strength or rebellion, nor boys and men, who might be attracted by her open sexuality. Instead, Madonna's most ardent admirers are usually young, middling girls whose prospects for marriage are of more interest to them than their careers. One could hardly conceive of a star less apt to meet these young women's ideals of ladylike behavior; her behavior differs vastly from the pretty, reserved demeanor of a girl like Leila, for example. Yet Madonna's picture surfaces everywhere.

Some young women actively cultivate a sort of cult around Madonna. When her face appears on television Leila yells out, "Oh! She's so beautiful!" In discotheques, health clubs, and other haunts

of middling or wealthy Moroccans, her songs are ubiquitous. In an aerobics class girls who are particularly supple or can dance well are complimented by their friends through comparison to the pop star: "She moves like Madonna," they say. I even had the dubious honor of being referred to as "like Madonna" by the children of friends, although all that we have in common is our gender and the color of our passports. The kids wanted to "play makeup" and transform me into a semblance of the "real thing" with red lipstick, plastic earrings, sunglasses, and other accoutrements. Soumaya, about twelve at the time, told me all about the singer, putting particular emphasis on the fact that she was of Italian origin but lived in America. She asked me whether my parents had always lived in America. The rags-to-riches story of immigrants appealed to her. Yes, she said, Madonna was beautiful. She wanted to grown up to be just like her! An older woman commented that she loved to dance at discotheques; nevertheless, she said, "I'd never want my daughter to be a singer. Here in Morocco there are just too many bad associations with that." Even those who have no interest in Madonna end up being influenced by the styles associated with the singer. While the singer's bleached hair is rarely imitated (at that time she herself seemed to imitate her patron saint, the eternal Marilyn), some groupies streak their locks in blond. Tight pants, miniskirts, black stockings, red-red lips, and other details that may or may not have originated with her are now connected with her persona.

In 1834 a visitor from the Middle East to France noted that "in Egypt dance is designed for women to stimulate desire, but in Paris, one doesn't sense the smell of adultery."[19] At first glance Madonna seems to correspond more to the notion of the Arab female dancer, associated with sexuality and often with prostitution, than to the apparently sexless ballet dancer. Her lyrics speak of sex and occasionally of love. But she also appears to walk onto the stage straight out of an aerobics class, more intent on demonstrating her muscles than actually seducing anyone. With her frequent changes of hair and costume, she seems more like a child playing roles than an adult woman inviting a sexual encounter. If she seeks anyone's pleasure, it is her own. Most of the young women I spoke with about Madonna saw her as beautiful, rarely noting that she might be sexually provocative or in any other way shameful. For some she represents just

another version of that well-known figure of sexual provocation, the Western woman, who, in the eyes of some people, is always shame-less.

Madonna's gestures and outfits were often perceived as somehow superficial, permissible in a star who, after all, lives in another uni-verse. In the sense that she does inhabit another world, she is similar to the traditional singer or dancer, who, by being assimilated to the world of the prostitute, is pushed out of the recognized world of good women. From the start those who play these roles are not expected to follow the path of the respectable homemaker. Yet for all her distance from the role of the good woman, Madonna still serves as a model. In this respect she differs from the Moroccan *šīxāt*, female singers and dancers, who are associated with licentiousness. Judging from the discussions I had with women, calling someone a *šīxāt* is an insult. Singers and other stars can afford to please themselves and no one else; Madonna thus offers an image of the "free" woman. Nev-ertheless, although many women may fantasize about being like her, few actually wish to play out these fantasies.

Madonna, like all stars, is associated above all with a universe that is "elsewhere"; she only secondarily evokes the kinds of sexual asso-ciations that appear obvious to those who easily understand the words of her songs. Instead of a model of sexual behavior, Madonna rep-resents the revolving door of fashion. Most of the avid Madonna fans I spoke with were middle-class teenage girls, born to civil servants, bankers, or teachers during the 1970s. Many of them spent a lot of time shopping, watching television serials, and seeing their friends at the beach. Often they had limited budgets, but most of their allow-ances or earnings went toward clothing, makeup, and other beauty products, since they lived with their parents. If they sometimes sought some kind of alternative feminine image in the star, it seemed that most of her appeal came from her obvious status as a "material girl" who could show them what to buy next.

Young Moroccan women who scrutinize Madonna seem more con-cerned about learning how to combine available elements in a ward-robe than about learning how to move once they are dressed. Nev-ertheless, some young women have accepted this provocative role and wear their "Madonna-wannabe" outfits in public. They seem to want to fit the part and can be seen displaying their legs at cafés or standing

very close to unfamiliar men. Some adopt exaggeratedly feminine voices: sometimes a high, Dolly Parton–like tone, sometimes a low-toned drawl. Older people or visitors to Casablanca sometimes express intense confusion while watching these young women, some of whom adopt extremely suggestive postures. Most of these young women seem to play with these gestures just as they play with fashion, using them as an approach to self-discovery in a way that many people see as a threat to public morality. This game can become scary to the girls themselves if they become too enmeshed in their play. Most of these girls are not prostitutes, but in the absence of other names for sexually aggressive feminine behavior, they are often labeled as such by passersby, most aggressively by men.

One might conclude that people follow fashion blindly, more because it is *la mode* than because they have a clear sense of how these modes relate to significant signals. Jeans, a miniskirt, a suit—all evoke a world that is part of the everyday. No one expresses the desire really to live like a movie star or rock singer, except as a dream. In talk of actual futures, the vocabulary of social mores takes precedence. However, all of these "elsewheres" are as important to daily life as are nightly dreams. By bringing visible elements of that never-never land into mundane settings, individuals can imagine themselves as part of the magic world of the stars. Just as a Walkman sets daily life to music, certain styles of dressing and walking transform everyday reality into an individual fantasy. Many young Moroccans, mimicking the dress or behavior of stars like Madonna, are engaging in play: an activity that may seem childish, undignified, from the perspective of the father, of *huwa*. Yet this play is quite serious, for it allows people to feel that they are indeed capable of creating their personal selves, of inventing new social rites in a world that is literally opening itself to view.

Social change has quickly altered appearances and practices, but words, and the social categories they designate, have changed more slowly. It becomes difficult to link thought and word, knowledge and right action. Many young men continue to consider women as less able than themselves, yet they often find themselves unemployed while their sisters work in offices or factories. A girl walking alone at night continues to bear the label of prostitute, whatever her real purpose for being out. Likewise, professions that are reputed to require a slackening of self-control—for example, the professions of the poet or

artist—are in some way suspect. Again, humor itself, if it touches on sacred subjects, is doubtful.

His image and ideas sum up the nation. As we have seen, various strategies frame and reframe the royal image for political events, yet some of the models for behavior and practice, for visibility, cannot be summed up in the image of the ruler. Can the kinds of behaviors played out on public streets continue to be dismissed as superficial, as invisible, because they are not easily designated? What new frameworks of judgment may develop to organize the relation of men and women, of the masculine and the feminine, in urban spaces?

Many different strategies evolve in this situation, but all imply new forms of social visibility for women in a culture where sight is as much related to fortune-telling and the evil eye as it is to clairvoyance.[20] New social figures become problematic—because they are personified in mass imagery or, more urgently, because they appear in public. Flirting boys and "loose," uncontrolled women transfix the public imagination. The accoutrements associated with these figures—lipstick, gold chains, expensive cars—are also valued by many people as emblems of social success. The fascination of these figures stems perhaps from the way in which they congregate in public areas of the city. They become targets for discussion about issues that come up each day for all Casablancans when they turn on their television, select their clothing, or worry about the future of their children. The pictures in the street are their children.

Boys and Girls

Recent debates concerning public flirting (*la drague*) illustrate the widespread anxiety over issues that juxtapose morality and visibility. One young writer commented: "The 'dragueurs' of today possess several methods to catch girls in their nets. Among these methods we find beautiful, luxurious cars, villas, and well-furnished apartments that will make more than one girl dream."[21] This argument was seconded by one young girl: "We no longer see the 'dragueur,' or at least the girl doesn't. She sees only the material things that he uses to attract women."

One recognizes the dragueur according to a procedure as stereotyped as the television's Hollywood sequences. A luxurious car is driven slowly, seductively, close to the sidewalk. By its prowling,

purring advertisement the young pedestrian knows to expect some remarks to be thrown out at her—and she must respond. A frown, a smile, an aggressive rebuttal, indifference—the woman's reaction is an index to her availability. In the evening during Ramadan, people of all ages stroll along the avenues in Casablanca and other Moroccan cities. One observes the ensuing spectacle at the same time that one becomes a part of it, but only certain people are susceptible to the flirters' magic.

> Dragueurs are people who are on the lookout for the weak sex all day long. They especially follow those who wear tight clothes.[22]

Some women who are susceptible to the dragueurs and their cars, villas, or Lacoste alligators are clearly visible. They wear revealing clothing, walk with a slightly exaggerated gait, thus advertising their willingness to play the game. One girl remarked, "Sometimes between the dragueur and the one being dragued there's not much of a difference. I'd even dare say that these two actions, active and passive, move in the same direction, the same way."[23] She added that some girls are secretly happy to hear the words of the dragueurs, and they express their gratitude with a smile or a look of encouragement. At the same time, the seducers are considered plausible enough to surprise unwary passersby. One young man offered "advice for girls": "Don't listen to their remarks. Don't look at their 'objects of attraction.' They can attract you to them, and once you've fallen into their net, it becomes difficult to get out of their vicious cycle."[24] No one ever identifies the end of this vicious circle: it remains unsaid. If Habiba can follow the plot of her film to the end without actually seeing the kiss, we too are expected to understand what awaits a girl who falls under the spell of a young man in possession of a magic charm.

The condemnations of this fetishization of luxury goods resemble arguments suggesting that the way to avoid televised love scenes is simply not to watch television: each argument recognizes the inherent attraction and consequent danger of the thing in question. Some propose that this censoring ought to be conducted by the "authorities," either by banning certain programs or by inhibiting draguing (in Arabic ṣiyyeḍ, "fishing, hunting"). Each of these procedures is employed, but few seem willing to rename the objects that cause problems. Does the difficulty arise precisely in the very figures and stereotypes used to identify people and things?

People can condemn, commend, or ignore the way in which flirting or television kisses demonstrate individual morals, but other arguments exist for those more attuned to ideological debate. Who is the actual author of these social forms, whether stereotyped interactions between the sexes or television news and soap operas? What agent is responsible for the existence of these forms of seeing? The debates about these matters reveal intense struggles for power, but the location of the battleground is unclear—or only too clear for those who posit an essentialist collective consciousness or exclusive morality founded in religion or race. We can decide that some agent exterior to Moroccan society has introduced this anxiety-provoking activity; but does a publicist or an author impose himself on the collectivity as the dragueur is assumed to do?

> The "drague" is a wave of madness originating in the West . . . that has unfortunately invaded nearly all countries toward the end of this century.[25]

But, with looks centered around objects and how they allow possession of others, sight does serve utilitarian purposes. In some situations the creation of a personal look may simply be amusing and playful; in Casablanca, though, the self-presentation based on television images and most vividly displayed in the drague is rarely idiosyncratic or "just for fun." Gilles Lipovetsky talks about the idea of creating an individualized "look":

> What is of value is the creation of a separate, creative personality and surprising images and no longer the perfection of a model. Linked to the success of psychologism, to increased desires for independence and self-expression, the "look" represents the theatrical and aesthetic face of a neo-narcissism that is allergic to imperatives and to homogeneous rules. On one hand Narcissus is searching for inner richness, authenticity, psychological intimacy, and on the other he tends to rehabilitate the spectacle of himself.[26]

Models drawn from international fashion are important in Morocco, but the copying is often a serious project, not a fun-filled exploration of one's psyche. Television also shows mix-and-match images, which suggest that a solid individual ego can be constructed simply by combining different ideas to create a self, much in the way that one chooses clothes or hairstyles.

As I have already noted, exhibitionism takes many forms in Casablanca, but the playfulness observed on TV 5 is rarely witnessed in the street. A "look" is created to show oneself as a virtuous, liberated, or powerful figure. The gaze is not free or playful; rather, it is intended to "catch" others, if simply to influence their ideas of what they ought to do. Instead of offering fresh fields for expression and new claims to freedom and dignity, the technic of visibility is apparently a matter of commerce and power. One of the problems posed by the new, public encounters between young men and women is the lack of adequate paradigms for flirting practices. In the past, openly seductive women in public places were prostitutes, and this idea continues to color many people's condemnation of those engaged in the drague. One woman in her mid-thirties explained that when she was in her teens,

> men in the street could be much more aggressive than they are now. They would try to touch women, and they seemed to think that any woman who appeared in a summer dress in the street was up for grabs. Among the younger boys now I've noticed a real change. They are sometimes aggressive, but they rarely touch women. Also, they seem to be learning to speak more softly and more nicely. I think that there are new mores developing about how boys and girls should meet. It certainly has changed quickly.

One might say that now not only girls but boys too are "up for grabs," at least judging from the attention many young men pay to their appearance. In the past women were exchanged between families or sold themselves in the streets; today, by contrast, men's and women's positions are becoming more and more alike.

Status is associated with conspicuous consumption in many places, but the codes of distinction are more or less stable depending on the continuity of moral and aesthetic ideals and practices. In Casablanca, where men's and women's roles and spaces have changed rapidly and where the "traditional" elite culture of older cities like Fes and Sale is losing its primacy, a rough social hierarchy is established by money. People are ranked according to the quality of their cars, jewels, and clothing. Yet the social hierarchy marked out by such objects is often fragile. Even many people who spend their savings on gold chains or fancy shoes complain that there is too much materialism in Casablanca. Some seek a less commercial society, while others simply

advocate a more reserved and distinguished display of wealth. Many people struggle to buoy their self-worth with the flotsam of social criteria washed from other shores or rising from their own pasts. Many Fasis, for example, claim that, while they now share the nation's wealth and commerce with other groups, their typical cuisine and "good taste" places them above others. This reaction can be characterized as urban or bourgeois, but only if these terms are detached from notions of economically determined social class. (Even poor Fasis make this kind of argument.) Berbers from the Sous aver that their recent commercial successes are linked to personal characteristics that they cultivate: sobriety, thrift, seriousness. The fact that some of the wealthier Soussis fill their palatial homes with gilded furniture and elaborate crystal objects seems not to belie this image of the hard-working and austere Berber. Together with these regional identities, identities based on political, religious, or other factors offer multiple sets of possible identities by which people may be classified.

Amid the bright lights of the modern city, it is the individual who picks and chooses among his or her pasts to decide how to act. Often people resent the more restrictive customs of their past—for example, expectations about marriage or personal behavior—while cherishing others. For example, Touria will not watch kisses, and she married a young militant Muslim who shared her stringent religious beliefs. However, neither the husband's poor ʿrubi family nor Touria's wealthy Fasi one appreciated the young couple's style of Islamic piety. While the two families came to accept one another, neither saw their children as following tradition.

While practices are directed by reference to varied sources, word-less debates are carried on between practices themselves. The national image, embodied in the king's photograph and official pronouncements, suggests a homogenization of "Moroccan" experience. Official speeches spin fantasies about norms for all Moroccans, but the limits of this ideal figure are only too apparent to those who are not central to it. Those whose existence is categorically denied by the central image, those who call for social diversity and social change, feel the strain between social practice and legitimate representations of the community.

This tension is also felt, if less keenly, among other groups, often because they continue to preserve a strong sense of their own exclusivity. Thus, for example, regional identities might have less im-

portance at work or school, but they persist as models of distinctiveness. The notion of a homogeneous social body is instinctively rejected in daily social interaction. "Ordinary people" often accuse Fasis of elitism, and Fasis in turn scorn the ᶜ*rubi* lack of taste. While these differences encourage a sense of social variety behind national identity, they do not answer questions of social judgment. No single group or model of excellence has established its predominance.

Cast into a dizzying plethora of seemingly ungrounded judgments and practices, people attempt to create hierarchies. Possessing valuable objects might reassure one of one's own worth. People arrange objects on their shelves or leave empty spaces for those they do not yet own. Each object might provoke a long tale of its acquisition and its relationship to its owner. One indicates personal power by associating oneself with precious objects. The dragueur has his car, his clothing, his body; in front of TV 5 one becomes associated with less tangible but no less real or less marketable objects. One can learn how to consume, learn how to create a personal self, by calling on religion, education, French television. But even those possessing an acute understanding of the new images are often at a loss for words. Throwing off the cloak of uncertain but persistent social norms might involve a total loss of one's bearings. Many people have already lost their sense of social balance, yet they do not necessarily have words to produce ideals of action more appropriate to their problems or their questions.

One result of this lack of words is a general lack of trust. There is always a lurking suspicion that the flirting boy doesn't really possess "his" car or "his" villa, that somehow these objects are stolen or borrowed.[27] The young protagonist in the film *Wechma* hides his fetishes in the hills, far from the avaricious and moralizing hand of his stepfather; but he possesses these objects only momentarily, and then the fetishes take on a life of their own and fail to help the boy construct a positive image of self. Objects come to represent hopes and fears, parts of oneself. When the various parts of one's own life and imagination are incoherent, things themselves appear mysterious and meaningful. Like dreamy stars on television or the clear laws of correct behavior traced in Islamic literature, objects can crystallize a search for guidance and self. While some people speak of struggling to come to terms with new objects, or talk of how they are torn between fragments of doctrines and discourses, others express strong, clear opinions about the "correct" positions of objects and people. The

television itself is an object of discussion and debate, as though its very plastic and metal and glass symbolize the dominant world order. In this case resistance to the television becomes a way of manifesting alternative social and political visions.

Methods of resisting modern techniques are often described as being grounded in traditional symbolic systems, which are in turn reputed to reveal breaks in the development of a unified capitalist worldview.[28] This theory, which contrasts oppression to resistance, has served many authors in their attempts to understand the effects of modernization and the influence of capitalist labor.[29] But neither the world system of global capitalism nor the traditional worldviews described by anthropologists can be observed. Indeed, the complexities of the Moroccan situation suggest that we cannot locate the potential for creative action and thought in alternate traditions. The problem of relating images and practices to ways of talking about them indicates not the persistence of mappable worldviews but rather the difficulty of creating and selecting among ideas and objects in today's varied and confusing situation.[30] In Morocco, resistance to worldwide systems of economic and cultural integration is neither consistent nor systematic, just as the oppressive forces themselves are neither traditional nor modern but a blend of both. And, indeed, it seems likely that Morocco's situation mirrors that of other societies.

Along Casa's wide boulevards on Monday morning, women and men rush to work in buses, on foot, or on motor scooters. Boys and girls flock to school, the girls in pink, white, or blue uniforms. While others are in the office, unemployed girls or students with flexible schedules stroll about. Football and flirting, Madonna and Prince provide food for discussion. Fouzia and Hakima discuss the athletes on the Moroccan soccer team: "No, we don't know much about the game really. We only watch the most important games. Our brothers are real fans, but we're mainly interested in knowing about the players." The girls do not comment on the athletic prowess of the various players; instead, they talk about the interviews they've seen on television or in magazines, about the players' personal lives. Good looks, they admit, are important for the players. But even more crucial to their judgment is the kind of family life the individual

player leads. Although the two friends often complain about the lack of "good" men (they are both single), both hope to marry, the sooner the better.

Most young unmarried women look forward to marriage. They dream about their future husbands and their wedding ceremonies. Young men speak less about the wedding ritual, but they too discuss the characteristics they hope to find in a spouse. A group of young male university students explained to me that, while they all see physical attractiveness as important, they prefer a "serious" girl, which for Hamid means "a girl who doesn't wear makeup, or only a little bit." Even these young men, who come from relatively similar social backgrounds, maintain different ideals concerning women's education and their role in the family and at work. Like most young women, all of the youths put the accent on honesty, beauty, and sometimes "the right family background." The qualities that both men and women express as desirable come quite close to what Fariba Adelkhah describes as the values of the *Hiẓāb* in Iran. There, she says, people contrast the qualities of those with *Hiẓāb*—gravity, chastity, modesty, and self-respect—to those without *Hiẓāb*. Those without *Hiẓāb* exhibit themselves, appear to lack any sense of social norms, to drift along without gravity. The woman who is without *Hiẓāb*, like one who has no shame (*Hṣuma*), is often perceived as a social threat. If Touria, who wears a *Hiẓāb*, fits this ideal, Leila can hardly be excluded, for on Casablanca's boulevards Leila's demure, "bourgeois" behavior is perhaps even less exhibitionist than Touria's blatant Islamic piety. What remains important is the expression of one's femininity or masculinity, the maintenance of social order between the sexes. This difference is judged to be natural, divine. Marriage is seen as the most desired and most natural and blessed relation between the sexes. But while people can usually describe the ideal spouse, finding her or him demands individual modes of action unknown to parents, and most certainly to grandparents.

While many members of the older generations accepted arranged marriages, most young people hope to meet a potential spouse on their own or through friends. The *ixwān* arrange marriages among themselves more often than through family networks, as was the norm in the recent past. As Leila has shown, many youths hope that the spark of love will be lit by vision. In the street, at a social event, or at a friend's

house, the boy is typically expected to "see" (preferably at first sight!) that a particular girl is the one of his dreams. She is and becomes his vision, and he hers. Sight must be acutely attentive, ready to exert itself at any moment to focus on a likely bride, and, most of all, able to recognize individual qualities and social status through appearances. If all goes well, if that first sight is confirmed by the subtle details, a wedding may follow. Now let us examine how sight continues to play new roles in the acting out and memory of this important ritual.

Chapter Seven

TAKE MY PICTURE!
Wedding Videos and Invisible Brides

 Zohra and Mariam smile as I sit down for tea.
"So you like to watch wedding tapes?" they ask. "Nadia told us that you like to see home videos."

"You should see the video from my wedding!" Zohra exclaims proudly.

She promptly puts it into the VCR as her sister says, "Turn it to when you come in," referring to the moment when the bride makes the first of her four entrances among her guests.

"Just a minute," says Zohra. "It will come."

Zohra starts the video at the beginning. We watch the guests arrive, all well dressed for this upper-class occasion and smiling at the camera placed next to the entrance of the huge tent set up in the bride's parents' backyard.

"There's your Uncle Mohammed and their son Tariq," Nadia observes. "Isn't he handsome?"

"Hey, there you are, Nadia!" the girls nearly scream. "Look, you had on your orange caftan that day. It's a good color for you."

"It really was a fancy wedding," remarks Nadia. "I had a good time. Look, there are my sisters too."

The first thing one notices in this wedding, as in most wedding videos, is the parade of sparkle and brilliance passing by the camera's lens. The women, dressed in dazzling silk or satin caftans, wearing gold belts and jewelry, their hair drawn back in a chignon or lavishly styled, could have stepped from a fashion magazine photo. Makeup and nail polish finish the picture, and we need stretch our imaginations only a little to catch a whiff of the mingling of many perfumes. The men are less colorful, dressed in suits and ties or in *zellāleb*. As with

many other weddings, a professional cameraman was hired for the occasion; indeed, some businesses specialize in wedding videos.

The camera catches the guests as they enter, then takes some shots of a band. The musicians, sitting at the side of the room, play softly at first. We hear a mixture of soft music, scattered conversation, random noise. As the guests sit down, we glimpse each group of guests. The girls watching the video discuss the qualities of those they know or inquire about those they don't. Nadia and Hakima keep mentioning one of the young men, who was killed in an automobile accident shortly after the wedding; through their comments the video becomes a postmortem tribute to him. They speak of his kindness, his intelligence, his recent marriage. They reflect on the uncertainty of destiny, referring to the young man's smiling image on the screen. When their mother enters, they tell her, "Come look, there's Abdelqader!"

"Oh, what a terrible thing!" She sighs. "He was such a nice boy."

The video brings back memories for everyone for a moment, and faces around the television appear sad or pensive: the death of this young man has evoked a sense of the finitude and fragility of life. Zohra's mother gazes at Abdelqader's image intently, as though his image has brought him back from the grave as a reminder of this and other profound issues.

We watch the wedding guests sit at long tables, drink tea, and eat pastries. Finally, the bride appears in the first of the four outfits that she will wear. The singing and clapping become deafening as she walks slowly toward her place next to her husband. She is surrounded by attendants who chant a traditional wedding song; these servants (*nqqāffāt*) are professionals who specialize in making up women for weddings and acting as their servants during them. The bride looks like a beautiful, glimmering doll. The weight of her jewels and the diadem she wears make it difficult for her to move. The camera zooms in on her face, glittering with rhinestones, a rainbow of colors. The entire room gazes only at her as she appears like a blinding beacon in her white and gold caftan. She slowly joins the groom at the top of a small stage, where the couple will preside over the festivities. She smiles, and we see her exchange happy looks with her new husband, then glance across the room at the guests. Her eye seems to catch that of one, then another, as the party continues.

People clap with the music and smile when the camera passes. One woman laughs and points straight at the camera as she tells her

friend sitting beside her to look toward it. Everyone seems to feel very comfortable with the camera, as though it were an old family friend. It seems to elicit only smiles and seductive glances. The guests look at the central stage where the new couple form the focus of the celebration. The camera moves about this stationary set until young women get up to dance, bringing movement to the spaces between the long tables where the guests are seated. They seem to pay no attention to the camera or to the many eyes turned toward them. Only later will their talents be scrutinized on home television sets.

While watching another wedding celebration with a different family, a young girl teases her older brother: "Look there's Najat dancing! Hey, Susan, Mohammed thinks she's the best dancer! He was in high school with her. He thinks she's beautiful!"

"No, I didn't say that!" her brother grumbles as he passes through the living room on his way out. "I just said that she dances well. She was also pretty stupid in school."

But his sister persists. "She's married to a doctor now. She couldn't have been that ugly."

"No, she wasn't ugly, just not my type. Anyway, doctors' wives have all of their time to take dancing lessons in the afternoon."

His sister seems to agree with this comment and even appears a little jealous of the other woman's good match. She herself is still only twenty-two, but she would like to get married as soon as possible. And of course, she says, "A doctor is a good husband, since he must be intelligent and understanding, not just rich."

We continue to watch the tape, and finally she herself appears. "There I am," she says. "I didn't look very good that day. You see, I had my period. There's the rest of the family, the girls and the boys. See my sister, she's dancing. She's the only one of us who's really good at dancing. I like to dance, but I'm shy and not good at it. See, all of the men are looking at Bouchra."

Men at weddings typically discuss the grace or figures of the girls who dance. Some girls hope that their performance will entice some nice man to take an interest in them. Many men, however, seem to be extremely critical in their comments, about both the dancing and even the whole wedding party.

While women see the festivities as a time to meet family, friends, and perhaps even young men of similar social background, men seem

to feel constrained at such parties. Yet some men do get up to dance and enjoy themselves. Sometimes men and women are separated even when both sexes are present at a single ceremony. At most of the weddings I've attended in Casablanca, however, men and women mingle, although women especially tend to seek one another's company at social gatherings. (Sometimes conversations are segregated by sex even though the space is not.) People usually dance either individually or in relatively large circles; however, some weddings mix in "rock" or "rai" music, and couples may then dance together.

As we watch all of these happenings on video, people comment on themselves and others and exchange biographical information about distant uncles and aunts. Often we skip ahead or rush back to see favorite scenes: the arrival of the bride, one's own image. The video brings back the memory of the event and the particularity of each wedding among other weddings. Young people talk about the video-tape with a mind to their own wedding, which they often describe. In response to a tape of a very elaborate, costly wedding, Mariam thinks aloud about her own wedding plans: "I wouldn't like anything that grandiose. I want a simple wedding. It's silly to spend that much money, even if you have it. I'm a simple person."

If television programming elevates the "nobody" to star status through elaborate attention to biographical detail, videos bring up the auto-biographical question directly. Hans-Dieter Rath remarks that

> the question "how have you become what you are today and would
> you do everything the same way a second time round?" has—since
> the mid-seventies—had a secure place in the entertainment and edu-
> cation and business of the mass-media: in documentary programmes,
> in interviews—in the most extreme form in "real life" psycho-trans-
> mission—most frequently in talk shows but often also in quiz and
> game-shows, public figures (as well as nobodies) are asked to give bio-
> graphical information or a detailed curriculum vitae.[1]

As mentioned above, television programs can offer occasions for people to discuss sensitive topics indirectly, by speaking about a character or a problem in a soap opera instead of referring directly to themselves. In home videos, by contrast, oneself and one's family appear on the screen as important characters. Television is usually the space of stars and faraway places, but the video camera presents us

with a cast of characters we can (and sometimes must) encounter in daily life. As we watch each other on tapes, we acquire a certain distance. When our own picture appears, we feel almost as though we were watching someone else. Discussions invariably turn to the relations between guests. The image's biographical importance, inherent in any video, is amplified in wedding videos since weddings are important turning points in people's lives.

At most weddings I've attended or observed in videos, guests readily celebrate along with the camera; indeed, the camera can become the main spectator. One young woman complained to me about her widowed aunt, who was dependent on her brother (the young woman's father) for support. The aunt borrowed a substantial sum from her brother to help pay for her daughter's wedding. On the day of the wedding the cousins all arrived and found to their surprise that the wedding was being videotaped.

> We were greeted at the door by two cameras, one for video, the other for photographs. Everything had been laid out for the cameras, so that good shots could be had of the guests and especially of the lavishly arranged refreshments. I really found it horrendous that this poor woman was spending such a lot of money on a single party. She has so very little, yet here she was hiring a professional video company to film the wedding.

Most Moroccan weddings feature video cameras and their lights; those who cannot afford a video camera will at least try to have someone take snapshots. The moment when pictures are taken with the bride and groom on their separate stage has become a standard part of the festivities; couples, families, and friends take their turn posing with the bridal couple. Even while watching videos, people sometimes take out photos of the occasion as well. The poses in the photographs make the festivities appear more formal: people tend to look right at a still camera, enhancing the solemnity of the affair. While videos seem to capture all of a party's tumultuous noise and laughter, photographs offer historic records and can be set on night tables or hung on walls as everyday reminders. While videos are usually viewed by groups, photographs are often contemplated in solitude. The video captures the social aspects of the affair as relations between families and friends are discussed. In talking about photographs, however, people often conjure up a sort of myth of origins: this is the moment

we were first together. A more sacred tone is apparent. Sometimes historical observations are made, but the stillness of the photographic image resuscitates memories less linked to linear biography than those elicited by video: "Look at my parents in this old photo. That was the day they were married. My mother was very beautiful, wasn't she? Look at how she was then, before she had all of us children." While the video seems to be concentrated on the festivities of the wedding, evoking ideas about other parties, photographs remain more personal and nostalgic. They point more to the revelry of the past than to the idea of future festivities.[2]

It is noteworthy that religious rituals are sometimes photographed but, from what I have seen, rarely videotaped. The video camera witnesses not the sacred but the festive. In most discussions of wedding videos, little mention of these other scenes is made; sometimes, though, someone will comment on the henna ceremony, which is restricted to women. This ceremony, like the larger party, is marked by relaxed sociability and joy. Women adorn the bride's hands and feet with henna, symbolic of the blood that should be spilled on the marriage's consummation. The video camera records the most social aspects of the marriage, with photographs supplying a more personal memory; the most sacred moments, however, remain hidden, undiscussed. Indeed, compared to other accounts of weddings in ethnographic accounts, those I have attended or discussed over videos in Casablanca appear to move toward greater visual and verbal protection of what is now generally considered a private matter: the consummation of the marriage. Rural weddings still follow the old custom of displaying a bloody rag to all of the guests, thus proving the virginity of the bride and saving the honor of her and her family. But most Casablancans now characterize this practice as barbarous, and one girl from Aïn Chok told me, "You know that in the country a lot of girls use chicken blood for the rag anyway." Urban families emphasize the bride's beauty and the sumptuous and graceful arrangement of the wedding, not the public spectacle of her hymenal blood.

If the video camera has become a means of inspecting oneself and others, it has also been accompanied by a growing sense of *Hsuma* in regard to the intimacy of the newlywed couple. This visual modesty may reflect new expectations for intimate exchange and self-fulfillment in marriage. This point merits more attention than I can give

it here, but it is important to mention that both women and men seem to desire a rich and very private relationship with their spouses.[3] This does not mean that all couples live out this ideal or that the nature of "private" issues is clear. Many people still view any contact between men and women as sexually charged, or at least ambiguous. This attitude makes it difficult for people to have friends of the opposite sex and even to acknowledge the kinds of friendly but nonsexual relations that do exist between men and women. The strongest friendships tend to be among people of the same sex, and as noted above, even mixed groups usually break into separate-sex conversations.

New curtains between the life of the couple and that of the extended family are accepted with ambivalence by parents and society at large.[4] Perhaps the new sense of privacy concerning the bride's virginity helps maintain honor by marking a realm beyond the reach of the image, outside any visual illustration for the society. Cameras may capture social relations and displays of beauty and wealth, but the most sensitive and intimate issues are kept increasingly hidden, protected from any clever trick of the camera, from portrayals of desire that might parody it.

Watching wedding videos or looking at wedding pictures nearly always brings observers to discuss their own weddings, past or planned. It is assumed in Morocco that everyone will, or at least should, marry. Being unable to wed and have a family is considered a great misfortune; as Vincent Crapanzano notes in his story of a man who was married not to a real woman but to the mythic demon Aicha Qandisha, the unfortunate groom "lived as dead."[5] Anxiety about marriage has perhaps increased in recent years with the steady rise in age at marriage. Along with the difficult economic situation, new notions of courtship and marriage have made young people more apprehensive. The difficulty of getting married might make it even more important to preserve images or mementos from weddings.

People seek to remember the wedding party in all of its detail so they may discuss it among themselves afterward. Even those who sit across the room from one another and exchange only a few words can later meet to chat about who was there, and what they said or did. Women especially indulge in this kind of talk. Men seem less willing to admit that they too enjoy family videos, but they still sit and watch them. At weddings the public and private meet in different fashion

than they do in the street. Usually family and friends come from more or less similar milieus, and seeing oneself in a wedding video helps solidify one's sense of belonging to that group. This sense of belonging may be intensified if the wedding party is distinguished, as in the case of the first video described here. Zohra's family is quite wealthy, and Nadia, of a more modest background, was clearly happy to see herself on television, participating in such a grand affair, associated with Zohra's family. In such gatherings, the hairs of distinction are more finely combed than they are in the street. One knows the kind of person who will likely attend, and, although comments about family origin are common, most judgmental talk is aimed at those of one's own age group—in a sense, at those with whom one is "competing" for recognition. While a mother points out the beauty of *her* daughters as compared to those of another older woman, her daughters make passing comments about older people and concentrate their attention on the details of dress and comportment of their peers.

> "There's Fatima-Zohra; she's got that Brazilian look, doesn't she? Oh, and here comes Fatna. She's such a snob. Look at how much jewelry she's got on! The way that she walks to make it move around!"

At one wedding I attended, the bride was less stuck in her place. She moved about, chatted with her guests, and even complained that her sister's suggestive dancing was "a bit much." Quarrels and differences are usually not openly mentioned at weddings. Watching videos, however, brings back the memory of the festivities without the corresponding constraints on expressing one's opinions. Viewers often debate styles of self-presentation, particularly those of the dancers. It is not uncommon to be told many stories about family arguments or continuing feuds. These subtexts are invisible to the camera, but the images preserved on film or videotape bring back old stories. Perhaps it is this implication of narratives beyond the square frame of the image that makes some people wary of it.

Invisible Brides

Some people do not want to videotape their weddings. Many people reject videotaping for economic reasons, but others, as in the two examples I discuss below, refuse the camera for ideological reasons. The first case concerns a Muslim sister who chose not to have a camera

because of religious beliefs: Islamic fundamentalists generally shun the use of images, particularly those of women.[6] The second wedding was photographed, but it was deliberately informal and definitely unconventional. The newlyweds said, "We've been going out for three years anyway; why bother to have such a big and expensive to-do?"

Mohammed, the groom in the first wedding, had seen his fiancée once before the wedding: when he met her in order to ask her to marry him. Thereafter the young woman visited his family regularly but met only the women. When her future mother-in-law asked her why, she replied simply that it is the law of Islam. Her prospective sisters-in-law found this attitude odd, but their brother had gone through periods when he refused to eat with them because, they say, he felt that they were too impure. The fiancée, Jamila, was understandably shy; as her new in-laws noted, "She's not one of us. Her family are ᶜ*rubi*, but that's not really the problem. Even they don't like the extremism of the *ixwān*. But what can we do?" One brother commented that he couldn't have strong feelings about his own brother's marriage since he hadn't even met his future wife. While such segregation was common in the "old days," he (in his thirties) had never "seen anything like it."

The wedding was held, as was the custom among all groups until recently, in separate shifts for men and women. In this case both ceremonies were held at the home of the groom, since the family is fairly well off and has their own house. (The bride is from a modest background.) On one evening the party for the men was held. It was remarked that there was no music, just recitations from the Koran. Very few people attended—only close family members.

I attended the women's party the following day. When I arrived, I greeted some of the male family members who had gathered outside to smoke. They were grumbling about the way the wedding was segregated. When I entered the women's area, they too were complaining. The bride's friends, all "sisters," sat in one corner while her family sat between them and the groom's family. The bride remained hidden, upstairs, as in all of the other weddings I had seen or attended. After a time I asked to meet her, and I was then escorted upstairs where she sat with her sister. I congratulated her on her marriage, but she looked tired and sad. As I went back down toward the living room, I noticed that there had been no effort to decorate the house or even the room. The "sisters" had started to beat drums and sing songs, their lyrics calling out to Allah. They encouraged everyone to sing and even

to dance, although they said that they themselves couldn't dance. Eventually some of the other women did dance, but they sat down quickly, saying that they just couldn't dance to the songs' rhythms. (I later learned that the groom had requested that his wife's party play only tapes of the Koran, but the women in his family had told him that if they couldn't play their own tapes they would put on no music at all.)

We listened to some popular Arabic songs on the cassette player, alternating these with the sisters' songs. When the bride entered, the usual wedding chants were performed, then some songs by the sisters. The bride then sat on a blanket spread for her next to the groom's sisters. Some of these were dressed in handsome caftans, but some of the cousins arrived in jeans. One girl began to speak loudly about discos and proclaimed that premarital sex should be accepted in Morocco.

The bride's family tried to explain to me that this was not a "normal" Moroccan wedding. Had I been to any others, they asked? One woman told me, "The *ixwān* are like the Iranians. They don't like to have fun, and they think that they alone know how to interpret the Koran. We Moroccans like to dance, sing, have a good time. Weddings are joyful and exciting."

When I complimented the groom's mother about how nice one of her daughters looked, she sighed, saying, "It's a pity that there's no one here to see her!" She added, "Some girls just have more luck than others." Her daughter was single, and in her beautiful satin gown she would have been lovely on a videotape that might have been seen by some nice young man. But there were no male eyes here, no cameras. The bride herself was invisible to the world of men, although after the marriage was consummated she would be allowed to see male family members. Her invisibility to the male world put her at ease, but most of the young women present had fewer opportunities to meet men, to dance and dress up, than they would have liked. They and their parents resented being drawn out beyond the eye of the camera and into a zone where only the sacred word would be allowed to echo. Their disappointment hung heavy on all of us, and they did not linger at the party.

The photo acts as a witness to events and to the past reality of people. Young women eager to be seen by men seek to have the video bear witness to their beauty; the *ixwān*, by contrast, consider Allah their witness.

Abderrahim and Latifa held a far different view of wedding fes-
tivities. They did not reject images outright, but they seemed less
eager for the witness of society or family than most of those I have seen
married. Their attitudes and actions were instead a confirmation that
they are their own witnesses to their acts; indeed, the sacred nature
of their union did not really depend on the celebration of marriage.[7]
Employees in the same company, they had recently moved to Ca-
sablanca and had in fact dated for three years and lived together briefly
before they actually married. As Latifa said, "It's just a formality."

Their wedding party was held in a working-class quarter of the city
at the home of the groom's family. A nice dinner was served to guests,
but there was only recorded music and no effort at ostentation. The
crowd was a mixture of men and women, family and friends; most were
dressed nicely but not luxuriously. The bride appeared in a single
red-and-gold gown and moved about freely, talking to her guests. Only
when a camera was taken out did the newlyweds move aside to have
pictures taken with friends and family members. The evening passed
pleasantly, as we talked, listened to music, or watched television.
Toward the end of the evening, however, some of the older women
complained that they hadn't been able to sing the traditional chant,
which usually accompanies the arrival of the bride with the *nqqāffāt*.
This chant gives everyone a chance to acclaim the bride, and this
collective enthusiasm was missed by some of Latifa's and Abderra-
him's family members. Latifa, however, was not at all anxious to have
them chant. As she changed out of her red caftan and into jeans and
a black leather jacket to go home, the older women began to sing
regardless of her feelings. She bolted for the door with her new
husband laughingly rushing after her. As they jogged to the car,
laughing hysterically, they appeared to be fleeing some verdict of the
elders.

Latifa's attitude brings to mind Peter Burke's remarks about how
ritual in Europe cannot be conceived in the same way as in some other
places:

Western Europeans (unlike the Tikopia or the Balinese, at least as
these people are described in the anthropological classics) sometimes
refuse to participate in rituals, sometimes perform them in an embar-
rassed or shamefaced way, and sometimes distance themselves from
rituals while enjoying them as a peculiar custom which impresses visi-
tors. Even if many people still take rituals seriously, even if television

has to some extent remystified authority, a detached, indeed dismissive attitude toward ritual has become firmly rooted in Western culture.[8]

This second wedding was not willfully "invisible" to cameras, and in fact Latifa conscientiously gave copies of photos of the occasion to each of her guests. Yet the handling of the feast—especially its conclusion—was as much a critique of the now-traditional Moroccan wedding as was the marriage of the Islamists. In each case unnecessary expense was eschewed. While both brides were nicely attired, they did not go through the Fasi ritual of changing their dresses several times throughout the evening. Nor was either of these parties ideal for guests who think of weddings as opportunities to meet potential mates. The kind of spectacle encouraged by cameras, lights, and large crowds of bejeweled guests appears to have become the ideal in Casablanca. Those who might build their memories on events other than the marriage ritual, or who reject the memory-evoking image altogether, offer a practical comment on marriage, spectacle, and relations between men and women.

These examples from Casablanca show that the meaning of the wedding ritual is perhaps not as unified as anthropologists sometimes assume. We must consider the extent to which people can participate in rituals that suggest power relations from the past or that point to an ideal world in which custom and authority would be differently attributed. Here individual choice determines the way in which the ritual will be performed: choice again joins personal as well as social and political concerns.

The new centrality of the image in Moroccan culture has altered the meanings created by people performing in spectacles of power or participating in private events. In both public and private realms we see not less personalism, not a more abstract or bureaucratic modernity, but an explosion of self-referential gazes, novel categories of judgment and distinction. Just as the French "pacified" Morocco by making it a uniform administrative territory, so any person seeking personal or political power today must "pacify" the image, learn to turn it in his or her direction. Such pacification means mastering both the image and the various discourses that extend beyond its edges. The weaving of the image into narratives of self is not a political statement in any narrow sense, but it is involved in a realignment of male/female relations and a more uniform understanding of space and time ac-

cording to modern ways of picturing knowledge. It is what surrounds an image that makes the image itself clear to us; it is through our narratives about time and place and affection that images become powerful elements in our lives. Power asserts this presence of images, but authority wins our respect and love for certain ways of telling stories about them.

DRAWING CONCLUSIONS

◆◆◆ Like heavenly bodies on an astrologer's chart, mass-produced images have brought a new cosmogony to Morocco, promising different futures. Understanding and knowing rely on ways of seeing and on the ways in which things seen shed light on the invisible or hidden. Their corollary forms of knowledge have placed these new images in frameworks that have rapidly affected societies across the globe.[1] Frames arrest motion, imprison experience; but they can also create spaces to depict utopian ideas.[2] Frames also distinguish between pictures and the scenes of action. Like appearances, pictures are often brushed aside as mere reflections of the world, not active constituents.

If we adopt this perspective, televised images and stories merely relay strategic information. Scenes projected from international conferences would be just veils hiding the true workings of power. Something deeper than appearances and sights would lie beneath arrangements of the visible, grounding their elusive effervescence.[3] But how one might separate the real from the imaginary, the substratum of the concrete from the serious world of social forces? Mass imagery is often understood according to how it might be used to illustrate power that resides elsewhere, in states, classes, or modes of production.

Images may be mere façades, but this does not mean that they are always shadows of more fundamental facts. In Casablanca pictures and sounds extend beyond their frames into the street, altering the ways in which we think about society. Social frames move between two types of infinities. The framework of the television opens out on an apparently boundless space that is both elsewhere and everywhere. The experiential space of the city moves out indefinitely toward the

countryside or the sea. Between the infinities promised by pictures and the ideas of a vast, unbounded space, modes of power can be characterized according to the frameworks by which they order sight. Michel Foucault, writing of disciplinary power, notes that "to be executed this power must give itself an instrument of a permanent, exhaustive, omnipresent surveillance, capable of rendering everything visible, on the condition that it rendered itself invisible. It must be like a gaze without a face that transforms the social body into a field of perception, thousands of eyes posted everywhere. . . ."[4] If people in Casablanca attempt to conceal things for protection or self-determination, this invisible power must lurk somewhere, most probably within themselves. Everyone partakes in the scenes and screens of power. Still, Foucault's definition of discipline seems not to apply to Morocco, for here it is absurd to say that there is a power "without a face."

In the past Moroccan sultans traveled continually around the country to demonstrate the continuity of power in the ritual of the *Harka*. Today the monarch's picture gazes down on everyone from the walls of cafés, offices, and homes. His image has become a *palpable* part of everyday life. The arrangement of the king's portraits is reminiscent of mosaics, found sometimes in old urban homes and modern palaces in Morocco, whose tiles trace stylized, unframed Koranic verses. Walls and doorways set arbitrary limits to the scrolling calligraphy, but there is no predetermined center. The book is echoed without being cited, and one can begin reading this profusion of script at any point. Mosaic patterns focus on the figure of the viewer. Allah remains unrepresentable, a presence behind the patterns without end.

Earthly power too may demonstrate its centrality through a similar patterning of multiple pictures. Today the king's myriad images seem intent on filling our gaze. As Barthes notes, "Photography is violent not because it shows violence, but because each time it forcefully fills sight, and in it nothing can be refused, nothing can be transformed."[5] The fullness of sight keeps us from noticing what cannot be included in the royal picture. Possible versions of power whirl about the city. But to what stories might they be linked?

The scrolling patterns of mosaic-filled walls do not circle around a central, framed motif, yet they do suggest both the historical depth of a specific artistic tradition and a sacred text that can be given voice. The experience of sight is related to the viewer's relationship

to the narratives of history and of the sacred text, even if the citations are only possible, not necessary.[6] Can multiple pictures of power offer such a framework, where the center ceases to shift according to the watcher?

In a discussion of Max Weber's concept of charisma, Clifford Geertz notes that Edward Shils emphasizes the relationship between the symbolic value of persons and their relation to the active centers of social order.

> Such centers, which have "nothing to do with geometry and little with geography," are essentially concentrated loci of serious acts; they consist in the point or points in a society where its leading ideas come together with its leading institutions to create an arena in which the events that most vitally affect its members' lives take place. It is involvement, even oppositional involvement, with such arenas and with the momentous events that occur in them that confers charisma. It is a sign, not of popular appeal or inventive craziness, but of being near the heart of things.[7]

With this definition of "serious acts" in mind, we perhaps need to remap Casablanca and other cities, for the leading "ideas" in Casablanca rarely meet with leading institutions. Knowledge and power do not necessarily walk hand in hand;[8] frameworks of knowing and decision making reach beyond the city and the nation. Narratives of science and of calligraphic art may be used in attempts to illustrate present powers, but they remain attached to claims to power that cannot be limited to any central, human figure. Dangerous persons or dangerous words often bear the mark of knowledge that cannot be assimilated to a central image. *He* defines serious acts rather than being defined by them; *he* appears like a black hole in space, absorbing meanings, not generating them. Discipline in this situation depends not on hiding but on blurring the precise features of power's face, the lineaments of truth, for the centripetal pull attracts words and pictures indiscriminately.

Remember the journalist's serious joke: "Words we do not understand are dangerous, Mr. Qador, dangerous." Danger cannot always be located in discrete objects or whispers. Words that appear "technically" neutral may refer to discourses that are implicitly critical, if only because they deny the possibility of sealing knowledge within the nation. Often the neutrality of words is reinforced by using them

without reference to their original contexts. In the Moroccan press Marx becomes a royalist or a Muslim, and we read about how *glasnost* can be applied to Moroccan problems.[9] Words become picturelike. Like diplomas from famous universities or clothes from top designers, fashionable words attest to one's familiarity with international trends: one can pull out a collection of them to dazzle visitors.

When the center consists of a collection of alternative pictures of power, it is difficult to associate these images with concrete social relationships and the differences of opinion or interest that constitute communities. In Morocco the multiplicity of the central image denies conflict because it refuses to select any of its many faces as the true one. This collection of pictures is incapable of constituting a "line," which in Goffman's language is "a pattern of verbal and non-verbal acts by which [a person] expresses his view of the situation and through this his evaluation of the participants, especially himself."[10] Collages of photographs suggest multiple "lines." Amid all of the pictures, perhaps *because* of all of the pictures, power remains invisible. Only the unseen narrator behind all of the pictures seems to hold the key to meaning. Or does he?

People in Casablanca often mirror the additive process of power in their own lives when they construct different stages on which to act out varied roles. Invisible brides remind us that judicious ordering of the visible in this sea of objects and pictures may help overcome the incessant assaults of numberless pictures. Not to show is to preserve the possibility of alternative visions. Flirting boys with their "material" offer visions of plenitude that parody signs of authority. Yet such practices often produce more pictures that suggest, yet fail to designate, clear alternatives to figurative powers. Gilles Lipovetsky writes that "fashion is less a sign of the ambitions of classes leaving a world of tradition than it is one of these mirrors in which our historical destiny shows what is most singular about it: the negation of immemorial power of the traditional past, the modern fever for novelties, the celebration of the social present."[11] But how can we apply this comment to Casablanca, where so many of the "unseen" rely on references to tradition? The "celebration of the social present" has a different relation to history in various contexts, and the issue of "novelty" requires a more thorough investigation than is possible in the area of fashion alone.

Images can be juxtaposed to another, but they cannot refute one another; they thus remain open-ended. Images may propose utopian

ideas or concepts of personal excellence, but such notions can be linked to critical perspectives and decisions only if they are mediated by discourse. Narrative can propose this *or* that.[12] Talking about pictures requires shared meanings. Umberto Eco comments on how these meanings take form:

> If the sign does not reveal the thing in itself, the process of semiosis produces in the long run a socially shared notion of the thing that the community is engaged to take as if it were in itself true. The transcendental meaning is not at the origins of the process but must be postulated as a possible and transitory end of every process.[13]

The nature of this "community" is in question. In everyday circumstances many unnamable people and practices in Morocco are perceived as existing at the edges of society.[14] New vocabularies are born and grow in the dark, where one's daylight social image will not be challenged, or they are relegated to the realm of the risible, as, for example, when some people denigrate colloquial Arabic because it is not a "real" language.

Disciplinary power assures a certain order and presents the edges of community as reminders of the edges of the frame. Yet disciplinary power cannot always command the stories that accompany pictures of groups, individuals, or the nation. We see this inability in extreme circumstances: when rioting takes place in cities, or an international conflict erupts. During the Gulf War, for example, official discourses assumed an apparently conciliatory stance. According to the official pronouncements, Moroccans were with the Iraqis "in their hearts" but opposed the invasion of Kuwait;[15] on a more concrete level, Moroccan troops had been sent to Saudi Arabia. As people expressed their views on the war, it became clear that the conflict could be understood through multiple frames of reference, all grounded in individually nonproblematic but mutually competing discourses. Communities formed around references to Islam, Arab nationalism, anti-imperialism, and human rights, each of which provided possible centers from which to develop personal or collective "lines." For the government's "line," fields of international power took precedence over the pretension to represent a *polity*. The government's position could be explained only by reference to historic alliances with the gulf states and the West.[16]

The government chose a line of action that avoided the usual imagelike logic for framing the nation; however, the framing of verbal negotiation among citizens was not innovative. Once war was declared, army trucks lined the streets of Casablanca as a local reflection of the war in the gulf. Schools were closed, and spontaneous demonstrations were forbidden. In a televised speech the king explained that it was fine to express one's opinions in one's own home, but not in the street. During the war the threat of physical and symbolic violence reminded people that the even gaze of disciplinary power depended on less serene and "invisible" types of control. Debates did break out on the street and in grocery stores as national concerns were upstaged by international events and calls for Arab and Islamic unity. And the state deftly permitted the public expression of outrage in an enormous demonstration in support of the "Iraqi people" in Rabat.[17] During the demonstration people assembled not simply as "Moroccans" but as members of one or another political party, association, or profession. Individuals demonstrated their group allegiance in visually striking ways. Yet one wonders whether this assembly itself was not merely another example of the national collage. Individuals I interviewed following the march in Rabat were clearly touched by their experience. But if this demonstration permitted or encouraged a collective negotiation of meaning, it has yet to surface. Perhaps in time memories of the demonstration will be used to illuminate and illustrate potential pictures of more distant futures.

The importance of individual explorations of meaning and parameters for action should not be overlooked. The images that enter everyday life in Casablanca may create multiple paths of meaning and feelings of frustration *without* proposing communal "lines" or alternatives.

Looking and Saying

I walk into a corner grocery store during Ramadan and hear the music of Bob Marley, whose photo hangs on the wall. While the young shopkeeper serves me, I tell him that I like the song playing on his cassette recorder.

"Ah, madame," he responds, "it's nice, isn't it?" And then he goes on, "But you know, we have only the records here. What's it like where you're from? I think you have freedom, no?"

Another song begins: "Get up, stand up for your rights, / Get up, stand up, don't give up the fight."

I ask him, "Why don't you have freedom?"

He looks at me, takes my receipt, and, after glancing around to see where the other clerk is, writes in French, in large, ill-formed letters, "*La religion islamique.*"

The young clerk's stark expression of protest is clear, and it is startling. I cannot convey the intensity of this young man's eyes as he extended his note to me. *La religion islamique.* Three years after this unique encounter, I am still not sure what response he expected from me. How can individual responses that might be construed as an affront or a rejection of the very basis of the community (*?umma*) become meaningful? Can reggae or fashion be opposed to such deep historical realities as Islam? The frivolity of much political discourse might not merit more attention than rock videos—but how can degrees of meaning, and especially of the meaningless, be measured?

Certain practices or political decisions are clearly promoted by their relationship to dominant forms of knowledge or to the potential for violence or economic control. Others can be linked to historical realities of the *longue durée*. Generally we try to base understandings of contemporary power relationships and resistance on the binary oppositions of inside and outside that are often used in everyday discourse. But this approach, in which situations are viewed from specific perspectives, fails to recognize, for example, how declaring oneself "outside" one community may or may not involve one in other communities. Did this young shopkeeper feel that my liking Bob Marley was sufficient proof for him to trust me and reveal his radical views? In any case he carefully disguised his personal views from others around us.[18]

If individuals participate in various communities, they must form different kinds of links with each one. Notions of community and solidarity must likewise be diverse. In the Moroccan context, I hesitate to label any of these communities as "countercultures," for I think that what Jean Comaroff calls "Western" forms of "bourgeois-liberal secularism" are not as hegemonic anywhere as she supposes.[19] Whether in Morocco, Los Angeles, or Berlin, part of the problem of measuring deviance is determining orthodoxy. Some Moroccan youths might see reggae as a secular-liberal attack on Islam, but others explained that they liked Bob Marley because his "mellowness" can be harmonized

with feelings of piety. In addition, reggae is part of a highly lucrative business for music company executives in the United States. But even promoters dealing in "ethnic music" often see their product as a counter to mainstream, "top forty" music. Moroccans are caught up in layers of references and repertoires that overlap with those that ensnare you and me and more and more people throughout the world. But the question remains: which of these layers will dominate in a given setting?

In analyzing strategies of individual or group resistance to power holders or cultural hegemony, scholars often assume, on the one hand, a dominant system and, on the other, a subversive, partially hidden structure of dissent.[20] But perhaps we should turn our attention to the processes by which merely tactical expressions of discontent are transformed into strategic actions. Michel de Certeau sees tactics as practices of refusal that employ the signs of the prevalent order;[21] these signs may, of course, take the form of images. If some elements of this order are reframed, then tactics can become strategies. Those who can master the process of making images and setting them to subversive narratives can implement strategic designs. But particular actions or expressions may be defined at different times as either strategic or tactical, the definitions shifting gradually over time, sometimes rocking back and forth to the rhythms of world events. Designating one or another action as tactical or strategic is informative only once one has already determined a specific framework of study or action.

Many anthropological works on modern societies echo W. B. Yeats's vatic pronouncement "Things fall apart; the center cannot hold; / Mere anarchy is loosed upon the world."[22] Moralistic anthropologists, seeing "traditional" cultures as menaced, blame that decline on evil human intentions. Faced with this sense of loss, anthropologists have often advocated redefining the goals of our discipline, whose practitioners, as Roger Sanjek argues, have *always* felt that they came to the field "after it was too late."[23] As Sanjek notes, we all have a stake in the common human condition. Perhaps we must accept that "mere anarchy" is a part of this condition that cultures and those who study "them" might like to tame. We could consider "anarchy" as merely the point of departure for our studies, an effort at moving beyond self-evident truths to present new ways of approaching problems of "cosmopolitical import."[24] This study represents such an effort, be-

ginning with a special interest in pictures and their production. Specialists of one or another issue addressed here might consider my treatment of their areas of interest too brief. I have preferred a collage approach as an aesthetic response to the settings evoked here; indeed, part of the point of this exercise has been to show that if aesthetics cannot be narrowly confined in the category of "art," neither can aesthetic practices be divorced from the most fundamental problems of knowledge and power.

Mass images bring to the forefront the connection of aesthetics to commerce and war, a link that General Gallieni so astutely pointed out. Aesthetic principles pervade social life and are directly involved in the creation of power; these principles often imply ethical positions.[25] Yet we continue to study aesthetics as separate from power's projects or, alternatively, as an artful tool in the hands of the powerful. Sometimes we relegate aesthetic issues to the domain of "art" and then go on to provide statistics of national production, as though aesthetic power could be counted like socks or bullets.

The example of Casablanca tests a notion of art put forward by Weber and developed later by Jürgen Habermas: "Art takes over the function of a this-worldly salvation, no matter how this may be interpreted. It provides a *salvation* from the routines of everyday life, and especially from the increasing pressures of theoretical and practical rationalism."[26] From this perspective, art is a bastion against encroaching rationality. Yet many Casablancans seek not to escape but to be allowed to participate in the "increasing pressures of theoretical and practical rationalism." Similarly, "otherworldly" aesthetics may be devoid of "art," as when someone seeks transcendence by looking at flowers or people in the park or refusing all pictures of people.

Social arrangements of vision, like artworks, demonstrate potential relations of concrete elements and engender constant speculation on the resulting combinations.[27] Such speculation occurs in the street when people offer themselves to the gaze of others; it goes on at home when they talk about ads or soap operas or people they know. This play of vision and visibility is more than a reflection of pre-existing realities; but this game of forms cannot give meaning to social relations unless it points toward alternative communities of meaning, memory, and potentiality. Only through the process of naming the previously unnameable can a group render these objects and practices meaningful.[28] The stakes of collective conversation may appear high, for

inevitably old words are discarded or reinterpreted. Conflicts often arise when new rhythms animate paintings, ways of dancing, and debates. Yet there is no standing still. Where no words emerge to inform unprecedented sights, old boundaries may be redrawn by people searching everywhere for new words, and in the process conjuring further visions and novel silences.

GLOSSARY

ʔdāb	Literature, manners.
ʔumma	Community of believers.
badiya	Country.
baraka	Blessing, grace.
bay ᶜ a	To greet with a bow; to pledge allegiance to a person or to recognize his or her authority.
belg̱a, Blāg̱i	Slippers.
berqaq, berqaqa	Busybody.
bg̱a ybān	To show off; literally, "he wants to appear."
bid ᶜ a	Innovation.
bit ed ḏiāf	Living room.
chantier	Construction site.
colons	Colonists.
ḍahīr, ḍawāhīr	Decree. A royal *ḍahīr* automatically becomes law.
dar al-Maxen	Area taxed and controlled by the Maxen.
dar es-Siba	Area declaring allegiance to the sultan, but not paying taxes.
dāriža	Colloquial Arabic.

daxel, daxliyya	Inside, interior. *Daxliyya* is also used to refer to the Ministry of the Interior.
dīn	Religion.
drague	Flirting.
dūnya	The world, everyday affairs or those of government.
écoles normales	Schools where primary school teachers are educated.
fātiHa	The opening verse of the Koran.
fellaH, fellāHīn	Peasant.
finn, finān	Art, artistry, the arts.
fitna	Agitation, rioting, revolt.
fqih, fuqahā	Religious scholar.
francophonie	An association of French-speaking countries or peoples.
fūḍā	Chaos, disorder.
Hāḍara	Urban.
Hadīt	Sayings of the prophet.
Haīk	Draped woman's garment.
Hammām	Public steam bath.
Harka	The periodic movement of the sultan and his court around the country.
Hiẓāb, Huẓūb	Scarf, veil.
hiẓra	The Islamic year.
Hmār, Hmīr	Donkey.
Hšuma	Shame.
huwa	Third-person masculine singular; "he."
iṣnād	Links between scholars that attest to the truth of the knowledge they pass down.
Istiqlāl	Independence; a Moroccan political party.

ixwān	Brothers; used to designate those in Islamist movements.
Maxen	Moroccan system of government.
medīna, mūdūn	City; now refers to the parts of cities that originated before the Protectorate.
medrasa, medāris	School.
MellāH	Jewish quarter.
mission civilisatrice	Policy of French colonialism by which subjected populations, or their elites, would be progressively introduced to French education and culture.
musṭawa	Level.
nahḍa	Renaissance.
nāṣāra	Christians, foreigners.
nisba	Attributes, name.
nqqāfāt	Women who prepare the bride for her wedding.
paideia	Comely behavior.
photo-roman	A comic book with photographs.
populaire	Working class, common.
qāʔid, quwwād	Leader, official, commander.
Salafite	Modern school of Islamic thought that calls for the renewal of the sources on which Islam is based.
šanṭe	Street.
sid, syad	Master, lord.
sidna	Our master.
ṣināᶜa	Manufacture, artistry.
šīxa, šīxāt	Female dancer and singer.
ṣiyyeḍ	To hunt or fish.
šrīf, šurfā	Descendant of the prophet Mohammed.

suq, swāq	Market.
šuwwāfā	Fortune-teller, seer.
tajine	Stew.
tāžer	Merchant, businessperson.
villes nouvelles	"New towns"; as opposed to the Protectorate towns, referred to as *medīna*.
vitrine	In French, shop window; in Moroccan Arabic, a cupboard used to arrange knickknacks and valuables.
wālī	Governor, guardian.
wilāya	Governor's office.
xāriž	Outside, foreign land.
za ᶜ īm	Leader.
zawiyya, zawāyya	Brotherhood.
žellāba, žellāleb	Long hooded robe.
zellīž	Tiles, mosaics.
zgārid	Ululations.
žil	Generation.
žinn, žnūn	Genies, invisible beings.
ᶜ *ālem,* ᶜ *ulamā*	Scholar, notable; plural, community of religious scholars.
ᶜ *aql*	Reason, reasonable.
ᶜ *id*	Holiday.
ᶜ *ilm,* ᶜ *ulūm*	Science, knowledge.
ᶜ *rubi*	Country dweller; considered pejorative.
ᶜ *ṣbiyyah*	Group feeling; concept developed in the work of Ibn Khaldun.
ᶜ *ṣri,* ᶜ *ṣriyya*	Modern, contemporary.

NOTES

Introduction

1. *Le Film*, August 1914, quoted in Edgar Morin, *Le cinéma et l'homme imaginaire* (Paris: Éditions de Minuit, 1956), 43.

2. Military and commercial interests were linked from the beginning. Gallieni, Marchand, and Demaria of the French Cinema Syndicate refer to the same "terror." See Paul Leglise, *Histoire de la politique du cinéma français* (Paris: R. Pinchon and R. Durand, 1970), and Paul Virilio, *Guerre et cinéma I: Logistique de la perception* (Paris: Cahiers du Cinéma, Éditions de l'Étoile, 1984).

3. Many authors trace the development of modern art to the emergence of photography; some artists sought to use new media according to their own designs. See, for example, A. Scharf, *Art and Photography* (Baltimore: Penguin, 1969).

4. John Berger, *Ways of Seeing* (London: Penguin, 1972).

5. Many "progressive" thinkers such as Georg Lukács and conservative writers such as T. S. Eliot held similar opinions concerning the "seventh art." Walter Benjamin was central in developing these ideas; see his classic study "The Work of Art in the Age of Mechanical Reproduction," in his *Illuminations* (New York: Schocken, 1969), 217–52.

6. Pierre Francastel, *Peinture et société* (Lyon: Audin, 1951), 47.

7. Roland Barthes, *Camera Lucida: Reflections on Photography*, trans. Richard Howard (New York: Hill and Wang, 1983).

8. This was not simply a problem of Islamic law. For recent points of view on the relationship between words and images in Islamic art, see Moulim Alaroussi, *Esthétique et art islamique* (Casablanca: Afrique Orient, 1991), 13–16, and Abdelwahab Meddeb, "L'icone et la lettre," *Cahiers du Cinéma*, nos. 278–80 (1977): 81.

9. For an overview of Islamic art and examples of figurative art, see David Talbot Rice, *Islamic Art*, rev. ed. (London: Thames and Hudson, 1975).

10. Ibn Khaldun, *The Muqaddimah: An Introduction to History*, trans. Franz Rosenthal, ed. N. J. Dawood (Princeton: Princeton University Press, 1967), 316–32, 340–43. For a general introduction to Ibn Khaldun, see Abderrahmane Lakhsassi, "Ibn Khaldun," in *The Routledge History of Islamic Philosophy*, ed. Seyyed Hossein Nasr and Oliver Leaman (London: Routledge and Kegan Paul, forthcoming).

11. For information concerning the various "exterior" influences in Moroccan art, see Georges Marçais, *L'art musulman*, 2d ed. (Paris: PUF and Quadrige, 1981), 168–80, and Henri Terrasse and Jean Hainaut, *Les arts décoratifs au Maroc* (Casablanca: Afrique-Orient, 1988).

12. Musée des Arts d'Afrique et d'Océanie, *Broderies marocaines, textiles* (Tours: Presses de Mame, 1991).

13. Jacques Berque, *Le Maghreb entre deux guerres* (Paris: Le Seuil, 1980), 89–90; translated as *French North Africa: The Maghrib Between Two World Wars*, trans. Jean Stewart (London: Faber and Faber, 1962).

14. For Egypt, see Timothy Mitchell, *Colonising Egypt* (Cambridge: Cambridge University Press, 1988).

15. Yves Gonzales-Quijano argues that too much concentration on the *nahda* has skewed our current comprehension of contemporary culture in the Middle East ("Les enjeux politiques de la culture," in *Les nouvelles questions d'Orient* [Paris: Les Cahiers de l'Orient / Hachette, 1991], 210–15).

16. On the *tanzimat* reforms in the Ottoman Empire, see Ira M. Lapidus, *A History of Islamic Societies* (Cambridge: Cambridge University Press, 1988), 597–601. Lapidus also outlines other nineteenth-century reform movements and provides an extensive bibliography.

17. For a general introduction to Maghrebian history in English, see Jamil Abun-Nasr, *A History of the Maghreb*, 2d ed. (Cambridge: Cambridge University Press, 1975). For the precolonial period, see Edmond Burke III, *Prelude to Protectorate in Morocco: Precolonial Protest and Resistance, 1860–1912* (Chicago: University of Chicago Press, 1976).

18. For an account of the development of French discourses of the city and their application in Morocco and other colonies, see Janet Abu-Lughod, *Rabat: Urban Apartheid in Morocco* (Princeton: Princeton University Press, 1971); Paul Rabinow, *French Modern: Norms and Forms of the Social Environment* (Cambridge: MIT Press, 1989).

19. A nineteenth-century Moroccan traveled to Paris and was impressed by the theater; he made a point of noting that *respectable* men and women enjoyed it there. See Susan Gilson Miller, *Disorienting Encounters: Travels of a Moroccan Scholar in France in 1845–1846* (Berkeley: University of California Press, 1992), 142–50.

On the introduction of printing, see Aberazak Fawzi, "The Kingdom of the Book: The History of Printing as an Agency of Change in Morocco Between 1865 and 1912," Ph.D. diss., Boston University, 1990. The printing press and newspapers reached Morocco before many other European-inspired forms of art and information. Jamaā Baïda, of the University of Mohammed V in Rabat, kindly shared his lecture notes on the subject of pre-Protectorate newspapers with me. He notes that while there were local publications—for example, the newspaper *El Haqq* in Tangier—prior to the Protectorate, a mass press began to take form only with the rise of the nationalist movement. The individuals who were active in this nationalist press shaped the postindependence press as well.

20. Susan Ossman, "Le cinéma marocain et l'authenticité: Discours et image," *Les Cahiers de l'Orient*, no. 18 (1990): 175–88.

21. Western-style theater was first introduced in the Arab world in Beirut in 1847. In 1868 a theater was built in Egypt to serve visiting companies. See Ahmed Shams el-edin Al-Haggagi, *The Origins of Arabic Theater* (Cairo: General Egyptian Book Organizations, 1981).

22. For more on the first Moroccan theater, see Kenneth Brown's study of Sale, the former center of piracy on the Moroccan coast. Brown details the nature of urbanity in the context of one of the "Imperial" cities in a period during which Casablanca was becoming the prominent urban center (Brown, *The People of Sale: Tradition and Change in a Moroccan City, 1830–1930* [Cambridge: Cambridge University Press, 1976]). On general intellectual trends in the Middle East during the period, see Albert Hourani, *Arabic Thought in the Liberal Age 1798–1939* (London: Oxford University Press, 1962).

23. Pierre Boulanger, *Le cinéma colonial de l'Atlantide à Laurence d'Arabie* (Paris: Seghers, 1975).

24. Ossman, "Cinéma marocain," 176; see also the discussion of film and education, 181–82.

25. Mill Cissan, "Au fil des films," *Comoedia Illustré*, December 1913; my italics.

26. Jamaā Baïda, "Situation de la presse au Maroc sous le "proconsulat" de Lyautey (1912–1925)," *Hesperis-Tamuda* 30, no. 1 (1992): 67–92.

Speaking of the many foreign films shot in Morocco, Jacques Chevallier writes that "the making of these films marks an important date in the history of French cinema. It is not one, however, for North African cinema. Everyone makes use of North Africa, but not one has served it" ("A la recherche du cinéma nord africain," *IFOCEL Informations*, no. 40 [1951]: 6–7).

27. In Europe the development of widely circulated print media, especially popular genres, is comparable to the diffusion of the cinema, as is the rise of popular theater forms like vaudeville. Nonetheless, it is too simple to

see any of these elements as a uniquely important force in European or world history. Roger Chartier reminds us that in early modern France reading was a multifaceted practice; in literate societies—especially after the introduction of printing presses—even nonreaders are involved in the world of the book. See Chartier, *Lectures et lecteurs dans la France de l'ancien régime* (Paris: Le Seuil, 1987), and Elizabeth Eisenstein, *The Printing Revolution in Early Modern Europe* (Cambridge: Cambridge University Press, 1983).

28. Ira M. Lapidus, *A History of Islamic Societies* (Cambridge: Cambridge University Press, 1988), 688.

29. The subject of saints and holy lineages (*šurfā*) in Morocco has been treated in many important studies. See, for example, Vincent Crapanzano, *The Hamadsha: A Study in Moroccan Ethnopsychiatry* (Berkeley: University of California Press, 1973); Dale Eickelman, *Moroccan Islam: Tradition and Pilgrimage in a Pilgrimage Center* (Austin: University of Texas Press, 1976); Hassan Elboudrari, "La maison du cautionnement: Les Shurfa d'Ouezzane de la saintété à la puissance," thesis, 3ème cycle, École des Hautes Études en Sciences Sociales (EHESS), Paris; Clifford Geertz, *Islam Observed* (New Haven: Yale University Press, 1968); Ernest Gellner, *Saints of the Atlas* (Chicago: University of Chicago Press, 1969); Michael Gilsenan, *Recognizing Islam* (New York: Pantheon, 1982); Nikki R. Keddie, ed., *Scholars, Saints, and Sufis: Muslim Religious Institutions since 1500* (Berkeley: University of California Press, 1972); and Paul Rabinow, *Symbolic Domination: Cultural Form and Historical Change in Morocco* (Chicago: University of Chicago Press, 1975). These might be compared to Peter Brown's study of sainthood in an earlier era: *The Cult of the Saints: Its Rise and Function in Latin Christianity* (Chicago: University of Chicago Press, 1979).

30. The emergence of new varieties of piety cannot be understood if they are abstracted from the lived context of everyday life. This context includes magic spells and the "evil eye," phenomena that are perhaps not discouraged but amplified by contact with mass images that include *The Blob*, *Poltergeist*, and ghost stories. Hannah Davis has recently discussed magic and horror films from America as they are viewed in a midsized town in Morocco ("American Magic in a Moroccan Town," *Middle East Report*, July–August 1989, 12–17. On the "American" aspect of images, see Jeremy Turnstall, *The Media Are American* (New York: Columbia University Press, 1977). However, one should not forget that Cairo and India are major producers of images for Morocco and other Arab countries.

31. Images are ambiguous because they offer ways of thinking about issues without necessitating choices. For an interesting treatment of sorcery and images, see Jeanne Favret-Saada, "L'embrayeur de violence: Quelques

mécanismes thérapeutiques de désorcelement," in J. Contreras et al., *Le moi et l'autre* (Paris: Denoel, 1985), 95–125.

32. John Waterbury, *The Commander of the Faithful: The Moroccan Political Elite—A Study in Segmented Politics* (London: Weidenfeld and Nicolson, 1970), 48.

33. On the image of Marianne, see Maurice Agulhon, *Marianne au pouvoir* (Paris: Flammarion, 1989), and Agulhon, "Marianne Devoilée," *Terrain*, no. 15 (October 1990): 91.

34. Few studies of new image technologies address the relation of aesthetic forms and social arrangements. In *Colonising Egypt* (Cambridge: Cambridge University Press, 1988), Timothy Mitchell discusses the relationship between maps, plans, and emerging types of knowledge in Egypt in a way that is closer to this study's preoccupations than are many media analyses. In the vast majority of studies of contemporary media technology, images are studied with respect to already constituted political and social fields. See, for example, Armand Mattelart, *Multinationales et systèmes de communication* (Paris: Anthropos, 1976); Stuart Hall, "Encoding and Decoding in the Television Discourse," in S. Hall, A. Lowe, and P. Willis, eds., *Culture, Media, Language* (London: Hutchinson, 1980), 128–38; David Morely, ed., *The Nationwide Audience* (London: British Film Institute, 1980); and Anthony Smith, *The Geopolitics of Information: How Western Culture Dominates the World* (New York: Oxford University Press, 1980).

35. Roland Barthes, *La chambre claire: Notes sur la photographie* (Paris: Gallimard, Le Seuil, and Cahiers du Cinéma, 1979), 21–22.

36. Pierre Bourdieu speaks of the familiar and the falsely familiar to emphasize the process of relearning through research. He insists that reflexivity cannot form the sole object of interest if we hope to understand the ethnographic process (Bourdieu, *Réponses avec Loic J. D. Wacquant* [Paris: Le Seuil, 1992], 47).

By characterizing my own position as "strong," I hope to show myself from the start as having a certain type of "investment" in the field, both in my approach to research and in the way in which my accounts of this research necessarily require the introduction of a strangeness between myself as author and the image I propose of myself in the study. This approach might thus take into account the concrete ways in which "my" worlds and those of the "informants" are actually intermeshed and diverse. I hope to avoid the simple positing of here and there, field and "home," that authors like Johannes Fabian have criticized as all too prevalent in anthropology (*Time and the Other: How Anthropology Makes Its Object* [New York: Columbia University Press, 1983]).

37. By focusing on the limits of political representation, for example, we can use Foucault's idea of the limits of the possible as a guide for research. What can or can't be displayed and when? Where are the limits of interpretation? Umberto Eco, responding to his own previous insistence on the open text, addresses the problem of "unlimited semiosis" by referring to habit and community (*The Limits of Interpretation* [Bloomington: Indiana University Press, 1990], 39). I will return to this problem, but suffice it to say that ways of investigating the frameworks of habit and community are themselves fraught with the same issues of establishing meaning as any other understanding.

38. For a discussion of Berber languages (or the languages of the Imazighen, the appellation used by those who find "Berber" pejorative), see Mohammed Benihya, "Ces Bèrbères oubliés," *Al Asas* (Rabat), no. 29 (1981): 26–30.

Protectorate officials drew lines between Berbers and Arabs, an approach that became official policy with the issuance of the Berber Dahir of 16 May 1930. The *dahir* took Berber courts out of the jurisdiction of Muslim law. Other policies included creating schools for Berber children in which Arabic was not taught and efforts to Christianize Berbers. See Edmond Burke III, "The Image of the Moroccan State in French Ethnological Literature: A New Look at the Origins of Lyautey's Berber Policy," in Ernest Gellner and Charles Micaud, eds., *Arabs and Berbers: From Tribe to Nation in North Africa, 1175–1200* (London: Duckworth, 1972).

39. Ernest Gellner writes that "there are in Islam three major types of legitimation: the Book (including its extension by Tradition), the consensus of the community, and the line of succession" (*Muslim Society* [Cambridge: Cambridge University Press, 1981], 117).

40. See Hassan Elboudrari, ed., introduction to *Modes de transmission de la culture religieuse en Islam* (Cairo: Institut Français d'Archéologie Orientale du Cairo, 1993).

41. Concerning the return of Mohammed V, see Abun-Nasr, *History of the Maghreb*, 373–77.

1. Urbanity as a Way to Move

1. Susan Sontag, *On Photography* (New York: Farrar, Straus and Giroux, 1979), 5.

2. The last census was taken in 1981. Predictions of rural exodus to the city have certainly been exceeded, particularly because of the very long and intense drought of the 1980s. Royaume du Maroc, *Analyses et tendences démographiques au Maroc* (Rabat: Centre d'Études et de Recherches Démographiques, 1986), 225.

3. Photographs of this event are often published in the press or shown on national television (RTM). Today the "typical" Moroccan clothing for women is the *zellāba*, which—like another favorite article of clothing among Moroccan women, blue jeans—was formerly a man's garment. A *zellāba* is a long-sleeved, loose-fitting garment with a hood and large pockets. It usually has a zipper up the front and slits up the sides to make is easier to walk. (The length of these slits is a frequent source of comment.) The switch from previous women's clothing to the *zellāba*—a process not unlike European or American women's donning trousers in the 1930s—has not excluded other modes of dress. The array of traditional clothing worn by Moroccan women is quite varied according to region, time of day, and social occasion. The *zellāba* and Western-style clothing—and various local designers' reinterpretations of the two—are the most common choices of urban women for attending school or work as well as for conducting other "outside" activities. The head scarf, originally a symbol of liberation since it shows the face, is now a subject of debate. Worn in a particular way, it is a sign of a woman's identification with Islamist groups. In some rural areas of Morocco women have always gone unveiled, while in others they are strictly confined to the home or nearly covered in long garments draped from head to foot. The variety in traditional dress was matched by comparably diverse attitudes about women's social roles, linked to a great variety of modes of social organization in various regions or among different groups.

4. Julio Caro-Baroja, "The City and the Country: Reflexions on Some Ancient Common Places," trans. Carol Horning, in J. Pitt-Rivers, ed., *Mediterranean Countrymen* (Paris: Mouton / Maison des Sciences de l'Homme, 1963).

5. Ibn Khaldun, *The Muqaddimah*.

6. Quoted in Kenneth Brown, "Profile of a Nineteenth-Century Moroccan Scholar," in Nikki R. Keddie, ed., *Scholars, Saints, and Sufis: Muslim Religious Institutions since 1500* (Berkeley: University of California Press, 1972), 134. See also, in the same collection, Edmond Burke III, "The Moroccan Ulama, 1860–1912: An Introduction," 93–126.

7. For more on tourism, see Mohammed Berriane, *Tourisme national et migrations de loisirs au Maroc (étude géographique)* (Rabat: Presse de la Faculté des Lettres et des Sciences Humaines), 1992.

8. It would be interesting to study the numerous jokes concerning the major monuments in Casablanca. For example, at the time of my research the Hyatt hotel in the center of town stood out against the white walls of the rest of the city. Some people referred to the striking black edifice, with its red accents, as the "Dada with red lipstick." (*Dada* refers to female slaves who used to be brought to Morocco from the Sudan.) The Hyatt has since been repainted beige. The new Court of Appeals (MoHakma al Istinaf) is

called the "MoHakma alf-franc," the court of a thousand francs—a punning reminder of the common practice of bribing judges.

9. John Waterbury has remarked, "There has been a territorial inversion of the blad es-siba [area of disorder] and the blad al-makhzan [area of government]. The mountains are now the source of the surest support for the monarchy while the urban centers of the Atlantic plains have become the most likely environments for dissidence. The king strives to remain the sole Moroccan with a following, influence, and authority in both camps" (*Commander of the Faithful*, 315). See also Jean-François Clément, "Les tensions urbaines au Maroc," in Jean-Claude Santucci, ed., *Le Maroc actuel: Une modernisation au miroir de la tradition?* (Paris: CNRS, 1992), 393–406.

10. Umberto Eco claims that this open-endedness is due to the fact that the director of *Casablanca* himself did not know how the film would end while the film was being shot: Ilse (Ingrid Bergman) didn't know whether she would leave with her husband or stay with Rick (Eco, "Casablanca," in his *Travels in Hyper Reality* [New York: Harcourt Brace Jovanovich, 1986], 197–217).

11. Rabinow, *French Modern*, 304.

12. For more, see René Gallisot, *Le patronat européen au Maroc, 1931–1942* (Casablanca: Eddif, 1990).

Union activity, like political activity, among European workers could not include their "indigenous" neighbors. As Rabinow points out, the development of Morocco as an "ideal" environment for urbanists depended to a great extent on the inability of the population, Moroccan or European, to fight any official decisions. Land appropriation was phrased as a technical not a political issue. Rabinow notes that laws concerning the government's right to substitute land it had appropriated were instituted by the Protectorate but did not exist in France (*French Modern*, 291–92, 295).

13. See Mohammed Naciri, "Petites villes et villes moyennes dans le monde arabe," *Fascicule de recherches* (Tours), no. 17 (1986); see also Naciri, "Regard sur l'evolution de la citadinité au Maroc," in K. Brown et al., eds., *Middle Eastern Cities in Comparative Perspective / Points de vue sur les villes du Maghreb et du Machrek* (London: Ithaca Press, 1986), 249–70.

Not only those who migrate are changed through contact with Casablanca. Studying an election in the 1960s, Rémy Leveau had already remarked Casablanca's influence in other regions:

> Before I finish with the elites of the coast it is necessary to remember how Casablanca has influenced the electoral behavior of large regions from which immigrants come: the close regions of the Chaouia and Doukkala, or even more so, the mountainous and arid regions of the southern provinces. These areas of departure keep up complex relations with Casablanca, which mix

ideas and economic factors, models of behavior—modernization in one sense, religious values on the other.

(*Le Fellah marocain: Défenseur du trône* [Paris: Presses Nationale des Sciences Politiques, 1976], 136).

14. Rabinow (*French Modern*) notes that because of the difficulty of trying out new planning strategies or aesthetic forms in France, many French architects used the colonies as a sort of laboratory in which to test urban and social forms that would later be employed in France. Hygiene was one of the requirements of these plans—and it is noteworthy that Casablanca was much "healthier" than Paris in this respect. One young *pied-noir* (a French national born in Morocco) explained to me that when she moved to France in the mid-1960s, she was struck by its relative dirtiness. As a Rabat schoolgirl who lived in "planned" areas, she had never seen apartments without bathrooms before, nor had she witnessed the squalor of the shantytowns.

15. Rabinow, *French Modern*, and Rahal Moujid, *L'agence urbaine de Casablanca* (Casablanca: Afrique-Orient, 1989).

16. Janet Abu-Lughod, *Rabat*, 156–57.

17. The new thoroughfare is planned between the center of Casablanca and the new Hassan II mosque on the coast. This road will cut through the old, crowded *medīna*, effectively destroying much of it; the *medīna's* residents, who will apparently be relocated to housing projects on the city's outskirts, are understandably dismayed. This massive construction—carried out by the French construction firm Bouygues, which also has a share in the new private Moroccan television station 2M—has provoked many reactions on the part of the populace of Casablanca.

Le Matin du Sahara, a pro-government newspaper, runs a headline each day asking people to donate funds for the project; in addition, photographs and captions compare the mosque to other world sites such as the pyramids, Notre Dame, or Saint Paul's cathedral in Rome. The fall 1988 "subscription" drive, which required people to donate a certain percentage of their salaries to the building, provoked anger and many jokes about the new mosque. Businesses were expected to contribute to the building project and to display a "diploma" with a drawing of the future mosque as proof of their generosity. In some neighborhoods *muqadim* (local officials) went door-to-door to collect funds—even from people who had already been required to pay at work. Large businesses were given directions as to the percentage to be contributed by their employees. Farmers were sometimes asked to contribute several times; if they refused to pay the often outrageous amounts demanded by local *quwwād* (officials), they or their families might be imprisoned until the funds were raised. (Local officials compete among one another to impress their superiors on these occasions, and thus they are often overzealous. Consequently, the sums required were not the same everywhere.)

18. Mohammed Boughali, *La représentation de l'espace chez le marocain illettré* (Paris: Anthropos, 1974), 162–74. This study can be compared to ideas of space in a small southern village; see Stephania Pandolfo, "Detours of Life: Space and Bodies in a Moroccan Village," *American Ethnologist* 16, no. 1 (1989): 3–23.

19. Boughali, *Représentation de l'espace*, 183–203.

20. Waterbury, *Commander of the Faithful.*

21. Noureddine Sraïeb, "Enseignement, décolonisation et développement au Maghreb," in *Introduction à l'Afrique du Nord* (Paris: CNRS, 1975), 113.

22. Daniel Wagner, "Quranic Pedagogy in Modern Morocco," in L. L. Adler, ed., *Cross-cultural Research at Issue* (New York: Academic Press, 1982), 153–62.

23. Abdellatif Felk, "Société civile et espace scolaire: De l'espace scolaire comme espace d'autorité," in *La société civile au Maroc: Signes du présent* (Rabat: SMER, 1992), 285–95.

24. There are many universities in Morocco, but their resources are limited and classes are crowded. All of those who pass the baccalaureate exam are allowed into the *faculté*. Professors complain that the level of the entering students is declining yearly. Most of the students who have the resources try to bypass public education at all levels—first by attending private elementary and high schools, and then by going to private institutes or foreign universities. On recent student demonstrations, see Mounia Bennani-Chraïbi, "Les représentations des jeunes marocains," thesis, Institut d'Études Politiques de Paris, 1993.

25. Deniz Kandiyoti writes that in Turkey men who seek to demonstrate their own "modernity" and alienation from the traditional system often use their discourses on women to express their own concerns about change ("End of Empire: Turkey," in Deniz Kandiyoti, ed., *Women, Islam, and the State* [Philadelphia: Temple University Press, 1991], 26).

26. Bourdieu develops the concept of the field throughout his work. For a recent discussion of the concept and its relation to the practice of sociology, see Bourdieu, *Réponses.*

27. Here I am referring to theories that focus on the relationship of center to periphery. In this study I attempt to avoid viewing the Moroccan situation in terms of its relationship to "centers"; I am especially wary of equating such centers with specific nation-states. I agree with Elbaki Hermassi that we should not simply apply rules developed in Europe or America to various "case studies" elsewhere. However, the problem remains that many Moroccans talk about their own experiences in social scientific jargon developed elsewhere, and they categorize many objects and people according to a nation-state system.

See Anthony Giddens, *The Nation State and Violence* (Berkeley: University of California Press, 1987), and Elbaki Hermassi, *The Third World Reassessed* (Berkeley: University of California Press, 1980).

28. Quoted in Waterbury, *Commander of the Faithful*, 315.

29. According to official statistics, in 1982 the birthrate in Casablanca itself was 3.2; the national average was 2.6. In 1960 the average household in Morocco comprised 4.8 people; in 1971, 5.5; and in 1982, 5.64. (Rahal Moujid, *L'agence urbaine de Casablanca* [Casablanca: Afrique-Orient, 1989], 15.)

30. For information on income in Casablanca, see Moujid, *L'agence urbaine de Casablanca*, 14. Concerning the use of child maids, see Touria Hadraoui, "Ces petites qui travaillent pour nous," *Kalima*, November 1988, 16–19.

31. See the special edition of *Signes du Present*, no. 3 (1988), directed by Saïd Mouline, concerning urbanism.

When old houses are demolished, as when a bidonville is "reabsorbed" into the urban landscape, residents are usually offered simple one-story homes at low prices. Nevertheless, new informal housing continues to spring up. See "Autoproduction de l'espace," *Signes du present*, no. 3 (1988): 40–67 (articles by Mohammed el Malti, Fadel Guerraoui, Hassan Bahi, Jellal Abdelkefi, Françoise Navez-Bouchanine, Saïd Mouline, and S. Santelli).

32. André Adam, *Essai sur la transformation de la société marocaine au contact de l'occident* (Paris: CNRS, 1968). We must remember that this distinction is relative, for many people—under either the Protectorate or the present regime—cannot hope to match European standards of wealth.

33. See Pierre Bourdieu, *La distinction: Critique sociale du jugement* (Paris: Éditions de Minuit, 1979). Bourdieu's analysis, based on differences between social classes, is not directly applicable in Morocco. However, it is interesting to notice that competition in terms of distinction or taste is strongest between groups in the same economic category, whereas those that are in least competition are at the extremes of the socioeconomic spectrum. One might also notice that in terms of taste, contemporary Casablanca resembles Thorstein Veblen's portrait of America at the turn of the twentieth century more than it does Bourdieu's France. Consumer goods appear to play a particularly important role in developing social distinctions among "new" societies, defining social groups and demonstrating individual success and, ultimately, "quality." I delve into these problems more later, but keep in mind that Moroccans and economists alike claim that the "economic" sphere is relatively free from state control. This freedom might, as Rémy Leveau suggests, reflect the inability of the central power to control all economic life—but the development of models of consumption and success also has an important ideological impact (Leveau, "Pouvoir politique et pouvoir

économique dans le Maroc de Hassan II," *Les Cahiers de l'Orient*, no. 6 [1987]: 31–42). For a historical account of state and economic power in Morocco, see Mohammed Ennaji, "État, société et pénétration marchande dans le Maroc du XIXe siècle," in Santucci, *Le Maroc actuel*, ed., 17–49.

34. In chapter 6 I discuss weddings and the spread of home video recorders. While many "traditional" marriage customs continue to be important, how they have been recombined and reinterpreted is of special interest here. Wedding practices become part of the "invention of tradition" process described by Eric Hobsbawm and Terrence Ranger, eds., *The Invention of Tradition* (Cambridge: Cambridge University Press, 1983).

35. Lawrence Rosen, *Bargaining for Reality: The Construction of Social Relations in a Muslim Community* (Chicago: University of Chicago Press, 1984).

36. The stark contrast between this type of male/female socializing and the types of interaction permitted in rural areas and small towns is apparent if we read most of the anthropological literature concerning Morocco. In some areas, particularly the Middle Atlas, relations between non-kin young men and women have not always been as restricted as one might expect from studies of other regions. These relations remained codified and controlled, as they are in urban flirting today, and, likewise, male roles were dominant. For more on male/female relations in Morocco, see Susan Schaffer Davis, *Patience and Power: Women's Lives in a Moroccan Village* (Cambridge, Mass.: Schenkman, 1983); Fatima Mernissi, *Sex, Ideology, Islam* (Cambridge, Mass.: Schenkman, 1987); Soumaya Naamane-Gessous, *Au-delà de toute pudeur: La sexualité feminine au Maroc* (Casablanca: Eddif, 1987). For interviews with Moroccan women on the subject, see Fatima Mernissi, *Doing Daily Battle: Interviews with Moroccan Women*, trans. Mary Jo Lakeland (London: Women's Press, 1988).

37. The kind of urban anonymity and "anomie" that Durkheim associated with the modern city does not precisely describe the Casablancan experience. Individuals have greater latitude for individual action in Casablanca than in smaller towns, but neighborhood eyes remain alert. The details of one's life—origins, profession, friends, and so on—are generally known to local people, especially the grocery store clerks, mail carriers, and parking attendants. However, having left the immediate neighborhood and regular haunts, one can become essentially anonymous. People still attempt to gain knowledge about others, but initial contacts, as in job interviews situation, are usually more based on individual attributes like physical appearance, education, dress, and the like. Again, even these tend to "place" one; for example, certain physical "types" are recognized as indicating certain regional backgrounds.

38. Naamane-Gessous goes as far as to say that men's interest in women's charms in Muslim countries fills a void left by the lack of figurative art (Naamane-Gessous, *Au-delà de toute pudeur*, 228).Be that as it may, a vast literature proclaims the "dangers" of feminine beauty; most notably, in the Koran evil angels teach women to use makeup to be seductive. The importance of seeing must be related to the relatively recent presence of women in the street. New institutions such as the beauty salon, and the "feminine" images it helps to create, offer means to continue to distinguish between men and women and, most especially, to delimit feminine and masculine characteristics in this newly "mixed" public space. See Susan Ossman, "Les salons de beauté au Maroc," *Les Cahiers de L'Orient*, no. 20 (1990): 181–89. Much of the discussion about proper behavior and morality turns around this question, which I discuss in depth in chapter 5.

While many "traditional" practices persist in male/female relations, even practices as central as marriage and child rearing are changing. The visual aspects of these changes, the ways in which women choose to see and be seen, men's manners of watching and being watched—all are essential parts of redefinitions of sexual identities. As we shall see, many people claim to act in conformity with social norms, yet they see and do things that contrast markedly, even contradict, those same norms.

39. The objects of complaint are often young, unmarried men. See, for example, complaints concerning these "dragueurs" in the weekly column "Opinion des Jeunes," which appears in the Istiqlal party's newspaper *L'Opinion*. In particular, see *L'Opinion*, 13 April 1989, 4–6; see also columns published during Ramadan in subsequent years. (I discuss dragueurs at greater length in chapter 6.)

40. On the use of masks and masquerade in Morocco, see Abdellah Hammoudi, *Le victime et ses masques: Essai sur le sacrifice et les mascarades au Maroc* (Paris: Le Seuil, 1989).

41. Many people perceive even professional actors and actresses as immoral. This is a subject I hope to explore in further research.

42. Adam, *La transformation*, 142.

43. See Rabinow, *French Modern* (347), for details concerning how models of housing introduced in Morocco were subsequently brought back to France.

44. See Daniel Pinson, *Modèles d'habitat et contra-types domestiques au Maroc*, fasicule de Recherches, no. 23 (Tours: URBAMA, 1992).

45. People talk in this room, but they also tend to call for others from it. "Mariam, ya mariam!" cries out a housewife to her daughter, whose bedroom is upstairs. Several Europeans have told me that Moroccans, "like many Americans," tend to speak loudly among themselves.

46. Mohammed El Malti, Fedel Guerraoui, and Hassan Bahi, "Habitat clandestin," *Signes du Present* (Rabat), no. 3 (1988): 48.

47. Leveau, "Le Fellah Marocain difenseur du trône, Presses de la Fondation nationale des sciences politiques" (Paris, 1985), 132.

48. For the history of the introduction of television, see Ahmed Akhchichine and Jamal Eddine Neji, *Le contact avec les médias au Maroc: Étude sur les publics à El Kelaa*, thesis, University of Paris 2, 1982.

49. François Chevaldonné, "Médias et développement socio-culturel: Pour une approche pluraliste," in *Lunes industrielles: Les médias dans le monde arabe*, special issue of *Revue de l'Occident Musulmane et de la Méditerrannée*, no. 1 (1988): 11–22.

50. Jacques Berque, *De l'Euphrate à l'Atlas*, vol. 1, *Espaces et moments* (Paris: Sindbad, 1978), 400.

2. Televisions as Borders

1. Raymond Barre emphasizes his "good sense" and offers a reassuring, teddy-bear-like impression that is accentuated by his heavy, slow-moving physique.

2. Benedict Anderson, *Imagined Communities: Reflections on the Origin and Spread of Nationalism* (London: Verso, 1983; revised ed., 1991), 6. I have also explored the notion of participation and image-making in France with regard to the anti-racist movement S.O.S. Racisme. See Susan Ossman-Dorent, "S.O.S. Racisme: Studied Disorder in France," *Socialist Review* 18, no. 2 (1988): 39–53.

3. Ghassan Salamé, Introduction to Salamé, ed., *The Foundations of the Arab State* (London: Croom Helm, 1987), 3.

4. Giddens, *Nation State and Violence*, 31.

5. Marc Abélès, "Modern Political Ritual," *Current Anthropology* 29 (1990): 391–404.

6. Both approaches conceptualize dyadic relationships between the powerful and the powerless, the hegemonic and the dominated. The concrete construction of power, including the intertwining of state and international politics, is necessarily more nuanced if we consider it from any concrete situation. Rather than seeking modes of "resistance" to capitalism or hegemonic culture solely with reference to models of the past, I hope to suggest that even these models are "mixed" because of cultural distinctions both within any nation-state and between different groups and states. For some interesting studies of how travel and especially pilgrimage alter notions of self and society, see Dale Eickelman and James Piscatori, eds., *Muslim Travelers:*

Pilgrimage, Migration, and the Religious Imagination (Berkeley: University of California Press, 1990).

7. For information on the history of this division in Tetouan, see Miller, *Disorienting Encounters*, 33–35.

8. Abderrazak Moulay R'chid goes on to explain that nothing in Islamic law would prohibit equality in bequeathing nationality between the mother and the father. In addition, while a foreign woman married to a Moroccan man can request Moroccan nationality, the opposite is not true. As Moulay R'chid notes, however, men and women are equal with respect to the "perpetual allegiance" to the nation; that is, it is not possible to renounce one's inherited status as a Moroccan national. See Moulay R'chid, *La femme et la loi au Maroc* (Casablanca: United Nations University and Le Fennec, 1991), 62, 75–76.

9. Ibid., 96–100.

10. This is not to say that territory has no importance. The relationship between territory and nationhood cannot be reduced to a view as schematic as that presented by Anthony Giddens in his *Nation State and Violence*. In Morocco it would be instructive to reconsider the relationship between royal movements and the state. See, for example, Jocelyne Dakhlia, "Dans la mouvance du prince: La symbolique du pouvoir itinérant au Maghreb," *Annales ESC*, May–June 1988, 735–60; Abderrahman El Moudden, "État et société rurale à travers la harka au Maroc du XIXe siècle," *Maghreb Review* 8, nos. 5–6 (1983): 141–45; D. Norman, "Les expéditions de Moulay Hassan: Essai de statistique," *Hespéris-Tamuda* 19 (1980–81): 123–52; Salamé, *Foundations of the Arab State*.

11. The Moroccan parliament includes representatives of parties of all ideological currents. This "national unity" has been in effect since 1974, when Hassan II launched the national march toward the Western Sahara in the name of Morocco. This action brought opposition parties into the fold. In the current government, laws are voted and the administration resembles bureaucratic agencies anywhere else in the world. However, this system functions within the framework of the traditional Moroccan political system, the *Maxen*. The *Maxen* relies on patron-client relationships and personal decision making rather than on an abstract notion of law or bureaucratic procedure. It is not simply a parallel system to the "modern" government of Morocco; rather, it is involved in decision making and styles of representing power throughout the society.

12. Waterbury, *Commander of the Faithful*, 79.

13. While some French politicians, including François Mitterand, have spoken in favor of allowing resident foreigners to vote in local French elections, the Moroccan government is vehemently opposed to this possi-

bility. The king rejects the notion of "integration," insisting that his subjects belong only to Morocco.

14. The list of studies of the "phénomène Le Pen" is endless. Some argue that the influence of the National Front has increased because of the collapse of the Communist Party. Others point to the fact that the entire "political class" in France has become involved in discussions of immigration since the 1980s. The issue of immigration has not failed to concern political leaders in France and Morocco since the 1988 election. Indeed, tensions between immigrant communities and those who say they are "French French" have only intensified. For an anthropologist's discussion of the "French French," see Lawrence Michalak, "The French French, the Non-French, and the Non-French French: Negotiating Power and Identity in a French Town" (unpublished paper).

15. The ways in which nationalist, Arab, and Islamic references are used is a complex subject. See the critique of Abdellah Laroui in Elbaki Hermassi, "State Building and Regime Performance in the Greater Maghreb," in Salamé, *Foundations of the Arab State*, 91–111.

16. Yves Pourcher, "Un homme, une rose à la main," *Terrain*, no. 15 (October 1990): 77–90.

17. Erving Goffman, *The Presentation of Self in Everyday Life* (New York: Anchor, 1969), 216.

18. Appadurai, Arjun, "Theory in Anthropology: Center and Periphery," *Comparative Studies in Society and History* 28, no. 2 (April 1986).

19. Jürgen Habermas, *The Theory of Communicative Action*, vol. 1, *Reason and the Rationalization of Society* (Boston: Beacon, 1984), 139.

20. Hall, "Encoding and Decoding."

21. People understand messages according to their "cultural capital," but this understanding is not simply a reflection of competence. Bourdieu's notion of *habitus*, which is a set of dispositions, reminds us that our understanding is conditioned not only by what we know but also by how we have come to know it.

22. Bourdieu (*La distinction*) feels that the Kantian "separation" of the aesthetic and the ethical is a class-related characteristic in France. I would suggest that what are often called "figurative" links of ethics to aesthetics— for example, judging the "content" of a photograph's subject rather than the manner of its presentation—can lead to confusion. While discourses on art separate modern and nonmodern according to their "figurativeness," what is in fact in question is a transformation of ideas about the nature of art.

With respect to transnational culture, various approaches have been forwarded. However, most of these approaches show how members of some group—say, intellectuals or employees of multinationals—are particularly caught up in a cosmopolitan world. I argue that just as the illiterate are

immersed in a world of print, whether or not they themselves read, all relations are touched by the intensification of common elements of culture. See, for example, Paul Rabinow's appeal to cosmopolitanism in his introduction to the special edition of *Cultural Anthropology*, vol. 3, no. 4 (1988).

23. It is interesting that one of France's foremost sociologists wrote an article on this subject shortly after the reelection of Mitterand; see Pierre Bourdieu, "La vertu civile," *Le Monde*, 16 September 1988, 1–2.

Marc Abélès discusses changing political behavior in France and suggests that we need not emphasize only the negative aspects of the current lack of interest in politics in France and other European countries. He sees the ethnographic study of contemporary politics to be a means of coming to understand these changes, which indicate a shift in the political space. See Abélès, "Anthropologie politique de la modernité," *L'Homme*, January–March 1992, 15–30.

24. The themes evoked here were brought up in conversations in both France and Morocco. They were also present on television news, in the French and Moroccan press, and on the radio. The creation and reception of information needs to be considered as a single process, an approach that is possible only if we consider more than microscopic visions of exchanges of messages. It also entails greater flexibility than the kind of chart-like class structure which is often called upon to make sense of varying "capacities" for comprehension of messages. Some suggestive studies are Chartier, *Lectures et lecteurs*; John Fiske, "Television: Polysemy and Popularity," *Critical Studies in Mass Communication* 3, no. 4 (1986): 391–407; and Yves Gonzalez-Quijano, "La littérature des trottoirs et l'invention du livre islamique," *Les Cahiers de l'Orient*, no. 20 (1990): 169–80.

25. In *Le desordre: Éloge du mouvement* (Paris: Fayard, 1988), Georges Balandier remarks:

> In traditional societies all of these (symbols and imagination) display themselves through the sovereign and by his ritualized actions. In modern societies this image is clouded, one expects it to be reconstituted, which requires that technology be used, and also symbols and political imaginations. The time of the remaking of sovereigns has come. . . . The campaign for the French presidential elections in 1988 can be partially interpreted beginning with this demand for the comeback of politics. The resuscitated curiosity for the former royal figure. This image was kept lively by the constitutional regime, now qualified as "monarchical" by political scientists. (211)

For essays on "traditional" rituals and the mysticism of kingship, see David Connadine and Simon Price, eds., *Rituals of Royalty, Power, and Ceremonial in Traditional Societies* (Cambridge: Cambridge University Press, 1992). See also Ernst H. Kantorowicz, *The King's Two Bodies: A Study in Medieval Political Theology* (Princeton: Princeton University Press, 1957).

26. Giddens, *Nation State and Violence.*

27. Timothy Mitchell (*Colonising Egypt*) argues that the separation of politics as a distinct field of action outside of regular social interaction came to the Arab world with colonialism. In the European worldview the abstract notions of "society" and "polity" could be contrasted to the "real" workings of social life. If the colonial gaze imagined politics as existing alongside society, it also brought the colonizing nations into a new relationship with the image at the same time that it "tamed" the colonized through photography.

28. See Rémy Leveau, "Quel avenir pour la présence culturelle française dans le monde arabe," *Esprit / Cahiers de l'Orient*, no. 172 (1991): 108–32.

3. Creating Sights: The City as Event

1. Gavin Maxwell, *Lords of the Atlas* (London: Century, 1966), 189–90.
2. Ibid.
3. Ibid., 190–91.
4. Rachida Cherifi, *Le Makhzen politique au Maroc* (Casablanca: Afrique-Orient, 1984), 40.
5. Many people in Morocco emphasize that there are many physical "types" in Morocco, ranging from people with very dark skin and hair to light-haired people with freckles and blue eyes. This emphasis appears to be a reaction against stereotypes of Moroccans and, more generally, of Arabs.
6. Medi-1 is a joint French-Moroccan private radio station. Bouygues, the French construction company that is building the new Hassan II Mosque in Casablanca, is among its major stockholders. The station's mix of French and Arabic language and music was seen as a model for the new private station on television, 2M International, in which Bouygues and other "francophone" companies also participated. It is interesting that in Casablanca I've heard young people speak of a "look Medi-1." The mixed language and modish style of the station have been transposed into a visual category to describe people who are youthful, fashionable, conspicuously cosmopolitan. For readers in the United States, the clearest explanation of this look is perhaps to say that they look rather like "Benneton" posters.
7. The intertwining of politics and culture between the states of North Africa is a subject in itself. Today the Union of the Arab Maghreb (UMA) unites Mauretania, Morocco, Algeria, Tunisia, and Libya.
8. For a discussion of language and television in Algeria, see Aziza Boucherit, "Complexités linguistiques des programmes à la télévision algerienne. Essai d'analyse d'une production locale," *Revue de l'Occident Musulman et de la Méditerranée*, ed. François Chevaldonné, no. 47 (1988): 35–46.

9. This image, often used in the press and on television, would be in itself an interesting subject for study.

10. *Le Monde*, 15 December 1988, 7.

11. *Le Matin du Sahara*, 1988.

12. Mitterand did not accommodate his hosts, almost certainly because he did not want to be associated with a monument that had already caused quite a stir in the French media because of its financing. (Part of the money was raised through "donations" required of all Moroccans.) The author of these lines was pursued in court for defaming Morocco. The charge was eventually dropped, but Hassan II didn't fail to refer to the impertinence of *Le Monde*. See *Le Monde*, 22 December 1988, 1, 5.

13. Daniel Dayan, "Presentation du pape en voyageur: Télévision, expérience rituelle, dramaturgie politique," *Terrain* 15 (October 1990): 13.

14. Raymond Jamous, *Interdit, violence et baraka: Le problème de la souveraineté dans le Maroc traditionel* (Paris: CNRS, 1981), 3.

15. This comment was made in an interview on French television (Hassan II, "Heure de verité," *Antenne* 2, 12 December 1989).

16. For a discussion of humor and the nonchalance of fashion, see Paul Yonnet, *Jeux, modes et masses, 1945–1985* (Paris: Gallimard, 1985).

17. Hammoudi, *Le victime et ses masques*. For more on festive occasions when masquerades are common, see Abderahman Lakhsassi, "Réflexions sur la mascarade de Achoura," *Signes du Present* (Rabat), no. 6 (1989): 31–39.

The Moroccan situation might be compared to others in which theater has become an important arena of social critique. See Susan Slyomovics, "To Put One's Fingers in the Bleeding Wound: Palestinian Theater under Israeli Censorship," *Drama Review* 35, no. 2 (1991): 18–38.

18. Clifford Geertz, H. Geertz, and L. Rosen, *Meaning and Order in Moroccan Society* (Cambridge: Cambridge University Press, 1979).

19. Rosen, *Bargaining for Reality.*

20. For examples of how "traditional" forms and various uses of time have informed a specific notion of Moroccan history and historical consciousness, see Lucette Valensi, "Le roi chronophage: La construction d'une conscience historique dans le Maroc postcolonial," *Cahiers d'Études Africaines* 30, no. 3 (1990): 279–99.

21. Hubert L. Dreyfus and Paul Rabinow, *Michel Foucault: Beyond Structuralism and Hermeneutics*, 2d ed. (Chicago: University of Chicago Press, 1983), 153.

22. In short, how can we determine which symbols might be "activated" by political spectacles? Marc Abélès considers the problem of the deterritorialization of political rituals, but his approach may be just a first step to understanding how the entire framework for viewing space, and not just

politics, is being transformed. This new undertaking will require comparison between groups receiving certain messages; more important, it will force a remapping of the way in which states and other institutions must continually reinterpret what sovereignty means. This complex process of relocation demonstrates the extent to which the "places" from which people receive messages are themselves deterritorialized. See Abélès, *Anthropologie de l'état* (Paris: Armand Colin, 1990), 127.

4. Time's Power

1. For more on patience, particularly with respect to home life in rural Morocco, see Susan Schaffer Davis, *Patience and Power*.

2. Joshua Meyrowitz, for example, claims that live and media communications were previously "vastly dissimilar." He thinks that the more a medium of communication separates the knowledge of different people in society, the more it allows for varied ranks. This is a convincing argument to the extent that "knowing" has to do with power. However, as this chapter suggests, more attention needs to be given to the ways in which nondiscursive aspects of electronic media transform everyday life. See Meyrowitz, *No Sense of Place: The Impact of Electronic Media on Social Behavior* (Oxford: Oxford University Press, 1985).

3. Often the person who determines who chooses a program or a video is the one who has the most authority because of age, sex, or some other quality. However, this is far from a general rule. I have seen few cases in which family members are not given access to radio, television, and other media, although household servants must usually ask permission.

4. Throughout my interviews, journalists and other professionals in the media constantly commented on the issue of timing. They remarked on the problem of hourly versus religious times and, even more often, on the problem of "speeding up" Moroccan programming. It is noteworthy that the period during which I did research (1987–1991) was a crucial one, marked by the introduction of a new aesthetics in radio and television and to a lesser extent in the press. This new approach was inspired by international trends and was often expressed as snappier, faster, more eye-catching than previous styles.

5. E. P. Thompson, "Time, Work-Discipline, and Industrial Capitalism," *Past and Present*, no. 38 (December 1967): 52–92.

6. Ibid.

7. Pierre Bourdieu, "The Attitude of the Algerian Peasant Toward Time," in J. Pitt-Rivers, ed., *Mediterranean Countrymen* (Paris: Mouton, 1963), 55–72.

8. Pierre Bourdieu, *Algerie 60* (Paris: Éditions de Minuit, 1977), 67–81.

9. This question appears paradoxical if we follow the dominant discourse, according to which bureaucracy is antithetical to "old" forms of government. What is remarkable in Morocco is that, although in discourse people often contrast traditional and modern ways of doing things, in practice the distinctions are never so clear-cut. Administrators are aware of the technical advantages offered by modern forms of knowledge, but those forms often receive novel interpretations. For comparisons with other cultures, see Evitar Zerubavel, *Hidden Rhythms* (Chicago: University of Chicago Press, 1981).

10. Leveau, "La Fellah marocain."

11. Recognizing this novel articulation of forces makes us wary of arguments linking the perpetuation of the monarchy to either rural or ritual concerns. For example, the recent arguments put forward by M. E. Combs-Schilling are suggestive, but they do not completely account for the link between politics and ritual in contemporary Morocco. While the importance of ritual in maintaining the power of the monarchy is clear, the details of ritual performance are also used as expressions of opposition. For example, those who belong to the various groups of Muslim "brothers" do not slaughter their rams at the same time as the king does on the $^c id$ holiday. In chapter 7 I discuss some of the ways in which weddings, too, are changing. See Combs-Schilling, *Sacred Performances*; Hannah Davis, "Review of Combs-Schillings' *Sacred Performances*," *MESA Bulletin* 25 (1991): 48–49. For a broader perspective, see David I. Kertzer, *Ritual, Politics, and Power* (New Haven: Yale University Press, 1988).

12. Akhchichine and Eddine Naji, *Le contact avec les médias*, 282.

13. Krzysztof Pomian, *L'ordre du temps* (Paris: Gallimard, 1984), i–xiv.

14. Abdesselam Cheddadi, "Maîtrise du temps (au premiers siècles de l'Islam)," *Signes du Present* (Rabat), no. 4 (1988): 11–13.

15. E. Evans-Pritchard, *The Nuer: A Description of the Modes of Livelihood and Political Institutions of a Nilotic People* (New York: Oxford University Press, 1974).

16. B. Lewis and P. M. Holt, eds., *Historians of the Middle East* (Oxford: Oxford University Press, 1962); Franz Rosenthal, *A History of Muslim Historiography*, 2d ed. (Leiden: E. J. Brill, 1964).

17. For an analysis of the political implications of these "totalities" posited by chronosophy and the role of the Enlightenment in the history of historiography, see Pomian, *L'ordre du temps*, 300–302.

18. See McLuhan, *Understanding Media*.

19. On the "filling" of space and time in the layout of audiovisual and print media, see Raymond Williams, *Communications* (London: Penguin, 1968).

20. Waterbury, *Commander of the Faithful*, 75.

21. The relationship between writing and history is suggestive in this respect; see, for example, Jack Goody, *The Logic of Writing and the Orga-*

nization of Society (Cambridge: Cambridge University Press, 1986), and Walter Ong, *Orality and Literacy: The Technologizing of the Word* (Ithaca: Cornell University Press, 1977). On power strategies and "tactics" of resistance, see Michel de Certeau, *The Practice of Everyday Life* (Berkeley: University of California Press, 1984).

22. See Ossman, "Le cinéma marocain."

23. Bourdieu, *Algerie 60*, 76.

24. The reference is to Milan Kundera's novel *Life Is Elsewhere*.

25. The media are not uniformly available throughout Morocco. Among television networks, the RTM has only recently begun to cover most of the national territory; TV 5 and 2M International are available only in the largest cities, and the latter must be paid for by individual subscribers. Many people claim that the development of these two new channels will force the countryside and the city even further apart. However, the advent of these stations wrought a certain change in the RTM, which put forth more efforts to satisfy demands expressed by media professionals (see chapter 5). Although the uneven distribution of television has been noted, fewer people have commented on regional differences in the density of other forms of mass media and imagery—for instance, posters, neon signs, billboards, and so on—or on the relative difficulty of obtaining printed materials, especially foreign publications.

5. Objects and Objections

1. TV 5 Europe was already available prior to this date in Rabat and Marrakesh.

2. Quoted in Al Haggagi, *Origins of Arabic Theater*, 23.

3. See, for example, Wilbur Schram, *Communication and Change in Developing Countries* (Honolulu: East-West Center Press, 1967).

4. Robert C. Allen, *Speaking of Soap Operas* (Chapel Hill: University of North Carolina Press, 1985), 14, 48–51.

5. See W. Haug, *Critique of Commodity Aesthetics: Appearance and Advertising in Capitalist Society* (Minneapolis: University of Minnesota Press, 1986); Raymond Williams, *Communications* (London: Penguin, 1968).

6. Again, the importance of establishing hierarchies and limits concerning reality is utmost.

7. Barthes, *La chambre claire*, 182.

8. The relationship between religious and erotic desire has often been pointed out; see, for example, Georges Bataille, *L'erotisme* (Paris: Éditions de Minuit, 1957), and Gerard Pommier, *L'ordre sexuel* (Paris: Aubier, 1989).

9. I thank Mounia Bennani for first bringing this way of reading to my attention.

10. Quite often my male informants made clear that while *they* tolerated "modern" subject matter, including sex or humor, on television, the "average Moroccan" did not understand such things. This argument is similar to that which sees the French elections as a sort of school for democracy. Most interesting is the speaker's desire to distance himself (these are always men) from the "average" and appear at once closer to me, or at least to the idea he makes of what I represent as a "Western" woman and researcher. Only women suggested that men may desire to capture all of the "illicit" images for themselves or that they may feel their power to be threatened by such images. See, for example, Geertz, *Meaning and Order.*

11. I will develop this point in further research; see Ossman, "Les salons de beauté."

12. The *Huẕūb* can take on various meanings in different contexts; see Fariba Adelkhah, *La revolutions soius le voile: Femmes islamiques d'Iran* (Paris: Karthala, 1991), 197–215.

13. Ossman, "Les salons de beauté."

14. Dreyfus and Rabinow, *Michel Foucault,* 251.

15. The relationship of truth to ways of recording it and the moral position of the "knower" is presented from the perspective of oral versus literary and pictorial knowledge in Paul Zumthor's study of the relationship between these elements in medieval Christian scholarship (Zumthor, *La lettre et la voix: De la "litterature" medievale* [Paris: Le Seuil, 1987], 138–41).

16. Here I am of course referring to Weber's theory about bureaucracy and rationality. It is important in my study because it has, through its various "modernist" strains, been incredibly influential in shaping local discourse. The march toward rationality, as related to bureaucratic, impersonal procedure, is ever present in Casablancans' conversation. When referring to the field of science, most Casablancans approve of this sort of "rationalization." The idea that such a rationalization would also imply a progressive secularization is much less often brought up. Few people today try to base their social or political criticisms on any reference to secularism (which is not the same as saying that there has not been a secularization of the society). See Max Weber, *The Protestant Ethic and the Spirit of Capitalism,* trans. Talcott Parsons (New York: Scribner's, 1958).

17. Latifa Akharbach, "La presse des parties politiques de gauche au Maroc," thesis, University of Paris 2, 1988, 19–20.

18. This tendency is perhaps linked to the fact that students receive little instruction in world history. Even doctoral students and professors nearly always focus on subjects limited to Morocco or, at most, the Arab World.

19. Akhchichine and Eddine Naji, "Le contact avec les médias."

20. Todd Gitlin, "Television Screens: Hegemony in Transition," in Michael W. Apple, ed., *Cultural and Economic Reproduction in Education:*

Essays on Class, Ideology, and the State (Boston: Routledge and Kegan Paul, 1982), 202–45.

On audience research and theorizing, see also Ien Ang, "Wanted Audiences: On the Politics of Empirical Audience Studies," paper presented to the symposium Rethinking the Audience, University of Tübingen, Blaubeuren, West Germany, February 1987.

21. David Morely and Roger Silverstone, "Domestic Communication: Technologies and Meanings," paper presented to the International Television Studies Conference, British Film Institute, London, 1988.

22. Jamāa Baïda of the University of Mohammed V is currently completing a thesis on the subject of the origins of the press in Morocco. His comments have been helpful in understanding the relationship of the print medium to the introduction of radio and later, of television.

23. Pierre Bourdieu, "Les usages du 'peuple,'" in his *Choses dites* (Paris: Éditions de Minuit, 1989); R. Escarpit, *Théorie generale de l'information et de la communication* (Paris: Hachette, 1976) 165–88.

24. These comments, like others cited, are taken from interviews with journalists. Like the other informants quoted here, they are not named except when I cite specific articles or programs available in Morocco.

The term *journalist* covers a very broad range of meanings in Morocco. For example, people call professional video camera operators who videotape weddings "journalists." What does this imply about how the profession is perceived by the "public"?

25. See Kevin Dwyer, *Moroccan Dialogues* (Baltimore: Johns Hopkins University Press, 1982).

26. Abdellah Laroui, *The Crisis of the Arab Intellectual: Traditionalism or Historicism?* trans. Diarmaid Cammell (Berkeley: University of California Press, 1976).

27. The face-to-face nature of professional contact does depend on which professions are under consideration. Indeed, the varying scale of diverse groups should be taken into consideration in further research.

28. Giddens, *Nation State and Violence*.

29. Susan Ossman, "Le cinéma marocain et l'authenticité."

30. I am referring to the fact that it is illegal to poke fun at the king or national institutions.

31. Olivier Vergniot, "Khatri Ould Joumani: Blagues à part," in Nourreddine Sraïëb, ed., *Pratiques et résistance culturelles au Maghreb* (Paris: CNRS, 1992), 317–38.

32. "Fatneck" apparently refers to a certain highly placed official who is known for his thick neck. See Abd Errafih Jowhri, "Boum Belkefta," *Itihad Al Ichtiraki*, 6 March 1991, 10.

33. Lapidus, *History of Islamic Societies*.

34. The magazine *Kalima* was repeatedly threatened with censorship because it discussed "unsavory" aspects of Moroccan society. For example, the authorities were offended by *Kalima's* coverage of male prostitution, although it is widely known that Marrakesh is a favorite destination for tourists who seek sexual services. On a bus ride a young man explained to me that he liked the *Kalima* article on this subject not because of its sensationalism but because he wanted to know what really happened in that world. He explained to me that his younger brother seemed to be getting involved in such money-making practices. He felt that the publication of this article made it easier for him to approach his brother and try to dissuade him from engaging in prostitution.

35. An analysis of the different uses of Arabic and French for various subjects, whether in conversation or in articles, would be an interesting matter for further research.

36. Peter Brown, "Late Antiquity and Islam: Parallels and Contrasts," in Barbara Daly Metcalf, ed., *Moral Conduct and Authority: The Place of 'adab' in South Asian Islam* (Berkeley: University of California Press, 1984), 23–37.

6. Portraits and Powers

1. It would be interesting to examine the use of the third-person singular in this context. For example, Paul Ricoeur argues that this "third person" assures equity between the "I" and the "you" with respect to promises; in his view, individualism offers the possibility of opening a public space linked to this third person. See Ricoeur, "Individu et identité personelle," in *Sur l'individu* (Paris: Le Seuil, 1987), 54–72.

2. There are many examples of this anonymous *he* in everyday speech. For a recent example in the press, see, 'bd er Rafi' Jouahri, "Slou' la el Hlib," *Al Itihad al Ichtiraki*, 24 March 1990, 10.

3. Rosenthal, *History of Muslim Historiography*, 60.

4. The remarks in this section are based on field research. Only after formulating this problem for myself did I read Jacqueline Sublet's essay on Arabic names during the Middle Ages. Her study similarly draws attention to the way in which names can act as veils. She writes that "the one hundreth name of Allah, the 'supreme name,' remains unknown, either 'huwa' (he) or Allah" (*Le voile du nom: Essai sur le nom propre arabe* [Paris: PUF, 1991], 188).

5. The older traditions of scholarship have not died, but they have been increasingly replaced by new forms, just as the kinds of training and institutions of learning—indeed, the very notion of the role of the scholar—have altered. See Dale Eickelmann, *Knowledge and Power in Morocco: The*

Education of a Twentieth Century Notable (Princeton: Princeton University Press, 1985).

6. See Moulay R'chid, *La femme et la loi*.

7. Latifa Akharbach and Narjis Rerhaye, interview with Khenatha Bennouna, in *Femmes et media* (Casablanca: Le Fennec, 1992), 80.

8. Mernissi, *Doing Daily Battle*, 14.

9. Aihwa Ong, *Spirits of Resistance and Capitalist Discipline: Factory Women in Malaysia* (Albany: State University of New York Press, 1987), 179.

10. Relationships to fathers are discussed in Daisy Hilse Dwyer, *Images and Self-Images: Male and Female in Morocco* (New York: Columbia University Press, 1978).

11. Rosen, *Bargaining for Reality*.

12. This goes back to the issue of *'adab*. See Ira Lapidus, "Knowledge, Virtue, and Action: The Classical Muslim Conception of Adab and the nature of Religious Fulfillment in Islam," in Metcalf, *Moral Conduct and Authority*, 19.

13. Veyne goes on to explain that an offense by the state against an individual is perceived in much the same way as a personal offense by another individual. The person feels attacked in his very identity. We can thus see how "individualism" can coexist with obedience or deference; however, this obedience or deference is calculated and chosen, not blind. See Veyne, "L'individu atteint au coeur par la puissance publique," in Veyne et al., *Sur l'individu* (Paris: Le Seuil, 1987), 7–19.

14. Eickelman, *Knowledge and Power in Morocco*, xv. Eickelman argues that the values shaped by the older system remain important.

15. Jean Baudrillard, *Simulacres et simulations* (Paris: Galilée, 1981), 130.

Michel Foucault says that "social control no longer has to go through a bombardment of moral principles since encouragement to consume normalizes comportment in an equally efficacious manner. But what can one do for those excluded from these modes of consumption? Are they pushed toward a greater marginalism at the same time as they cannot express themselves in the dominant dialect?" ("Entretien avec Michel Foucault," trans. Renée Morel, *History of the Present* [Berkeley], February 1985, 2–3, 14).

In Casablanca, the problem is that both of these remarks can be held to be true for only parts of the population at certain times. The notion of the "deep subject" that speaks is problematic in a situation in which speech is overtly limited by both political and social power. And while many people are excluded from the consumption of many material goods, the invasion of

urban spaces by mass imagery can "normalize" comportment but also intensify some groups' desire to hold on to "moral principles" that may or may not correspond to their real practices and social constraints.

16. Jean Noël Ferrié and Saadia Radi, "Convenance sociale et vie privée dans la société musulmane immigrée," *Annuaire de l'Afrique du Nord*, 27 (1988): 230. The *fātiHa* is the opening verse of the Koran. It is recited to begin all manner of events and is known by heart by all Moroccans I've met, even some who are not Muslim.

17. For more on the "bourgeois" style as developed in France, see Philippe Perrot, "Pour une généologie de l'austerité des apparences," *Communications*, no. 46 (1987): 157–80.

18. Pierre Bourdieu's work on taste in France is instructive on the relationship between social position and aesthetic preferences. We should not, however, imagine that Moroccan (or perhaps European) society bases social position on *class* as clearly as Bourdieu suggests. See Bourdieu, *Distinction: A Social Critique of the Judgement of Taste*, trans. Richard Nice (Cambridge: Harvard University Press, 1984).

19. Quoted in Al Haggagi, *Origins of Arabic Theater*, 63.

20. *Šuwwāfā*, taken from the word meaning "to see," is the word for fortune-teller or seer. The evil eye, which can be aimed only at those it can catch sight of, expresses desire and jealousy. The image of an eye is also a sign of protection.

21. *L'Opinion des Jeunes*, 13 April 1989, 4–6.

22. Ibid.

23. Ibid.

24. Ibid.

25. Ibid.

26. Gilles Lipovetsky, *L'empire de l'ephémère: La mode et son déstin dans les sociétés modernes* (Paris: Gallimard, 1987), 151.

27. In Moha Souag's novel *Les années U.* (Rabat: Al Kalam Éditions, 1988), one of the characters turns out to be precisely in this situation. Among the typical figures of the militant student, the loose girl, and the more prim classmate, the dragueur is shown to be a lowlife who corrupts women using objects that he doesn't really possess. The issue of possession is provocative, because the "dragueur" is ostensibly offering the use of his "material" (including, we assume, his own body) in exchange for possessing the women he flirts with. By whom is he in turn possessed? I will give this question close attention in further studies.

28. For example, see June Nash, *We Eat the Mines and the Mines Eat Us: Dependency and Exploitation in Bolivian Tin Mines* (New York: Columbia University Press, 1979).

29. Again, the issue of labor as confined to the workplace must be questioned. For interesting comments and comparisons, particularly concerning young working girls, see Aihwa Ong, *Spirits of Resistance.*

30. Morocco's wealth of "statistics" on all manner of things is of little help in understanding who does what and why, because these figures have been gathered on the premise of divisions of experience and thought that objectify certain acts or conditions in a way that is divorced from social relations as a whole.

7. Take My Picture! Wedding Videos and Invisible Brides

1. Hans-Dieter Rath, "Your Life Please! Autobiographical Moments in Television Programs," paper presented to the International Television Studies Conference, British Film Institute, London, July 1988, 1.

2. Barthes, *Camera Lucida.* Again we come across the relationship between photography and death that Barthes evokes. For more on photography and social position, see Pierre Bourdieu, *Un art moyen: Essai sur les usages sociaux de la photographie* (Paris: Éditions de Minuit, 1965).

3. Many of the hopes and patterns for thinking about romance must surely be changing with the influence of both photo-romans and television. Fatima Mernissi has collected some thoughts and many quotes on the subject from classical Arabic literature in *L'amour dans les pays musulmans* (Casablanca: Éditions Maghrebines, 1985). The importance of the novel in the development of courting rituals and discourses in Europe is described in Isabelle Grellet and Caroline Kruse, *La déclaration de l'amour* (Paris: PLON, 1990).

4. This is not to suggest that family ties have diminished in intensity, but simply that relatively more emphasis is placed on the separate life of the couple. Many people visit their families regularly, and one young bride I met spent every day at her mother's home. (Her husband picked her up there after work.)

5. Vincent Crapanzano, *Tuhami, Portrait of a Moroccan* (Chicago: University of Chicago Press, 1980).

6. For an exposé of the "nefarious" effects of "modern" women, especially female television announcers, see Idris El-Kettani, *Al-talfaza al maghribiyya wal-ghazw al lughawi al alibi al fransawi lil-maghrib* (Rabat: Nadi al-fikr al-islami, 1406H).

7. "Living together"—indeed, any sexual intercourse outside of marriage—is formally illegal in Morocco. Many people have made a point of telling me that people have sexual relationships but hide them from public view. I have no way of knowing the truth of this matter, my only evidence being a few anecdotes, and I am not sure that it is really an issue of who "does"

what. Most of those who claim to tell me about how it "really is" seem to be trying to argue that Moroccan youths are as "evolved" as those they imagine living in America or France. Sometimes they seem themselves to be involved in perplexing sexual situations.

8. Peter Burke, "Historians, Anthropologists, and Symbols," in Emiko Ohnuki-Tierney, ed., *Culture Through Time: Anthropological Approaches* (Stanford: Stanford University Press, 1990), 282.

Drawing Conclusions

1. Mitchell, *Colonising Egypt*; Rabinow, *French Modern*.

2. Guy Gauthier remarks that the Western preference for rectangular frames perhaps reveals an incarcerating mentality; it might likewise be related to utopian ideas that posit ideal spaces separate from the here and now. See Gauthier, *Vingt leçons sur l'image et le sens* (Paris: Edlig, 1986), 15; see also Susan Ossman, "La télévision et les cadres dans la vie quotidienne des casablancais," *L'image dans le monde arabe*, special issue of *l'Annuaire de l'Afrique du Nord*, ed. Gilbert Beaugé, forthcoming.

3. For a critique of work on political ritual and reflective theory, see Marc Abélès, "Mises en scene et rituels politiques: Une approche critique," *Hérmès* 8–9 (1990): 241–59.

4. Michel Foucault, *Surveiller et punir: Naissance de la prison* (Paris: Gallimard, 1975), 215–16.

5. Barthes, *La chambre claire*, 143.

6. The aesthetic of Koranic recitation goes beyond formal religious settings. See Jean-Noël Ferrié, "Disposer de la régie: Anthropologie religieuse d'un réseau social marocain du point de vue du du'a'," doctoral dissertation, Université de Droit, d'Économie et des Sciences d'Aix-Marseille, 1993.

7. Clifford Geertz, "Center, King, and Charisma: Symbolics of Power," in *Local Knowledge: Further Essays in Interpretive Anthropology* (New York: Basic Books, 1983), 122–23.

8. This complex question is at the heart of studies of colonialism and of power imbalances between the "center" and the "periphery." It merits further detailed study in the context of Casablanca.

9. This tendency is well represented in the editorials of *Le Matin du Sahara*, but it is not confined to any single political or social milieu.

10. Erving Goffman, *Interaction Ritual: Essays on Face-to-Face Behavior* (New York: Pantheon, 1967), 5.

11. Lipovetsky, *L'empire de l'éphémère*, 12.

12. Gauthier comments that the polysemic nature of images makes it easy to avoid selecting any single meaning for them. Unlike language, they cannot

express functions of choice because they propose only additions of meaning, not lines that make one select a single meaning: that is, images can express "and" but not "or." The issue is not, however, one of images as opposed to words, but of how we allow or do not allow images to be given novel meanings, and "stronger" ones, through naming. See Gauthier, *Vingt leçons*, 188. For another viewpoint on the relationship of words and pictures, see Paul Virilio's recent work *L'art du moteur* (Paris: Galilée, 1993).

13. Eco, *Limits of Interpretation*, 41.

14. The recent case of "Commisaire Tabit" is an astounding example of this fascination with liminality. Tabit, a Casablanca police chief, used his position to abduct hundreds of women, abusing them all while fastidiously videotaping his activities. His trial during early 1993 was passionately followed throughout Morocco.

15. The king also said, "We have decided that at the smallest sign—I will not say the slightest perturbation—we will proclaim a state of siege" (*Le Matin du Sahara*, 17 January 1991, 2). During the war Moroccans obtained information from the newspapers *al'lm, Al itihad al ichtiraki, Le Matin du Sahara*, and *L'Opinion* as well as some foreign newspapers, particularly *Liberation, Le Monde*, and the *International Herald Tribune*.

16. This point could form the topic for an entire book, including the implications of these continuing alliances since the end of the war. See, for example, *Paysage après la bataille, contre la guerre des cultures*, special issue of *Esprit / Cahiers de L'Orient* (Paris), no. 172 (1991). It is interesting that during the Gulf War the concept of the *?umma* became a matter of heated debate in France and consequently in Morocco through the French press. See Fehti Ben Slama, "A propos de l'Oumma: Réponse à Daniel Sibony," in *Paysage après la bataille*, 53–60.

17. See Susan Ossman, "Saying Spaces: Casa, New York, Paris, and the Gulf War," in Susan Slyomovics and Tom Zummer, eds., *Caricatures of War* (forthcoming), and "La demonstration des sentiments: Les slogans contre la guerre du golfe au Maroc," *Les Cahiers de l'Orient* (forthcoming). For an "Algerian" perspective, see Susan Slyomovics, "Algeria Caricatures the Gulf War," *Public Culture* 4, no. 2 (1992): 93–100.

18. According to Jean-Noël Ferrié, the difficulty of publicly stating unorthodox opinions is characteristic of Moroccan society. See Ferrié, "Disposer de la regle."

19. Jean Comaroff, *Body of Power, Spirit of Resistance: The Culture and History of a South African People* (Chicago: University of Chicago Press, 1985), 254.

20. History has been called on as the source of values that help people exploited by the international system of capital to find courage and persevere. June Nash writes that for Bolivian tin miners, "Rituals from the pre-

conquest can reinforce identity of a people in such a way as to strengthen their resistance to external domination. The same ritual acted out in a changed historical context can have a new meaning" (*We Eat the Mines*, 39). However, this is just as true of the rituals of those in power as it is of those of the "oppressed." Yves Gonzalez-Quijano and I have suggested how scholarship in the Arab world might look at new objects of study to develop novel approaches to issues of domination in the contemporary context. See Gonzalez-Quijano and Ossman, "Les nouvelles cultures dans le monde arabe," *Les Cahiers de l'Orient*, no. 20 (1990): 161–67. In a recent article Mohammed Tozy takes up the study of the popular use of political images: Tozy, "Orient et Occident dans l'imaginaire politique d'un babouchier de Fès. Essai de lectures sur un mur d'images," in Kacem Basfao and Jean-Robert Henry, eds., *Le Maghreb, l'Europe et la France* (Paris: CNRS, 1992), 237–50.

21. Michel de Certeau, *L'invention de quotidien*, vol. 1 *Arts de faire* (Paris: Gallimard, 1980).

22. W. B. Yeats, "The Second Coming," in his *Collected Poems* (New York: Macmillan, 1977), 184.

23. Roger Sanjek, "The Ethnographic Present," *Man* 26 (1991): 613.

24. This means considering how those who study culture and society help to create these concepts. It does not imply that we engage in simple processes of deconstruction ad infinitum. See Paul Rabinow, "Beyond Ethnography: Anthropology as Nominalism," *Cultural Anthropology* 3 (1988): 359–60.

25. Pierre Bourdieu illustrates the connection between social positions and moral attitudes toward art in several of his works, but this approach cannot account for how people "relate" to images.

26. Max Weber, "Religious Rejections of the World and Their Directions," in his *From Max Weber: Essays in Sociology*, ed. H. H. Gerth and C. Wright Mills (New York: Oxford University Press, 1977), 342. Note the similar role given to "Art" by Habermas as well as Bourdieu's criticism of Kantian "disinterest" in his *Distinction*.

27. "Wholes and forms are combinations, the places or aspects of the possible, not the reflection of a limited number of categories and representative of the universe's entire order" (Francastel, *L'image*, 27).

28. Pierre Bourdieu, *Ce que parler veut dire l'économie des échanges linguistiques* (Paris: Fayard, 1982), 152.

SELECTED BIBLIOGRAPHY

Abélès, Marc. *Anthropologie de l'état*. Paris: Armand Colin, 1991.
———. "Anthropologie politique de la modernité." *L'homme*, January–March 1992, 15–30.
———. "Mises en scène et rituels politiques: Une approche critique." *Hérmès* 8–9 (1990): 241–59.
———. "Modern Political Ritual." *Current Anthropology* 29 (1990): 391–404.
Abu-Lughod, Janet. *Rabat: Urban Apartheid in Morocco*. Princeton: Princeton University Press, 1980.
Abun-Nasr, Jamil. *A History of the Maghreb*. 2d ed. Cambridge: Cambridge University Press, 1975.
Adam, André. *Essai sur la transformation de la société marocaine au contact de l'occident*. Paris: CNRS, 1968.
Adelkhah, Fariba. *La révolution sous le voile*. Paris: Karthala, 1990.
Agulhon, Maurice. *Marianne au pouvoir*. Paris: Flammarion, 1989.
———. "Marianne devoilée." *Terrain*, no. 15 (October 1990): 91.
Akharbach, Latifa. "La presse de parties politiques de gauche au Maroc." Thesis, University of Paris 2, 1988.
Akharbach, Latifa, and Narjis Rerhaye. *Femmes et media*. Casablanca: Le Fennec, 1992.
Akhchichine, Ahmed, and Jamal Eddine Naji. *Le contact avec les médias au Maroc: Étude sur les publics à El Kelaa*. Thesis, University of Paris 2, 1982.
Alaroussi, Moulim. *Esthétique et art islamique*. Casablanca: Afrique-Orient, 1991.
Allen, Robert C. *Speaking of Soap Operas*. Chapel Hill: University of North Carolina Press, 1985.

Anderson, Benedict. *Imagined Communities: Reflections on the Origin and Spread of Nationalism*. London: Verso, revised edition, 1991.

Ang, Ien. "Wanted Audiences: On the Politics of Empirical Audience Studies." Paper presented to the symposium Rethinking the Audience, University of Tübingen, Blauberen, West Germany, February 1987.

Baïda, Jamāa. "Situation de la presse au Maroc sous le 'proconsulat' de Lyautey (1912–1925)." *Hesperis-Tamuda* 30, no. 1 (1992): 67–92.

Balandier, Georges. *Le desordre: Éloge du mouvement*. Paris: Fayard, 1988.

Barthes, Roland. *Le chambre claire: Notes sur la photographie*. Paris: Gallimard, Le Seuil, and Cahiers du Cinéma, 1979. English trans.: *Camera Lucida: Reflections on Photography*. Trans. Richard Howard. New York: Hill and Wang, 1983.

Bataille, Georges. *L'erotisme*. Paris: Éditions de Minuit, 1957.

Baudrillard, Jean. *Simulacres et simulations*. Paris: Galilée, 1981. English trans.: *Simulations*. Trans. Paul Foss, Paul Patton, and Philip Beitch. New York: Semiotext(e), 1983.

Benihya, Mohammed. "Ces Bèrbères oubliés." *Al Asas* (Rabat), no. 29 (1981): 26–30.

Benjamin, Walter. "The Work of Art in the Age of Mechanical Reproduction." In his *Illuminations*, 217–52. New York: Schocken, 1969.

Bennani-Chraïbi, Mounia. "Les représentations des jeunes marocains." Thesis, Institut d'Études Politiques de Paris, 1993.

Berger, John. *Ways of Seeing*. London: Penguin, 1972.

Berque, Jacques. *De l'Euphrate à l'Atlas*. Vol. 1, *Espaces et moments*. Paris: Sindbad, 1978.

———. *Le Maghreb entre deux guerres*. Paris: Le Seuil, 1980. English trans.: *French North Africa: The Maghrib Between Two World Wars*. Trans. Jean Stewart. London: Faber and Faber, 1962.

Berriane, Mohammed. *Tourisme national et migrations de loisirs en Maroc (étude géographique)*. Rabat: Presse de la Faculté des Lettres et des Science Humaines, 1992.

Boucherit, Aziza. "Complexités linguistiques des programmes à la télévision algerienne. Essai d'analyse d'une production locale." *Revue de l'Occident Musulman et de la Méditerranée*, ed. François Chevaldonné, no. 47 (1988): 35–46.

Boughali, Mohamed. *La représentation de l'éspace chez le marocain illettré*. Paris: Anthropos, 1974.

Boulanger, Pierre. *Le cinéma colonial de l'Atlantide à Laurence d'Arabie*. Paris: Seghers, 1975.

Bourdieu, Pierre. *Algerie 60*. Paris: Éditions de Minuit, 1977.

———. *Un art moyen: Essai sur les usages sociaux de la photographie*. Paris: Éditions de Minuit, 1965.

————. "The Attitude of the Algerian Peasant Toward Time." In J. Pitt-Rivers, ed., *Mediterranean Countrymen*, 55–72. Paris: Mouton, 1963.

————. *Ce que parler veut dire l'économie des échanges linguistiques*. Paris: Fayard, 1982.

————. *Choses dites*. Paris: Éditions de Minuit, 1989.

————. *La distinction: Critique sociale du jugement*. Paris: Éditions de Minuit, 1979. English trans.: *Distinction: A Social Critique of the Judgement of Taste*. Trans. Richard Nice. Cambridge: Harvard University Press, 1984.

————. *Réponses avec Loïc J. D. Wacquant*. Paris: Le Seuil, 1992.

Bromberger, Christian. "Paraître en public." *Terrain*, no. 15 (October 1990): 5–12.

Brown, Kenneth L. *The People of Sale: Tradition and Change in a Moroccan City, 1830–1930*. Cambridge: Harvard University Press, 1976.

Brown, Peter. *The Cult of the Saints: Its Rise and Function in Latin Christianity*. Chicago: University of Chicago Press, 1979.

————. "Late Antiquity and Islam: Parallels and Contrasts." In Barbara Daly Metcalf, ed., *Moral Conduct and Authority: The Place of 'adab' in South Asian Islam*, 23–37. Berkeley: University of California Press, 1984.

Burke, Edmond, III. "The Image of the Moroccan State in French Ethnological Literature: A New Look at the Origins of Lyautey's Berber Policy." In Ernest Gellner and Charles Micaud, eds., *Arabs and Berbers: From Tribe to Nation in North Africa*, 1175–1200. London: Duckworth, 1972.

————. *Prelude to Protectorate in Morocco: Precolonial Protest and Resistance, 1860–1912*. Chicago: University of Chicago Press, 1976.

Caro-Baroja, Julio. "The City and the Country: Reflexions on Some Ancient Commonplaces." Trans. Carol Horning. In J. Pitt-Rivers, ed., *Mediterranean Countrymen*. Paris: Mouton, Maison des Sciences de l'Homme, 1963.

Certeau, Michel de. *The Practice of Everyday Life*. Berkeley: University of California Press, 1984.

Chartier, Roger. *Lectures et lecteurs dans la France d'ancien régime*. Paris: Le Seuil, 1987.

Cheddadi, Abdessellam. "Maîtrise du temps (au premiers siècles de l'Islam)." *Signes du Present*, no. 4 (1988): 11–14.

Cherifi, Rachida. *Le Makhzen politique au Maroc*. Casablanca: Afrique-Orient, 1988.

Chevaldonné, François. "Médias et développement socio-culturel: Pour une approche pluraliste." In *Lunes industrielles: Les médias dans le monde arabe*, special issue of *Revue de l'Occident Musulmane et de la Mediterrannee*, no. 1 (1988): 11–22.

Chevallier, Jacques. "A la recherche du cinéma nord africain." *IFOCEL Informations*, no. 40 (1951): 6–7.

Clement, Jean-François. "Maroc: Les menaces et les composantes internes de la sécurité." In Jean-Claude Santucci, ed., *Le Maroc actuel: Une modernisation au miroir de la tradition?* 393–406. Paris: CNRS, 1992.

Comaroff, Jean. *Body of Power, Spirit of Resistance: The Culture and History of a South African People*. Chicago: University of Chicago Press, 1985.

Combs-Schilling, M. E. *Sacred Performances: Islam, Sexuality, and Sacrifice*. New York: Columbia University Press, 1989.

Crapanzano, Vincent. *The Hamadsha: A Study in Moroccan Ethnopsychiatry*. Berkeley: University of California Press, 1973.

———. *Tuhami, Portrait of a Moroccan*. Chicago: University of Chicago Press, 1980.

Dakhlia, Jocelyne. "Dans la mouvance du prince: La symbolique du pouvoir itinérant au Maghreb." *Annales ESC*, May–June 1988, 735–60.

Davis, Hannah. "American Magic in a Moroccan Town." *Middle East Report*, July–August 1989, 12–17.

———. Review of M. E. Combs-Schilling, *Sacred Performances*. *MESA Bulletin* 25 (1991): 48–49.

Davis, Susan Schaffer. *Patience and Power: Women's Lives in a Moroccan Village*. Cambridge, Mass.: Schenkman, 1983.

Dreyfus, Hubert L., and Paul Rabinow. *Michel Foucault: Beyond Structuralism and Hermeneutics*. 2d ed. Chicago: University of Chicago Press, 1983.

Dumont, Louis. *Essays on Individualism: Modern Ideology in Anthropological Perspective*. Chicago: University of Chicago Press, 1986.

Dwyer, Daisy Hilse. *Images and Self-Images: Male and Female in Morocco*. New York: Columbia University Press, 1978.

Dwyer, Kevin. *Moroccan Dialogues*. Baltimore: Johns Hopkins University Press, 1982.

Eco, Umberto. *The Limits of Interpretation*. Bloomington: Indiana University Press, 1990.

———. *Travels in Hyper Reality*. New York: Harcourt Brace Jovanovich, 1986.

Eickelman, Dale. *Knowledge and Power in Morocco: The Education of a Twentieth Century Notable*. Princeton: Princeton University Press, 1985.

———. *The Middle East: An Anthropological Approach*. Englewood Cliffs, N.J.: Prentice Hall, 1981.

———. *Moroccan Islam: Tradition and Pilgrimage in a Pilgrimage Center*. Austin: University of Texas Press, 1976.

Eickelman, Dale, and James Piscatori, eds. *Muslim Travelers: Pilgrimage, Migration, and the Religious Imagination*. Berkeley: University of California Press, 1990.

Eisenstein, Elizabeth. *The Printing Revolution in Early Modern Europe*. Cambridge: Cambridge University Press, 1983.

Elboudrari, Hassan, ed. *Modes de transmission de la culture religieuse en Islam*. Cairo: Institut français d'archéologie du Caire, 1993.

Ennaji, Mohammed. "État, société, pénétration marchande dans le Maroc du XIXe siècle." In Jean-Claude Santucci, ed., *Le Maroc actuel: Une modernisation au miroir de la tradition?* 17–49. Paris: CNRS, 1992.

"Entretien avec Michel Foucault." Trans. Renée Morel. *History of the Present* [Berkeley], February 1985, 2–3, 14.

Escarpit, R. *Théorie général de l'information et de la communication*. Paris: Hachette, 1976.

Evans-Pritchard, E. *The Nuer: A Description of the Modes of Livelihood and Political Institutions of a Nilotic People*. New York: Oxford University Press, 1974.

Fabian, Johannes. *Time and the Other: How Anthropology Makes Its Object*. New York: Columbia University Press, 1983.

Favret-Saada, Jeanne. "L'embrayeur de violence: Quelques mécanismes thérapeutiques de désorcelement." In J. Contreras and Jeanne Favret-Saada, eds., *Le moi et l'autre*, 95–125. Paris: Denoel, 1985.

Fawzi, Abderazak. "The Kingdom of the Book: The History of Printing as an Agency of Change in Morocco Between 1865 and 1912." Ph.D. diss., Boston University, 1990.

Ferrié, Jean-Noël. "Disposer de la regle: Anthropologie religieuse d'un réseau social marocain du point de vue du du'a'." Doctoral dissertation, Université de Droit, d'Économie et des Sciences d'Aix-Marseille, 1993.

Ferrié, Jean-Noël, and Saadia Radi. "Convenance sociale et vie privée dans la société musulmane immigrée." *Annuaire de l'Afrique du Nord* 27 (1988): 229–34.

Fiske, John. "Television: Polysemy and Popularity." *Critical Studies in Mass Communication* 3, no. 4 (1986): 391–407.

Foucault, Michel. *Le souci de soi*. Vol. 3 of *Histoire de la sexualité*. Paris: Gallimard, 1984.

———. *Surveiller et punir: Naissance de la prison*. Paris: Gallimard, 1975. English trans.: *Discipline and Punish: The Birth of the Prison*. New York: Vintage, 1979.

———. *L'usage des plaisirs*. Vol. 2 of *Histoire de la sexualité*. Paris: Gallimard, 1984. English trans.: *The Use of Pleasure*. New York: Pantheon, 1985.

Francastel, Pierre. *Études de sociologie de l'art*. Paris: Denoël, Gonthier, 1970.

———. *L'image, la vision et l'imagination: De la peinture au cinema*. Paris: Denoël, Gonthier, 1983.

———. *Peinture et société*. Lyon: Audin, 1951.

Gauthier, Guy. *Vingt leçons sur l'image et le sens*. Paris: Edlig, 1986.

Geertz, Clifford. *The Interpretation of Cultures*. New York: Basic Books, 1973.

———. *Islam Observed*. New Haven: Yale University Press, 1968.

———. *Local Knowledge: Further Essays in Interpretive Anthropology*. New York: Basic Books, 1983.

Geertz, Clifford, H. Geertz, and L. Rosen. *Meaning and Order in Moroccan Society*. Cambridge: Cambridge University Press, 1979.

Gellner, Ernest. *Muslim Society*. Cambridge: Cambridge University Press, 1981.

———. *Saints of the Atlas*. Chicago: University of Chicago Press, 1969.

Giddens, Anthony. *The Nation State and Violence*. Berkeley: University of California Press, 1987.

Gilsenan, Michael. *Recognizing Islam*. New York: Pantheon, 1982.

Gitlin, Todd. "Television Screens: Hegemony in Transition." In Michael W. Apple, ed., *Cultural and Economic Reproduction in Education: Essays on Class, Ideology, and the State*, 202–45. Boston: Routledge and Kegan Paul, 1982.

Goffman, Erving. *Interaction Ritual: Essays on Face-to-Face Behavior*. New York: Pantheon, 1967.

———. *The Presentation of Self in Everyday Life*. New York: Anchor, 1959.

Gonzalez-Quijano, Yves. "Les enjeux politiques de la culture." In *Les nouvelles questions d'Orient*, 210–15. Paris: Les Cahiers de l'Orient / Hachette, 1991.

———. "La littérature des trottoirs et l'invention du livre islamique." *Les Cahiers de L'Orient*, no. 20 (1990): 169–80.

Gonzalez-Quijano, Yves, and Susan Ossman. "Les nouvelles cultures dans le monde arabe." *Les Cahiers de l'Orient*, no. 20 (1990): 161–67.

Goody, Jack. *The Logic of Writing and the Organization of Society*. Cambridge: Cambridge University Press, 1986.

Grellet, Isabelle, and Caroline Kruse. *La déclaration de l'amour*. Paris: PLON, 1990.

Habermas, Jürgen. *The Theory of Communicative Action*. Vol. 1, *Reason and the Rationalization of Society*. Boston: Beacon, 1984.

Hadraoui, Touria. "Ces petites qui travaillent pour nous." *Kalima*, November 1988, 16–19.

Al Haggagi, Ahmed Shams el-edin. *The Origins of Arabic Theater*. Cairo: General Egyptian Book Organizations, 1981.

Hall, Stuart. "Encoding and Decoding in the Television Discourse." In S. Hall, A. Lowe, and P. Willis, eds., *Culture, Media, Language*, 128–38. London: Hutchinson, 1980.

Hammoudi, Abdellah. *Le victime et ses masques: Essai sur le sacrifice et les mascarades au Maroc*. Paris: Le Seuil, 1989.

Haug, W. F. *Critique of Commodity Aesthetics: Appearance and Advertising in Capitalist Society*. Minneapolis: University of Minnesota Press, 1986.

Hermassi, Elbaki. *The Third World Reassessed*. Berkeley: University of California Press, 1980.

Hobsbawm, Eric, and Terrence Ranger, eds. *The Invention of Tradition*. Cambridge: Cambridge University Press, 1983.

Hourani, Albert. *Arabic Thought in the Liberal Age 1798–1939*. London: Oxford University Press, 1962.

Ibn Khaldun. *The Muqaddimah: An Introduction to History*. Trans. Franz Rosenthal. Ed. N. J. Davood. Princeton: Princeton University Press, 1967.

———. *Le voyage d'occident et d'orient*. (French translation of *Safara el garb w el šrq*.) Introduction by Abdessellam Cheddadi. Paris: Sindbad, 1980.

Jamous, Raymond. *Honneur et baraka: Les structures sociales traditionelle dans le Rif*. Cambridge: Cambridge University Press; Paris: Les Éditions de la Maison des Sciences de l'Homme, 1981.

———. *Interdit, violence et baraka: Le problème de la souveraineté dans le Maroc traditionel*. Paris: CNRS, 1981.

Kandiyoti, Deniz. "End of Empire: Turkey." In Kandiyoti, ed., *Women, Islam, and the State*, 22–47. Philadelphia: Temple University Press, 1991.

Kantorowicz, Ernst H. *The King's Two Bodies: A Study in Medieval Political Theology*. Princeton: Princeton University Press, 1957.

Keddie, Nikki R., ed. *Scholars, Saints, and Sufis: Muslim Religious Institutions since 1500*. Berkeley: University of California Press, 1972.

Kertzer, David I. *Ritual, Politics, and Power*. New Haven: Yale University Press, 1988.

Lakhsassi, Abderrahmane. "Ibn Khaldun." In Seyyed Hossein Nasr and Oliver Leaman, eds., *The Routledge History of Islamic Philosophy*. London: Routledge and Kegan Paul, forthcoming.

———. "Réflexions sur la mascarade de Achoura." *Signes du Present* (Rabat), no. 6 (1989): 31–39.

Lapidus, Ira M. *A History of Islamic Societies*. Cambridge: Cambridge University Press, 1988.

————. *Muslim Cities in the Later Middle Ages*. Cambridge: Cambridge University Press, 1967.

Laroui, Abdellah. *The Crisis of the Arab Intellectual: Traditionalism or Historicism?* Trans. Diarmaid Cammell. Berkeley: University of California Press, 1976.

————. *L'idéologie arabe contemporaine*. Paris: Maspero, 1967.

Leglise, Paul. *Histoire de la politique du cinéma français*. Paris: R. Pinchon and R. Durand, 1970.

Leveau, Rémy. *Le Fellah marocain: Défenseur du trône*. 2d ed. Paris: Presses Nationale des Sciences Politiques, Paris, 1985.

————. "Pouvoir politique et pouvoir économique dans le Maroc d'Hassan II." *Les Cahiers de l'Orient*, no. 6 (1987): 31–42.

————. "Quel avenir pour la présence culturelle française dans le monde arabe." *Esprit / Cahiers de L'Orient*, no. 172 (1991): 108–32.

Lewis, B., and P. M. Holt, eds. *Historians of the Middle East*. Oxford: Oxford University Press, 1962.

Lipovetsky, Gilles. *L'empire de l'ephémère: La mode et son destin dans les sociétés modernes*. Paris: Gallimard, 1987.

McLuhan, Marshall. *Understanding Media: The Extension of Man*. London: Penguin, 1964.

El Malti, Mohammed, Fedel Guerraoui, and Hassan Bahi. "Habitat clandestin." *Signes du Present* (Rabat), no. 3 (1988): 49–51.

Marçais, George. *L'art musulman*. 2d ed. Paris: PUF, 1981.

Mattelart, Armand. *Multinationales et systèmes de communication*. Paris: Anthropos, 1976.

Maxwell, Gavin. *Lords of the Atlas*. London: Century, 1966.

Meddeb, Abdelwahab. "L'icone et la lettre." *Cahiers du Cinéma*, nos. 278–79 (1977): 81.

Mernissi, Fatima. *L'amour dans les pays musulmans*. Casablanca: Éditions Maghrebines, 1985.

————. *Doing Daily Battle: Interviews with Moroccan Women*. Trans. Mary Jo Lakeland. London: Women's Press, 1988.

————. *Sex, Ideology, Islam*. Cambridge, Mass.: Schenkman, 1987.

Metcalf, Barbara Daly, ed. *Moral Conduct and Authority: The Place of 'adab' in South Asian Islam*. Berkeley: University of California Press, 1984.

Meyrowitz, Joshua. *No Sense of Place: The Impact of Electronic Media on Social Behavior*. Oxford: Oxford University Press, 1985.

Miller, Susan Gilson. *Disorienting Encounters: Travels of a Moroccan Scholar in France in 1845–1846*. Berkeley: University of California Press, 1992.

Mitchell, Timothy. *Colonising Egypt*. Cambridge: Cambridge University Press, 1988.

Morely, David, ed. *The Nationwide Audience*. London: British Film Institute, 1980.

Morely, David, and Roger Silverstone. "Domestic Communication: Technologies and Meanings." Paper presented to the International Television Studies Conference, British Film Institute, London, 1988.

Morin, Edgar. *Le cinéma et l'homme imaginaire*. Paris: Éditions de Minuit, 1956.

El Moudden, Abderrahman. "État et société rurale à travers la harka au Maroc du XIXe siècle." *Maghreb Review* 8, nos. 5–6 (1983): 141–45.

Moujid, Rahal. *L'agence urbaine de Casablanca*. Casablanca: Afrique-Orient, 1989.

Moulay R'chid, Abderrazak. *La femme et la loi au Maroc*. Casablanca: United Nations University and Le Fennec, 1991.

Musée des Arts d'Afrique et d'Océanie. *Broderies marocaines, textiles*. Tours: Presses de Mame, 1991.

Naamane-Gessous, Soumaya. *Au-delà de toute pudeur: La sexualité feminine au Maroc*. Casablanca: Eddif, 1987.

Naciri, Mohammed. "Regard sur l'évolution de la citadinité au Maroc." In K. Brown et al., eds., *Middle Eastern Cities in Comparative Perspective / Points de vue sur les villes du Maghreb et du Machrek*, 249–70. London: Ithaca Press, 1986.

Nash, June. *We Eat the Mines and the Mines Eat Us: Dependency and Exploitation in Bolivian Tin Mines*. New York: Columbia University Press, 1979.

Norman, D. "Les expéditions de Moulay Hassan: Essai de statistique." *Hespéris-Tamuda* 19 (1980–81): 123–52.

Ohnuki-Tierney, Emiko, ed. *Culture Through Time: Anthropological Approaches*. Stanford: Stanford University Press, 1990.

Ong, Aihwa. *Spirits of Resistance and Capitalist Discipline: Factory Women in Malaysia*. Albany: State University of New York Press, 1987.

Ong, Walter. *Orality and Literacy: The Technologizing of the Word*. Ithaca: Cornell University Press, 1977.

Ossman, Susan. "Le cinéma marocain et l'authenticité: Discours et image." *Les Cahiers de l'Orient*, no. 18 (1990): 175–88.

———. "Les salons de beauté au Maroc." *Les Cahiers de l'Orient*, no. 20 (1990): 181–89.

———. "S.O.S. Racisme: Studied Disorder in France." *Socialist Review* 18, no. 2 (1988): 39–53.

Pandolfo, Stefania. "Detours of Life: Space and Bodies in a Moroccan Village." *American Ethnologist* 16, no. 1 (1989): 3–23.

Perrot, Philippe. "Pour une généologie de l'austerité des apparences." *Communications*, no. 46 (1987): 157–80.

Pinson, Daniel. *Modèles d'habitat et contra-types domestiques au Maroc.* Tours: URBAMA, 1992.

Pomian, Krzysztof. *L'ordre du temps.* Paris: Gallimard, 1984.

Pommier, Gerard. *L'ordre sexuel.* Paris: Aubier, 1989.

Pourcher, Yves. "Un homme, une rose à la main." *Terrain,* no. 15 (October 1990): 77–90.

Rabinow, Paul. "Beyond Ethnography: Anthropology as Nominalism." *Cultural Anthropology* 3 (1988): 355–64.

———. *French Modern: Norms and Forms of the Social Environment.* Cambridge: MIT Press, 1989.

———. *Symbolic Domination: Cultural Form and Historical Change in Morocco.* Chicago: University of Chicago Press, 1975.

Rath, Hans-Dieter. "Your Life Please! Autobiographical Moments in Television Programs." Paper presented to the International Television Studies Conference, British Film Institute, London, July 1988.

Rice, David Talbot. *Islamic Art.* Rev. ed. London: Thames and Hudson, 1975.

Ricoeur, Paul. "Individu et identité personelle." In Ricoeur et al., *Sur l'individu,* 7–19. Paris: Le Seuil, 1986.

Rosen, Lawrence. *Bargaining for Reality: The Construction of Social Relations in a Muslim Community.* Chicago: University of Chicago Press, 1984.

Rosenthal, Franz. *A History of Muslim Historiography.* 2d ed. Leiden: Brill, 1968.

Royaume du Maroc. *Analyses et tendances démographiques au Maroc.* Rabat: Centre d'Études et de Recherches Démographiques, 1986.

Said, Edward W. *Orientalism.* New York: Vintage, 1979.

Salamé, Ghassan, ed. *The Foundations of the Arab State.* London: Croom Helm, 1987.

Sanjek, Roger. "The Ethnographic Present." *Man* 26 (1991): 609ff.

Santucci, Jean-Claude, ed. *Le Maroc actuel: Une modernisation au miroir de la tradition?* Paris: CNRS, 1992.

Schram, Wilbur. *Communication and Change in Developing Countries.* Honolulu: East-West Center Press, 1967.

Servaes, Jan. "Development Theory and Communication Policy: Power to the People!" *European Journal of Communication* 1 (1986): 203–29.

Slyomovics, Susan. "Algeria Caricatures the Gulf War." *Public Culture* 4, no. 2 (1992): 93–100.

———. "To Put One's Fingers in the Bleeding Wound: Palestinian Theater under Israeli Censorship." *Drama Review* 35, no. 2 (1991): 18–38.

Smith, Anthony. *The Geopolitics of Information: How Western Culture Dominates the World.* New York: Oxford University Press, 1980.

Sontag, Susan. *On Photography.* New York: Farrar, Straus and Giroux, 1979.

Souag, Moha. *Les années U.* Rabat: Al Kalam Éditions, 1988.

Sraïëb, Noureddine. "Enseignement, décolonisation et développement au Maghreb." In *Introduction à l'Afrique du Nord contemporaine.* Paris: CNRS, 1975.

Sublet, Jacqueline. *Le voile du nom: Essai sur le nom propre arabe.* Paris: PUF, 1991.

Terrasse, Henri, and Jean Hainault. *Les arts décoratifs au Maroc.* Casablanca: Afrique-Orient, 1988.

Thompson, E. P. "Time, Work-Discipline, and Industrial Capitalism." *Past and Present* 38 (December 1967): 52–92.

Tozy, Mohammed. "Orient et Occident dans l'imaginaire politique d'un babouchier de Fès: Essai de lectures sur un mur d'images." In Kacem Basfao and Jean-Robert Henry, eds., *Le Maghreb, l'Europe et la France,* 237–50. Paris: CNRS, 1992.

Turner, Victor. *Dramas, Fields, and Metaphors: Symbolic Action in Human Society.* Ithaca: Cornell University Press, 1974.

Turnstall, Jeremy. *The Media Are American.* New York: Columbia University Press, 1977.

Valensi, Lucette. "Le roi chronophage: La construction d'une conscience historique dans le Maroc postcolonial." *Cahiers d'Études Africaines* 30, no. 3 (1990): 279–99.

Vergniot, Olivier. "Khatri Ould Joumani: Blagues à part." In Nourreddine Sraïëb, ed., *Pratiques et résistance culturelles au Maghreb,* 317–38. Paris: CNRS, 1992.

Veyne, Paul. "L'individu atteint au coeur par la puissance publique." In Veyne et al., *Sur l'individu,* 7–19. Paris: Le Seuil, 1987.

Virilio, Paul. *L'art du moteur.* Paris: Galilée, 1993.

———. *Guerre et cinéma.* Paris: Cahiers du Cinéma, Éditions de l'Étoile, 1984.

Wagner, Daniel. "Quranic Pedagogy in Modern Morocco." In L. L. Adler, ed., *Cross-cultural Research at Issue,* 153–62. New York: Academic Press, 1982.

Waterbury, John. *The Commander of the Faithful: The Moroccan Political Elite—A Study in Segmented Politics.* London: Weidenfeld and Nicolson, 1970.

Weber, Max. *From Max Weber: Essays in Sociology.* Ed. H. H. Gerth and C. Wright Mills. New York: Oxford University Press, 1946.

———. *The Protestant Ethic and the Spirit of Capitalism.* Trans. Talcott Parsons. New York: Scribner's, 1958.

Williams, Raymond. *Communications.* London: Penguin, 1968.

———. *Television: Change and Cultural Form.* London: Fontana/Collins, 1974.

Yonnet, Paul. *Jeux, modes et masses, 1945–1985.* Paris: Gallimard, 1985.

Zerubavel, Evitar. *Hidden Rhythms.* Chicago: University of Chicago Press, 1981.

Zumthor, Paul. *La lettre et la voix: De la "littérature" medievale.* Paris: Le Seuil, 1987.

INDEX

?dāb (literature, manners), 134

Abdelkrim, 10
Abélès, Marc, 65, 213n. 23, 216n. 22
ad-Doukkali, 23
Adam, André, 40
Adelkhah, Fariba, 167
Aesthetic: forms of, 4; Moroccan vs. European, 3; and power, 191
Aïn Chok (Black Source), 13, 49–50
Aissawa, 10
Akharbach, Latifa, 127
Akhchichine, Ahmed, 107, 128
Algeria, 5, 6; French language in, 86; image of, 88–89; time sense in, 106
Al Itihad Al Ichtiraki, 133
Alawite monarchy, 136
Alpha 55 (department store), 43; stock, 44–45
America: influence of, 127; television programs from, 60
Anderson, Benedict, 64
Anfa, 13, 28, 38, 51
Anthropology: on decline of tradition, 190; as reflexive activity, 16; as study of the state, 65–66, 210n. 6
Aouwaïta, 11
Arab League Park, 14, 45
Arabic language: and French, 86; use in Morocco, 16
Architecture, 205n. 14; place in art, 3
Aristotle, 98
Audiences: mass influence of, 3–9; in Morocco, 129–30; research on, 129
Automobiles, and social class, 38–39

Baïda, Jamāa, 220n. 22
Balandier, Georges, 76, 213n. 25
baraka (grace), in photographs and film, 11
Barka, Ben, 10
Barre, Raymond, 63
Barthes, Roland, 14, 123, 184
Baudrillard, Jean, 149–50
Ben Omar Center, 50
Bennouna, Khenatha, 138–39
Berbers, 94, 202n. 38; character of, 164; languages of, 16
Berque, Jacques, 61
Bidonville (shanty town), 49, 56, 57, 207n. 31; urbanity in, 57
Biography: attention to detail of, 172; limits of, 137–38, 221n. 4; in photographs, 173; and the sense of time, 109
Bogart, Humphrey, 26
Boundaries: as way of life, 148; risks of transgressing, 147
Bourdieu, Pierre, 36, 75; on aesthetic and ethical, 212n. 22; on time sense, 106, 109, 113, 117
Bouygues, 214n. 6
Brides, invisible, 176–81. *See also* Marriage; Videos; Weddings
Bromberger, Christian, 92, 95
Brown, Kenneth, on urbanity, 23
Brown, Peter, 134
Burke, Peter, 179

California, 38, 51
Capitalism: and the use of time, 105; resistance to, 166